I

The Monster Leviathan
Anarchitecture

Aaron Betsky

THE MIT PRESS
Cambridge, Massachusetts . London, England

When I was in high school in the Netherlands, a new shopping mall opened in my hometown. This was 1973, so I was fifteen years old. We went to the opening and found a pleasure palace that was much more than a collection of stores. Sailing over block after block of the medieval city of Utrecht and a canal turned into a new highway, it contained restaurants, conference centers, movie theaters, offices, apartment buildings, and, eventually, a brand-new concert hall. Connecting directly to the main train station, which had also been also transformed from a neoclassical hall next to industrial sheds into an airy expanse of metal and glass scaffolding, Hoog Catharijne, as the mall was called, meandered past sky-lit atria clad in acres of polished stone, leading you on with all the seduction a pulsating consumer society could produce. This was the new world, a utopia of air-conditioned wealth and spectacle.[1]

By the time I had attended my first architecture classes at college in the United States a few years later, I came back to find Hoog Catharijne not only already going to tawdry pieces as the action shifted to the renovated old canal zone next door but also, in my newly enlightened mind, a hopelessly outdated example of a failed utopia. Whatever we should do in architecture, it should not be this.

The high school I attended was another moment of utopia. Laid out as an open grid of courtyards surrounded by glass-faced corridors leading to classrooms clad in more glass, brick, and wood trim, it had no clear center and light everywhere. Most of it was on a single floor, and all of it was small in scale. After I graduated, it was torn down and replaced by a utilitarian, multilevel box.[2]

A third moment of utopia I encountered as a young man was the three-dimensional Mondrian that was the Schroeder-Schrader House, designed by Gerrit Rietveld in Utrecht in 1924. A puzzle of pure geometry, primary color, and movable walls, it was the ideal machine for living in. When I returned from college, it had become a house-museum, its elements presented to us as relics as we shuffled by on slipper-clad feet.

I had come to architecture after the belief in utopias had faded. No longer would the discipline solve problems and build a better world. Architecture could be fun, or it could be a warning sign of dystopian images, or it could try to rebuild an imagined

former order, whether modernist or neoclassical, but it could not and should not pretend to build a perfect or even perfectible environment.

Instead of utopia, I found the dystopias of science fiction worlds and the endless labyrinths of signs into which postmodern and "deconstructive" architecture devolved. Yet always there was the echo of something else, something that I felt architecture could and should be doing. Some said architecture was dead, while others thought it was just a form of communication. I continued to look for forms and images that might haunt this present world of limited possibilities and prospects.

I remembered another moment: before they tore down the old train station, my father and I would drive there on Sunday morning to the one newsstand that carried the London *Times*. My father would wait in the car while I picked up the paper. One time, when I got back into the car and started leafing through the sections, there was a monster leviathan spread out across the front page of the arts section: a sea-striding, metallic monster approaching New York. It was Ron Herron's proposal for a "Walking City," and its memory stayed with me.[3]

I encountered the leviathan again when I read the Frank Lloyd Wright essay that is the subject of this book's first chapter. Over the years, I found more monsters in architecture. Sometimes they were near-literal, such as the factories designed by Albert Kahn or the beasts devised by John Hejduk. Sometimes they were metaphorical, or landscapes that were somehow both alive and architecture. In recent years, they have often been only the ghosts in the machine that slip away behind the face of my cellphone as I look for the latest building tidbit.

I was primed for this mythology by my love of Greek mythology, gained from years of studying Latin and Greek in high school. There I was taught that the tense used in writing myths, the aorist, was particular in that it could indicate acts that might have happened and be over; might still be occurring; or could take place in some future time. Although later studies taught me that this was an overly simple explanation, it made me even more interested in worlds that might be there, in a time and place uncertain, and that serve as analogies to our own. They are just believable enough to convince us, and just fantastical enough to open our eyes. Their scenes are similarly ambivalent between human and divine or

natural constructions, and they are peopled by monstrous beings who might be beasts, gods, or just like us.

Over time, I began hunting these beasts, both in my criticism and in the theory courses I taught at the Southern California Institute of Architecture and, much later, the School of Architecture at Taliesin.[4] This book is the result of, or perhaps part of, that hunt. It is a collection of images and proposals that do not quite live and breathe, but that haunt architecture. They are neither utopian nor dystopian, but they give force to architecture's continual search for meaning. They are, above all else, a collection of images in the manner Reinhold Martin has proposed as an alternative to totalizing systems:

> After all, is it not possible to imagine that the politics of political ecology might lie in some small part in the struggle over specifically and irreducibly architectural images— images of laboratories as images, perhaps—that actively reimagine and reorganize, rather that domesticate, the relation between nature and culture? Far from constituting one or more set of consumables for Jencks's "radical eclecticism," and unlike those images that make up the oikos, the well-kept if more inclusive house of both ecology and economics on which Latour ultimately stakes his claim, such images could be called authentic. But their authenticity would lie neither in their immediate legibility nor in their free play. Instead, it would lie in their very real capacity to stir the imagination toward something different, something like what modernists used to call Utopia, which to our tired, postmodern eyes might yet again be new.[5]

The bits and pieces I have found are limited as a collection by my biases, by a knowledge base centered on the Western world and on my own tastes and preferences. I offer these fragments as a collage of possible architecture, what I will call, in a phrase I have collected with all the other descriptions and proposals in this volume, anarchitecture: another architecture, a possible architecture, and even an anarchist architecture that will continually break down the power of utopia and dystopia and free us to build a better world.

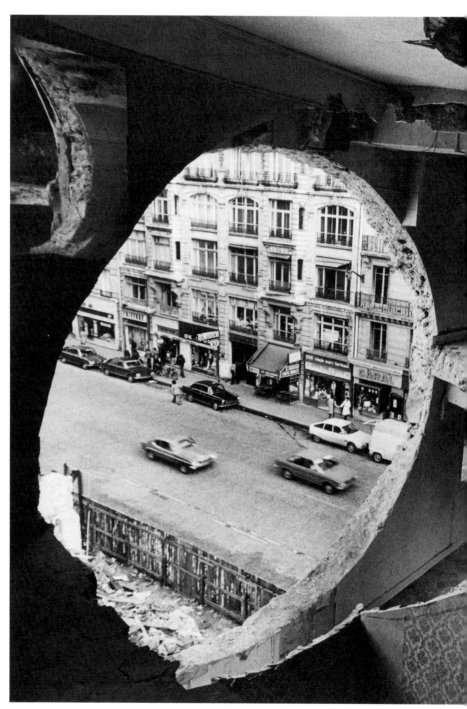

Gordon Matta-Clark, *Conical Intersect*, 1975 (© 2022 Estate of Gordon Matta-Clark / Artists Rights Society (ARS), New York).

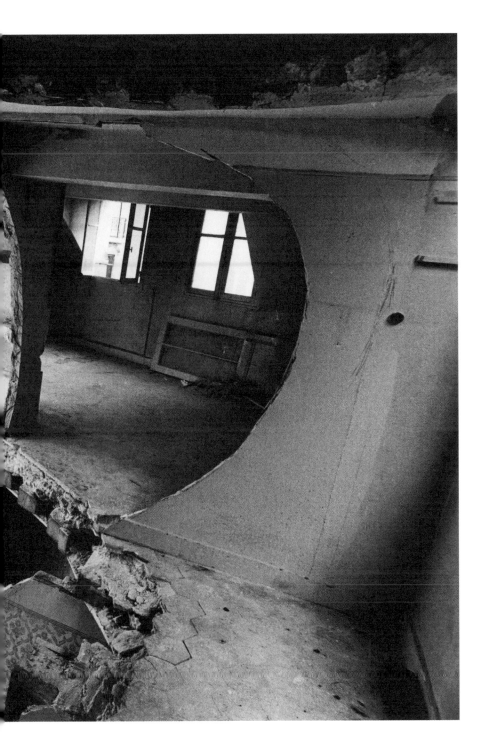

1 *The Monster Leviathan*

[The architect] must, somehow, tell us a fairy tale out of his head.
—John Ruskin, *The Two Paths*[1]

Imagine a young person in architecture. Filled with dreams of building a better world, they toil in an architecture office serving clients they do not know. Their work consists of helping to design efficient boxes. They wander the streets of the city or town where they live both admiring what past architects have left them and feeling that they can do better than most of what they see around them. They see a world full of human energy and violence, aspiration and nightmares, achievements and failings. On and in this world they want to operate.

Now imagine that young person is Frank Lloyd Wright, who has actually managed to open his own office and is busy designing structures that, in his own phrase, break boxes rather than just build them.[2] He can do so because he is living in Chicago at the beginning of the twentieth century. It is a city that is exploding, growing at a rate and scale most people who experience it find astonishing. Opportunities are everywhere, but so is social and economic injustice, along with filth and pollution. Wright, as member of a new generation of designers, thinkers, artists, and activists, is asked to speak at Hull House, the "settlement house" Jane Hull, who will later win a Nobel Prize for her work, has started to provide opportunities for workers, through education and what we today would call networking, to better their lot. Hull House also serves as a hub for those who believe in building that better

Photographer unknown, downtown Chicago, c. 1900.

world.[3] Wright calls his lecture—which later, in a manner typical for him, he revises many times, eventually into a completely different form—"The Art and Craft of the Machine."[4]

How does architecture contribute to such an effort? To answer that question, Wright focuses on what he sees as the engine of all of these promises and problems. That is, he presumes, exactly the engine: the machinery and technology that are mechanizing countless tasks, driving mass production, allowing for jumps in speed and scale that happen every day, and, at the same time, producing a world that is becoming less and less recognizable. The human-made environment is losing its human scale, the trace of the human hand, and any sense of a human community that together inhabits, continually remakes, and knows its environment. Things are changing too quickly and in ways that are not comprehensible to the senses. As Wright puts it in his address: "the machine goes on, gathering force and knitting the material necessities of mankind ever closer into universal automatic fabric; the engine, the motor, and the battleship, the works of art of the century! The Machine is Intellect mastering the drudgery of earth that the plastic art may live."[5] The task of the architect—or of any artist—is then to figure out how to use that machine.

That is easier said than done. As Wright points out, "the machine" encompasses not just actual tools and devices but the large processes of mass production, enhanced locomotion, mechanical systems such as lighting and heating, and also a taste culture that accepts the aesthetics that is the natural outgrowth of all this technology.

In this, Wright was just one of many voices around the world trying to define what was happening to the world into which they had been born and that was, through means they both could see and often found difficult to understand, changing into something they did not recognize. That change was, in fact, the biggest part of what they were grappling with: the continual movement of people, goods, and ideas, as well as the continual making and destruction of things, ideas, and even people, was the tenor of the times, if there was one. The critic Marshall Berman has vividly described these upheavals of twentieth-century modernization:

The maelstrom of modern life has been fed from many sources: great discoveries in the physical sciences,

changing our images of the universe and our place in it; the industrialization of production, which transforms scientific knowledge into technology, creates new human environments and destroys old ones, speeds up the whole tempo of life, generates new forms of corporate power and class struggle—immense demographic upheavals, severing millions of people from their ancestral habitats, hurtling them half-way across the world into new lives; rapid and often cataclysmic urban growth; systems of mass communication, dynamic in their development, enveloping and binding together the most diverse people and societies; increasingly powerful national states, bureaucratically structured and operated, constantly striving to expand their powers; mass social movements of people, and peoples, challenging their political and economic rulers, striving to gain some control over their lives; finally, bearing and driving all these people and institutions along, an ever-expanding, drastically fluctuating capitalist world market. In the twentieth century, the social processes that bring this maelstrom into being, and keep it in a state of perpetual becoming, have come to be called "modernization." These world-historical processes have nourished an amazing variety of visions and ideas that aim to make men and women the subjects as well as the objects of modernization, to give them the power to change the world that is changing them, to make their way through the maelstrom and make it their own.[6]

Any attempt to give shape to these processes, he says, is what we call modernism.

Wright's particular take on how to do this was peculiar, though rooted both in the traditions in which he was trained (in the office and through private reading and discussion, as he only attended one year of college, in engineering) and in the cultural life of Chicago at the time. Out of the various strands of idealism, transcendentalism, social activism, German phenomenology, and American pragmatism, Wright constructed the critique he articulated in his address.

He chose as his emblem of modernization not the steel mills, grain silos, slaughterhouses (which were then pioneering the mass production techniques Henry Ford was to adapt to the making

Is Man Doomed by the MACHINE AGE?

by BENNETT LINCOLN

Symbol of the Mechanical Age is the Robot, the iron man—Slave or Master?

View of an automatic telephone installation, a mechanical development which put thousands of "hello girls" out of jobs.

With thousands of men unemployed, many of them because machines have forced them out of their jobs, the old cry that man has created a Machine Age which will destroy him has been taken up again. Which is the true picture—is the Machine a destructive monster, or a means to leisure and wealth? Is our civilization doomed to destruction because of our dependence on machines? Read the opinions of eminent scientists and industrial leaders in this article.

EVER since the invention of the steam engine by James Watt in 1769—a date commonly accepted as marking the beginning of our present Mechanical Age of civilization—there have been two schools of thought regarding the Machine: one maintaining, with varying degrees of vehemence, that machines are works of Satan which will sooner or later engulf and destroy civilization; the other seeing in the mechanical age man's greatest hope for leisure and universal wealth.

As far as numbers go, those whose attitude toward the Machine Age is friendly are in the majority. Few of us, indeed, could conceive of living in an age or a country where there were no automobiles, or where power and light did not flow at the touch of an electric switch. Yet the present era of industrial depression, with millions of men thrown out of work—as some maintain, because machines have taken their places, working swifter and cheaper—has seen a renewal of the outcry against machinery. This protest was familiar to Arkwright, inventor of the spinning jenny, when his machine in 1769 began to put hand manufacturers of fabrics out of business; and familiar, too, to the engineers of the first locomotives who piloted their crude iron horses before the jeering

eyes of skeptics who held that the steam monsters were a violation of the laws of God, man, and common decency.

Well, where are we heading? Will machines, sooner or later, destroy civilization by putting all men out of work and concentrating wealth in the hands of a few? It is only fair to point out that machines create new jobs as well as destroying old ones.

Take the example of the radio. This invention has been with us ten years. During that time half the homes in America have been equipped with receiving sets, and the building of these millions of receivers has employed thousands of men and women. This is the pleasant side of the picture. Now let's look on the other side. The business of manufacturing and selling pianos, and, to a lesser extent, other musical instruments, has confessedly slumped. It is usual to charge this slump to the radio and other forms of mechanical music, which have supplied the need for music in the home. Business fell off alarmingly for talking machine manufacturers until they, too, started turning out radios, either alone or in combination with their standard product.

The obvious answer is that the invention of a new machine may throw out of work men in a particular job, but at the same time the

A play recently presented in New York depicts mankind, as represented in a man and a woman, hopelessly enmeshed in a tangle of machinery which eventually destroys them. This is typical of a current attitude toward the Mechanical Age. A scene from the play is shown above.

Bennett Lincoln, "Is Man Doomed by the Machine Age?," *Modern Mechanics and Invention*, March 1931.

of automobiles just a few years later),[7] or trains, but the printing press.[8] In this, he followed the comment Victor Hugo, in *Notre-Dame de Paris* (*The Hunchback of Notre Dame*, 1831), has his main villain, Archdeacon Frollo, make. He points from the first edition of the Gutenberg Bible to the Paris cathedral and proclaims: "Ceci tuera cela" (this will kill that).[9] Hugo's argument is that the availability of knowledge made possible by this prototype for mass production will render unnecessary both the framing device for faith and the idealization of that belief into one form. In the future, knowledge will lead to multiple interpretations, technologies, and communities that will gather around linguistic codes.[10]

For Wright, this great danger is also a source of redemption (a theme that many other artists and thinkers developed, as we shall see, in confronting modernization):

> The new will weave for the necessities of mankind, which his Machine will have mastered, a robe of ideality no less truthful, but more poetical, with a rational freedom made possible by the machine, beside which the art of old will be as the sweet, plaintive wail of the pipe to the outpouring of full orchestra. It will clothe Necessity with the living flesh of virile imagination, as the living flesh lends living grace to the hard and bony human skeleton. The new will pass from the possession of kings and classes to the every-day lives of all—from duration in point of time to immortality.[11]

The printing press, in other words, will be, as he goes on to say, a kind of engine of democracy, one that will allow more and more people to participate in the processes of production and consumption. It will do so with the knowledge that will allow them to discern the good from the bad, and the beautiful from the ugly.

To achieve this position, however, the machine has to be both liberated and controlled. In the Chicago he inhabits, Wright sees technology producing "masks" that not only hide the skeletons of the new skyscrapers, but in so doing produce a false image that precludes a true knowledge of and thereby control over built reality.[12] The basic problem is that the machine is used in an additive rather than a subtractive manner: the lathe can reveal the true nature of wood and make best use of it, but instead it is being utilized to produce ornaments that are pasted onto the skeleton

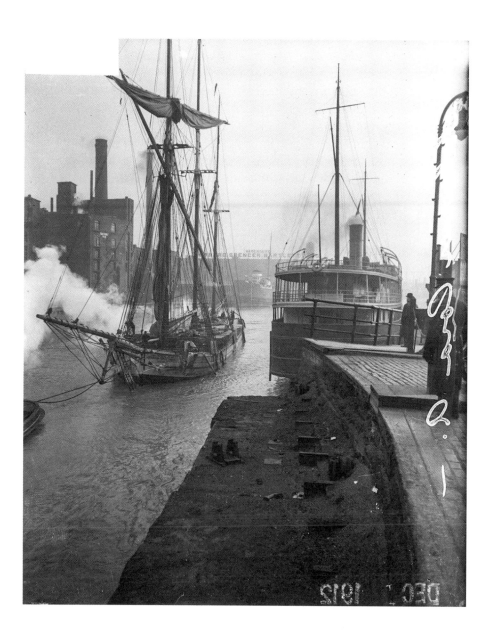

A. Cora, *Schooner, in a Chicago Port, after Trip from Washington Island, Wisconsin through Heavy Weather, 1912* (Chicago Daily News collection, Chicago History Museum).

of a piece of furniture, thereby both wasting time and material and producing a constructed lie. This is true for buildings as well, which architects cloak in ornaments from other times and places that do nothing to reveal what is below them, and thus do not allow users and observers to understand and make their own the true nature of the constructions.[13]

Wright calls for using new materials and processes, such as electroplating, and for employing the machine not just to make the meaning, but to make the objects of daily life available (through cost-reducing mass production) to the masses. To steer this effort, he proposes a "society of mutual education," perhaps not unlike Hull House, that will work with manufacturers, visit factories, hold debates, host lectures, and organize exhibitions. Led by architects (of course), who will be not so much artists themselves as conductors of an orchestra, this community of learning and experimentation will then guide both the makers (the companies and factories) and the masses in the uses of the machine as a tool to further democracy and what we today might call empowerment.[14]

In this model, Wright brought together in particular the work of pragmatists such as John Dewey and Francis Wayland Parker, who were then working to reform American education with Chicago as their base, with the tradition of arts and crafts communities that had emerged in England in the previous decades. Dewey had started a School of Education at the University of Chicago, while Parker led a high school dedicated to the same principles of reality-based learning. Both were dedicated to democratizing higher education through the development of trade- and craft-based academies, but also believed that society as a whole could benefit by basing its knowledge on direct experience of the real world and experimentation on it.[15]

The handicraft-based communities that started in England around the 1880s, and from there spread throughout the world, based themselves instead largely on the teaching of John Ruskin, and in particular on his 1862 *The Two Paths*—at one point the most-read treatise on art in the world.[16] Ruskin and his followers, most notably the entrepreneur William Morris, offered an alternative to the world of mass production and industrialization. They argued for the founding of small communities whose inhabitants would literally remake their own reality.[17] They would let themselves be guided in their work by the notion that whatever humans created should be an interpretation and expression of

natural laws and forms—what Wright would think of as organic design. As Ruskin said:

> We are about to enter upon a period of our world's history in which domestic life, aided by the arts of peace, will slowly, but at last entirely, supersede public life and the arts of war. For our own England, she will not, I believe, be blasted throughout with furnaces; nor will she be encumbered with palaces. I trust she will keep her green fields, her cottages, and her homes of middle life; but these ought to be, and I trust will be, enriched with a useful, truthful, substantial form of art. We want now no more feasts of the gods, nor martyrdoms of saints; we have no need of sensuality, no place for superstition, or for costly insolence. . . . So also, in manufacture: we require work substantial rather than rich in make; and refined, rather than splendid in design. Your stuffs need not be such as would catch the eye of a duchess; but they should be such as may at once serve the need, and refine the taste, of a cottager. . . . It should be one of the first objects of all manufacturers to produce stuffs not only beautiful and quaint in design, but also adapted for every-day service, and decorous in humble and secluded life.[18]

"Let it be for the furnace and the loom of England," he concludes, "as they have already richly earned, still more abundantly to bestow, comfort on the indigent, civilization on the rude, and to dispense, through the peaceful homes of nations, the grace and the preciousness of simple adornment, and useful possession."[19]

Ruskin and Morris, who gave that wish a concrete expression, inspired numerous concrete experiments in this area, such as the small community C. R. Ashbee started in Chipping Camden, which would later inspire Wright to start his own intentional community, Taliesin.[20] The German and Austro-Hungarian *Werkstätte* and the American Roycrofters also based themselves at least partially on these principles.[21]

Having laid out a methodology and a set of guiding principles—at least in the general terms a lecture allowed[22]—Frank Lloyd Wright then takes a remarkable turn at the end of his address.[23] Instead of either summing up his points or offering concrete action plans, he steps back from his analysis to offer a vision of Chicago.

Photographer unknown, C. R. Ashbee workshop, Chipping Camden.

It is neither a description of the city, at least in any way his listeners could recognize, nor a critique, but rather an evocation of what he saw as the metropolis's essence and therefore both its danger and its promise.[24]

"Be gently lifted at nightfall to the top of a great down-town office building," he starts, "and you may see how in the image of material man, at once his glory and menace, is this thing we call a city." Having established the traditional perspective of the architect, which is to say the God's-eye view hovering over the scene (and one that parallels Victor Hugo's own "Paris à vol d'oiseau" in *Notre-Dame de Paris*), Wright conflates that with the view from the top of what was then the pride of Chicago's architecture, the downtown skyscraper. Perhaps his time working for his "Lieber Meister," Louis Sullivan, whose office was at the top of the Adler & Sullivan-designed Auditorium Building, for a while the tallest building in the United States, gave him such a perspective.[25] What he sees from there is a supremely human creation. But in the next sentence the tone shifts:

> There beneath, grown up in a night, is the monster leviathan,[26] stretching acre upon acre into the far distance. High overhead hangs the stagnant pall of its fetid breath, reddened with the light from its myriad eyes endlessly everywhere blinking. Ten thousand acres of cellular tissue, layer upon layer, the city's flesh, outspreads enmeshed by intricate network of veins and arteries, radiating into the gloom, and there with muffled, persistent roar, pulses and circulated as the blood in your veins, the ceaseless beat of the activity to whose necessities it all conforms.[27]

Suddenly, the city is a living monster, made of flesh, veins, and arteries, and with a pulse. This is a supreme beast, controlling all. As Wright describes this animate city, suddenly we are back to the notion that it is something human, but now in an altered, almost unrecognizable form:

> Like to the sanitation of the human body is the drawing off of poisonous waste from the system of this enormous creature; absorbed first by the infinitely ramifying, thread-like ducts gathering at their sensitive terminals matter destructive to its life, hurrying it to millions of small

intestines, to be collected in turn by larger, flowing to the great sewer, on to the drainage canal, and finally to the ocean. This ten thousand acres of flesh-like tissue is again knit and inter-knit with a nervous system marvelously complete, delicate filaments for hearing, knowing, almost feeling the pulse of its organism, acting upon the ligaments and tendons for motive impulse, in all flowing the impelling fluid of man's own life.[28]

The description now keeps sliding between that of a city, that of an animate but not recognizable being, and that of a human. This uncertainty continues in the next paragraph, where another image mixes in, that of a machine:

Its nerve ganglia!—The peerless Corliss tandems whirling their hundred ton fly-wheels, fed by gigantic rows of water tube boilers burning oil, a solitary man slowly pacing backward and forward, regulating here and there the little feed valves controlling the deafening roar of the flaming gas, while beyond, the incessant clicking, dropping, waiting—lifting, waiting, shifting of the governor gear controlling these modern Goliaths seems a visible brain in intelligent action, registered infallibly in the enormous magnets, purring in the giant embrace of great induction coils, generating the vital current meeting with instant response in the rolling cars on elevated tracks ten miles away, where the glare of the Bessemer steel converter makes a conflagration of the clouds.

More quietly still, whispering down the long, low rooms of factory buildings buried in the gloom beyond, range on range of stanch, beautifully perfected automatons, murmur contentedly with occasional click-clack, that would have the American manufacturing industry of five years ago by the throat to-day; manipulating steel as delicately as a mystical shuttle of the modern loom manipulates a silk thread in the shimmering pattern of a dainty gown.[29]

This beast-city-factory-man thus produces something: some form of cloth or veil. Rather than reproducing itself, as you might expect, or making recognizable extrusions, it produces something that contrasts with the machinic and dense nature Wright has

Chapter 1

evoked above. Then the next paragraph returns to the notion that what we are observing is the industrial city:

> And the heavy breathing, the murmuring, the clangor, and the roar!—how the voice of this monstrous thing, this greatest of machines, a great city, rises to proclaim the marvel of the units of its structure, the ghastly warning boom from the deep throats of vessels heavily seeking inlet to the waterway below, answered by the echoing clangor of the bridge bells growing nearer and more ominous as the vessel cuts momentarily the flow of the nearer artery, warning the current from the swinging bridge now closing on its stately passage, just in time to receive in a rush of steam, as a streak of light, the avalanche of blood and metal hurled across it and gone, roaring into the night on its glittering bands of steel, ever faithfully encircled by the slender magic lines tick-tapping its invincible protection.[30]

Wright telescopes in on this view, finding what he believes is the true heart of this mythical thing, and revealing what the veil-like material might be that this city-beast is producing. It turns out to be the very thing that has killed the need for traditional building (as Hugo's Archdeacon Frollo would have it):

> Nearer, in the building ablaze with midnight activity, the wide white band streams into the marvel of the multiple press, receiving unerringly the indelible impression of the human hopes, joys, and fears throbbing in the pulse of this great activity, as infallibly as the gray matter of the human brain receives the impression of the senses, to come forth millions of neatly folded, perfected news sheets, teeming with vivid appeals to passions, good or evil; weaving a web of intercommunication so far reaching that distance becomes as nothing, the thought of one man in one corner of the earth one day visible to the naked eye of all men the next; the doings of all the world reflected as in a glass, so marvelously sensitive this wide white band streaming endlessly from day to day becomes in the grasp of the multiple press.
> If the pulse of activity in this great city, to which the tremor of the mammoth skeleton beneath our feet is but

an awe-inspiring response, is thrilling, what of this prolific, silent obedience?[31]

Finally, Wright sums up what he has seen, proclaiming it to be truly a fact, an organic being that we cannot control or even truly know: "And the texture of the tissue of this great thing, this Forerunner of Democracy, the Machine, has been deposited particle by particle, in blind obedience to organic law, the law to which the great solar universe is but an obedient machine." Stepping back from the image he has painted in words, Wright then proclaims: "Thus is the thing into which the forces of Art are to breathe the thrill of ideality! A SOUL!"[32]

Wright's version of Chicago is a mythical one, in the root sense of that mode of rhetoric: it presents a world that may have existed in the past, may exist in the future, may exist somewhere else, or may, in fact, be our reality, except that we do not see it as such. In this case, it is Chicago as a productive city, a machine, a beast, and a human, all at the same time. We can recognize parts of the metropolis, from its port to its factories and its newspaper offices, but they are all both interconnected and subsumed by animate forces. They have tissue and flesh, veins and nerves. They operate as one whole, while countless operations take place independently and automatically. This "monster leviathan" evokes—whether consciously or not—imagery from the Bible and literature, but also the interpretations and extensions of that first mention of the leviathan in the paintings of Thomas Cole or the prints and poetry of William Blake, and in the popular press of the time.

This Chicago, however, does not have Blake's "chartr'd streets" where the poet encounters "marks of weakness, marks of woe."[33] Nor is it Cole's capital of an Empire, doomed to fulfill its destiny by growing mighty and then falling apart due to its own hubris and sins.[34] Wright's Chicago is not the poet Carl Sandburg's active place of violent production and destruction,[35] nor is it the bustling, comprehensible, and ultimately soulless city Theodore Dreiser describes in *Sister Carrie*.[36] If it resembles anything, it is the futurist city as evoked by F. T. Marinetti, painted by Giacomo Balla, and proposed as a mechano-organic landscape by Antonio Sant'Elia.[37] For Wright, however, what he is describing is not necessarily something to be adored, let alone fought in and for. Rather, it is a rough, primeval landscape waiting for architects and their fellow thinkers and artists to perform some alchemic

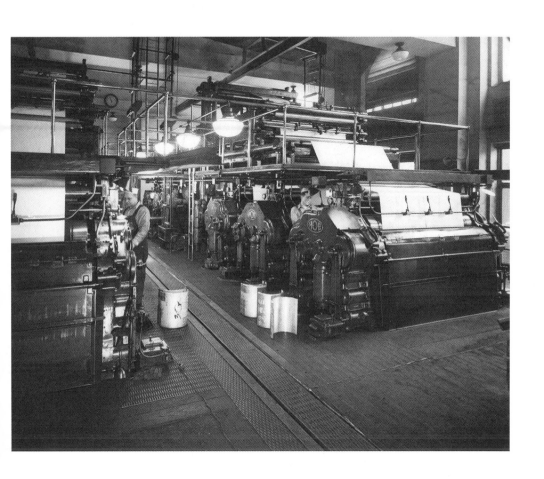

Photographer unknown, *Los Angeles Times* printing press, c. 1900.

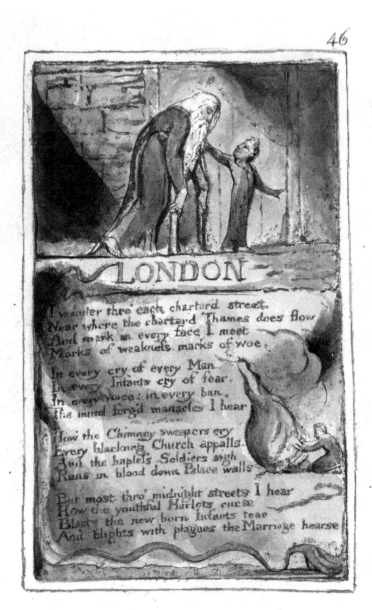

William Blake, "London," from *Songs of Innocence and of Experience*, 1789 (Fitzwilliam Museum, Cambridge).

act on it—or a vision of a negative future the architect must prevent through a similar activity. If there is any piece of writing that comes close to Wright's alternative Chicago, it is Henry Adams's more cosmic experience upon visiting the World's Columbian Exposition there in 1893:

> Did he himself quite know what he meant? Certainly not! If he had known enough to state his problem, his education would have been complete at once. Chicago asked in 1893 for the first time the question whether the American people knew where they were driving. Adams answered, for one, that he did not know, but would try to find out. On reflecting sufficiently deeply, under the shadow of Richard Hunt's architecture, he decided that the American people probably knew no more than he did; but that they might still be driving or drifting unconsciously to some point in thought, as their solar system was said to be drifting towards some point in space; and that, possibly, if relations enough could be observed, this point might be fixed. Chicago was the first expression of American thought as a unity; one must start there.[38]

By creating such a metropolis of myth, Wright is able to represent what he sees as the appearance of the city's reality, and to bring out its essence. He makes it recognizable and strange at the same time, creating a sense of the *unheimlich* at an urban scale.[39] He also is able to define what needs to be done—somehow drape the veil of architecture over this thing to cloak it with forms that will make it more democratic by drawing out its essence and offering an alternative to the printed word—without spelling it out and thus letting words rule.

While this is a remarkable achievement in terms of the creation of an urban vision and a role for architecture—one that Wright was never able to match in the hundreds of thousands of words he wrote over the course of his more than nine-decade-long life—what is even more interesting is the claim it makes for architecture as the production not of something new, different, or other, but as the drawing out of the reality of our world. This was a claim Wright did continue to develop throughout his life, claiming that, however strange or new the forms he designed looked, they were no more and no less than the "organic" nature of the site,

the program, the materials, and the larger laws of the universe, as his genius was able to draw them out and make them visible. The notion of architecture as not speaking, but revealing, whether nature, material, or structural forces, justified his practice.

In the much later "To the Young Man in Architecture," Wright in fact disavowed the very notion of modernity, claiming instead that all he saw was a "scientific affirmation of an old order."[40] The truly modern, he claimed, was "power, that is to say, material resources, directly applied to purpose."[41] He agreed with Le Corbusier that a house might be a "machine to live in" (in a slight mistranslation of the original) but claimed that "architecture begins where that concept of the house ends."[42] That architecture, he made clear elsewhere, would be an unfolding from the innate nature of site and material: "I have used the machine and evolved a system of building from the inside out, always according to the nature of both man and machine."[43]

In so doing, however, he found himself caught in the position every architect does: in claiming to reveal, he built a complex fact whose true meaning or import remained hidden within the building itself. An observer might be able, if they studied a Wright-designed building long enough, to discern some sense of its significance, but the moment they articulated it, that meaning had already turned into words and was no longer inherent in the building. The built artifact becomes the tomb of architecture, holding and memorializing its essence, but burying it as well.

What Wright held onto in "The Art and Craft of the Machine," if only for a moment, was the notion of an architecture that did not inhere in building but was evoked through words. The other way he was able to create such architecture was in his drawings, especially the partial perspectives, fading into landscapes, or combinations of plans and views, that he continued to either produce or have his office make under his direction throughout his life. It was architecture, in other words, that existed as preparatory or descriptive, evocative or analytic, rather than as buildings. Wright's myth-telling at the end of this short lecture was a palimpsest, but a double one: it traced both the scene in which he operated and his architecture, like a translucent veil.

This is, of course, how some of the best architecture has operated. By "best" I mean architecture that is able to effect its significance or impact in the most impactful way. There is a cliché that buildings are, as the core of architecture's discipline, its most

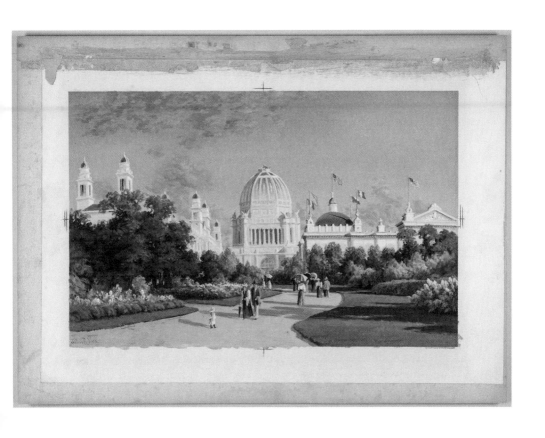

John R. Key, *Administration Building at the World's Columbian Exposition*, 1893 (Chicago History Museum).

complete representation and highest achievement. I would argue that, instead of these mute monuments to intentions, we should look instead for architecture before or after, within or beyond the building.[44]

This is not only because buildings are built compromises, both in an aesthetic and a social sense, as they have to grapple with the reality of materials, structure, site, codes, and client wishes, but also, and perhaps at a more fundamental level, because of the problem of transference. First used in 1915 by Sigmund Freud to describe the manner in which patients transfer their desires and fears to the analyst,[45] which allows them to come to terms with them in a concrete manner but also puts patient and doctor at risk of romantic entanglement, its definition has changed over time to encompass a variety of tricks of consciousness and false mirroring that could be either coping mechanisms or rabbit holes of deferred desire and further enslavement to misplaced phobias and fascinations.[46] What has remained is the ability, which Freud proposed, to suspend the dreams or images transference evokes as such, which is to say, as "something unreal . . . a fantasy."[47] In architecture, it was adopted by Bernard Tschumi in 1987 to describe the manner in which a building (in this case, Tschumi's design for the Parc de La Villette in Paris) could become the emblem of modernism's insanity—one driven by the inherent contradictions of modernization.[48]

In a more general sense, however, transference in architecture means the way the client has to transfer their inchoate hopes and desires to the architect, hoping they will receive back some concrete embodiment of those hopes in the building they are commissioning. Whether more or less successful, this process certainly is clear in its mode of operation. More troublesome is the architect's own transference. Most of what they produce is a proposal that has to embody the wishes and visions of the client. Even if they are building something for themselves, they still must fit whatever they want to build into the images and forms society demands of them through codes, building regulations, zoning ordinances, and other legal models, as well as through popular expectations of what a building truly is. The architect as architect is committed to designing what they see as right, beautiful, or needed, but the only way to do so is to realize that ideal model to which they aspire as a desired object or image. The building as an ideal is what embodies the architect's desires, what makes them whole, but when it comes

Chapter 1

to actualizing the ideal, their desires become bound up not only with material reality but with societal and client visions.

This situation is codified in the discipline's professional definition. As most associations of architects around the world see it, and as the profession is codified in laws and regulations, architecture is a service profession, in which the designer's task is to translate the needs of the client in the most efficient manner possible. The final product's appearance is dictated by innate social norms or the necessary character of the particular type of building. If there is any expression involved, it serves either to make the building appear appropriate or as a form of advertising or monumentalizing the client's life or beliefs.[49]

Since the end of the seventeenth century, architects have found ways to produce architecture that avoids the problem of transference or, rather, that keeps that process under their control. They have done so by making their fantasies, at least in some manner, real. They have done so by creating utopias or dystopias, or visionary or distorted versions of built reality.[50] The *locus classicus* for such attempts lies in the work of Giovanni Battista Piranesi, the Venetian architect who built only one structure (a small church for the Knights of Malta in Rome), but who not only found a way to make his fantasies pay, but influenced the course of architecture around the world through his etchings that were both archaeological and inventive in nature.

Piranesi's prints, which were a commercial venture in which he involved several of his children, served as mementos of Rome to the aristocrats and nouveaux riches who made their way to the city on their Grand Tour of Europe. What Piranesi gave them, as many critics have noted, was something both more and less than postcards of the Eternal City. While his *Vedute*, or views, claimed to show the ruins of imperial Rome, they were in fact combinations of inventions and digs that turned the past into a source of an architecture that, though made mostly of the elements that were on a site, used that base material as a kind of *spolia*, or remains, from which to construct an alternate Rome. That imagined city's scale was vast and overwhelming. It mixed various religious and imperial buildings together and also gave room to contemporary observers, hermits living in huts, and nature running rampant over the ramparts.[51] It was also a model, as the critic Susan Stewart has pointed out: "What is the function of such a ruins image for Piranesi? As we can tell from the climbing and discoursing figures

Giovanni Battista Piranesi, *Veduta dell'avanzo del Castello*, from *Vedute di Roma*, c. 1758.

a fontana che gli'era aderente, e decorata da M. Agrippa fra gli altri ornamenti de' Trofei d'Augusto che ora si
r di Pistole sul Monte Celio
amandavano l'acqua nella fontana, e per il Celio 4. Muri e Casino moderni 5. Villa Palombara.

scrambling about the scene, the ruin is a site of discovery, valued intrinsically as an index to the building it once was, as a model for future building, and as an evidence of a tradition."[52]

Even more inventive and famous were the *Carceri*, or prisons, which appear to have been based only vaguely on existing catacombs or places of imprisonment. Instead, they offered another world, one buried underground, in which gravity and logic gave way to labyrinths of towers, stairs, bridges, and canted walls that spiraled up to an unseen source of light. We assume that there, beyond the top edge of the image, is our real world, but our point of perspective puts us firmly at the bottom of the drawing, part of this other world and removed from reality. As Stewart says:

> The vast and looming *carceri*, their stairs and ladders leading to nowhere, continually drawing the eye upward to where glimpses of "life" and light might appear, as they do to the inhabitants of Plato's cave, are defined by lack. We search in vain for exchange beyond pain, finding the inexorable fact of human limits within a silence that cries or screams would only echo or erase.[53]

She concludes: "All of Piranesi's early work manifests the tension between the closed actuality of material fact and endlessly open possibilities tradition offers to invention."[54] The critic Manfredo Tafuri is even clearer, also in terms of the connection between Piranesi's work and Wright's leviathan: "Here the order in the details does not produce a simple 'tumult in the whole.' Rather, it creates a monstrous pullulation of symbols devoid of significance." "Formal invention," he goes on to say, "seems to declare its own primacy, but the obsessive reiteration of the inventions reduces the whole organism to a sort of gigantic 'useless machine.' . . . The archaeological mask of Piranesi's Campo Marzio fools no one: this is an experimental design and the city, therefore, remains an unknown."[55]

If Piranesi imagined worlds buried under our feet, or in the past, three French architects working right before, during, and after the French Revolution performed a similar operation on the future. The triad—Claude-Nicolas Ledoux, Étienne-Louis Boullée, and Jean-Jacques Lequeu—made famous by Emil Kaufmann in 1952 in his *Three Revolutionary Architects*,[56] still stand today as a confluence of approaches and images that came out of a desire both to

found architecture on more fundamental principles—be they geometric, structural, classical, or typological—and to create forms that would be appropriate for a new sort of society, one of absolute order and revelation. Developed from a standard practice, their most interesting designs were liberated by the French Revolution, both because they had to find other work, and because they joined the efforts to refound reality according to revolutionary principles. The work combined this return to sources with an interest in designing the festivals and creating the monuments needed by the new regime. None of those monuments were built, although the most practical and successful of the three architects (in a professional sense), Ledoux, also proposed and constructed buildings.

The strangest and least discussed of the three was Lequeu.[57] His was work rife with Masonic symbolism, evoking tombs and tents rather than palaces or factories. Its sources were as eclectic as Piranesi's, but where the latter looked toward the unity of classical civilization, Lequeu looked to a confluence of mystical cults and hidden practices whose enigmatic quality the precision of the drawings belied. In a more direct sense, they were also designs for theatrical events and public performances, and thus looked toward the history of masques which, already in the sixteenth century, had presented alternatives to the formalization under state control of both architecture and theater. As forms, they were also related to the fantastical and symbolic gardens of Bomarzo in Italy and the Désert de Retz in France.[58]

What these projects had in common, along with the many utopias that spread throughout both the Western world and the field of architecture in the nineteenth century, was a refusal by their practitioners to accept both the society in which they lived and operated and the role they played in its social and economic relation. Instead they drew, and in rare instances built, alternative worlds. While the intentional communities and utopian colonies they founded rarely lasted very long and were rife with contradictions, the images they produced had a continuing effect. They offered architects an alternative model, or a form of escape. This was—and is—especially important both to young architects trying to find a way to define their own placc in the discipline, and to those architects who continue to resist the normative definition of their societal role.[59]

Less important than what actual modes of living or building these utopias proposed is how they installed themselves in the

discipline as an unending stream of theoretical projects. They also resulted in the creation of spaces, often ephemeral or hidden, that gave sensual and immediate moments of realization for their fantasies. These places ranged from certain interiors and gardens to the flickering world that appeared in the pages of literature and later on the screens of movie theaters, televisions, and computer monitors. As Philip E. Wegner puts it:

> They are not real in that they portray actual places in the world; rather they are real . . . in that they have material, pedagogical, and ultimately political effects, shaping the ways people understand and, as a consequence, act in their worlds. In short, narrative utopias serve as a way both of telling and of making modern history, and in this lies their continued importance for us today.[60]

While mainstream architecture continued to build on its past achievements and work toward ever more efficient construction practices, a kind of palimpsest of architecture developed as what I would call "anarchitecture," following the coinage by the artist Gordon Matta-Clark for an exhibition of his work in 1974[61] and later picked up by the architect Lebbeus Woods (who also called it "an architecture of resistance").[62] The phrase invokes three ideas: that this is a possible architecture, "an architecture" rather than the normative "architecture"; that it is an architecture that is analogous, a parallel world that unfolds at the same time, within, through, or somehow about (in both senses of the word) architecture; and the suggestion that there might be something anarchistic about it, which is to say that it proposes or imagines architecture that fights, rather than affirms, order and power, and that it represents or enables self-organizing and free communities.[63]

The first of these ideas is semiotic but serves to break open the monolith of architecture-as-building. If it is possible to have more than one architecture, this undercuts the profession's definition of itself as striving toward efficiency and total modernism, which is to say the correct representation of all current conditions, from the prevailing microcosm of functions and material properties to larger social and philosophical conditions. Moreover, it opens up the possibility of architecture existing through interpretation or perspective. Each user or observer, but also each maker, whether architect, client, or construction worker, creates in time and space

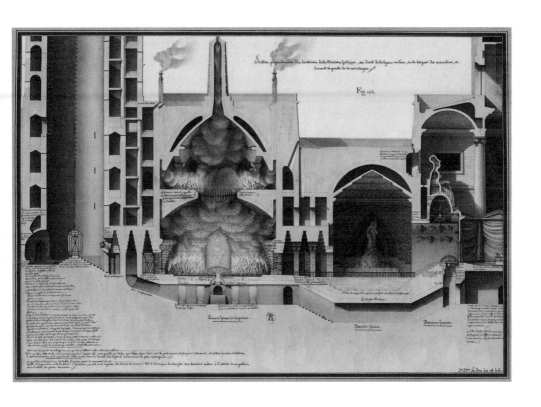

Jean-Jacques Lequeu, Underground of a Gothic House, from *Civil Architecture*, 1794
(Bibliothèque Nationale, Paris).

an architecture out of the built environment or its evocation. If architecture is the product of representation, projection, construction, use, and interpretation, that means that many architectures can exist over time and in space, extending, overlapping, and curling back on each other.

All this also means that the building is itself mute, a fact that critics who think that a building "says something" would do well to keep in mind. Buildings might be the tomb of architecture, as the critic Mark Wigley (building on the work of Anthony Vidler and others) has pointed out, but it is a leaky tomb: possible architectures emanate from its constructed form, escaping from this place of burial and being built upon it as a superstructure.[64] As a built fact, it maintains the properties of real things, including their necessary resistance to human forces, their changing over time, their accretion of additions, and their fundamentally inessential qualities. The building can never be an ideal, in a Kantian or almost any other definition. Its use over time adds even more complexity, from marks to furnishings to narratives, which supersede the geometries and statics of construction. Finally, because the building by definition is based on existing knowledge and practices, it always reminds us of something: buildings we have known, their types, the forces inherent in them, or what we have experienced in these structures. In all these ways, Wigley point out, a building lets in exactly what it means to bury, which is the unconscious, the unknowable, that which is bigger or beyond us, whether it be nature or some sense of primal self: Freud's unnatural fantasies cannot be repressed. Buildings try to structure, to organize, to allocate, but wind up becoming harbors for all that we cannot and perhaps do now want to know.

The parallel, ephemeral construction that seeps out and envelops the building is thus fundamentally different from that of built architecture and cannot be removed or posed against it. It is what you perceive, if we can use that word, in a glance. In this manner, it avoids the barriers of selection and sorting according to relevance, whether according to some primeval "flee or shelter" mechanism[65] or to operate efficiently in society, while also not overwhelming you—an alternate manner of knowledge that can thus be your own. Two important definitions I will discuss later come into play here: the notion of the work of art seen in distraction,[66] and the notion of "representational space" as opposed to "representations of space."[67] Both point to the ability for a certain awareness

of spatial and material properties assembled in the structure of a building or buildings to create an amount of freedom for the individual human. This space of the self-in-the-world is ephemeral by its nature and cannot be described without destroying it; it can only be experienced, if only for a moment, and evoked. According to Frances Richard, Gordon Matta-Clark himself continually sought such hidden, latent architecture:

> For Matta-Clark . . . hidden space beckons thought, and a wall is never simply a surface. Like subway tunnels, tombs, sewers, catacombs, the New York Central Railroad tracks, or the down-going stairway-hole dedicated to [dead twin brother] Battan, the COMPLETELY WOVEN UNDERGROUND is a web of interrelation. If shadows play *in* the wall, the wall must be penetrable, honeycombed with cracks along which paradoxically dimensional shadows flit. One of Matta-Clark's names for this signifying cleavage is "the thin edge." Another is "the space between." In keeping with his resistance to theoretical fixity, he never distinguishes these terms from one another. . . . The thin edge describes a dimension of built structure that has been sliced edge-on, revealing the LAYERED REALITY of construction materials and air pockets trapped between them. . . . The space between, conversely, is secondary—or prior—to structure, latent in the negative spaces that perforate the built environment. The space between is that-which-is-not-structure, and no one has put it anywhere to purpose. No severance is necessary to create or reveal it, for it is made of air; its constitutive division occurs when some object interrupts it. The thin edge is hidden, interior. The space between is mobile.[68]

It is thus also not possible to consciously build for such experiences. At rare times, however, anarchitecture can be evoked or made possible through building. To make this occur, the architect has to consciously or unconsciously engage in an act of queering. By this I mean some form of "strange making": design that at first might seem to be normal, which is to say, appropriate to its function, its site, and prevailing taste culture, that might be correctly assembled and have the right hierarchy of elements, and which "works" on every level of use and perception, but which has something odd or eerie about it. As the critic Mark Fisher puts it:

The eerie concerns the most fundamental metaphysical questions one could pose, questions to do with existence and non-existence: Why is there something here when there should be nothing? Why is there nothing here when there should be something? The unseeing eyes of the dead; the bewildered eyes of an amnesiac—these provoke a sense of the eerie, just as surely as an abandoned village or a stone circle do. . . . The perspective of the eerie can give us access to the forces which govern mundane reality but which are ordinarily obscured, just as it can give us access to spaces beyond mundane reality altogether. It is this release from the mundane, this escape from the confines of what is ordinarily taken for reality, which goes some way to account for the peculiar appeal that the eerie possesses.[69]

That strangeness can come either through a lack or a surfeit. There can be gaps or lacunae in the design, like the slit in the master bedroom in Peter Eisenman's House IV, which runs right through the marriage bed, or like the partial frames, missing handrails, or fragments of walls in the houses of Luis Barragán. The surfeit can consist of elements that are redundant, as often happens in the work of Jože Plečnik, or through an elaboration of decoration so that it becomes too much, as in the decorative excesses blooming in much of Louis Sullivan's late work. It can also come through many of the disjunctions in scale or juxtapositions and superimpositions of forms cataloged by Robert Venturi in his *Complexity and Contradiction in Architecture*.[70] Shadows and shades, both literal and phenomenal, can also produce such a strangeness, through the use not only of darkness as a deliberate tool, but also of translucency rather than transparency or opacity.[71]

Even more powerful, though, are the buildings or built pieces that do not at first appear strange at all but have something queer about them. This, again, can be both literal and phenomenal. The perversion of architectural form that is subtle enough for you not to notice it at first can include slight deformations of brick or stone patterns, or even the manner in which rooms are pinched or extend, misaligned or connected at odd corners. Giulio Romano's rear courtyard facade at the Palazzo del Te in Mantua, of 1524–1534, with its slipped dentils and misaligned columns, is perhaps the model here. The remix of normal elements works especially well at the domestic scale, as the facades of Sir John Soane's house in

Lincoln's Inn Fields in London, of 1812, and the facade of the house Robert Venturi designed for his mother in Chestnut Hill, Pennsylvania (1962–1964) both show.

The phenomenal side of such deformation, however, is more powerful and widespread. It mainly occurs through the appropriation of spaces for acts that are illicit, usually of a sexual nature. Certain cruising grounds, from Amsterdam's stock exchange in the seventeenth century to the unused docks of New York in the late twentieth century and the "tea rooms" or public bathrooms, were used in particular by gay men, whose assignations were illegal.[72] However, the appropriation of public parks and "love hotels" by those seeking some form of bodily connection, as well as the pop-up rave parties that started to appear in the 1990s, also transformed spaces designed in a more or less functional and public manner for one particular use into spaces of shadows, sensuality, shared bodies and secrets, and pure joy. More recently, such spaces have snuck into the virtual spaces blossoming on computers, tablets, and phones, shedding some of their transformative power even as they extend the reach of social connection and break through spatial distances and social barriers at an unprecedented scale.

This kind of appropriation can occur in even more subtle ways, as in the manner in which West African traditions that highlighted the mythical significance of the crossroads influenced the placement and use of rural American communities and, through their appearance in music in particular, wound their way into popular culture. More evident is the appropriation of public space through squatting and extended sit-ins or occupation, as happened in Paris in May of 1968—an event that uncovered, if even for a moment, "the beach below paving stones" (when those pavers were hurled at police) and then wound its way into the occupation of the Dam Square and Vondel Park in Amsterdam, as well as the still-active community of Christiana in Copenhagen.

Even more pervasive is the use of the designed interior as an alternative to the structures architecture imposes on daily life. Through the accumulation of objects and textures, each of which both trace and make possible more intricate patterns of social connection and gathering and bring other times and places into the confines of the middle-class interior, such spaces offer a pause in or accumulation of time and an implosion of space. Their highly associative and allusive assemblies, spread like a palimpsest over

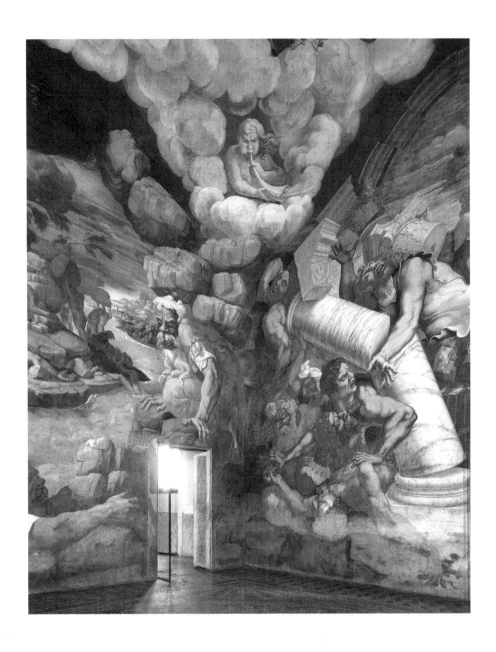

Giulio Romano, Camera dei Giganti, Palazzo del Te, Mantua, 1524–1534 (Mantua, Civic Museums, Palazzo Te).

the wood or stucco of the private home and spaces such as ateliers, restaurants, clubs, or art galleries, offer not just one but many possible worlds, all amassed through the act of collecting and assemblage. It is out of this world that the art of collage emerged, offering in itself an alternative to modes of art-making that sought ever more revelatory or at least representational truths. It was here that architecture could become a mirror of the secret, desirous self, a monument to what could not be built by either user or designer. As the critic Mario Praz put it:

> The surrounds become a museum of the soul, an archive of experiences; it reads in them its own history, and is perennially conscious of itself; the surroundings are the resonance chamber where its strings render their authentic vibrations. And just as many pieces of furniture are like molds of the human body, empty forms waiting to receive it. The ultimate meaning of a harmoniously decorated house is, as we have hinted, to mirror man, but to mirror him in his ideal being; it is an exaltation of the self.[73]

Walter Benjamin connects this task of self-mirroring to the attempt by the collector to place themselves in a larger world:

> The interior is asylum of art. The collector is the true resident of the interior. He makes his concern the transfiguration of things. To him falls the Sisyphean task of divesting things of their commodity character by taking possession of them. But he bestows on them only connoisseur value, rather than use value. The collector dreams his way not only into a distant or bygone world but also into a better one—one in which, to be sure, human beings are no better provided with what they need than in the everyday world, but in which things are freed from the drudgery of being useful. The interior is not just a universe but also the étui of the private individual.[74]

Architecture of the sort taught at schools, codified in the profession, and constructed all around us has repressed or excluded all such possible realities. It also has defined itself against those fields that offered even more powerful alternative spaces, such as literature, film, and video, by claiming that they lacked exactly

such a reality. Landscape could similarly be dismissed as not performing the functions central to the discipline.

Yet this also meant that architects had to live with their own self-alienation through transference and, what might be even worse, with the rejection of architecture by most of its public as being alien and alienating, harsh and overbearing and, above all, made by someone else for somebody else. The more perfect architecture became, the more it seemed to have nothing to do with any of our daily lives. It was the other, the grid, the man and The Man, power, and the grind all personified. Only those structures that escaped from such strictures, either by adopting some of the means outlined above, or through an exuberance that also made them suspect to most professionals (the Guggenheim Bilbao being the most famous recent example), had any power to appeal.

What, then was the architect to do? First of all, they had to make the issue concrete, or at least effective and understandable. They had to evoke, open up, and make more unknowable structures we thought we knew. They had to develop a fantastical unreality out of reality, one that was all their own. That is in particular why Frank Lloyd Wright's vision of a possible Chicago, like the evocations of the futurists, the "Crystal Chain Letters" written between Bruno Taut and architects including Walter Gropius and Hans Scharoun in 1919–1920,[75] or the "retroactive manifesto" Rem Koolhaas wrote in 1978 for Manhattan[76] are so powerful. So are some of the evocations, analogies, and mythologies created by critics who have wound their way through the discipline, such as Walter Benjamin, Martin Heidegger, Manfredo Tafuri, Robert Venturi, and Henri Lefebvre, to name just a few. With their imaginary monsters they present the problem and the possibility of architecture in a manner that we can see. They show us a possible architecture, not as a solution, not as a nightmare, not even as another place, but as what we have and where we have it, transformed through architecture. It is here that the secret and parallel history of architecture and its transformative power comes into view.

To be clear: what I am trying to define is not pure descriptions, either in language or in form. Nor am I here evoking narratives that describe possible architecture. This is not a question just of images evoked by buildings or fiction. What I wish to concentrate on here is a possible, analogous, anarchic architecture that appears, not quite as an icon, not quite as a complete structure, and not quite

as thing, but as a mirage hovering just beyond the field of vision. This work of architecture seen in distraction emerges from some buildings, but more forcefully appears in works of what recent critics have called parafiction, or that we might think of as fairytales:

> Parafictional art intervenes in the world through constructed fictions in an attempt to open alternative plausible realities. . . . It acts through aesthetics. . . . Parafiction questions our assumptions about the way reality looks and feels. It demands that the viewer pay closer attention, which can incite in the viewer a desire for knowledge or a desire to be just; a conceptual art initiated by an aesthetic provocation. These are not hidden "meanings," implicit in the artwork and requiring a close reading for their extraction, but potential outcomes. . . . Parafiction directly addresses mediation itself, not as a search for the truth within a specific medium, but through the manners in which each medium builds an image of the world.[77]

These are leviathans that are almost real, monsters that hide not under our beds but in the myths of architecture.

2 *The Explosion of the Tenth of a Second*

If you are going to give shape to the world, you have to know where to start. What is the world made of, what is its shape, what are its characteristics? For architects in the generation following Frank Lloyd Wright these were not simple questions. Of course, they also grew up in an era in which technology was changing the scale and speed of everything they experienced—that was something humans in Europe and the United States had been experiencing for at least a century—but the very fabric of reality was coming apart.[1] The First World War and the influenza pandemic and other upheavals that followed it not only killed untold numbers of this generation, but also changed the nature of nations and many social relations. The emergence of the Soviet Union and the coming to power of socialists in some countries offered the prospect of a new social reality being realized and inhabited. On a theoretical level, the years right before that war showed the dynamic relation between space, time, energy, and matter, the difference between what a human being could perceive and what they could understand.[2] The emergence of theories on uncertainty and chaos further opened the door to new, nonperceptual and nonlogical realities. To match that external world, Sigmund Freud and others were questioning our ability to truly know ourselves, or for our consciousness to be unitary. Perhaps Karl Marx's and Friedrich Engels's 1848 prediction of the ultimate development of

modernity, that "all that is solid melts into air . . . all that is holy is profaned, and men at last are forced to face . . . the real conditions of their lives and their relations with their fellow men," was finally coming true.[3]

Artists and writers responded to these conditions with forms, images, and narratives that mirrored and mapped the dissolution of both reality and our knowledge of or suppositions about it. Their efforts are now the standards by which we understand the contours of contemporary art: cubism, expressionism, futurism, constructivism, purism, and other "isms" and schools. They developed methods of learning and teaching the contours of this new world, created magazines to chronicle those endeavors, and identified new programs or types, as well as new audiences and working methods. This was the peak period of modernism if we understand that style or collection of styles as the attempt to fully represent a modernity that was more explosive, in every sense of the word, in the first few decades of the twentieth century than ever before.[4]

What concerns me here is not just the choice of technique or imagery, but the making of a structure—an architecture—that provided a concrete model, through analogy and allusion, for the assembly of a possible new world. Rather than asking which style was most appropriate, constructed out of which materials and for which audience, I am interested in attempts to build the home of modernity. The attempts to create an interpretive structure that fully traced the dissolution of reality is to me the central task of modernist architecture. That this structure proved to be unstable, ephemeral, and uninhabitable—that it was, in fact, explosive itself—only reinforces its ambition to make modernity at home in architecture, and architecture at home in modernity.

We know such structures from science fiction.[5] With ancient roots that had been reinvigorated by the spread of technology and the sense that the future was arriving ever more quickly, such imagery had spread from the proposals of "other places" (utopias)[6] or fictional reports of other lands to future versions of then-current society (*News from Nowhere*, *Erewhon*)[7] and, by the period under discussion here, had installed itself in popular literature and was soon to take control of a whole section of the nascent film industry.

Yet the images under discussion here did not aim to go to other places or construct alternatives—at least not fully. They did not imagine a completely formed other world, nor did they detect

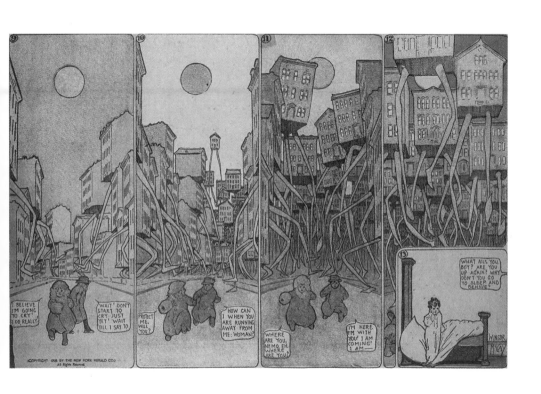

Winsor McCay, "They Are Looking for Us," from *Little Nemo in Slumberland*, 1907.

the animate qualities of technology or its personal other, the scientifically split self (as in Kafka's writing). They looked toward the ability of symbolist writers such as Lautréamont[8] to animate aspects of the city fabric itself and pick up on the vividness of such language. In the United States, they built on a native-born idealism,[9] exemplified in the work of Emerson, animated by the type of the jack-of-all-trades tinkerer,[10] and inspired by the vivid urban imagery of Walt Whitman.[11] Given the novelty of this syncretic urban mythology, however, I also suspect influences from popular culture, certainly in the United States, where comics such as *The Adventures of Little Nemo in Slumberland*[12] are the clearest analogy to what Wright dreamed up.

The most concrete call for the making of such a new reality came in revolutionary Russia, where, at least in the first years after the Revolution, the notion that everything, including science and art as well as the patterns of everyday life, had to be rethought from the ground up engaged countless artists and architects in the construction of everything from impossible monuments to "agitprop" trains to the cutlery, ceramics, and service uniforms in workers' canteens.[13] However, even this work remained in the realm of objects, with its most radical proposals for buildings such as the cosmological clock of the Monument to the Third International remaining unbuilt.[14] What was needed as an architecture for this revolutionary era was something altogether different. It would need to be, by definition, self-destructive.

The most coherent proposals came at first from the group that called themselves the futurists. F. T. Marinetti's "Futurist Manifesto"[15] was the first such conscious effort, but what interests me about it also is its milieu: the environment in which it emerged, out of which it erupted, and which it proposed. I do not mean the literary traditions and salons out of which this self-proclaimed poet developed his craft, steeped as he was in the symbolist writings of Mallarmé, Verlaine, and Baudelaire,[16] accepting their delight in language that bloomed and connected while rejecting their reliance on natural imagery. I mean his physical milieu. That decorated and enclosing space was, first of all, that of the middle-class European drawing room or, to be more precise, breakfast room.[17] This is where the average reader of *Le Figaro*, the French newspaper in which the "Futurist Manifesto" appeared on the front page on February 20, 1909 (after Marinetti had refined earlier versions),[18] would have encountered a combination of short story and screed.

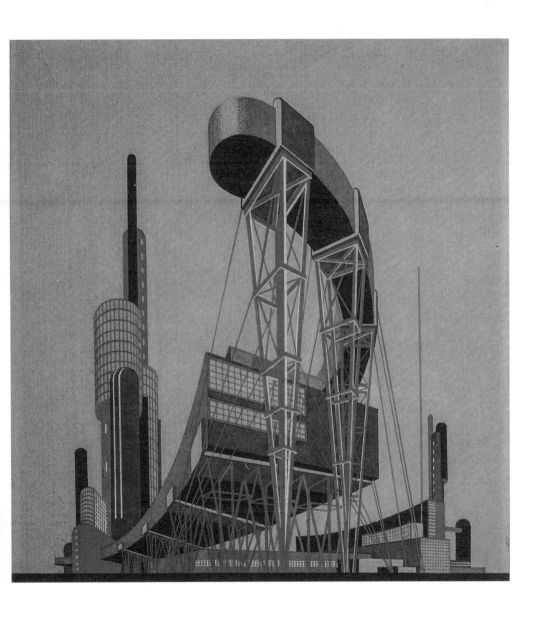

Yakov Chernikov, *Architectural Fantasy*, c. 1930.

Filippo T. Marinetti, "The Futurist Manifesto," *Le Figaro*, February 20, 1909, 1.

Isolated from the confusion of the street outside, as well as from other classes, clothed and surrounded by materials that comforted the body and assembled the crafts and styles, let alone the raw materials, of cultures from around the world, the space in which the intended reader would have sipped his coffee and read the manifesto would have itself mirrored, mapped, and confirmed the values of the readers.

Marinetti mirrored that place in the opening paragraphs of his paid submission. As he starts his narrative, an all-night party of drinking and discussing is drawing to an end. A small group of intellectuals is sitting "beneath mosque lamps whose brass cupolas are as bright as our souls."[19] Moorish artifacts suffused with the "internal glow of electric hearts" and made out of metal, these lamps light "opulent Persian carpets."[20] Marinetti is in his native Milan, but he surrounds himself with objects from other worlds that to him, and to many like him, evoked a sensual dreamworld and escape from their daily reality. He finds solace, in other words, in the Orientalist mass culture that allows him and his friends to escape the reality of the industrial revolution.

Yet something lives within these borrowings from other cultures that are making the space comfortable and usable for these men: electricity, but beyond that, a whole world of technology. Shifting focus, as Wright had done, within a sentence, Marinetti now imagines that these men are neither at home nor in an imagined harem. Rather, they are "standing quite alone, like lighthouses or like the sentinels in an outpost, facing an enemy of stars encamped in their celestial bivouacs."[21] Humans have become buildings, which in turn are soldiers, who then suddenly are part of cosmic war reminiscent of nothing so much as the creation myths, fundamental to every religion or shared myth, about battles between primeval forces that separate light and dark from chaos.

Then Marinetti draws his perspective down again, seeing his group crouching "alone with the engineers in the infernal stoke-holes of great ships, alone with the black spirits which rage in the belly of rogue locomotives."[22] Why the locomotives have run amok is not clear, but clearly the battle has now descended into a kind of guerrilla warfare within the machines. The primeval battle is taking place within the industrial might of the twentieth century and its embodiments. But then, in the very next sentence, Marinetti denigrates his warriors, making the partners out to be "drunkards beating their wings against the walls."[23] These are not only mad

scientists and anarchistic warriors—they are also drunkards who are out of touch with the reality that surrounds them.

Then another reality cuts through both the upholstered surfaces of the drawing room and the multilayered battlefield somehow hovering under its lamps. It is the world of the city, which evidences itself in various modes and levels: a tram comes by, its noise alerting the intellectuals not only to the presence of the urban scene, but also to the rituals and motions of everyday life. Morning has come. As if in reaction, Marinetti, again conflating images, scales, and human and natural forces, compares the trams riding by to "villages celebrating their festivals, which the Po in flood suddenly knocks down and uproots, and, in the rapids and eddies of a deluge, drags down to the sea."[24] The light of the tram's headlight becomes refracted into the many electrical lights of the festival, just as the scheduled rhythms of that mass transit device now become a ritual that affirms a relationship between the community and its world through belief. It then turns into a natural phenomenon that destroys that certainty or faith. The world out there is dangerous, its seeming order and joy only another perspective on chaos—a state in which the human and the natural meld.

A quick pause in the noise, during which Marinetti and his friends become aware of endurance, time, and space ("we listened to the last faint prayer of the old canal and crumbling of the bones of the moribund palaces with their growth of beard"),[25] also offers a dead version of the monster leviathan. Then cars start moving by, and Marinetti has had enough. He and his gang exit the space in which the first few paragraphs had taken place, and they leap into three cars (a trinity?). While he sees this act as one of becoming one with the machines, it is also a mark of his bourgeois status. The author speaks for the first time, issuing the initial proclamation of what will become a lifelong parade of half-sensical proclamations about violence, modernity, and a new reality he seeks to make. They all amount to the same thing: he wishes to wage war on reality. Again, what will replace it is a human being, but also a centaur, a band of angels, and a sword:

> Let us go! At last Mythology and the mystic cult of the ideal have been left behind. We are going to be present at the birth of the centaur and we shall soon see the first angels fly! We must break down the gates of life to test the bolts and the padlocks! Let us go! Here is the very first sunrise on

earth! Nothing equals the splendor of its red sword which strikes for the first time in our millennial darkness.[26]

The friends' first attempt to conquer the world does not end well. Marinetti suffers a car crash, winding up in a ditch whose "strengthening muck" he compares, in one of the most racist and sexist passages in modernist writing, to the milk he received from his "Sudanese nurse." Perhaps because of this cushioning and animate land, both he and his car survive, leaving him free to then finally proclaim his "Manifesto of Futurism." Again like Wright, the culminating image in his eleven points is of a city-person-beast-factory:

> We will sing of the great crowds agitated by work, pleasure and revolt; the multi-colored and polyphonic surf of revolutions in modern capitals: the nocturnal vibration of the arsenals and the workshops beneath their violent electric moons: the gluttonous railway stations devouring smoking serpents; factories suspended from the clouds by the thread of their smoke; bridges with the leap of gymnasts flung across the diabolic cutlery of sunny rivers: adventurous steamers sniffing the horizon; great-breasted locomotives, puffing on the rails like enormous steel horses with long tubes for bridle, and the gliding flight of aeroplanes whose propeller sounds like the flapping of a flag and the applause of enthusiastic crowds.[27]

Bridges and gymnasts, cutlery and rivers, locomotives with breasts and horses as steel rails, airplanes and crowds are all conflated into this vision that also equates labor, recreation (or perhaps sex), and the revolution that will bring about the world Marinetti envisions. However, it is important to point out that he does not actually propose a utopia, let alone a revolutionary state. Instead, it is the act of revolution itself, the continual act of destruction that parallels the working of technology in all its violence—the uproar of the city, the crash of the cars, the battle of cosmological forces—that he describes. His architecture is one of explosion.

If there is a political equivalent to Marinetti's ideas, it is that of anarchism: the alternative to Marx's and Engels's thinking that developed distinctly from the main branch of socialism in the 1870s.[28] It split into myriad interpretations, which broadly

fell into two main streams: the communitarian one, whose main thinker became Prince Kropotkin,[29] who shared the arts and crafts movement's vision of a poststate world of free association of small communities devoted to agriculture and craft; and the violent one, exemplified by the writing of Mikhail Bakunin,[30] who inspired the bombings and other acts of sabotage with which anarchism became associated. What the anarchists shared was a denial of the notion that there would be a transitional stage after the revolution, during which party leaders would take over the state before slowly dissolving it. What came to be known as the "leading role of the Party" or the "dictatorship of the proletariat"[31] was anathema to those who dreamed of complete individual freedom and feared the complete and corrupting evil of power. Continual revolution or just the dissolution of all bonds was better.

Like anarchitecture, anarchism became a thread within the various resistance movements of the twentieth century, exploding into view in moments of violence, but also embedding itself in mainstream movements such as the International Workers of the World (IWW, or Wobblies),[32] at one point one of the most significant labor movements in the United States, or as anarcho-syndicalism in the pre-Second World War mainstream politics of Spain, Italy, and France.[33] The ability of anarchism to propose a world that was not a concrete alternative, one that was not logical or stable, offered a tantalizing alternative to many free-spirited artists.

That it also shaded over into violence-addicted fascism is evident, certainly in the case of Marinetti and many of his followers. At the same time, anarchism also shaded into the collection of spiritualist theories proposed by such self-proclaimed gurus as Madame Blavatsky,[34] George Gurdieff,[35] and Rudolf Steiner,[36] whose belief in the necessary dissolution of reality in order for humans to become one again with the all were, in the end, more successful as models for artists, ranging from Piet Mondrian to Frank Lloyd Wright in his later years.[37]

Marinetti's text does not extend into either political action or spiritual retreat. Instead, it ends with a vision of Marinetti's and his friends' death, destroyed by the next wave of revolutionaries. For there is no life possible except in the explosion of the new, in which man and world together can be reborn as the proclamation of that destruction. The manifesto's last words are: "Standing on the world's summit we launch again our insolent challenge to the stars!"[38]

Marinetti did become an old soldier, but he died as a has-been, ignored and ridiculed by the next generation. This perhaps was the real fate of the revolutionary of the anarchist sort in a capitalist society that again and again proves its ability to appropriate all revolutions. The movement he founded did try to create images that incorporated the aesthetics of revolution, for instance in the paintings of cities bleeding into animals and their own construction created by Giacomo Balla, but they failed by definition to be that explosion.[39] The same can be said for the visions Antonio Sant'Elia drew before he died as a soldier in the First World War. He, too, tried to encompass his vision in a form of a mechanical leviathan, although more as a proposal than a vision:

We must invent and reconstruct the futurist city on the model of an immense, bustling shipyard, every part agile, mobile and dynamic; the futurist house must become a kind of gigantic machine. Lifts mustn't be hidden away like solitary worms in stairwells, stairs—now obsolete—should be abolished, and lifts should wriggle up façades like steel-and-glass snakes. The concrete, steel and glass building, bare of painting and sculpture, enriched only by the inherent beauty of its lines and modelling, will be extraordinarily brutal, ugly in its mechanical simplicity and as tall and large as necessary, unlimited by municipal building restrictions. It must rise on the edge of a tumultuous abyss. Streets will no longer stretch out like doormats at the entry level, but will plunge many levels underground and consolidate metropolitan traffic with interconnecting links to metallic cat-walks and high speed conveyor belts.[40]

The drawings he made of this world, though provocative and, according to some critics, indicative of a deep (if perhaps unconscious) understanding of then-contemporary physics, are weak extractions of such attempts at vision.[41]

For a true vision of what anarchitecture of the explosive kind might be, we have to turn to a writer who, though interested in architecture and the arts, was above all else a literary critic. Walter Benjamin spent most of his life, which was cut short by the Second World War, writing about literature, drama, and film.[42] He did so from a perspective clearly and unabashedly steeped in his reading of Karl Marx. He also, however, had a strong interest in

Umberto Boccioni, *The City Rises*, 1910 (The Museum of Modern Art New York, Mrs. Simon Guggenheim Fund).

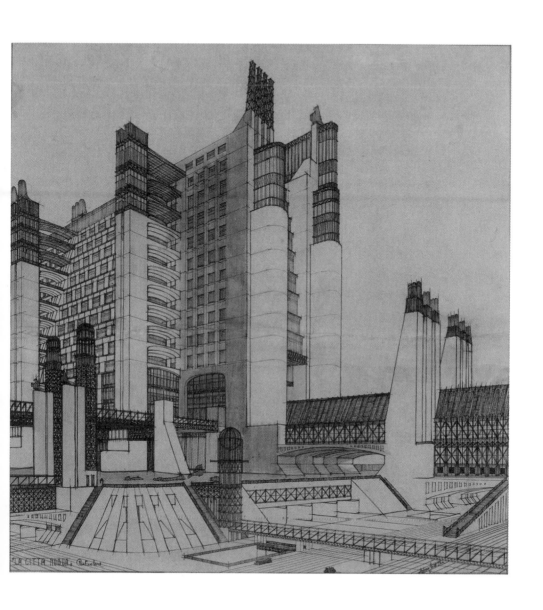

Antonio Sant'Elia, view from Città Nuova, 1914.

architecture and the city. His life's work, unfinished at his death in 1940, was *The Arcades Project*: a collection of notes, aperçus, comments, and fragments of analysis centered around the phenomenon of the Paris shopping arcade.[43] This physical place, which had largely disappeared by the time Benjamin began writing, brought together a number of different figures and social developments. Its hero was the flâneur, the ultimate consumer of both goods and ideas, who produces nothing. The space itself has no beginning or end, and was a break in the urban fabric that has been sutured over with the new materials of iron and glass. The space thus created is like a welt or addition to the urban body, a veil thrown over a bit of emptiness that is now the place of appearance of the bourgeois. The arcade was both a condensation of the city and its voided, almost invisible mirror. It was also a counterpoint to the Haussmannian boulevards and the solidity of middle-class architecture.

By focusing on—or at least returning often to—the arcade, Benjamin can discuss everything from the rise of the department store to Haussmann's operation on Paris; the urban novels of Zola and Balzac; the arts and furnishings of the nineteenth century, as well as its fashions; and the structure of urban life in general.

Out of this then emerges a new image, one that resembles our monster leviathan:

> Corresponding to the form of the new means of production, which in the beginning is still ruled by the form of the old (Marx), are images in the collective consciousness in which the new is permeated with the old. These images are wish images; in them the collective seeks both to overcome and to transfigure the immaturity of the social product and the inadequacies in the social organization of production. At the same time, what emerges in these wish images is the resolute effort to distance oneself from all that is antiquated—which includes, however, the recent past. These tendencies deflect the imagination (which is given impetus by the new) back upon the primal past. In the dream in which each epoch entertains images of its successor, the latter appears wedded to elements of primal history—that is, to elements of a classless society. And the experiences of such a society—as stored in the unconscious of the collective—engender, through interpenetration with what is new, the utopia that

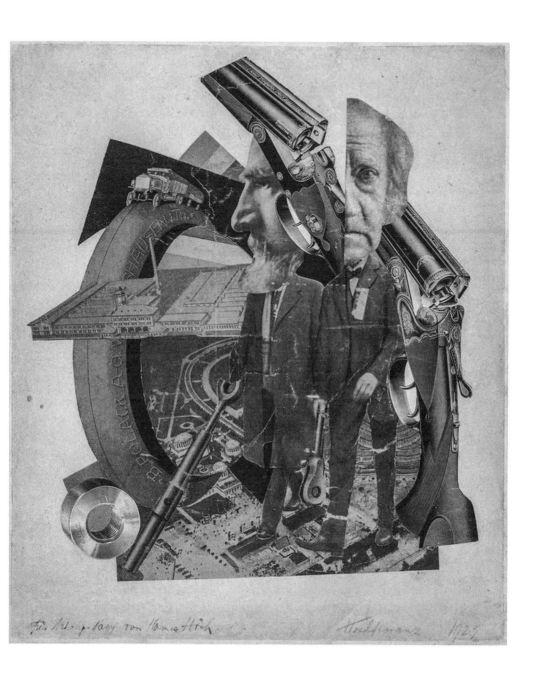

Hannah Höch, *Hochfinanz*, 1923 (courtesy of Galerie Berinson, Berlin).

has left its trace in a thousand configurations of life, from enduring edifices to passing fashions.[44]

The nature of this imagery or "dream" of the epoch is utopian, but "interpenetrated" by not just current reality but the lived experience of its social and physical conditions, as reflected, more than anywhere else, in fashion.

Benjamin goes on to describe this kind of image in later fragments as a "phantasmagoria," which he says is "the intentional correlate of immediate experience" that has no duration.[45] Here it is not fashion but "architecture [that] is the most import testimony to latent 'mythology.'" It can only exist through and in the immediate and ephemeral perception (in distraction) of the masses: "The crowd is the veil through which the familiar city beckons to the flâneur as phantasmagoria—now a landscape, now a room."[46]

Not that the city or its rulers do not resist: they invent the notion of planning, which tries to suppress the labyrinth this phantasmagoria inhabits and, in fact, is suppressing the real life of the city down into hidden places and cellars. Benjamin collected quite a few fragments on the underground Paris of crypts, sewers, abandoned mines, and hidden passageways and saw it as a counterpoint to the arcades.

In the end, cut through and undermined by such half-hidden, half-abstract, half-free spaces, the city casts its own spell, one developed in the art of collecting that fetishizes disparate objects and tries to fix architecture as it is: "to put things under a spell, as though at a touch of the magic wand, so that all at once, while a last shudder runs over them, they are transfixed. All architecture becomes pedestal, socle, frame, antique memory room."[47]

It seems possible that the *Arcades Project*, had the author completed its fragments, would have been Benjamin's own leviathan, although the "soul" or consciousness his writing would have breathed into it would have been of an altogether different sort. What we do have is his most coherent and influential writing on the relation between art, technology, the urban scene, and the masses, an essay originally translated into English as "The Work of Art in the Age of Mechanical Reproduction" (1936, first German version 1935).[48] Although its subject is ostensibly the changes wrought in the work of art by the camera (both still and cinematic), it reads as the culmination of Benjamin's aesthetic theory.

The task the author sets himself is to see what happens with the work of art when it becomes reproducible—something it has been for a very long time, at least since the invention of lithography—and in particular what happens when photography enters this process. He traces the development of the work art out of the realm of magic and ritual, where it evokes a fundamental quality of "authenticity" that goes beyond the mortal and ephemeral reality of all other things and beings. When religion recedes, art becomes its own cult, "l'art pour l'art." Art thus presents itself as a coherent alternative to the world that yet mirrors or maps it. Benjamin doubts that is anything but a lie.[49]

The photograph, he points out, is the first work of art to divorce the object one sees completely and fundamentally in three ways: from what it represents, from what it is made of, and from where it is seen. This, he argues, brings into question its authenticity, or what makes it "real." And that, in turns, brings him to what he believes is the photograph's real effect, which is to destroy time (endurance, tradition), and space. The photograph is modern technology made real, blowing up any sense of continuity between the thing and its representation, material and form, and making and seeing art.

Benjamin's name for what is lost is aura, "a strange tissue of space and time: the unique apparition of a distance, however near it may be."[50] Photography causes the "stripping of the veil from the object."[51] From now on, art has two choices: to dissolve into the continual act of remaking of the world in and through technology, or to erect a false image or aura around itself. The latter is the way of fascism, claims Benjamin, while the former lets the masses assimilate the work of art. Or, to put it more bluntly: "The function of film is to train human beings in the apperceptions and reactions needed to deal with a vast apparatus whose rule in their lives is expanding almost daily." This, combined with political action, "will release them from their enslavement to the powers of the apparatus."[52]

In order to have such a revolutionary form of art, however, it has to disappear. Benjamin describes in some detail, though not in a linear manner, the manner in which a film, more than a photograph, "is produced by means of montage. And each individual component of this montage is a reproduction of a process which neither is an artwork in itself nor gives rise to one through photography."[53] The film consists of moments of acting, usually

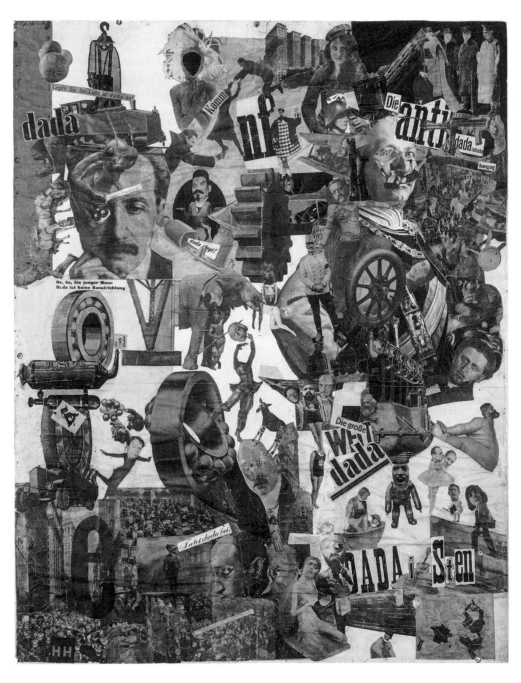

Hannah Höch, *Cut with the Dada Kitchen Knife through the Last Weimar Beer-Belly Cultural Epoch in Germany*, 1919 (photograph by Jörg P. Anders; bpk Bildagentur /Nationalgalerie, Staatliche Museen, Berlin, Germany, Jörg P. Anders / Art Resource, NY).

shot out of sequence, on sets rather than in reality. The actor does not perform in front of an audience, and their performance only exists as a sequence of impressions or chemical arrangements on a negative. Those implied images, which already capture an only momentary assembly of acting, sets, makeup, and lighting, are then further cut apart by the editor and reassembled by the director and packaged by the producer, only to be seen as something that is more or less coherent, but exists only in time as a flickering image in a dark space.

In a further irony, Benjamin points out, all of those technological processes, materials, and actors (he calls them "experts") dissolve when you actually see the film, creating "the equipment-free aspect of reality." It is then up to the machinery of propaganda and public relations to create a completely false aura, that of film actor as idol, and of the movie as a coherent work of art that tells a story unfolding in time, in order to recreate the work of art.[54]

What matters for me here is Benjamin's rejection of the kind of idealized worlds, whether they be nostalgic, rose-colored versions of reality or utopias and dystopias, that would let us flee reality in the safety of the cinema. As both the work of art, at least in terms of the photograph and film, and what it represents are just embodiments of an aura that is illusionary and elusive, what is needed is an uncovering of reality. The instrument for that has to be something that is both analytical and radical. Its quality has to be scientific, and, if there is an art to it, it is the art of collage. It is produced by somebody whom he compares to a surgeon:

> In short: unlike the magician (traces of whom are still found in the medical practitioner), the surgeon abstains at the decisive moment from confronting his patient person to person; instead, he penetrates the patient by operating— magician is to surgeon as painter is to cinematographer. The painter maintains in his work a natural distance from reality, whereas the cinematographer penetrates deeply into its tissue. The images obtained by each differ enormously. The painter's is a total image, whereas that of the cinematographer is piecemeal, its manifold parts being assembled according to a new law. *Hence, the presentation of reality in film is incomparably the more significant for people of today, since it provides the equipment-free aspect of reality they ate entitled*

to demand from a work of art, and does so precisely on the basis of the most intensive interpenetration of reality with equipment.[55]

Benjamin goes on to describe the power of such a technique with a forcefulness that still reads as a clarion call for a new kind of world-making, one that combines scales and techniques, implodes and explodes scale and time, and also now breaks down the boundaries of the space-time continuum into the very realm of the conscious individual. The image/act he evokes is an anarchist one:

Our bars and city streets, our offices and furnished rooms, our rail-road stations and our factories seemed to close relentlessly around us. Then came film and exploded this prison-world with the dynamite of the split second, so that now we can set off calmly on journeys of adventure among its far-flung debris. With the close-up, space expands; with slow motion, movement is extended. And just as enlargement not merely clarifies what we see indistinctly "in any case," but brings to light entirely new structures of matter, slow motion not only reveals familiar aspects of movements, but discloses quite unknown aspects within them—aspects "which do not appear as the retarding of natural movements but have a curious gliding, floating character of their own." Clearly, it is another nature which speaks to the camera as compared to the eye. "Other" above all in the sense that a space informed by human consciousness gives way to a space informed by the unconscious. Whereas it is a commonplace that, for example, we have some idea what is involved in the act of walking (if only in general terms), we have no idea at all what happens during the split second when a person actually takes a step. We are familiar with the movement of picking up a cigarette lighter or a spoon, but know almost nothing of what really goes on between hand and metal, and still less how this varies with different moods. This is where the camera comes into play, with all its resources for swooping and rising, disrupting and isolating, stretching or compressing a sequence, enlarging or reducing an object. It is through the camera that we first discover the optical unconscious, just as we discover the instinctual unconscious through psychoanalysis.[56]

Chapter 2

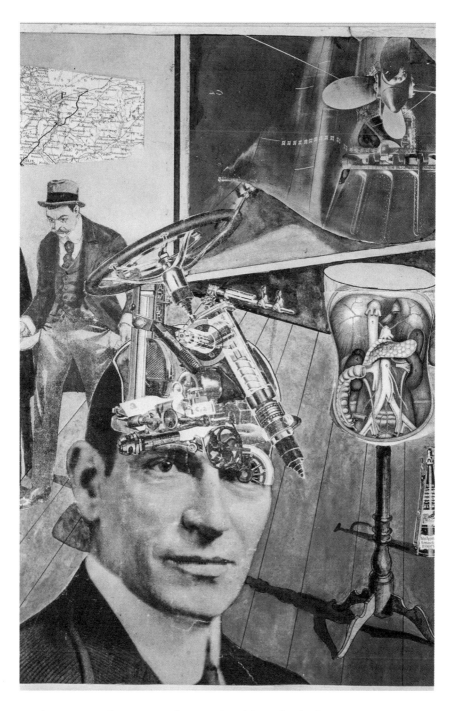

Raoul Hausmann, *Tatlin at Home*, 1920 (© 2022 Artists Rights Society (ARS), New York / ADAGP, Paris).

Moreover, Benjamin goes on to say, this world can turn into a film, or a form of a work of art, but its very phantasmagoric quality is central to such an operation: "Thanks to the camera, therefore, the individual perceptions of the psychotic or the dreamer can be appropriated by collective perception."[57] The monster leviathan is now an explosion that is a dream or a psychotic episode: a lacuna in the cycle of production and consumption, but also in the smooth functioning of the individual human being, appropriated by technology, that allows them to find themselves again, but only by becoming part of the masses. The veil, the ideality of democracy or the spirit of the new, is a poetic madness.

Benjamin is careful to point out that this particular psychosis cannot have the status or form of art in the traditional sense. He finds his countermodel, interestingly enough, exactly in what he has just blown up:

> Buildings are received in a twofold manner: by use and by perception. Or, better: tactilely and optically. Such reception cannot be understood in terms of the concentrated attention of a traveler before a famous building. On the tactile side, there is no counterpart to what contemplation is on the optical side. Tactile reception comes about not so much by way of attention as by way of habit. The latter largely determines even the optical reception of architecture, which spontaneously takes the form of casual noticing, rather than attentive observation. Under certain circumstances, this form of reception shaped by architecture acquires canonical value. *For the tasks which face the human apparatus of perception at historical turning points cannot be performed solely by optical means—that is, by way of contemplation. They are mastered gradually—taking their cue from tactile reception—through habit.*[58]

Architecture as the work of art seen in distraction, built out of impressions that do not privilege the eye, that only exists in time and space, that has the quality of a collage, that makes sense in mass use, rather than in individual absorption, and that is tied inextricably with use and the patterns of daily life, rises out of the shards and shreds of architecture as the built affirmation of what is and was. This new architecture is the old architecture, exactly the same, with no difference. It just has been reinterpreted and revalued, given to the masses and divorced from its history to be seen

and valued afresh. It is architecture without aura. So, perhaps, we should rather rephrase Benjamin and say that anarchitecture—a revolutionary one—rises out of the ruins of traditional buildings.

The act of destruction here refracts into several phenomena: the destructiveness to any sense of coherence that is embodied by the technologically determined urban scene; the pervasiveness of the technology that breaks down time and space, and replaces association or aura with functioning and a reassembling in time and place; the dissolution of the self, but also of individual machines and buildings into a continuous explosion; and emergence of something, by definition uncatchable and undefinable, sensed only in distraction, out of the corner of one's eye.

It is that other, that veil over the explosion that Benjamin then finally contrasts to what he sees as the final end of technology and capitalism, which is the total war on the eve of which he wrote. He predicted that ever more efficient planning and extraction of resources would, through its own logic, lead to the most efficient end goal of technological planning, namely the potlatch of an all-encompassing war. There, art would reach the point where mankind "can experience its own annihilation as a supreme aesthetic pleasure."[59] Against this prophetic outcome, which has extended long after the Second World War, Benjamin offers not a model but the alternative of "politicizing art," or turning it into that continuous explosion seen in distraction.[60]

It is clear that Benjamin's vision is not a nihilistic one. His notion of an explosive modernism was rooted in much of the art he had seen arise in Europe in the two decades before he wrote this essay. Moreover, this model has continued to fascinate artists and theoreticians since then. It also proves, by its very nature, the limits of the ability of this version of a monster leviathan to serve as a model. It was already difficult to imagine that shape-shifting palimpsest of urban conditions, but how do you imitate an explosion, or even an unconscious journey? What would be architecture seen out of the corner of your eye?

As for the latter, the answer is: it would not be, at least not in a conscious sense. Though generations of architects have consciously tried to make buildings whose banality, matter-of-fact construction, or "vernacular" quality (whatever that term might mean in a society in which building by hand only for one location is nigh impossible) would allow them to offer a critique to the auratic presence of monuments, they have succeeded only in

making buildings that are indeed forgettable at best, and aggressively banal at worst.[61]

The only solution would seem to be for architecture to truly dissolve or disappear—or at least for its embodiment, building, to do so. That is certainly what artists such as Piet Mondrian saw as the logical outcome of any attempt to truly address modernity.[62] Short of such a drive toward self-extinction, which was mainly championed by artists not engaged in or interested in the insertion of their work in daily life, architects experimented with forms of semiautomatic or machinic construction. Inspired by movements such as Dada, but also by the sheer beauty of machines, they began to see their work as assemblages of machines. None did so with more conviction (at least until the Second World War) than Le Corbusier, who claimed to want to adopt the "engineer's aesthetic," and to use scientific principles to assemble forms, planes, and sequences of spaces.[63] His best built work of the 1920s, especially the Cité de Refuge in Paris and the three villas in and near that same city (La Roche, 1923–1925; Stein, 1927; and Savoye, 1928–1931) came closer than any major designed structures to having both a filmic sweep and a collage-like character informed by a largely hidden technology. Only the renovation of a Parisian townhouse by the interior designer Pierre Charreau and the architect Bernard Bijvoet, of 1932, goes further toward being a collage of machined elements, whose ties to an unconscious phantasmagoria are even stronger because many of its elements seem to develop out of the stirrups and other invasive gadgets and furnishings of the client's gynecology practice.[64]

In fact all such work ultimately was not an attempt to build the explosion of the tenth of a second, but exactly its reverse: they devolved into attempts to both picture it and repress its violence, providing a way between the false aura of fascism and the revolution Benjamin hoped for by creating an image of technology that was not only understandable but inhabitable. After all, Le Corbusier's motto remained: "Architecture or revolution. Revolution can be avoided."[65]

The question for those architects trying to develop a critical stance toward the explosion of the tenth of a second became not one of either building the monster leviathan or finding a mode of transference that would safeguard its construction as a possible only subconscious other; but rather how to not build. Architecture

(or a certain branch of it) after Benjamin became unbuilding, an activity of either demolition or archaeological exploration.

Most simply, this meant finding the exploded city and its forms already present, pressing around us in an unconscious manner, and then constructing that explosion, or at least evoking it. As T. S. Eliot famously put it in his bleak representation of modernity that foreshadowed the Second World War and nuclear explosion to come: "Unreal City, / Under the brown fog of a winter dawn, / A crowd flowed over London Bridge, so many, / I had not thought death had undone so many."[66] This was the same poet who, in his earlier "Love Song of J. Alfred Prufrock," had produced one of the strongest conflations of urban scenes, animate form, and culture:

> Let us go then, you and I,
> When the evening is spread out against the sky
> Like a patient etherized upon a table;
> Let us go, through certain half-deserted streets,
> The muttering retreats
> Of restless nights in one-night cheap hotels
> And sawdust restaurants with oyster-shells:
> Streets that follow like a tedious argument
> Of insidious intent
> To lead you to an overwhelming question . . .
> Oh, do not ask, "What is it?"
> Let us go and make our visit . . .
>
> The yellow fog that rubs its back upon the window-panes,
> The yellow smoke that rubs its muzzle on the window-panes,
> Licked its tongue into the corners of the evening,
> Lingered upon the pools that stand in drains,
> Let fall upon its back the soot that falls from chimneys,
> Slipped by the terrace, made a sudden leap,
> And seeing that it was a soft October night,
> Curled once about the house, and fell asleep.
>
> And indeed there will be time
> For the yellow smoke that slides along the street,
> Rubbing its back upon the window-panes;
> There will be time, there will be time
> To prepare a face to meet the faces that you meet;

There will be time to murder and create,
And time for all the works and days of hands
That lift and drop a question on your plate;
Time for you and time for me,
And time yet for a hundred indecisions,
And for a hundred visions and revisions,
Before the taking of a toast and tea . . .
Shall I say, I have gone at dusk through narrow streets
And watched the smoke that rises from the pipes
Of lonely men in shirt-sleeves, leaning out of windows?[67]

Here it is not the city itself, but its product, the miasma of smog that obscures its machine nature, that becomes animate, while it is not the human-made buildings but the sky that becomes both a surgical operating room and a human patient. The city, meanwhile, becomes rhetoric—an endless argument. Only briefly do humans become chimney pipes: Eliot's strategy is more abstract and descriptive, though highly cinematic in its swoops and pans and its sudden close-ups and quick edits, as well as in its conflation of time and space.[68]

If there was one city where both architects and critics thought they could find this explosion, it was Los Angeles. A favorite anti-model to the traditional metropolis, both its scale and its seeming divorce from but integration into nature (with no season, no water, and isolated from what was, before the Second World War, most of the known world, it was yet promoted as a Garden of Eden where you could pluck an orange from your kitchen window), it seemed not to make sense according to any model that had developed out of cities in Europe or Asia. Consisting of fragments collaged together in a landscape so large it could not be comprehended, this semimythical California was tied together by the automobile and highlighted by factories that produced nothing visible: the movie lots and the oil derricks and refineries. Its largest industry was, in fact, "FIRE": finance, insurance, and real estate, or selling this concatenation of human dwellings to itself and newcomers. As its longtime state historian, Kevin Starr, famously remarked: "California was not so much made as it was sold."[69]

Ironically enough, for all the mythmaking to which Los Angeles was subject, nobody really developed a mythic image for it. There were instead just more fragments: the spaces seen in dark and shadow in the noir detective stories, the attempts to make

technology and real estate visible in *Chinatown,* and the various science fiction fantasies in subsequent years that tried to reveal the machine hidden in the fragments of everyday life. Even when the Disney Company's "imagineers" try to create a condensed and mirror version of it, as they did in the California Adventure theme park, they failed to do more than collage together a few urban moments from Los Angeles (Cathay Circle, the remaining facade of Centennial Park) together with a loose evocation of a larger Southwestern landscape.[70]

Perhaps the movie that came closest to revealing the machinic, cinematic, and explosive nature of the metropolis was Michelangelo Antonioni's 1970 *Zabriskie Point.* The movie starts with a long shot of the city's boulevards as seen in the rear-view mirror of the protagonist's car, thus condensing the city into a continually changing, mechanically produced collage. The scene shifts to a student riot on the UCLA campus, where the attempts to start the revolution fail, sending our hero on the lam. He becomes involved tangentially with a real estate scheme, and cruises in and out of the seedy side of Los Angeles's development, until he winds up on its very edges, where it fades into the desert that gives the film its name. There he engages in a kind of (clothed) orgy, choreographed by Anna Halprin,[71] in which humans and nature attempt to merge. The final apotheosis of this Los Angeles that develops from collage to revolution to its own future self to an orgiastic attempt at spiritual renewal is a slow-motion explosion of the real estate developer's modernist home at that edge. The explosion of the tenth of a second happens, but in slow motion, and only within the film itself.

While Los Angeles thus remained a potent image, interpreted not only by filmmakers and writers but also by artists such as David Hockney (as a 360-degree collage of Mulholland Drive, for instance),[72] Ed Ruscha,[73] and Carlos Almarez (as burning cars),[74] it did not produce a metaphor or anarchitecture of itself. Reyner Banham's critique in particular,[75] which treated it as a collection of "ecologies," or complete environments, and which included the fragmentary edge condition of the beach with its open spaces, the "planes of id" stretching out on the flatlands, the fragments of modernism clinging to the unstable hills, and the "autopia" connecting it all, came closest.[76] Had Banham managed not just to evoke these places by name and in examples, but to perform a kind of post- (or pre-)analytic myth-making, perhaps it would have offered an alternative to Wright's Chicago.

An early taste of what that might have looked like is presented by the hero of Nathaniel West's *The Day of the Locust*, who, as the city explodes in a riot, imagines painting it as he lives it, thus bringing the city, the narration, and the image close, if not completely, together:

> Despite the agony in his leg, he was able to think clearly about his picture, "The Burning of Los Angeles." After his quarrel with Faye, he had worked on it continually to escape tormenting himself, and the way to it in his mind had become almost automatic.
>
> As he stood on his good leg, clinging desperately to the iron rail, he could see all the rough charcoal strokes with which he had blocked it out on the big canvas. Across the top, parallel with the frame, he had drawn the burning city, a great bonfire of architectural styles, ranging from Egyptian to Cape Cod colonial. Through the center, winding from left to right, was a long hill street and down it, spilling into the middle foreground, came the mob carrying baseball bats and torches. For the faces of its members, he was using the innumerable sketches he had made of the people who come to California to die; the cultists of all sorts, economic as well as religious, the wave, airplane, funeral and preview watchers—all those poor devils who can only be stirred by the promise of miracles and then only to violence. A super "Dr. Know-All Pierce-All" had made the necessary promise and they were marching behind his banner in a great united front of screwballs and screw-boxes to purify the land. No longer bored, they sang and danced joyously in the red light of the flames. . . .
>
> He had almost forgotten both his leg and his predicament, and to make his escape still more complete he stood on a chair and worked at the flames in an upper corner of the canvas, modeling the tongues of fire so that they licked even more avidly at a corinthian column that held up the palmleaf roof of a nutburger stand.[77]

As a "bonfire of architectural styles," this apotheosis of Los Angeles becomes one with the mob, with the depiction of the whole scene, and with the observer who is composing the painting as he

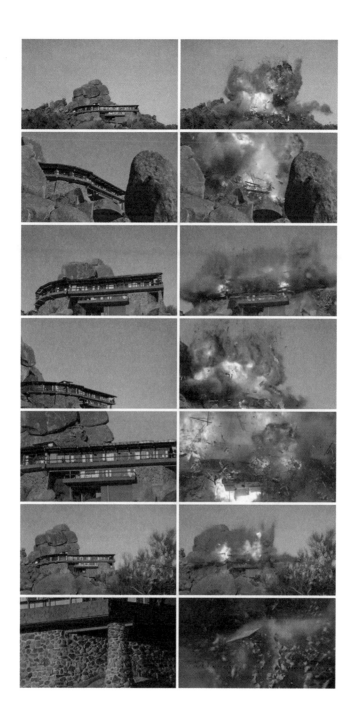

Michelangelo Antonioni, still from *Zabriskie Point*, 1970.

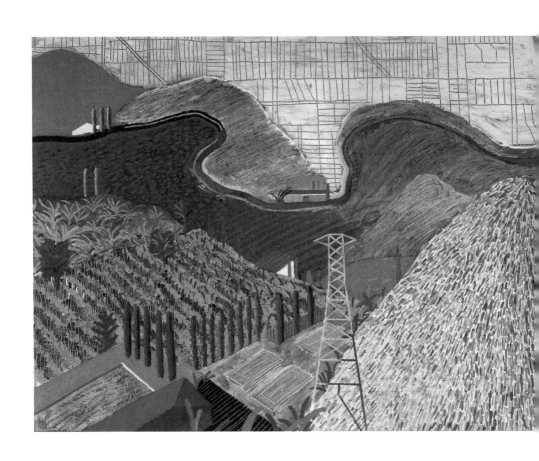

David Hockney, *Mulholland Drive: The Road to the Studio*, 1980 (Collection Los Angeles County Museum of Art, photograph Richard Schmidt; © David Hockney).

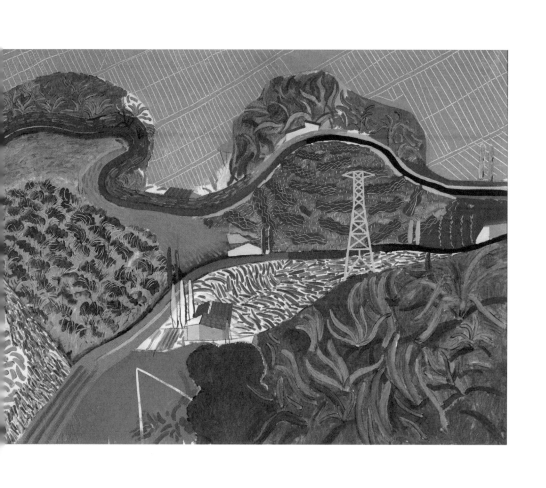

Carlos Almarez, *Untitled (Car Crash)*, 1987 (Estate of Carlos Almarez).

is part of the action. The artist is burning down the city as he is painting it, and vice versa—as is the writer of the story.

Fiction and poetry have been major producers of the kind of explosive and cinematic, not to mention unconsciously critical, anarchitecture of which architects have seemed, despite Benjamin's optimism, incapable. The obvious reason is that these writers are free to make things that can explode continually, as you read or hear them. By collapsing any sense of endurance of time and space, they can create an exploding architecture. Central to some of their work is, in fact, the implosion of time and space, and the destruction of monuments and the very idea of monumentality. The city also cannot stand as a separate entity, and the human being is condemned to death. Only out this destruction can something emerge, which is the unfolding reel of modernity. Here, for instance, is Robert Lowell's version of Boston in the 1960s:

> The old South Boston Aquarium stands
> in a Sahara of snow now. Its broken windows are boarded.
> The bronze weathervane cod has lost half its scales.
> The airy tanks are dry.
>
> Once my nose crawled like a snail on the glass;
> my hand tingled
> to burst the bubbles
> drifting from the noses of the cowed, compliant fish.
>
> My hand draws back. I often sigh still
> for the dark downward and vegetating kingdom
> of the fish and reptile. One morning last March,
> I pressed against the new barbed and galvanized
>
> fence on the Boston Common. Behind their cage,
> yellow dinosaur steamshovels were grunting
> as they cropped up tons of mush and grass
> to gouge their underworld garage.
>
> Parking spaces luxuriate like civic
> sandpiles in the heart of Boston.
> A girdle of orange, Puritan-pumpkin colored girders
> braces the tingling Statehouse,

shaking over the excavations, as it faces Colonel Shaw
and his bell-cheeked Negro infantry
on St. Gaudens' shaking Civil War relief,
propped by a plank splint against the garage's earthquake.

Two months after marching through Boston,
half the regiment was dead;
at the dedication,
William James could almost hear the bronze Negroes
breathe.

Their monument sticks like a fishbone
in the city's throat.
Its Colonel is as lean
as a compass-needle.

He has an angry wrenlike vigilance,
a greyhound's gentle tautness;
he seems to wince at pleasure,
and suffocate for privacy.

He is out of bounds now. He rejoices in man's lovely,
peculiar power to choose life and die—
when he leads his black soldiers to death,
he cannot bend his back.

On a thousand small town New England greens,
the old white churches hold their air
of sparse, sincere rebellion; frayed flags
quilt the graveyards of the Grand Army of the Republic.

The stone statues of the abstract Union Soldier
grow slimmer and younger each year—
wasp-waisted, they doze over muskets
and muse through their sideburns . . .

Shaw's father wanted no monument
except the ditch,
where his son's body was thrown
and lost with his "niggers."

The ditch is nearer.
There are no statues for the last war here;
on Boylston Street, a commercial photograph
shows Hiroshima boiling

over a Mosler Safe, the "Rock of Ages"
that survived the blast. Space is nearer.
When I crouch to my television set,
the drained faces of Negro school-children rise like balloons.

Colonel Shaw
is riding on his bubble,
he waits
for the blessèd break.[78]

The cars are fish, the aquarium and its content fuse with the past, while the destruction of that space by both construction and the television evokes the death of heroism, as well as the uselessness of monuments or even attention to individual deeds. As Lowell says: "Space is nearer," by which he here means the extraterrestrial place opened up by rockets, but also the emptiness of the city, its continual change, and the lack of history. We are almost at a lived explosion, or rather, implosion. It is only one step from here to the advent of revolution, as imagined a decade later by Philip Levine:

Out of burlap sacks, out of bearing butter,
Out of black bean and wet slate bread,
Out of the acids of rage, the candor of tar,
Out of creosote, gasoline, drive shafts, wooden dollies,
They Lion grow.
 Out of the gray hills
Of industrial barns, out of rain, out of bus ride,
West Virginia to Kiss My Ass, out of buried aunties,
Mothers hardening like pounded stumps, out of stumps,
Out of the bones' need to sharpen and the muscles' to
stretch,
They Lion grow.
 Earth is eating trees, fence posts,
Gutted cars, earth is calling in her little ones,

"Come home, Come home!" From pig balls,
From the ferocity of pig driven to holiness,
From the furred ear and the full jowl come
The repose of the hung belly, from the purpose
They Lion grow.
 From the sweet glues of the trotters
Come the sweet kinks of the fist, from the full flower
Of the hams the thorax of caves,
From "Bow Down" come "Rise Up,"
Come they Lion from the reeds of shovels,
The grained arm that pulls the hands,
They Lion grow.
 From my five arms and all my hands,
From all my white sins forgiven, they feed,
From my car passing under the stars,
They Lion, from my children inherit,
From the oak turned to a wall, they Lion,
From they sack and they belly opened
And all that was hidden burning on the oil-stained earth
They feed they Lion and he comes.[79]

The city and the machine, or rather its many machines, have
merged again with a primeval version of nature, and have become
a vision of an ancient myth of shovels that are animals, cars that
are lions, sacks of wheat that are human bellies that burn. In the
end, this hybrid beast comes, and, as the vengeful embodiment
of the masses, wins. This is a primal and primitive version of the
revolution for which Benjamin hoped.

Much of late twentieth-century writing is full of such language,
especially as it merges with the fights against colonialism, racism,
sexism, and other forms of oppression. Few instances, however,
outside of poetry achieve the particular merger of the animate,
the human, the machinic, and the urban that Wright evoked, or
the explosion Benjamin saw as the beginning point of the uncon-
scious journey toward revolution.

If any other twentieth-century architect came close to evok-
ing this exploding leviathan, it was the Japanese designer Arata
Isozaki. In his 1962 story "City Demolition, Inc.," he describes
meeting an old friend ("s.") who is a professional assassin.[80] In
him Isozaki, long fascinated by hybrids between Japanese tradi-
tions and Western forms, found the perfect embodiment of that

tension: an ancient craftsperson who destroys humans, who tells him that he is now transferring his knowledge to destroying the modern city. To Isozaki this change of profession seems strange, as he seems to have the perfect job, one which he sees as paralleling and even improving on the work of the architect:

> The careful, long-term planning and scheming of a murder well done, as well as a perfect disposal of the body! It was just like an artist engaged in designing. Without the snobbery of Frank Lloyd Wright or the bluff of Le Corbusier, he could produce a complicated vision in which, while extinction was coupled with existence, the concept of emptiness was caught in the very midst of action.[81]

What the assassin is doing in executing his craft, in other words, is getting rid of a human being, and so producing a vision which is akin to that of the century's greatest architects. And what was that vision? Emptiness, "caught in the very midst of action."[82]

Now, however, "a monster had emerged that kept hurting his professional pride." That "monster" is "modern civilization," and, in particular, the city: "The killer was the killer of all killers and, worse still, being anonymous, it was a curious enterprise to which no responsibilities were attached."[83] S. notes that traffic accidents alone, for instance, kill far more people than he ever could. It is for this reason that the assassin decides to take his revenge:

> The aim of his company, therefore, was to destroy cities by all possible means. Tokyo, for him was especially easy to undermine. It was like a building whose foundations had decayed, walls collapsing and water pipes getting thinner, structures barely standing, braced by numerous struts and supported by a jungle of props and buttresses, patches and stains from the leaks in the roof.[84]

In a perverse revision of Wright's vision (and I have no idea whether Isozaki knew of it when he wrote this piece), the author imagines a machine-city person (killer) that is not so much exploding as it is becoming ruinous and returning, like Levine's fermenting urbanity, to nature. That, however, does not make it any less dangerous than the exploding city: "Imagine such a deserted house—decorated gaudily on the surface, it goes on killing people,

goes on emitting a vigorous energy. A gigantic monster on the brink of extinction; a pig roasted whole; the ultimate evil of unintentional, inevitable mass massacre." "He said," Isozaki concludes, "that such a city must be destroyed as soon as possible." The killer, which is now the city, which descends back into a primeval state, must be killed.[85]

With the overtones of the "Futurist Manifesto" already coursing through the text, Isozaki's S. goes on to deliver his own screed, which he calls the "Prospectus for the Establishment of the City Demolition Industry, Inc., and the Content of its Business." Like Marinetti, he does not want to do away with violence, but rather seeks to perpetuate and even institutionalize it: "Our company aims at the complete destruction of large cities which have been repeatedly engaged in vicious mass murder, and at the construction of a civilization in which elegant, pleasant, and humanistic murder can be carried out easily."[86] What is needed, in other words, is a humane and human form of destruction, perhaps of the kind performed by the surgeon of the unconscious, the psychoanalyst—or their urban equivalent, the architect.

The methods Isozaki's friend proposes are, however, more straightforward: physical, functional, and image destruction. The first of these evokes the use of that ultimate destroyer, the atom bomb. The second wants to replace chaos by poisoning wells to reduce population, but also by just creating confusion by taking away traffic signals and house numbers. The third form of destruction is the strangest: it involves absolute planning, which will mass produce housing "corporation style" and "eliminate calamities" by continually introducing new plans. Any sense of reality, in other words, will disappear. The life of the city, both physical and phenomenal, would disappear.[87]

Isozaki discusses this proposal with S., but then points out a problem: even if you explode a city, it will rise again, larger than it was, "like a phoenix."[88] While there is civilization, there will be a city, even if that city is only notional: "Aren't cities merely abstract ideas? Nothing but ghost images which have been built up by citizens through mutual agreement for their practical purposes? And, so far as such a mirage has been transmitted, only the process of transmission exists as the substance of the city."[89] The city as a "complex feedback mechanism" can thus course through our bones—much as the printing press and its products gave life to

Wright's leviathan. Now, however, it is the city itself that is a ghost, something that is barely there.

What, then, should S. do? It turns out that Isozaki has the answer. In the architect's work, they are continually making plans, and those plans, the assassin has pointed out, help kill the city continually: "According to my friend S. the implementation of city plans would inevitably bring cities to destruction. He says, with a cynical smile, that as soon as I draw up a plan I should put it into practice. It is inexcusable, he argues, for the professional to only make utopian plans." Isozaki has to agree: "when I think of the hollow sound of the slogans for building, renewing and improving cities—in reality the political propping-up of the metropolis—I come to think in terms of destruction as the only reality."[90] In this bizarre twist of purpose and language, Isozaki affirms the identity of architecture, urbanity, destruction, and construction, as well as its justification in (transference to) utopia. What, then, is his task? "As for myself," Isozaki concludes, "I could continue to draw an unrealistic veil over my concrete proposals as a staff member of his company."[91] The architect has become an urban assassin—an identity he confirms by pointing out, in a postscript, that S. and he might be the same person.[92]

The explosion of the tenth of a second, then, is perhaps inherent in the act of architecture, but only if it is realized as such, as an "unrealistic veil." What that veil might be, which Isozaki remembers, in a postscript to the postscript, as "blending the reality and dream (fantasy) that I then saw" in a Tokyo marked by a "first wave of economic growth after the very real near-annihilation of the Second World War,"[93] would have to be something that above all is, represents itself as, nothing, that confused the sign of architecture. It would realize a degree zero.

3 *The Veil*

Technology shapes the modern world. That was one thing on which almost all architects, critics, and thinkers who tried to figure out how to give form to that modernity could agree. To some, technology was a force whose effect was above all else corrosive and destructive. From reducing people to operational cogs in machines to expanding cities to scales and speeds no one individual could understand, technology's effect was monstrous. It attacked the very core of what it meant to be human and what humanity had achieved in creating a culture and a civilization. Others saw such results as inevitable and even positive. They relished the thought of a world shaped and even controlled by machinery, in which we would be free, if perhaps also captured, to enjoy the perfection our own hands had wrought. Through technology, we could even come to a point of posthumanity, where we would be free consciousnesses floating through technology that would effect our place in the world and take the place of our bodies. Most observers in the discipline of architecture, like those in other parts of the cultural industry and academia, positioned themselves somewhere in the middle between these dystopian and utopian poles as they tried to image how to use technology for the better while avoiding its worst effects.[1]

Even as they tried to find such paths forward, of course, technology came to dominate the images, forms, and spaces of modern

life. Even those forms of architecture that offered alternatives or even outright rejected technology assimilated it into its bones, cladding steel skeletons with stone fitted together to evoke a Gothic past or streamlining their classical elements to reflect the mechanisms and precision of modern production. Architecture was produced by offices that were themselves marvels of technological efficiency and that worked in larger processes and bureaucracies that by their very nature promoted standardization, mass production, and recognizability of spaces and forms.

While the period before the Second World War thus saw an explosion of imagery that evoked machinery, from the purist collages of abstracted pipes and valves to the "house as machine" Le Corbusier tried to build, by the postwar period technology had become so embedded and obvious that the thrill of recognition was gone. Being modern now meant grids, expanses of human-made material such as aluminum, glass, laminate, or manufactured wood, as well as abstraction and flexibility of function and a repression of individual eccentricities and variations.

Architects began to compose reactions against this formlessness and lack of humanity, proposing a "New Monumentality"[2] or delighting, as the Finnish architect Alvar Aalto did, in adding sensual and eccentric elements to his white, gridded buildings, all the way from doorknobs that responded to the shape of the hand to reading rooms that fanned out in waves toward the light. To support such searches for form and meaning in architecture, designers and critics kept asking the questions: What is technology? How can and should we use or express it? If it cannot be avoided, can it somehow become a force that will make our architecture better, or are we doomed to retroactive attempts to close Pandora's box? To answer these questions, they found many suggestions within architecture, but few approaches that asked the questions in a more profound manner.

One philosopher who tried to do so in the most thorough manner possible was Martin Heidegger. Heidegger's attitude toward technology was ambivalent in a manner that was central to his whole philosophy. He saw his work as an attempt to inquire into the very nature of being and to do so through a continual questioning of what we can see and know about what ultimately always recedes from such understanding. Heidegger's stance toward the world around him was one of skepticism, but also of inquiry: only through a careful looking at technology, language, or any other

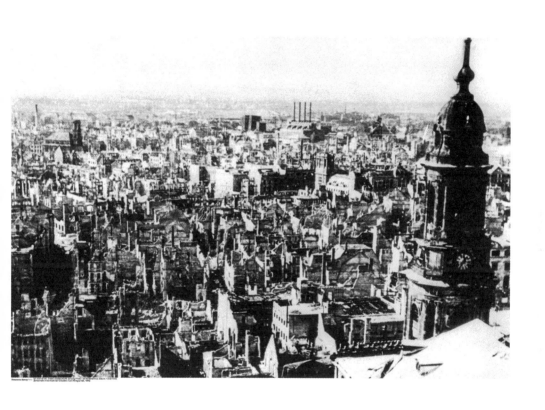

Unknown photographer, Dresden in ruins, 1945.

human artifact could we begin to formulate exactly what it is that "always recedes," namely being.[3]

There is no doubt that Heidegger was a deeply conservative man who also collaborated with the Nazi party. We cannot and must not divorce his political stance from his theoretical positions. What is odd is that he arrives, starting from an opposite standpoint, at a position that is not unlike that of Walter Benjamin and quite a few other writers in the Marxist tradition. There are crucial differences, of course, but those fundamental decisions about what to make of what he observed in his reality still manage to operate within the arena of evocation, palimpsests, and the obscure mirroring and mapping of the monster leviathan.

Heidegger's work is voluminous, and technology pervades many of its discussions.[4] One essay, however, addresses it directly: "The Question Concerning Technology," which he did not publish until 1954.[5] Most architects turn instead to a shorter—and easier to understand—text Heidegger wrote on their subject, the "Building Dwelling Thinking"[6] of the same year. This is a more conservative text, in the sense that it emphasizes the importance of finding a way to be at home in a nature and with humanity that Heidegger does not question here. Many college courses in the last half-century have returned especially to Heidegger's most evocative image in this text:

> Let us think for a while of a farmhouse in the Black Forest, which was built some two hundred years ago by the dwelling of peasants. Here the self-sufficiency of the power to let earth and heaven, divinities and mortals enter in simple oneness into things, ordered the house. It placed the farm on the wind-sheltered mountain slope looking south, among the meadows close to the spring. It gave it the wide overhanging shingle roof whose proper slope bears up under the burden of snow, and which, reaching deep down, shields the chambers against the storms of the long winter nights. It did not forget the altar corner behind the community table; it made room in its chamber for the hallowed places of childbed and the "tree of the dead"—for that is what they call a coffin there: the Totenbaum—and in this way it designed for the different generations under one roof the character of their journey through time. A craft which,

itself sprung from dwelling, still uses its tools and frames as things, built the farmhouse.[7]

Yet they forget that in the next sentence, Heidegger says: "Our reference to the Black Forest farm in no way means that we should or could go back to building such houses; rather, it illustrates by a dwelling that *has been* how it was able to build [Heidegger's emphasis]."[8] His whole text, he ends by saying, is meant to respond to the then-current need for more housing at a large scale because of the destruction of the Second World War by emphasizing that we should look beyond the mere scale of the problem to ask the question of how we can dwell, which is to say truly be, in a human manner, in the world: "The real plight of dwelling lies in this, that mortals ever search anew for the nature of dwelling, that they must ever learn to dwell."[9] Architecture, in other words, is beside the point, as the question is a philosophical one, in that human beings must learn to be human.

But what would that mean? In "The Question Concerning Technology" Heidegger gives a much more thorough, though ultimately also elusive answer. The article came out of a series of lectures he gave in 1949 that reflected his concerns about the manner in which technology and, on a larger or more pervasive scale, material culture were transforming not just the world but the human being itself and its consciousness into no more than what he called "standing reserve," or material to be used within technological processes. Heidegger revised the lectures in 1953 for publication, creating a unified discussion of how this occurs.

Heidegger's aim here is to get to the essence of technology, which he defines, after several purposeful feints, as being evidenced in tools, which he defines in turn as "a means to an end."[10] That leads him to the issue of causality, or what causes things to appear or happen. Very quickly, he thus redefines the issue from the outward accoutrements of machines and tools, toward the human intentions in their use. More than that, he now evokes the image of a world that belies our association of the term "technology" with the latest and most complex machinery, moving back toward a more basic and evocative element: a silver chalice.[11] In many ways, this is typical of Heidegger's reactionary approach, which draws attention away from the realities of our current condition toward its roots in an imagined past.

Yet Heidegger uses the chalice to build an alternative world of modernity that finds a direct connection between the kind of craft and care that go into the crafting of such a chalice and the environmental devastation and human alienation of the twentieth century. He does so by using the philosophical notion of causality to move from the notion of the five causes of why things appear (their material, their form, their maker, the medium, and their intention) to reverse our usual association of how the willful action of the maker, working toward a purpose, with a recalcitrant material, and with a limiting sense of what the thing should be, produces, in the process forcing a thing to appear: rather, he says, the thing owes "a debt" to material, form, end or function, and maker, as without those it would not come into existence.[12] Thus, the act of making ensnares the object of use in a web of debt and gratitude, in which the final product is beholden to, both in the sense that it is grateful to and in debt to, the technology. Though Heidegger does not make this connection explicitly, he seems to be implying the fact that technology is thus embedded in the transformation of a gift economy into a demand one, in which value is entombed in the object by the five causes and is extracted back out of it through trade and commerce.

Rather than concentrating on this set of operations, however, Heidegger continues to investigate through making and causality and the debt to its modes, to ask what the operation of making then is. Why is something brought into appearance with this debt loaded into it? To him, that question can only be answered by the act itself, as it is essential to human being and, in fact, to his whole definition of what it means to be human. Technology, in this sense, is what humans do: they make things, both as and with tools, that are the activity and the proof, as well as the operative parts, of their humanity. To bring something into being is the ultimate human act. This leads him again into a more general point. The human being is a "homo faber," or maker whose central activity is, as Heidegger puts it, "to bring into unconcealment." A thing is always already latent, or potentially there, and even essentially so. It is up to the human being to use the technology of making to bring it forth, to reveal it, to "presence" it. The human being is a revealer in the employment of technology, who lets what is of the essence, whatever that might be (and knowing what that is remains at the core of Heidegger's work), appear, or at least attempts to do so.

Beyond the importance of this argument for his overall philosophical project, Heidegger here brings together two strains of thought about objects. The first and most obvious is the notion that any one thing, if we look at it with enough care and analytical ability, will reveal some truth not only about the object itself, but also about what went into it—what it is made out of, who made it, why, and how the whole fits into a larger culture or aesthetic. Art history or art theory that focuses on this idea increases the value of the carefully made object by finding within it meaning and even truth about larger structures or realities. Whether that value comes out of the knowledge the observer brings to the analysis, or it is inherent in the thing itself, or is what the viewer gets out of the object, or some relation among all three, has been the subject of much debate. Heidegger here is more interested in what he calls the "truth telling" that an object effects.[13]

The second value the object has is that of a gift. Although Heidegger makes no reference to this notion, the idea that an art object is a form of potlatch, or the conversion of wealth into something that gains value by being given away and consumed, lurks through the text. The notion that one gifts the beauty of the thing to the observer, enriching or enlightening them, or stores it in the earth or, later, in a museum to preserve its ability to give that truth, guarantees the value in a manner that cannot be diminished by either use or analysis. The making of the work of art as such, as opposed to having its production disappear into its nature as a tool to, for instance, hold wine, or as part of a larger ritual, is a way of removing material and labor from the cycle of production and consumption, as well as from the mimicking of that cycle in religion. The work of art thus becomes a holder or burial device for value.

Instead of referring to ancient cultures, Heidegger speaks of the "freeing" of the object by the five causes to enter onto a "path" that he calls a "destining"—evoking, whether he intends to or not, the burial routes and the sheltering aspects of churches, sanctuaries, collections, or museums. Art makes us—as makers, observers, and users—free, but also frees the thing itself.[14]

The root of its value or ability to tell that truth lies for him in the twin terms of *techne* and *poiesis*. The latter—at least in his interpretation—is the Greek word for making, and it is convenient that in English the word "poetry" derives from it. For Heidegger, this kind of "revealing making" is a "truth telling" that "brings into

unconcealment" what is hidden within all things. He then sets up a dichotomy between a "good" and "bad" way of making, while being careful, at least at first, not to employ such value judgments overtly. He also echoes the split inherent in architecture between the making of the structure or base material and the crafting of the building's appearance, its poetry.[15]

There are, he explains, two kinds of revealing: the natural, organic kind, which is the general form of *poiesis*, and the human-produced kind, which is *techne*, or making, and obviously the root of the word "technology."[16] While natural making appears and unfolds or unfurls as a plant or landscape does, technology forces something to appear through the craft and will of the maker toward an end within a category of cultural artifacts that allows us to recognize and categorize the resulting object. As Heidegger says, technology is a form of revealing that "challenges" the elements of the object and thus "puts to nature the unreasonable demand that it supply energy that can be extracted and stored as such."[17] Technology, in other words, converts material into raw or base material, the maker into a worker, the use into a measurable function, and the form into something that can be categorized. All this drowns the "gift" with what Karl Marx might call "use value."

To explain this particular form of technology, Heidegger reverts to his favorite site of similes and warning stories, the Rhine. Evoking its mythical and mystical nature in traditional lore and modern art (think of Wagner's *Ring* cycle), he contrasts that ancient river with its modern version:

> The hydroelectric plant is set into the current of the Rhine. It sets the Rhine to supplying its hydraulic pressure, which then sets the turbines turning. This turning sets those machines in motion whose thrust sets going the electric current for which the long-distance power station and its network of cables are set up to dispatch electricity. In the context of the interlocking processes pertaining to the orderly disposition of electrical energy, even the Rhine itself appears as something at our command. The hydroelectric plant is not built into the Rhine River as was the old wooden bridge that joined bank with bank for hundreds of years. Rather the river is dammed up into the power plant. What the river is now, namely a water power supplier, derives from out of the essence of the power station.[18]

Chapter 3

Heidegger explains that such a technology represents a different kind of poetry or truth-telling:

> The revealing that rules throughout modern technology has the character of a setting-upon, in the sense of a challenging-forth. That challenging happens in that the energy concealed in nature is unlocked, what is unlocked is transformed, what is transformed is stored up, what is stored up is, in turn, distributed, and what is distributed is switched about ever anew. Unlocking, transforming, storing, distributing, and switching about are ways of revealing. But the revealing never simply comes to an end. Neither does it run off into the indeterminate. The revealing reveals to itself its own manifoldly interlocking paths, through regulating their course. This regulating itself is, for its part, everywhere secured. Regulating and securing even become the chief characteristics of the challenging revealing.[19]

He adds that human beings cannot escape from this regulating and revealing. They are also challenged, namely, to be "human resources" who are not independent makers but cogs in the same machine of distribution. In the end, says Heidegger, we are all "enframed": we are caught and imprisoned in, and made an essential part of, technology. Because we are thus an integral part of processes beyond our immediate control, technology does not reveal itself to us, but only to itself. Whatever we build remains enigmatic, mute, and defined only by its functional value.[20]

And yet Heidegger has just revealed technology to us in what he considers its essential nature. He has done so, moreover, in a manner that recalls Frank Lloyd Wright's evocation of the "monster leviathan" that subsumes its engineers and workers, as well as the city and its component parts, the "the incessant clicking, dropping, waiting—lifting, waiting, shifting" of this great machine. The printing press and the hydroelectric plant are both vast and all-encompassing alternatives to a mythic and unified, organic landscape of making and meaning, and both produce truth. For Wright, that truth comes issuing forth from the printing presses and, by implication, from his own words. For Heidegger, that truth is technology, the monster itself, that has swallowed us up completely, and with it the possibility of meaning. Even his own description, as he acknowledges, is part of the machine.

What is even more remarkable is that Heidegger comes up with a response and possible escape that is also eerily akin to Wright's: he offers poetry as a kind of veil that both reveals and shelters truth in order to preserve its power.

What technology removes from both nature and human beings, according to Heidegger, is the assumption that they are independent and whole. Rather, the human being is buried in a ground that is nothing but extractable energy, and all that remains is a "skeleton." These bare bones are the basic working elements that are akin to the columns and girders of a building or the roads and canals that connect all these elements. What disappears is the object or body as truth-teller; what comes forth is an abstract, dead, and deadening system without reality. It is made of relations that continually change. What emerges is the earth- and human beings-encompassing machine, but it is a dead corpse.[21]

The value is that our death and reality as nothing but bones or "challenged-forth" relationships is revealed. This is the ultimate truth of modern technology, that we are nothing, or no-thing. But the very truth of that challenging-forth has a shimmering of reality within itself: it is that, according to Heidegger, which calls us toward our destiny, or "sets us on our path." Instead of hanging onto the fiction that we are real, autonomous agents, it reveals the opposite to us. Yet, in that very act, it opens up another possibility. By the very act of explication, revelation, and truth-telling, "something shimmers": a death shroud laid over the bones of both humans and the technology they have made. This revelation is a challenging itself, forcing us to confront who we are, and in so doing "allots itself to man." The human being becomes not a maker but somebody "keeping watch over unconcealment." The highest act a human being can hope to be challenged toward is to act as a witness.[22]

To do so, they must somehow be both part of technology (as we cannot avoid that state) and just far enough away from it to be an observer. The truth, moreover, has to hover somewhere between being and nonbeing. The answer is, explicitly, the veil, as the taker and maker of impressions and revealer of underlying shapes and, implicitly, a kind of dream state, in which truth is revealed without burying or enframing us.

Heidegger's name for this state is "poetry." At the end of the essay, he thus rescues the organic and mythic nature of making

for a specific, modern type of activity. He calls it now not revealing but "questioning," thus revealing the ultimate reason for the essay's title. "Questioning is the piety of thought," he states. It is thus the philosopher, critic, or researcher, whether in the guise of a professional thinker or analyst or as poet, artist, or other poetic maker, who has the task of truth telling through intimation, evocation, and the art of questioning itself.[23]

What Heidegger has produced is another version of the kind of poetry that has no immediate presence or reality, but that in its speaking or writing brings out what might be the truth of things, and in particular the technological nature of our modern age. The virtue of this essay, despite its mysticism and occasional leaps of logic, is twofold. First, it presents technology not only as a system but as a whole: a reality in which we live and from which we cannot escape. Second, it proposes the possibility through some form of making of the poetic sort, something we might call art (or architecture), that what we can do is to name and describe, in a poetic manner, this monster leviathan.

I would further propose that architecture, which most closely mimics, traces, and is composed of technology in the manner of making Heidegger defines, also has, as it appears and is interpreted or questioned, the strongest possibility of "presencing" that veil of poetry.

Heidegger evoked the reality that became before, during, and after the Second World War. The "total war" revealed, as Benjamin had predicted, the reduction of human beings to standing reserve or troops and, after the war, to "human resources." Many theories and descriptions, as well as the architecture, of the postwar period took the triumph of technology as their starting point and sought to give it form. The image Frank Lloyd Wright had evoked actually came to pass, at least to some degree, in the emergence of purpose-built factories that were large and complex enough to be integrated landscapes. They were also often company towns, and within their precincts the human actors were indeed fully integrated into the machinery of production.[24] Though their design kept factory, home, and recreation separate, their logic, determined by mechanical and chemical processes rather than by human beings who might have organized space around their bodies and communities, exploded any sense of being able to understand this new reality from a static perspective. Moving way beyond the singular dam

sitting in the river, but also fixing into place the explosive nature of modernity, these complexes created a technological reality in which human beings were fully integrated.[25]

After the Second World War these complexes, which reached their peak in scale and complexity in service of the war machine, lost some of their logic as distributed modes of production came into being, while the processes themselves became more compact and eventually automated. That did not mean, however, that such monster leviathans disappeared. Instead, they turned into office complexes and large-scale organizational hubs in a manner that was pioneered before the Second World War in reaction to the Great Depression.

What is remarkable is that many of these complexes were designed by singular architects or architecture firms, and thus represented a truly integrated vision. The firms themselves turned into machines to produce designs and guide construction, growing along with their projects not only in size but also in their ability to integrate technical and (to a certain extent) social expertise into their practices. They also were able to provide visions to guide such projects, developing an aesthetic that they draped, eventually indeed like a glass veil, over structures whose internal complexity was intimated, but never revealed, in the overlapping geometries and materials of the buildings. These projects strained the abilities of architecture as it was traditionally practiced, leading, on the one hand, to situations in which the urban phenomena appeared not be controlled by its aesthetics or expressive capacities and, on the other hand, to the emergence of even grander but also more ephemeral images of a postmachinic architecture.[26]

Architecture in the middle of the twentieth century thus gave birth to a fusion of machines, buildings, and infrastructure in a manner that in some cases approached the realization of both Wright's and Heidegger's visions. The term that arose for such assemblages was "megastructures": the equivalent in built form of the sort of fantastical natural structures astronomers were then postulating. At first, such very large-scale constructions still consisted of a host of separate structures. The classic example is the River Rouge complex Henry Ford built outside of Detroit, Michigan, starting in 1917. Although it began as a single assembly building, by the time the more than thousand acres had filled with 90 miles of railroads and 93 buildings, Ford's vision was larger: ore would arrive along with rubber from his own plantations and the

other raw material for car manufacture on boats in the harbor, be transported on interconnected gantries and passageways to smelters, refineries, and other assembly buildings, to be there processed and put together until all these elements, suitably transformed and rearranged, would emerge as a finished car at the other end of the process and the site. Even the waste was recycled, and human beings were treated by management and its security apparatus, as Heidegger noted, as elements to be optimized, surveyed, and moved around like so much raw material.[27] As artists such as Charles Sheeler and Charles Demuth portrayed River Rouge, it was indeed close to Wright's monster leviathan, missing only the integration of offices and forms of dissemination (which Ford took care of in other places) to make the vision complete.[28]

In Sheeler's most iconic image, a collage based on photographs he took in 1927, conveyor belts cross in the middle of image, creating an X shape dominating the whole image. From the middle of their meeting point, eight smokestacks rise almost to the edge of the image, their smoke blending into the gray sky. The skeletons of railroad crossings and water towers confuse the foreground, cutting off the masses of production sheds at various levels, themselves connected by an angled building. A round water tower, a train car sitting on a siding, and fragments of other structures fill out the image to make a complex that at first seems centered and straightforward but becomes ever more contradictory and intricate as you try to imagine the connections between the pieces. Though we are given a scale through the presence of the train car and the windows, the compression of the perspective makes that sense of a human dimension more difficult to define, while the smokestacks and the round water tower gesture toward an intersection of geometrically shaped elements whose connections make little sense to the human being.

In other images, Sheeler dives right into the machinery, overwhelming us with the intersecting lines and pipes and the bulbous forms clad in metal and of uncertain purpose that dwarf the few people attending to their needs. He steps back to observe the sheds themselves, massive in their appearance, largely blank, and topped with roofs that deform what we expect such protection from the weather to be. Smokestacks stand by themselves, rising out of nowhere. From a distance, the structures sit impassively at the end of a railroad line, empty on what might be a Sunday morning, monuments to work without any human beings.

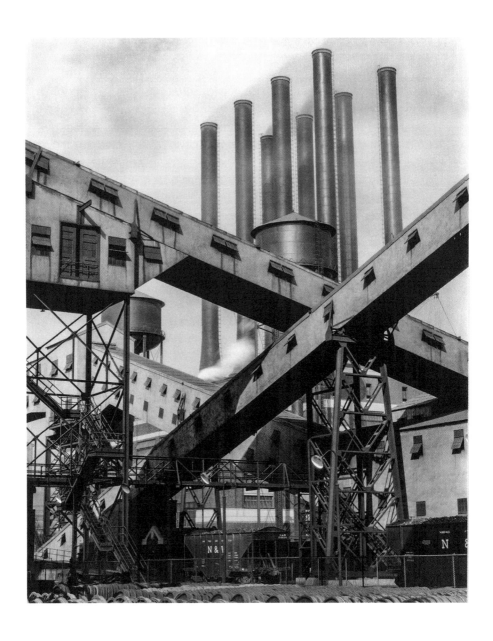

Charles Sheeler, *Criss-Crossed Conveyors, River Rouge Plant, Ford Motor Company*, 1927 (The Metropolitan Museum, Lane Collection).

Demuth's most overtly critical painting, *My Egypt* (1927), is actually not of the River Rouge plant or any factory. It depicts grain silos, those storage sites for industrially farmed grains that still stand as the tallest buildings in most agricultural landscapes, shot through with abstractions that represent either the rays of the sun or the slashing motion of the trains as they move by these monsters, connecting them to the even larger complexes of factories processing their contents into consumer goods. Like the pyramids that collected the wealth gained from grain and sank it into monuments, these structures represent concentrated power, but now in a manner that is devolved into a technology that cuts them apart into abstract elements, takes them out of context, and gives them back to us as sublime fragments standing for an infinitely large complex of accumulation and processing.

River Rouge's architect, Albert Kahn, produced many smaller versions across the country, but also designed hundreds more such integrated structures across the Soviet Union. Some of these, such as the tractor factory complex at Chelyabinsk, were in fact whole towns that integrated housing, offices, cultural and sports facilities, and all other aspects of concentrated urban living into a single megastructure built at one time.[29] Although the style and materials of these buildings were all of a piece, they never reached the sense of spatial and visual integration of the original vision. These factories (some designed by Kahn, some by others following his lead) became ever more abstract in their forms as the architect and the logic of economic necessity eliminated any detail or variance that might provide a human scale, while the sheer size of the structures continued to grow to accommodate even more complex assembly processes.

At the same time as these factories were rising on flat sites at the edges of metropolitan areas and beyond, creating their own landscapes, a new mode of making office structures was taking apart, fragmenting, and reassembling the centers of major cities. Among them were those that arose under the guidance of a team of architects assembled by Wallace Harrison: Rockefeller Center, starting in 1929, in New York City; the United Nations Headquarters complex, starting in 1947, also in New York City; and the Empire State Plaza in Albany, New York, starting in 1965. Rockefeller Center, which began as an opera house, turned into a collection of skyscrapers on either side of a public plaza that led up to the tallest of the towers, the RCA Building, which also contained a television

studio. What was most remarkable about this giant irruption of skyscrapers in the middle of New York was the total integration of these millions of square feet, both through their appearance as stripped-down, limestone-covered cliffs that made real the notion of Manhattan as range of humanmade mountains, and through the integration of the basement level into a stepping, meandering labyrinth of stores, services, and subways connections.[30]

In observing Rockefeller Center, the Swiss critic Sigfried Giedion, who had championed the primary importance of technology in understanding modern architecture, noted:

> The moment one begins moving in the midst of the buildings through Rockefeller Plaza, where the three largest structures rise in different directions and to different heights, one becomes conscious of new and unaccustomed relations between them. They cannot be grasped from any single position or embraced in any single view. There becomes apparent a many-sidedness in these simple and enormous slabs which makes it impossible to bind them rationally together. Through the free orientation of the thirty-six-story slab to the south ... a decisive force of planes is brought into play, separated by air combined unconsciously by the observing human eye. From these well-calculated masses one becomes aware of a new fantastic element inherent in the space-time conception of our period. The interrelations which the eye achieves between the different planes gives the clearly circumscribed volumes an extraordinary new effect, somewhat like that of a rotating sphere of mirrored facets in a ballroom when the facets reflect whirling spots of light in all directions and in every dimension.[31]

What Giedion was describing was a reality that had reached such a scale and complexity that a human being could not take it in from one perspective. Instead they were taking it in "unconsciously," in the manner Benjamin had already observed, and finding that they were surrounded by a collage of fragments at a giant scale. Though Giedion elsewhere imagines that a "man in equipoise" would be able to make sense of this new architecture, as long as they kept moving or dancing through the fragments with enough knowledge and action, never standing still long enough to be swallowed up by these blocks and the mountains they formed,

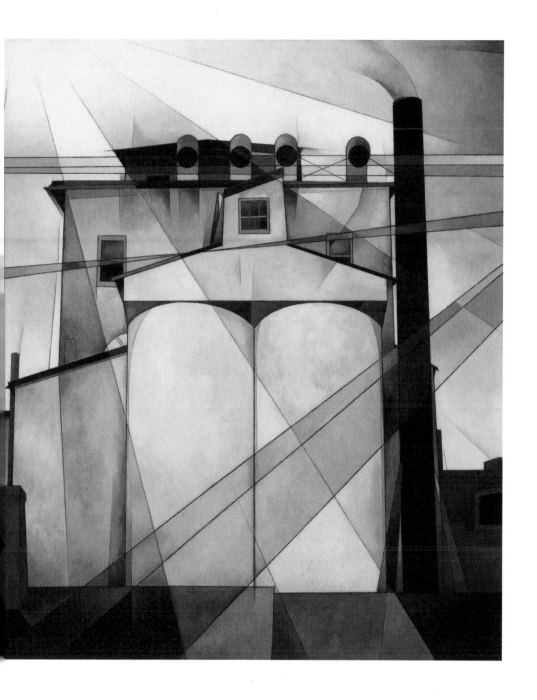

Charles Demuth, *My Egypt*, 1927 (The Whitney Museum of American Art; estate of Charles Demuth).

Photographer unknown, Harrison & Abramovitz, Rockefeller Center, New York, 1931–1940.

Photographer unknown, United Nations Architects, UN Building, New York, 1947–1951,
photo c. 1960 (United Nations Archive).

the sense of being overwhelmed is central to his experience.[32] The way we perceive this reality is broken apart in bits of time and space, while we always remain aware of the coherence of the whole, even if it is one we cannot directly experience. Even to this day, when Rockefeller Center is surrounded by taller buildings and similar clusters have risen around Manhattan and beyond, the collage of construction at such a colossal scale remains unrivaled in its effect.

While the UN Building is smaller and more focused in its function as the headquarters of a nascent world organization, it carried more symbolic weight in that function, and the architects were well aware of the exemplary aspect of what they were doing. The geometries that came together into a kinetic collage in the building, from the super-thin slab of the Secretariat, with its transparent skin shaded by the veil of sunscreen that revealed as much as it hid of that bureaucratic grid, to the dome of democracy supported by the saddle that evoked the upturned arms of the human figure that housed the Assembly, to the intersecting, machine-like stairs, balconies, and curving walls that wove together the complex's interior, the UN Building was the very emblem of a planet-integrating and -representing machine.[33] It showed up as such, not only in the many movies that used it as a backdrop (most notably Alfred Hitchcock's dystopian take on international relations, *North by Northwest*), but also in the hotels and conference centers Barron Hilton and the Russian Intourist organization spread around the world that mimicked, whether consciously or not, the appearance and the elements of the UN Building as a combination of hotel room slab, conference center, and public spaces and restaurants woven together around the base.[34] They did so in cities around the world, often as the largest such structure in their location, and thus were often the first harbinger of modernism in architecture and business. They were also inhabited by a new kind of businessperson, dressed in a manner that was standardized, connecting to other operatives around the globe, and acting to help create the globally interconnected economy and culture that defined the postwar era.

Empire State Plaza took these two protypes to their logical conclusion. A megastructure decreed by Governor Nelson Rockefeller, whose father had commissioned Rockefeller Center and whose family had been instrumental in bringing the UN to its site in New York, the Plaza wiped out the neighborhood of small houses and stores next to the New York State Capitol. It sucked

up a freeway connector into a slab of parking garages and services towering over the rest of Albany, New York, and then rose up to five separate monoliths—four midrise objects in a row and a taller, skyscraper-height facing them—arranged, again, around a central public plaza, with the "egg," a theater to offer a representation of public weal. This was a total environment in which all of the workings of the state government were assembled, rationalized, and enframed—including the bureaucrats who worked there.[35]

During these decades and on toward the end of the twentieth century, many such megastructures arose—or rather spread out, into incomprehensible mechanisms of connections arranged in planar grids and coalescing into geometric solids. Some, such as Brasília, Brazil's new capital, were completely new cities with millions of inhabitants. Others were cultural centers that were the basis for new forms of metropolitan living, such as the Barbican in London. Most common were universities, most notably such megastructures as Simon Fraser in Vancouver, Canada, where the campus became a machine for living. The ultimate ambition of such structures was to become a new reality, or at least a new and integrated city: a rationalized, fragmentized version of Sant'Elia's quasi-geological forms. The Japanese metabolists dreamed of complete new urban forms that would be both organic and industrial, oriented toward housing and putting to work the masses and their supervisors, but existing, as the name they chose for their movement indicates, as natural forms.[36]

Even after the logic of both the integration of processes into a singular site and the style that sought to express these forms had faded, structures evoking that heroic aspect of the integrated machinic assemblage continued to rise for decades. The Central University Hospital or Uniklinik of Aachen, which was not finished until 1982 after first being proposed in 1966, presents the fullest version of such a vision, rising from its suburban site as a healing version of Kahn's factories, all steel scaffolding, capsules, smokestacks, and roads rolling into the health machine. Covering four acres, it processes over three hundred thousand patients a year, and its interiors, as labyrinth-like as any such large medical center, but styled to resemble a factory, swallow all of the participants into a steady succession of fragmented sites for bodily intervention.[37]

As Giedion noted in his discussion of what he saw as the integration of buildings and urban forms into wholes that made sense in time as well as space, "urban planning has become three

Photographer unknown, Harrison & Abramovitz, Empire State Plaza, Albany, 1965–1976, photo c. 1975.

Photographer unknown, Arthur Erickson, Simon Fraser University, Vancouver, 1965–1967
(courtesy of Simon Fraser University).

Weber & Brand, Uniklinik, Aachen, 1972–1985 (author photograph).

dimensional." This was because "the dynamism of traffic and the dynamism of change have unavoidably become as much part of urban planning as the facts of nature."[38] This need in and of itself created the need for megastructures.

None of them, however, had the raw power, terror, or beauty of the monster leviathan. They never were the poetic veil that could fully express or even hint at the full triumph of mechanized capitalism. While some, such as the university, streamlined their forms so they could promise such a resolution, they only became symbols of a hopeful modernity in which technology would solve all our problems. Such dreams never lasted. Instead, the ultimate megastructure became the prison-like environment depicted in science fiction films. The first of these, *Things to Come* (1936), for which the artist László Moholy-Nagy was a set consultant, seemed to offer such a world of rational possibilities, but in the end its younger generation rebels and leaves this cocoon. Others, such as *Soylent Green* (1973), presented a true version of Heidegger's enframed reality, in which the workers were fuel not only for the economy but also for each other. Most poignantly, French filmmaker Jacques Tati spun out the new complexes built around the Gare de Lyon and La Défense into three-dimensional grids of gleaming materials in which there is nothing for a human being to do but to perform or get lost.[39]

What was missing in all such structures was exactly what Wright, Benjamin, Heidegger, and many other critics of modern architecture and culture were looking for: the truth-telling, the poetry, the explosion of the new, or the veil that would contain all that revealing and make it present in modern life. Where could one find such a shimmering of what was to be unconcealed?

For some, the answer was within the frame itself, or rather in the glass contained within that frame. The Apollo to Le Corbusier's Dionysus, Ludwig Mies van der Rohe, though he built a reputation with his design of minimal structures whose main surface area consisted of glass, had long realized that this medium did not provide transparency, but rather a combination of vision, occlusion, refraction, and the tints that gave it the ability to be present in a manner that was actually multifaceted.

Mies framed his glass in relentless grids, perfecting the large office or residential building's three-dimensional construction of metal or concrete that had replaced the more complex interplay of elements in traditional objects and turning it into the main visual element of the whole. He thus made enframing visible and, in such large complexes

as the Illinois Institute of Technology in Chicago (1939–1957) and the Lake Shore Drive housing complex in the same city, created a version of the kind of space-time continuum complex Giedion so admired in Rockefeller Center. Mies's structures were both more and less stable, in that their grids contained each one separately, and the architect insisted on hard edges, but the sameness of the structural and visual geometry across structures, as well as the reflections both across and between them and their surroundings, tended to confuse their separate natures.

It was the glass, though, that came closest to creating poetry in Mies's buildings. This was truer in his smaller, residential structures, such as the prewar Tugendhat House in Brno, Czech Republic, and the postwar Farnsworth House in Illinois, where the expanses of that material were large enough to overwhelm the frames in which they existed. The sense of these planes being almost not there, and yet completely altering the viewer's relation to the inside or outside, depending on where they were in the composition, was what created the essential beauty of such structures. The aesthetics they presented was of a machined unreality, which was itself nothing more or less than a reflection of the act of replacing nature with an artificial space that challenged forth electricity, heating or cooling, and all the other aspects of transformative environments, but now dissolving into "almost nothing."[40] That phrase (*beinahe nichts* in German) was what Mies cited as the ideal of his work. It was not pure nothing or abstraction, but exactly the nearness to such nothingness, in which the shimmering of reality kept alive the viewer as observer and the physical world as a reflection.[41]

The problem with the design of such veils is that they were almost impossible to achieve. None of Mies's followers were able to manipulate glass in frames with such delicacy, and even the German architect himself was challenged to do so in larger structures. Especially his larger and more successful late designs, such as the Seagram Building in New York, have too much solidity to recall any sense of poetry as veiling. It has only been in recent years, with advances in glass technology, that some architects, such as Kazuo Sejima, have come close to such delicacy, but in their case they seem more interested in creating uncertainty and a lack of affect than poetry.

The alternative to such an attempt to reflect the complexities of modernity was to embody them. The search for poetry in

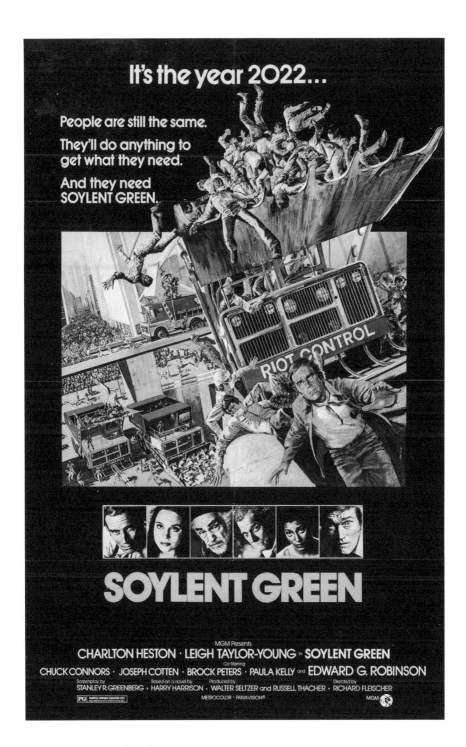

Designer unknown, poster for *Soylent Green*, 1973.

Jacques Tati, still from *Playtime*, 1967 (Continental Home Video, 1967).

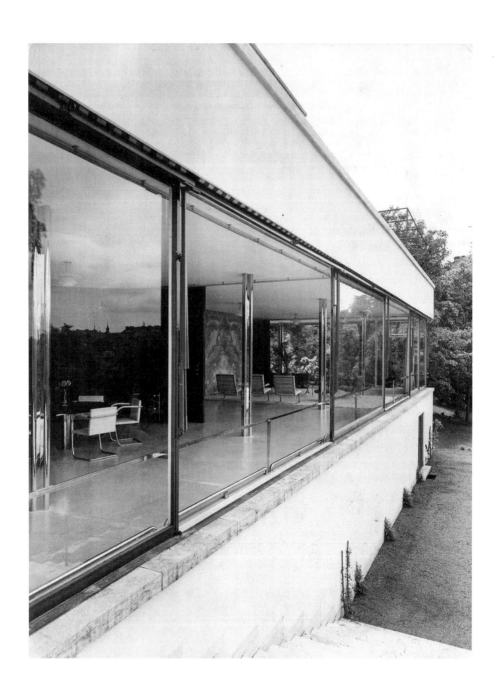

Photographer unknown, Ludwig Mies van der Rohe, Villa Tugendhat, Brno, 1929–1930
(Villa Tugendhat).

Photographer unknown, Ludwig Mies van der Rohe, Villa Tugendhat, Brno, 1929–1930, window mechanism (Villa Tugendhat).

architecture therefore also took a decidedly more monumental turn in the postwar era. Heidegger was certainly not the only one to lament the effects of technology, and some architects, though they could not escape using the materials and methods of that system, sought to find forms that would evoke something other, something inherent, and something natural. Ironically, that search led to the creation of large structures that usually relied on vast amounts of concrete and willful form-making.

Le Corbusier himself led the way in the postwar period, turning away from the slender structures he had created before that conflict, moving instead toward the design of massive objects that aspired to be sculptures as much as places of use and inhabitation. His model was the human form, to be clear, but he sought to transform the human body, through geometry, into building and urban, even regional scale. The "Modulor" that he claimed guided his designs in the postwar era used a scalar geometry to extrapolate a (male) human body into the basis for structures at many scales. Le Corbusier thus contributed his own megastructures to architecture's canon, most notably in Chandigarh in India.[42]

He also created shapes that, as Wright had dreamed of, evoked human forms, animals, and machines at the same time. The most notable of these was his Ronchamp chapel, high on a hilltop in eastern France, of 1950–1955. Its shape has been compared to a sail, a nun's cap, a ship, an ancient stele or pyramid, or a geological form. Its interior, disappearing into a mist of darkness and curving forms that never quite come together, has the strange effect of being veil-like in that you can never quite grasp its scale or coherence, leaving you only to intimate what it is. It still sits, however, as an isolated and mystic object, referring as much to a mythical past as to a machined present.

A generation of architects tried to follow Le Corbusier's footsteps in creating monumental veils (however contradictory that might sound). Although Le Corbusier was not their only inspiration—some reached back to a more ancient past, and others found inspiration in the work of the Finnish architect Alvar Aalto—they all made forms that were purposefully odd or, more precisely, enigmatic. The aim of creating this effect, which they achieved mainly through the uses of large forms poured in concrete, was to create buildings that evoked a variety of associations without representing any of them. These hinted-at images were, as was the case with Ronchamp, usually a combination of geological

Le Corbusier, the Modulor (Fondation Le Corbusier).

forms such as mountains, mountain ranges, or boulders; animal or animate forms; human figures, usually of the huge, muscular, and male variety; and machinery. They were condensed versions of the kind of imagery Frank Lloyd Wright evoked at the beginning of the century, while also claiming for themselves the organic connection to the human figure and to a community living in a natural setting of which both Wright and Heidegger had been so fond. These shapes also often formed the centerpiece of megastructures, in the manner of the Empire Plaza's State Theater (the egg).

Few, however, could remain as balanced in their evocation as to remain truly enigmatic. More often than not their geometries overwhelmed them or, as in the case of the most famous of all these attempts, Jørn Utzon's Sydney Opera House (1957–1973), the associations they brought forth were too one-dimensional. In other cases, as in either the Königin des Friedens church (1968–1972) or the Church of the Resurrection (1968–1970) by Gottfried Böhm, their primitivism overwhelmed them. In all such cases, the presence of the technology, whether in the shape of the reinforced concrete that allowed them to exist at all, or in terms of the more mundane circulatory systems of these architectonic behemoths, remained not just veiled but completely hidden.

It was, as so often, architects working as artists and artists properly speaking who were more successful in evoking the strangeness of a monster leviathan that could exist as a truth-telling veil. In the former category, the French architect Claude Parent, working with the philosopher Paul Virilio, drew versions of the coastal defense system, the so-called *Atlantikwall*, that the German Reich had built across France, Belgium, and the Netherlands, in a manner that transformed these bunkers into an unfolding landscape. Though Parent built some enigmatic buildings, it was his sloping topographies coalescing into cantilevered planes, bullnosed bunkers, and intersecting stairs, ramps, bridges, and other connective devices that were most powerful at evoking the true nature of a technology so deeply embedded in geology and so extended into forms of war against reality that they became all-encompassing.[43]

Robert Smithson, in his capacity as a critic rather than an artist, articulated what he saw as the purpose of the work of some of his colleagues:

Paul Virilio, image of individual shelter on the North Sea, from *Bunker Archaeology* (1967; New York: Princeton Architectural Press, 1994).

Instead of causing us to remember the past like the old monuments, the new monuments seem to cause us to forget the future. Instead of being made of natural materials, such as marble, granite, or other kinds of rock, the new monuments are made of artificial materials, plastic, chrome, and electric light. They are not built for the ages, but rather against the ages. They are involved in a systematic reduction of time down to fractions of seconds, rather than in representing the long spaces of centuries. Both past and future are placed into an objective present. This kind of time has little or no space: it is stationary and without movement, it is going nowhere, it is anti-Newtonian, as well as being instant, and is against the wheels of the time-clock.[44]

The work ultimately had to be abstract, he felt, to be able to reveal the city; so abstract, in fact, that it fell back on the observer to see the truth without anything being communicated or revealed:

This kind of nullification has re-created Kasimir Malevich's "non-objective world," where there are no more "likenesses of reality, no idealistic images, nothing but a desert!" But for many of today's artists this "desert" is a "City of the Future" made of null structures and surfaces. This "City" performs no natural function, it simply exists between mind and matter, detached from both, representing neither. It is, in fact, devoid of all classical ideals of space and process. It is brought into focus by a strict condition of perception, rather than by any expressive or emotive means. Perception as a deprivation of action and reaction brings to mind the desolate, but exquisite, surface-structures of the empty "box" or "lattice." . . . This is evident in art when all representations of action pass into oblivion.[45]

Still, artists and architects, and hybrid makers of all sorts, kept trying to reach toward some sort of veiled, constructed, but unreal or uncanny image. The most compelling vision of architecture as a veil intimating the technological nature of human-made reality while providing a critical and potentially free relation to that condition came from the hands of the artist Constant (Constant Nieuwenhuys). Starting in the mid-1950s, he developed an ongoing project he entitled *New Babylon*.[46] In paintings, sketches, models,

and especially slide presentations that brought all of this together into what Constant himself called a "gesamtkunswerk," the artist developed a three-dimensional grid that he eventually postulated as covering the whole globe. He did not intend this construction to be autonomous, but rather saw it as "a sort of extension of the earth-surface, a new skin that covers the earth and multiplies its living space." What was especially important to him was that in this new version of the earth, "every element that remains is left undetermined." He was building, in other words, a tracing or tracking of what he saw as modern reality, which was marked not by set objects and functions, but rather was determined by continual movement and change.

This unstable world was one of production and enframing, but Constant's new world was not:

> Human beings are more than machine fodder; life is more than well-oiled participation in the production process. The slavish existence of living, working and recreation cannot possibly constitute the starting-point for building our living environment, the starting-point for a creative urbanism. These functions, however essential they may be, are subordinate to the all-embracing function of life: creativity, the urge to manifest oneself, to turn life into a unique event, to realize life as such . . . the city is an artificial landscape built by human beings in which the adventure of our life unfolds.[47]

It was, in other words, the world of consumption and pleasure.

Constant rooted his design in then-current counterestablishment thinking, including the work of Guy Debord and the Situationist International (with which Constant was briefly aligned), which sought to break through the function-determined nature of the human living condition through the *dérive*, or purposeless wandering that would not only open the wanderer to experience, but in so doing would cut through the strictures that surrounded them, providing an art palimpsest over that reality. Constant also referred to the thinking of Johan Huizinga, the Dutch historian who followed his elegiac *Waning of the Middle Ages* (1919)[48] with *Homo Ludens* (1955),[49] an argument for the human being as an enjoyer of life who spun out social relations, as opposed to the "homo faber" who only existed as a human resource.

As such, Constant's *New Babylon* was a celebration of the post-war consumer-based society. As many economists and critics began to note during this period, the surfeit of production and the emergence of a middle class that in the United States and Europe was so large as to encompass most of the population, along with the "welfare state," created a situation in which production and work receded more and more into the background. This was true not only in terms of the time people spent engaged in work, but also of the factories and other physical emblems of making, which receded more and more from the urban scene.

What was left was a scenography increasingly anchored by places for shopping, entertainment, and culture, along with the buildings that housed the ever-burgeoning bureaucracy that controlled not only goods but also the acts of consumption, play, and enjoyment. The result was, in Constant's words, the "fanstasification of reality"[50] in which human beings did not experience made reality—or make reality—so much as they inhabited a fantasy world of consumer-oriented imagery and forms. Instead of living in poetry, human beings thus lived in advertising, propaganda, and culture.

It was up to the artist to transform that world into poetry, because, said Constant, "it is in poetry that life will reside."[51] The means to do so would be to reach back to before the industrial age to "develop the ancient forces of architectural confusion."[52] What emerged from the canvases and images Constant produced was the skeleton out of which the steel and concrete cages of that age of production were produced, now presented as a Piranesian set of fragments pinwheeling off to the murky edges of the canvas. In contrast to Piranesi, however, Constant emphasized horizontal extension and freedom, with lines leading off more in the manner of the prewar artists of the De Stijl movement.

Over time, these intersecting grids took on the character of a jungle gym at a vast scale (Constant produced maps showing it covering first whole cities, then whole regions of Europe), supported by a few splayed structures or hung from masts. There was little coherence or even object nature to these. When what Constant called "urban bodies" did cohere, as in the *Spatiovores* of 1959, it was into sections of domes and blobs that the artist made out of the relatively new material of Plexiglas, giving it a combination of transparency and translucency.

Constant apparently thought of these spaces as urban labyrinths with no particular beginning or ending, and his paintings and models showed only fragments, each one a continuation, zeroing in on or panning out on the last.[53] This was deliberate: adopting cinematic techniques, but also the manner of advertising, Constant was producing a collage of consumable images that promised a world of leisure and free wandering for the new "urban nomad." In this sense, he presaged both the work of such utopian collectives as the Italian group Superstudio and the hippie revolution, guided by the proposal to "tune in and drop out."

There is, in fact, a dreamlike or hallucinatory quality about *New Babylon*. Unlike utopian or dystopian plans, or even science fiction movies, it does not build up into a single proposal, but rather offers snapshots of an alternative world that might already exist, if only we wander through it properly. A clue to the nature of *New Babylon* comes most clearly in some of the later fragments Constant produced, such as *Ode à l'Odéon* of 1969. In this dark gray version of a theater set, ladders and planes pirouette around each other, while the actors in the space consist of splotches wandering through this environment. The *Ladder Labyrinth* of 1967 and the other three-dimensional playgrounds have become more explicitly theatrical versions of a free and fragmentary grid inhabited by shades, shadows, and specters who might mirror our own existence.

This "psychogeography" or merely "ambience" Constant created formed a shimmering, three-dimensional, continually developing set on which we as humans could engage in what the artist thought should be our main activity: creativity. To make without purpose or function, and to keep doing that, without end, was the human being tracing, tracking, and subverting the processes of production and consumption, as well as its distribution and enframing. It was the poetic version of technologically determined action. Disorientation was the aim of the labyrinth, perhaps so that we could "calmly go wandering" in the sense Benjamin predicted.

Constant's art or poetry constructed a fragmented, torn, imperfect and enigmatic veil over modern society as he experienced it in Europe in the postwar era. Yet Constant presented it as an actual proposal, producing manifestoes and arguments for its construction. That rhetoric and propaganda was an integral part of *New Babylon*, of course: it was the advertising for a product that, as it was art, you could make, but never actually consume, and that

would thus never be finished in any sense of the word. It proposed rather a continual construction, elaboration, diversification, consumption, reimagination, discussion, and more creativity without end, all for its own sake. It was, as an activity and a way of making, the veil over the enframing of technology, not a challenging forth or seducing into ever more unfolding and truth-telling that never manage to get there—wherever there might be.

New Babylon was not a blueprint for the production of cities or buildings, although generations of designers have been inspired by its imagery and forms. Most famously, the architect and engineer Cedric Price conceived his Fun Palace for London in 1961 as a "laboratory of fun" that consisted of an immense, open framework into which activities could be plugged to form a giant machine for learning and entertainment. It would be, wrote one critic, a "helium-balloon dream . . . where the British worker can realize his potential for self-expression by dancing, beating drums, Method-acting, tuning in on Hong Kong in closed-circuit television, action painting . . . the 'First Giant Space Mobile in the World.'" Price presented the project in an open version of Sheeler's vision of River Rouge, cut through by gantries from which the various bits of entertainment hung, while leaving open a large public square that would let human beings reoccupy the heart of the machine. Though the project was very real, it was never constructed.[54]

Certainly, some of the shopping malls and airports architects started to develop in modern idioms in the 1970s, ranging from Schiphol in the Netherlands, with its meandering, unfinished grids framed in glass, to the halls of mirrors and meandering passageways architects such as Cesar Pelli used in the design of retail centers, owed some debt, whether conscious or not, to Constant. The notion of an "electronic expressionism" that Denise Scott Brown, Steven Izenour, and Robert Venturi proposed in the 1972 *Learning from Las Vegas*[55] located *New Babylon*'s possibility in the Strip and proposed how it could develop in other settings, but they never followed up with this in their own work. New Babylon rather remained as poem developed over almost twenty years in hundreds of fragments showing more fragments, always approaching the unconcealment of technology, but remaining only an intimation of that truth.

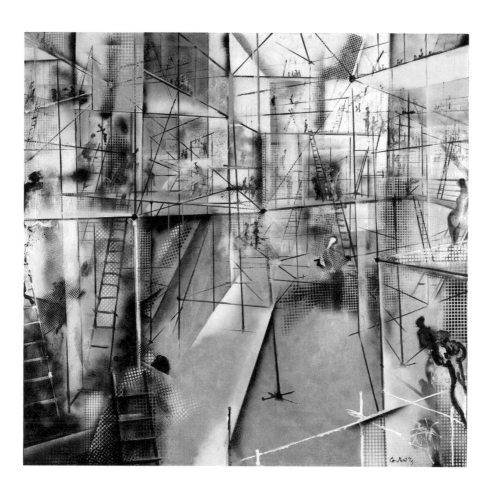

Constant, *Ode à l'Odéon*, 1969 (© 2022 Artists Rights Society (ARS), New York / c/o Pictoright Amsterdam).

4 Empty Signs

In 1973, the architecture historian Manfredo Tafuri wrote one of the most difficult and evocative opening paragraphs that has ever appeared on his subject:

> To ward off anguish by understanding and absorbing
> its causes would seem to be one of the principal ethical
> exigencies of bourgeois art. It matters little if the conflicts,
> contradictions, and lacerations that generate this anguish
> are temporarily reconciled by means of a complex
> mechanism, or if, through contemplative sublimation,
> catharsis is achieved.[1]

With these two sentences, Tafuri marked out what he saw as the main fallacies or distractions in which architecture had engaged since the Enlightenment, both to keep itself going and to fulfill the needs of the class for which it worked. It had delved with archaeological zeal into the past, studied its elements and lessons, drawn these out into a confrontation with a modern world in which it saw no clear function for itself, and tried to find a place for itself through that effort. It had done so either by creating a fictional and temporary fix, which, bathed in the forms of that past, made it seem as if all was well, or had fled into such depths of self-examination that it had found itself reborn in the pain and terror

139

of modernity to the point where it felt it had truly confronted itself, even if it was only staring at its own navel.

These efforts were useless because, thought Tafuri, they started from a false premise: "the 'free' contemplation of destiny."[2] The architect, who is both a member of the bourgeoisie and someone trying to build a home for that class, believes that they are engaged in independent work that will truly make themselves and theirs at home in the modern world, whose scene or environs is the metropolis. The reality is that modernity is destructive and that there is no way to create a stable relationship to it. The explosion of the tenth of a second, the monster leviathan, and the challenging forth of technology will turn the human being into nothing. To give away the ending: what is left for the architect to do is nothing, or perhaps the sign of nothing. To the list of answers to what the architect should do or hope for in modernity beyond building utopia or wallowing in dystopia, Tafuri adds—nothing. This burial of architecture leaves behind, though, a particular space and image which were oddly productive: the grave and its marker.[3]

Tafuri proceeds through a series of case studies that examine how certain architects tried to confront modernity, each of them thinking they could construct an architecture that would be appropriate and proper for that condition, each of them producing beautiful images and forms, and each of them failing. Tafuri does not concentrate on built structures. Rather, almost all of the short volume with which that evocative and depressing paragraph started, *Architecture and Utopia: Design and Capitalist Development*, is given over to the imagination of theoretical and experimental work, utopian and dystopian visions, art and urban proposals. When built work comes to the fore, it is as a failed fragment or indication of false intentions.

First, Tafuri, like most who have tried to construct an ontology of architecture, turns to the very moment of confrontation with the modern city and finds avoidance. In the work of the Abbé Laugier, who tried to find the basis for architecture through a postulation about its ancient origins (Tafuri's archaeology), did this by turning toward nature.[4] This was, so to speak, his original sin. As Tafuri points out, it is the desire to find in nature an escape or a remedy (again, either an avoidance or a temporary resolution) that becomes the central pursuit of architecture exactly at the time that the forces of industrialization and modernization are defining

nature as something that is not made by humans but has its own order. Finding in the not-human-made the order that is disappearing in the urban environment becomes the task, carried out in various modes, of architects and their critics.[5]

What Tafuri here latches onto is the manner in which the modern urban environment appeared to those who began to see its endless streets, open plazas, sun-occluding height, and confusion engendered by its sheer scale as not just new and thus alien but unnatural. While other critics have found this to be a natural reaction to a human-made environment indeed becoming so large as to rival the scope of the natural setting, Tafuri notes that "nature" here functions as much as a construct as it does a lived reality. It denotes several aspects of what is not modern, ranging from an organic nature, which implies that it represents and is in reality a deeper truth; to an order present in the serried ranks of trees in a forest or the logical division of trees, shrubs, and plants into roots, stems, or trunks, branches, and leaves; to a complexity that accepts contradictions and resolves them in itself, thus serving as a potential model for the modern city; to a pretty picture whose consumption offers a picturesque respite from the sensory overload the urban environment provides.

All these natures, according to Tafuri, serve no other function than to provide models through which architects can hide the contradictions and the anguish that is inherent in the world humans made for themselves in a capitalist city; its result is "control of a reality lacking organic structure, achieved by operating on that very lack."[6] Not only is that city beyond the human scale, destructive of human memory, dirty, and in many other ways the enemy of the human body and community, but it is built on expropriation of the work of its inhabitants. It is capitalism made real.

The number of models architects produced based on various notions of nature, in Tafuri's interpretation, were many. They include scientific theories about its orders and health effects, but also ideas based on appeals to beauty and the sublime. However nature and natural order appear in these postulations and their embodiments in built form, they are to this critic all lies based on the attempt to either wish away or cope with the unjust and destructive reality of modernity. Even the archaeologically minded and visionary architect Piranesi's "hallucinations," of which Tafuri is particularly fond as attempts to dig into literal and historical

foundations of modern architecture, find their labyrinths and impossible spatial sequences serving as elements in built form, where they become part of objects of contemplation or use.[7]

If Tafuri holds out any tentative model for how the shortcomings of the capitalist city might be continually revealed and posed both within and around the modern, human-made environment, it is in the genesis of American architecture in the work of Thomas Jefferson and in the L'Enfant plan of Washington:

> Jefferson thus produced the first eloquent image of what was to be the most dramatic effort of the intellectuals of "radical America": reconciliation of the mobility of values with the stability of principles, the individual impulse—always stimulated to the point of anarchy or neurosis—with the social dimension.[8]

What the American city achieved, in other words, was to maintain not just the image of individual freedom of action and expression, but, within bounds, the reality of that liberty. At the same time, it also allowed for an overall order that was seemingly open-ended. Though Tafuri does not go into detail in his sweeping assessment, he refers to such elements as the rows of individual houses that make up the original campus of the University of Virginia, strung together by a colonnade that follows the natural contours of the land, organized around a version of the Pantheon that is a library open to all students and faculty, which in turn faces an open landscape framed in all of its picturesque splendor.[9] This continual play between objects and series, the focus on central order and openness to nature, as well as the control of elements with a lexicon of classical elements carried out in simple materials in ways that remained comprehensible to builder and viewer alike, did in fact manage to become a model for one version of American democracy.

Similarly, the grid of Washington, which was cut through seemingly at random with radial boulevards that did not all radiate out from the source of power (which in this case was split between the White House, Congress, and the Supreme Court), provided a sense of repetition and order that seemed natural to a large city, while continually slicing open views and fragmenting building sites to allow for exceptions and contrasts. That these discontinuities were originally intended to make room for markets and that the largest of them, the National Mall, was meant to be

both a celebration of rational and democratic order and a slice of nature at a vast scale inserted into the heart of the city only further enhances Tafuri's case.[10]

That the Lawn, as the University of Virginia's core came to be called, was soon dammed up at one end, and that Washington managed to control its eccentricities to the point of boredom and a sense of overall order—partially through the suppression of Black people, an issue the author ignores—only enhances Tafuri's argument that the compromise was always an illusion. He sees the natural result of this kind of thinking in the "utopia of the rearguard" exemplified by Frank Lloyd Wright. He is referring here not to Wright's urban visions as exemplified in "The Art and Craft of the Machine," but rather to his attempts, starting in 1897 with a plan he developed for *House Beautiful*, to extrapolate to a larger scale his notion of the individual home as a free community in which bedrooms and other spaces for each inhabitant pinwheeled off into the landscape from a central core represented by the hearth as a gathering space. The pinwheels, Wright tried to show in his early plan, could lock into each other to create neighborhoods that would move beyond the notion of the single home place on its open lot to create a labyrinth of private, semiprivate, semipublic, and public spaces that could occupy the flat prairie of America's Midwest into the far horizon.[11]

Wright developed this notion into a decades-long project he dubbed Broadacre City, which envisioned the dissolution of the central city into what we would think of today as exurban sprawl. Endless nodes of habitation, directly tied to the land through agriculture at a small scale, would amalgamate into communities grouped loosely around civic centers such as schools and markets. Each individual structure was meant to be "organic," or open to nature, designed according to natural principles, and allowing for picturesque views. Wright thus embodied many of the compromises and escape mechanisms Tafuri documents as emerging in the eighteenth century, and for the author exemplifies the attempt to cope with capitalism more than any other twentieth-century designer.[12]

That Wright's comprehensive vision, built up out of individual elements that scale up in a fractal manner to encompass all of the landscape, failed to ever find itself implemented at any scale proves to Tafuri the inherent contradictions of this vision. Rather than detailing its hopeful elements, some of which have in fact

Frank Lloyd Wright, Quadruple Block Plan, 1900 (Avery Architectural & Fine Arts Library, Columbia University).

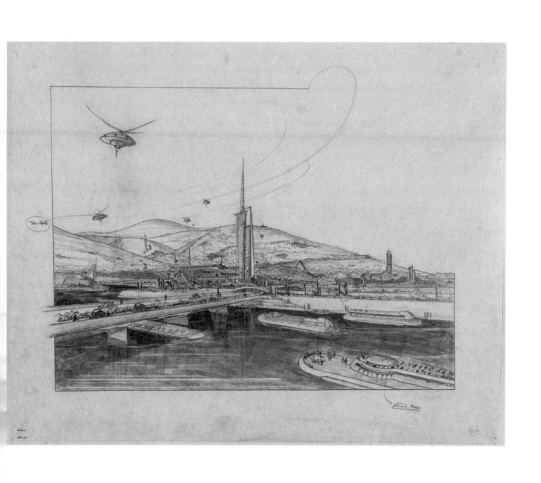

Frank Lloyd Wright, Living City, 1958 (The Frank Lloyd Wright Foundation Archives; The Museum of Modern Art / Avery Architectural & Fine Arts Library, Columbia University, New York).

influenced the development of suburbia in the United States and around the world, the author sticks to his native Europe, and there notes that the ultimate mechanism architects found for building the capitalist system was to plan themselves out of existence. Instead of the "liberty of the fragment" and the triumph of pragmatism as a philosophical movement in the United States,[13] he turns to the rise of planning and the rationalization of the city in the manner of complete abstraction. Instead of Wright's, L'Enfant's, and Jefferson's attempts to create alternatives based on antique and ancient models infused with a sense of being organic, which he sees as failures, he turns to the other side of his twin mode of reconciliation: confronting and expressing nothingness.

As Tafuri interprets the history of architecture in the early twentieth century, it consists not only of the growth of abstraction, geometries, and the application in the design process of human-made materials ranging from concrete to steel, glass, and even plastic, but also of the fact that these developments are in essence no more and no less than attempts to think and build away the problem of capitalism in its urban form. He interprets them not just in stylistic terms, but as representations of the rationalization of industry and movements of capital of which the architecture is only the representation.[14] As he summarizes: "Objectively structured like a machine for the extraction of surplus value, in its own conditioning mechanisms the city reproduces the reality of the ways of industrial production."[15] All that architecture and urbanism can do is let us live mutely in this world:

> Free the experience of shock from any automatism;
> found, on the basis of that experience, visual codes and
> codes of action transformed by the already consolidated
> characteristics of the capitalist metropolis (rapidity of
> transformation, organization and simultaneousness of
> communications, accelerated tempo of use, eclecticism);
> reduce the artistic experience to a pure object (obvious
> metaphor for object-merchandise); involve the public,
> unified in an avowed interclass and therefore anti-bourgeois
> ideology: these are the tasks that all together were assumed
> by the avant-garde of the twentieth century.[16]

What he calls the "utopia of the real"[17] finds its expression not only in the construction of such modernist emblems as the houses

of Le Corbusier and Ludwig Mies van der Rohe, or the *Gesamtkunst-werk* of the Bauhaus in Dessau, but also in the town plans for *Sied-lungen* or suburbs in northern Europe and the idealized plans for whole new towns. These plans, built up out of small cubes that, like Broadacre City, grow up into an overall whole that, however, is still controlled by a hierarchy of functions and of power, infiltrate the city from the outside and from the architects' imagination. To Tafuri, the formalization and codification of modernism by such a group as the Congrès Internationale d'Architecture Moderne (CIAM), especially in its Athens Charter of 1933, is itself a reflection of the conquest by planners of economic and social structures. Keynesian economics and Weberian sociology are attempts to find a rational order for capitalism that are superseded by the command states of the Soviet Union, Italy under Mussolini, the United States under Roosevelt, and, of course, Nazi Germany. The true nature of architecture is total order and dominion, even when built up out ideas of freedom or constructed in what are meant to be open compositions. Geometry is allied, he implies (though never states), to all other rationalizing tendencies in the ever-growing and ever more total state.[18]

This total order is a new kind of nature that dispenses with the notion of freedom and even the self. It is thus a revelation of the true nature of capitalism. In that sense, Tafuri agrees with Benjamin's analysis of the Second World War as the logical outcome of the desire for ever more rational planning and ever more total use of resources. He also parallels Heidegger's argument of the disappearance of the human being in favor of standing resources.

Ironically, however, this is not Tafuri's final vision. Total order becomes its opposite, chaos, in war and its aftermath, and then something else: an image of itself. Though he touches on the transformation of Albert Speer from a neoclassical architect to the head of planning in the Nazi regime, which led him to coordinate the transport of millions of victims to the gas chambers, Tafuri is more interested in the defeat of that effort and the anguish it causes. To him, the outcome of the Second World War seems only to reinforce his notion that no attempt to try to live with and in capitalism through architecture will succeed. The only way out is death.[19]

The last part of *Architecture and Utopia* rehearses the contradiction inherent in architects' continued attempt to prove him wrong through a rehearsal of the various reactions to total planning efforts, starting in the early twentieth century. He notes in

particular the embrace of chaos and contradiction, in a manner that to him recalls Piranesi, in the cubists' and Dadaists' unearthing of the organic, which is to say spatially and temporally determined, nature of how we experience the human form. Extended to architecture, this leads to experiments in expression, mechanistic representation, and collage planning. The city as machine, surrealism, and the resurrection of both form and the human body as proposed central elements in the endeavor of architecture all pass in front of us in the book's compact pages, and each in turn is shown to fail in its attempts to make sense of or make sensible the realities of the human-made, capitalist urban scene. They are images that delight in order's self-destruction, but no more than that.

In the end, the control of reality as the central project of modernity endures, transforming the work of architecture into that of planning that exists at the level of super- or infrastructure. Architects have less and less to do with the making of meaningful form, and instead set up grids, systems, and other mechanisms for the efficient delivery of functional structures. Ironically, those who rebel against this effort also disappear into abstraction, adopting tetrahedrons as their geometry or roaming in the landscape as nomads. Constant's *New Babylon* to Tafuri is just another neurotic attempt to transform capitalism into an innocuous and false image of itself, and the designers of megastructures are not just digging but giving shape to their own graves.

What we are left with is "objects that 'exist by means of their own death.'"[20] With this term Tafuri is referring to the lineage in particular of Mies, whose attempt to build "almost nothing" he saw as just an excuse for building nothing or, more precisely, nothingness. As Tafuri points out, the 1950s and 1960s saw the rise of nihilism, existentialism, abstract expressionism, and a dropout culture that to him are all just different versions of the same phenomenon: a collective suicide that seeks to jump into the void of nothingness in order to escape the realities of capitalism.

This "negative utopia" stands against the "ideology of permanent and planned innovation," but both have the same result: they produce nothing of enduring value or meaning. Rather, they produce and reproduce nothingness: the sign of nothing. As Tafuri points out, the rise, finally, of semiotics and related trains of thought reveals the emptiness, quite literally, of meaning in Western thought. What is produced as art, architecture, or philosophy is the "empty sign":

An architecture that has accepted the reduction of its own elements to pure signs, and the construction of its own structure as an ensemble of tautological relationships that refer to themselves in a maximum of "negative entropy"— according to the language of information theory—cannot turn to reconstructing "other" meanings through the use of analytic techniques which have their origins in the application of neo-positivist theories.[21]

Whether that sign exists as meaningless and dominant advertising images or their appropriation by artists; as the operator around which language can be reduced to code; or as the modern and postmodern facades built around rationalized structures, mechanical systems, and flows of people, goods, and information, matters less than the sheer emptiness itself.

Unlike Heidegger, Tafuri does not see any saving grace in that empty sign. You might think that he could hold up the white sheet produced by Robert Ryman, the unbuilding of Gordon Matta-Clark, or the archaeology of nothingness central to the early work of Peter Eisenman and Aldo Rossi as a kind of veil or emblem that would allow us to at least understand our own annihilation in the modern city, but he will have none of this. As he says: "No 'salvation' is any longer to be found within [art or architecture]: neither wandering restlessly in labyrinths of images so multivalent they end in muteness, nor enclosed in the stubborn silence of geometry content with its own perfection."[22]

What he proposes instead is to leave architecture. Only "class criticism" is necessary. If anything, *Architecture and Utopia* thus justifies itself in the end as a form of extra-architectural critique that shows that architecture is dead. That some of his best students, such as Aldo Rossi, proceeded to build death masques in the form of buildings that were or looked like cemeteries and ruins is itself telling.[23]

What Tafuri has in mind is something more active, but also outside of the realm of architecture: direct political action. He certainly was not the only one calling for architects to leave their profession during the 1960s and 1970s, and many did. Partially this exodus was also the result of the social unrest of the late 1960, the end of years of progress and the complete domination of capitalism in most of the world, and the economic crisis of 1973, caused by such upheavals as the oil crisis and the tensions inherent in

Kazimir Malevich, *Suprematist Composition: White on White*, 1918.

Ad Reinhardt, *Abstract Painting*, 1963 (© 2022 Estate of Ad Reinhardt / Artists Rights Society (ARS), New York. Digital image: The Museum of Modern Art / Licensed by SCALA / Art Resource, NY).

the transformation of the economy from one focused on production to one motivated by consumption and image-making; but for many it was also a deliberate choice. Schools began to title themselves with phrases such as "colleges of environmental design," and architects dove into community action. They also went into a new approach to architecture that actually developed the sign as the saving grace or activity of architecture.[24]

The attempts to engage in community action largely resulted in failure, although the tactics of architects working in collaboration with action groups, protesters, and what we would now call NGOs are currently being rehabilitated and developed. Unfortunately, architects proved to have precious few skills to offer these community groups, and the results of their activities were more often than not demonstrably no better or worse than what architects posing as professionals accomplished. Those designers who took their resistance most seriously disappeared into city bureaucracies, becoming part of the system they opposed and now sought to reform from the inside out. Ameliorative at best, the effects of the community design movement remained outside the main development of the modern city.

Yet even if Tafuri dismissed architects' attempts at reconciliation or escape, they did contain a force in themselves that continued to inspire designers. Sublimation and escape are both attractive activities, after all, and the point is that they allow the architect to be productive and satisfy themselves at the same time, even if the result is something that does not address the evils of capitalism. The most extreme examples of such coping strategies were often unbuildable exactly because they dug into the contradictions of the modern urban environment and delighted in a kind of sadomasochistic play of forms, spaces, and images.[25]

There is an ontology for the building of such uneasy grave sites, such emblems of resistance that are really monuments to the failure of architecture. It is the virtue of Tafuri's work that we can find them in exactly the heart of the utopian tradition. The triad of French architects who practiced around the time of the French Revolution is a case in point. Of the three (Étienne-Louis Boullée, Claude-Nicolas Ledoux, and Jean-Jacques Lequeu), only Ledoux left behind a legacy of buildings. Though many architects see them as generators of pure and grand form, what they instead did was to push then-standard modes of architecture toward the point of becoming proto-signs of self-annihilation that delighted in their

very grandeur. Boullée's vast spaces, such as those presented in his Cenotaph for Newton, his notions of a National Museum, and his Library, in turn have continued to inspire architects not because of the manner in which they resolved issues or proposed technological solutions, but rather because of the manner in which they proposed something impossible. A perfect, hollow globe where it is always night and the heavens themselves surround you (a notion realized in countless planetariums), an endless library with all of the world's wisdom stacked in rows dissolving in infinity, and a civic structure so open and contradictory in its geometry that it seemed tailor-made for a democracy—all these images proposed radically new ways of addressing the scale and nature of modern society. Yet they did so with forms that were literally hollow, that were unbuildable, and whose spaces faded into nothing. They were almost nothing at a humongous scale, posing the end of built form as existing somewhere in the dark of heavens or at the end of an endless perspective.[26]

Ledoux, on the other hand, presented an *architecture parlante* that was indeed a prototype for the destiny of architecture as a collection of empty signs, except that here these three-dimensional signifiers had functions. Each of the structures he proposed in the utopian projects he published in 1804 were to be elements in a postrevolutionary world in which types and uses had been rationalized to the point that the very appearance of the object would show what its use was, without the need for any other mode of expression. That they presented an absolutist society in which an all-seeing eye represents a theater and pyramids belching smoke embody and signal a factory only makes their visionary nature clearer. They represented architecture as a continual act of revolution, a war on nature, and a collection of ideal images. As with Boullée's work, none of these visions (unless you count the barriers or toll gates Ledoux designed for the outskirts of Paris before the Revolution) were constructed, but architects found themselves mining these emblems of absolute and perfect architecture for humbler, more functional work.[27]

Then there was Lequeu, whose enigmatic grottoes, shrines, and monuments to the heroes of the Revolution were assemblages of classical elements and nature integrated into forms that were essentially uninhabitable. Lequeu worked directly for the French Revolution, surviving several of its purges, and designed monuments that were meant to replace the deification of people with

Jean-Jacques Lequeu, *Design for a Temple of Equality*, 1794 (Bibliothèque Nationale, Paris).

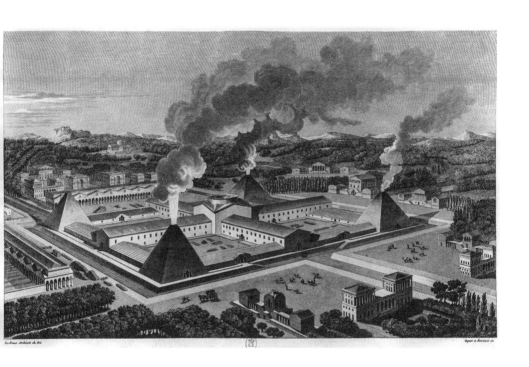

Claude-Nicolas Ledoux, *Perspective View of a Canon Forge*, engraved by Coquet et Bovinet, c. 1804 (Bibliothèque Nationale, Paris, France/Bridgeman Images).

the representation of pure ideas. He also created a body of still obtuse projects, almost all of them underground, that might have been related to Masonic or other practices but certainly do not represent anything other than pure enigma, or sign of nothing.[28]

This body of visionary work, together with that of Piranesi and a few other such impractical architects, became a dictionary of elements that we might see as a perverted parallel to the *Encyclopédie* Diderot assembled at the same time. If Diderot showed the tools capitalism was paying for, demanding, and helping to perfect, whether they were woodworking implements or the spaces in which such work took place, visionary architects showed the elements that could represent the social structures in which such tools worked. The factories, places of knowledge and assembly, and shrines proposed by the triad of revolutionary architects were not spatial or structural extensions of the rational pieces Diderot illustrated, but rather a form of commentary on them: a sign of them, if you will.[29]

As a form of critical semiotics, architecture developed a long line of such proposals throughout the nineteenth century. As Tafuri points out, they were all hopeful, though, ignoring the absolute nature of the original proposal, becoming continual attempts to find in the possible death of capitalism the elements of rebirth that would still be part of the world of architecture. As such, the utopian proposals became increasingly specific and even buildable, and some of them were constructed and even—for a while—used in a utopian manner. None of them, however, were anything but limited experiments in increasing the freedom and efficiency of production of the middle class.

It is thus not to the notion of utopia, which would seem to be at the core of an attempt to overcome architecture's limited place in modernity, that we must turn to find the true signs of nothing. Instead, we could consider architecture as a continual act of archaeology, assembly, and self-complication, perhaps an evocation of Piranesi's excavations and prisons, which became the source for stranger forms and images that were more corrosive to the rational self-image of the capitalist city.

Tafuri's emblem of death and meaninglessness became the starting point for a new generation of architects who eschewed utopia and dystopia and tried to make something other, something stripped of the promise of the future and the fear of reality, instead embodying an otherworldliness in every sense of

that word. This is not to say that they were mining Tafuri's work directly; rather, the generation that grew into architecture in the postwar era saw themselves as salvaging hope and possibility in the ruins, which was the situation in which they worked quite literally in much of Europe, the Soviet Union, Japan, and China.[30] This labor of excavation at first led to a reassertion of the importance of monuments that somehow by their very existence could resist capitalism and the rise of consumer culture. Whether this was through sublimation or exegesis, the results were the same: a parade of buildings that were more massive in their forms than their functions, structure, materiality, or any other logical measure would merit, and that were unfinished in appearance.[31]

During the early 1960s, this tendency crossed over from the creation of assertive and easily definable monuments as emblems of the state, to the making of megastructures that were altogether more enigmatic. They had a scale that, though not equal to what Boullée imagined, certainly towered over most existing structures and loomed over the street. They were made in plastic forms out of concrete. They took the geometries that Le Corbusier and others had developed and made them not only larger but also distended, bulbous, and bizarre. They did not propose perfection or function, but a strange otherness. The general name for such forms became new brutalism, at least retrospectively. Coined by the British critic Reyner Banham, the term at first referred specifically to those architects who used concrete in sculptural ways, often in what they saw as a continuation of the explorations of Le Corbusier in that area.[32]

There was a dystopian quality to these monuments, as filmmakers such as Stanley Kubrick noted when they used several of these structures in their films,[33] but they never abandoned their utopian roots either, proposing, in structures such as London's Barbican Center, to build an integrated city as a fortress plunked down in the middle of the metropolis. The results always looked unfinished, had no clear ground, and moved both into multiple basements and off into many levels (Paul Rudolph's Yale Art and Architecture Building, though only seven stories tall, has thirty-nine different levels) that made it impossible to understand them from any one point. Ugly and incomprehensible, they were yet grand and evocative facts in concrete.

While there were many reasons for the emergence and many forms of this mode or style, what is of interest here is the way it

Denis Diderot, *Encyclopédie, ou Dictionnaire raisonné des sciences, des arts et des métiers*, volume 8, plate 1, "Relieur": Procedures for Binding a Book, 1751–1765 (The Metropolitan Museum of Art, Bequest of Marianne Khuner).

created spaces and objects that contradicted each other, spiraled, and otherwise led to the sense that a user was inhabiting the ruin of a previous civilization. In one of the more "normal" (in terms of its formal language) of the structures at the heart of this movement, Boston City Hall, for instance, democracy becomes a sloping, irregularly shaped plaza fronting a facade made up of columns that do not so much form a colonnade as serve to create a chasm—divided, tall, and narrow—through which you can enter into the beginning of a set of courtyards. These become atria doubling (or meant to serve) as impromptu amphitheaters, stairs, balconies, and overlooks that spiral up to the mayor's office, which juts back out over the plaza, while the warrens of bureaucracy surround and rise above it. Power and public delegation, open and closed, and operations and deliberation all swirl around each other (originally even more so, as the plaza was intended as a marketplace), cutting through and deforming the block that is City Hall.

These images, and even more the "instant ruins" Louis Kahn produced in order to reinvigorate society's institutions with meaning and relevance in the period of nihilism, useless wars, and economic malaise during the 1960s and 1970s, were, however, built. As such, they were no more signs of failure or archaeological retreat than any of the other buildings architects designed to create a sense of power and reason within a society that was increasingly difficult to comprehend. Tafuri's true legacy, and the most powerful images of the useless in architecture as the making of buildings for which he argued (at least in *Architecture and Utopia*), lay in projects that appeared in the 1960s and beyond that were unbuildable by intent.

The work appeared mainly as an extension of megastructural dreaming, but without the heaviness of its forms. Rather, it was the ghost of new brutalism. Ironically, the designs produced by collectives (they were never firms in the capitalist sense) such as Archigram, Archizoom, and Superstudio appeared to be joyful reaffirmations of the liberating possibilities of technologies and the joy of consumer society. Archigram in particular produced cities floating in the water or air, tethered by advertising boards, and given over to the sort of hedonistic pleasure that Constant was propounding in a more abstract manner. Yet, lurking behind all the technophilia evident in their fascination with spacecraft, cars, and engines, lay a sense that none of this made sense.[34]

The best of their collages,[35] such as Peter Cook's *Montreal Tower* (1963), a tube hundreds of feet tall, sprouting geodesic dome

pustules as it rose from a platform of open scaffolding permeated with pleasure domes,[36] or Ron Herron's *Walking City* (1964), an armada of sea-striding beasts at the scale of horizontal skyscrapers connected to each other and the sea with telescoping tubes and bulging out into public spaces above and between what appeared to be endless living units, had the sense of being always moving or being under construction.[37] Then there was Peter Cook's *Plug-In City* (1964), a sprawl of housing units supported by a diagonal grid at a massive scale, blossoming into circular towers festooned by construction cranes and helicopters that emphasize both the always changing and always moving character of this community.[38] The collages, often colored to resemble cartoons or advertising, were surreal in their combination of human and machine parts, proposing a fragmentary version of Frank Lloyd Wright's monster leviathan that had dispersed even as the metropolis had by then begun to give way to urban sprawl.

David Green's *Living Pods*, developed first in 1966, on the other hand, were cocoons slinking around the body, acting as both house and living machine, as well as being temporary parasite on-site services, all made possible by an internal "food machine" for the body, a "teaching machine" for the mind, and other mechanisms of a yet-to-be-developed sort.[39] They may have inspired Michael Webb's *Cushicle* and *Suitaloon* (1966–1967), extensions of the human body into translucent blobs that would let the inhabitant roam freely around the planet.[40]

The group came together in the design of *Instant City* (1968), in which the machines fell apart into separate domes, balloons, and scaffolding integrated with giant projection screens and advertising billboards. *Instant City*, as well as analogous projects of the same era that focused on rebuilding parts of London, colonized existing landscapes with the exuberance of a world arising after the death of the modern city and the total victory of a consumer society governed only by signs floating on an infrastructure of technology present as continually constructed three-dimensional scaffolding.[41]

It is the society the critic Roland Barthes saw emerging already in Tokyo during the 1960s and 1970s as a place with no heart (as that was the inaccessible Imperial Palace), no names for most streets, and no definition of public space:

It is no longer the great continuous wall which defines space, but the very abstraction of the fragments of view (of the

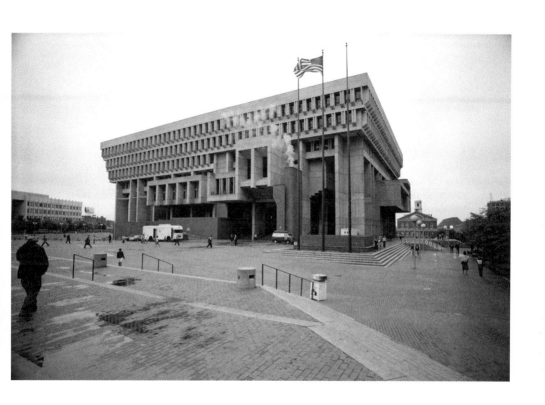

Kallmann, McKinnell & Knowles, with Campbell, Aldrich & Nulty, Le Messurier Associates, and J. W. Bateson & Company, Boston City Hall, 1965–1968 (Historic American Buildings Survey, Suffolk County Boston Massachusetts).

"views") which frame me; the wall is destroyed beneath the inscription; the garden is a mineral tapestry of tiny volumes (stones, traces of the rake on the sand), the public place is a series of instantaneous events which accede to the notable in a flash so vivid, so tenuous that the sign does away with itself before any particular signified has had the time to "take." One might say that an age-old technique permits the landscape or the spectacle to produce itself, to occur in a pure significance, abrupt, empty, like a fracture. Empire of Signs? Yes, if it is understood that these signs are empty and that the ritual is without a god.[42]

In such a Tokyo, as well as in the architects' visions, the leviathan had become a place to frolic and give yourself over to the oblivion of place and autonomous humanity that was part and parcel of consumer society. Only a future plugged into technology and surrounded by its signs was possible.[43] It was the Italian groups Archizoom[44] and Superstudio,[45] though, that brought the void seen as the true heart of that empire of signs into the heart of their vision of architecture. They started, innocently enough, with the grid: the mathematical reduction of the technology, and the science that made it possible, to nothing more than lines intersecting on a white background. This grid could, as in the case of the furniture produced by Archizoom, become three-dimensional, approaching the manipulation of the self-same trigonometry into abstraction by artists such as Sol LeWitt, Carl Andre, and Donald Judd, and could be sold as furniture (albeit not very successfully). It could also become the basis for collages that showed aborigines or naked *homines ludentes* adrift in a plane of nothingness that had wiped out everything around it, submerging both the natural and the human-made landscape until it might hit the sea or a set of mountains. Or the field and the furniture might combine into giant machines of abstraction that could float above cities such as New York, the ice-cold realizations of the tentative and hot lines of sensual connection Constant was drawing.

The grids that Superstudio and Archigran proposed, however, remained enigmatic, and purposefully so. Although their makers were generally critical of capitalism and even communist by conviction, their designs were not meant as political statements, at least not in an overt manner. Instead, they drew out an architecture of avoidance. The nothingness of the field surrounded,

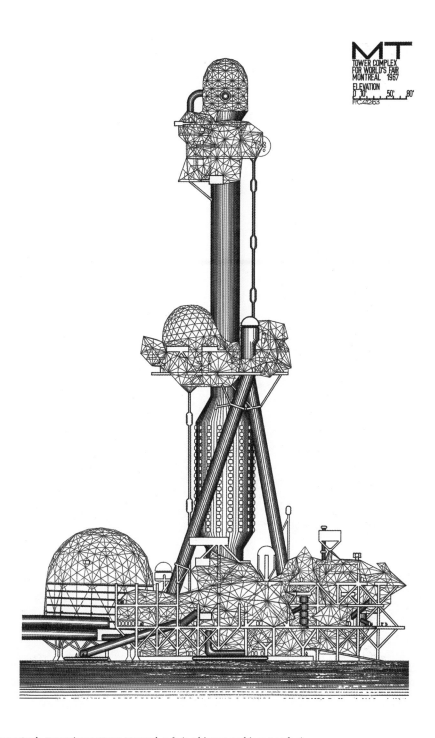

MT
TOWER COMPLEX
FOR WORLD'S FAIR
MONTREAL 1967
ELEVATION
0 10' 50' 80'
P.C.42263

Peter Cook, *Entertainment Tower Montreal*, 1963 (Archigram Archives, London).

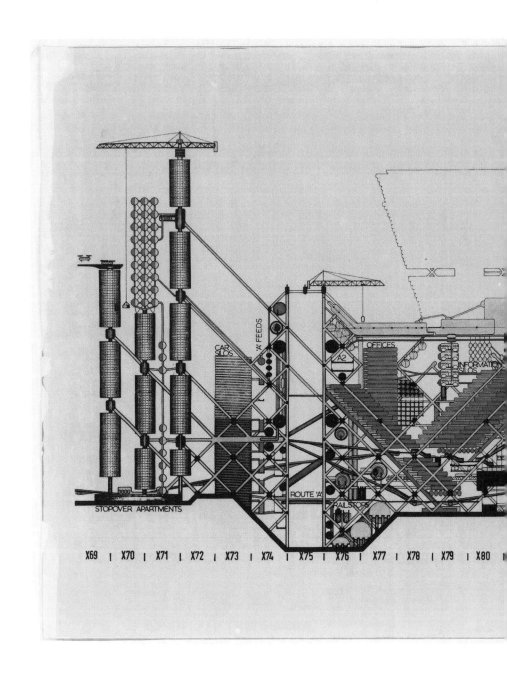

Peter Cook, *Plug-In City, Max Pressure Area*, 1964 (Archigram Archives, London).

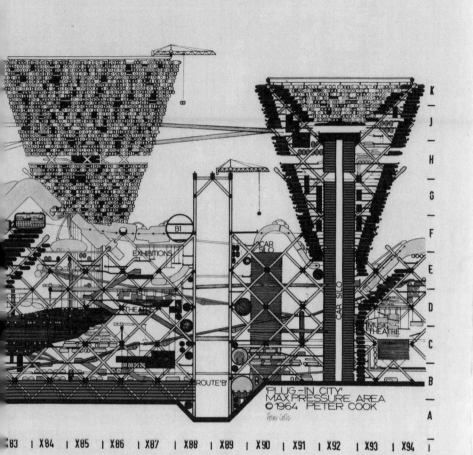

'PLUG-IN CITY'
MAX.PRESSURE AREA
© 1964 PETER COOK

EXHIBITIONS

CAR SILO

CAR SILO

MUSIC THEATRE

THEATRE

ROUTE 'B'

B1

K J H G F E D C B A

X83 X84 X85 X86 X87 X88 X89 X90 X91 X92 X93 X94

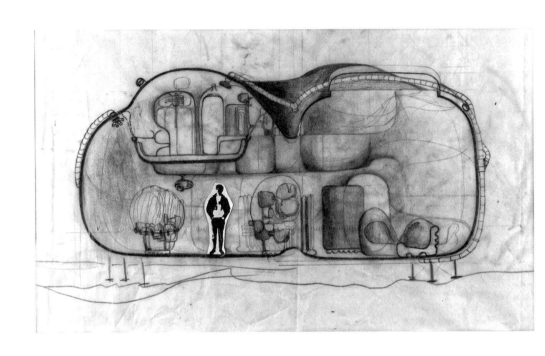

David Green, *Living Pod*, 1965–1967 (Archigram Archives, London).

encased, imprisoned, and relegated the inhabitants to the ghost status that comes from being a black-and-white, grainy photograph from a book or magazine cut out and pasted onto a field of intersecting lines drawn by hand.

The best of Superstudio's work brought together the then-new technology of airbrush, which had been developed in the auto industry, with collage and the delineating of grids in pencil or ink to produce fields in which the vividness of the landscapes or objects stood in deliberate contrast to the emptiness of the grids. The grid does have a form, or three different forms: a flat plinth, raised off of or floating through the landscape; a wall that combines into a supergrid of more walls; and squared-off gateways. These shapes correspond to installations and furniture the group made.

At times, the juxtaposition between the objects Superstudio was proposing and the setting is a violent one, as in *Le Dodici Città Ideali* (1971),[46] with its green hills enclosed by what appear to be prison walls. The team's most famous drawing, *The Continuous City* (1969–1970), performs the same operation on Manhattan.[47] In the *Supersuperficie* series of the following years, human beings occupy fields devoid of structures other than the grid itself.[48] They are sometimes naked, sometimes at work, but they all seem to have been liberated by a construction that has, despite its enormous size, or maybe because of it, become fragmented. In all cases, architecture, reduced to the indication of abstract form and the act of appropriation and collage of existing buildings, forms, and animate beings, is an indication of—well, nothing: of a stage set for humans or perhaps the grid paper on which architects draw, the beginning point of their apportionment of spaces, turned into the point itself.

The overt purpose of this almost nothing at a pop art scale was to protest capitalism by designing something that showed off its destructive nature but also delighted in denying what it supposedly made possible. As one of the leading members of Superstudio, Adolfo Naftalini, put it in 1971: "if design is merely an inducement to consume, then we must reject design . . . if architecture and town planning is merely the formalization of present unjust social divisions, then we must reject town planning and its cities until all design activities are aimed towards meeting primary needs. Until then, design must disappear. We can live without architecture."[49]

At least there were human beings present. Tafuri had noted the prevalence of abstraction in art, where it led, by the early 1960s,

Superstudio, *Prima Città: Città 2000t* [First City: City of 2000 Tons], 1972 (digital image CNAC/MNAM, Dist. RMN-Grand Palais / Art Resource, NY).

Superstudio, *Monumento Continuo, New York*, ca. 1969 (digital image CNAC/MNAM, Dist. RMN-Grand Palais / Art Resource, NY).

Alessandro Poli, photomontage for *Supersuperficie*, 1972 (Alessandro Poli Fonds, Canadian Centre for Architecture, Gift of Alessandro Poli).

to the sculptor Sol LeWitt's grids, which became instructions for semiautomatic painting. He did not cite, but could have easily noted, the all-white canvases of Robert Ryman. While some of the latter's works might delight still in displaying their brushwork, even if all the artist's labor was going into elimination of reference, the works of this era included those on metal in which any sign of the hand had disappeared in favor of all-white fields. Only the edge of the industrialized "canvas" revealed the limits of the creative endeavor.

The 1960s and 1970s saw artists and some architects attempt to make ever more minimal art, to the point that what was left was the "not doing" of artists such as John Cage, with his instruction for the pianist to not play during his 1952 *4'33"* and his reliance on games of chance.[50] We are here also in the realm of the white cube, critic Brian O'Doherty's description not only of the kind of gallery in which such work was exhibited, but also of the mechanism of art criticism, display, and even creation that demanded a supposed neutrality and detachment in order to remove the work of art from the machinations of production and consumption and thus free it from capitalism to be a completely free pursuit and object.[51]

Architecture might not have such freedom, but it also began a headlong flight from what its traditional realm had been, namely reality. If Constant and the members of the drawing "supergroups" had still thought of the inhabitants of their vision as engaging in some form of activity, even if they were only playing, the "paper architects" of the 1960s and 1970s dreamed of a world in which the total victory of rationality and its ideological and economic generator had reduced human beings to nomads who could do nothing but wander. The white sign was indeed that of the death of humanity.

Artists had gone further, imagining hybrids between humans and the scraps of mechanical forces or the forces of war itself. Eduardo Paolozzi, for instance, as Kurt Foster describes it, "understands natural history as a landscape of ruined things turned into obscure signs, yet the scrapheap that concerns him in *Psychological Atlas* is less the outmoded nineteenth century than the war-ravaged twentieth century;" in his work, "natural history has become a creaturely thing."[52]

It was then up to the next generation of architects to theorize death as an appeal to "posthumanity" that, though based on existentialism and poststructuralist thought, more than anything else

Robert Ryman, *Tower II*, 1976 (© 2022 Robert Ryman / Artists Rights Society (ARS), New York).

argued with much greater force and clearer imagery for the death of architecture as a productive discipline. What emerged was an involution that, in its best form, might be said to have a quality of transcendence, producing yet another version of the veil of poetry.

The path toward such an evocative sign of nothing took parallel paths in the United States, Europe, and Japan. In the last case, the route was an easier one, as the architects could draw on a tradition of abnegation and poetic emptiness inherent in certain versions of Buddhist practice. This led to the appearance of such uninhabitable spaces as the room of dirt produced by Kazuo Shinohara in the Tanikawa House of 1974 (which in itself paralleled a similar experiment by the artist Walter de Maria as the Earth Rooms in Munich [1968], Darmstadt [1974], and New York [1977])[53] and, most famously, the nearly uninhabitable 1976 home Toyo Ito produced in the center of Tokyo for his sister, which consisted of a horseshoe-shaped, concrete structure with no windows around a courtyard that thus could not be seen or used from inside the house. Within such spaces, the user or inhabitant was meant to experience their own nothingness, which paradoxically was caused by a surfeit of architecture or at least built structure.

The European variants of such poetic nihilism included ones that built on the Archizoom and Superstudio grids, particularly in the work of the Austrian architect Hans Hollein and the German O. M. Ungers, but it was in the structures of Tafuri's friend Aldo Rossi that the sign of nothing became most real.

The success of Rossi's work, and its ability to come closer than any other architect's to fulfilling Tafuri's self-abnegating path to nonarchitecture, came from its dense abstraction. Rather than starting from the imposition of grids on a piece of paper and thus, by implication, on the human landscape, Rossi began his work with a plethora of images. Drawn from both his childhood memories and the history of Italy, these evocations and renderings, sketched in endless notebooks, ranged from teapots to statues of Saint Augustine, from Milan's Duomo to its housing barracks, and from the ruins of Roman civilization to fragments of consumer society. Rossi drew these with dark hatchings of black ink, sometimes elaborated with watercolor, that made them appear like ghosts from some other civilization. The result was, as in the work of many other paper architects, a mythic presence that combined past and present to propose not a future so much as a place out of time that might already be present if we only looked at it

Akinobu Kawabe, Tanikawa House, Karuizawa, 1974.

through the framing device of Rossi's architecture. It was a myth that was both deeply romantic and dark in its ultimate sense of loss.[54] As Rossi himself said:

> Perhaps this alone was what interested me in architecture: I knew that architecture was made possible by the confrontation of a precise form with time and the elements, a confrontation which lasted until the form was destroyed in the process of combat. Architecture was one of the ways that humanity had sought to survive; it was a way of expressing the fundamental search for happiness.[55]

Though he very much believed in building, he believed in "the emergence of the relations among things, more than the things themselves"[56] and claimed that in his work this resulted in "a degree of silence. . . . Things are better experienced and then abandoned."[57] His practice, he said, was a way of making not so much things as rituals, adding: "I say this fully understanding the bitterness and the comfort of the ritual. Rituals give us the comfort of continuity, of repetition, of compelling us to an oblique forgetfulness, allowing us to live with every change which, because of its inability to evolve, constitutes a destruction."[58]

The landscape Rossi sought to collect, memorialize, and transform into a place filled with the empty cadences of colonnades, square windows, and turrets was above all else that of the ruined cities of the postwar era. Drawing an analogy to his own tendency to break bones (he died in a car crash in 1997), he noted that he loved "things which are broken and then reassembled."[59] That, in turn, led him to think of architecture as fragments and consisting of equipment that would not so much build something new as repair what was already there, namely a human-made environment made up of layers of elements on which he wanted to work as a constructive excavation based on his ability to "look at cities with an archaeological and surgical eye."[60]

The result was an architecture that was distinctly uncommunicative, at least in an overt sense. Rossi and most of the other followers of Tafuri felt that the ability to say something had been precluded by the impossible situation in which architecture found itself in a capitalist system, but also because of what they acknowledged to be the captured state of its system of representation. If all language was already a part of the system that turned us into

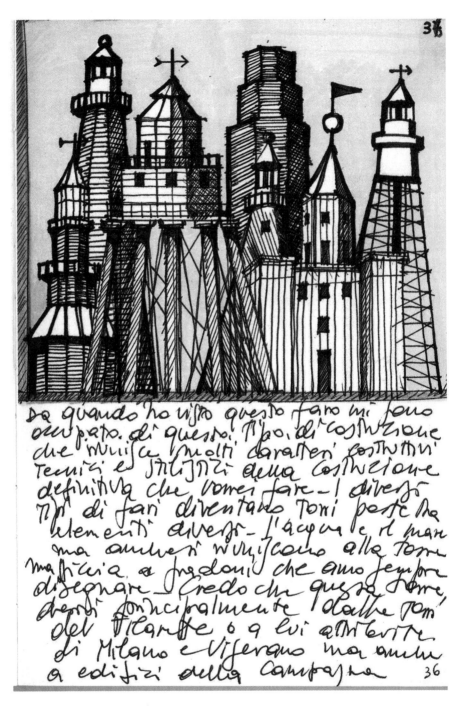

Aldo Rossi, drawing, from *Libro Azzurro*, c. 1978 (Jamileh Weber Galerie, Zurich, 1981; © Lars Müller Publisher).

Aldo Rossi, drawing, from *Libro Azzurro*, c. 1978 (Jamileh Weber Galerie, Zurich, 1981; © Lars Müller Publisher).

Aldo Rossi and Gianni Braghieri, Cemetery of San Cataldo, Modena, Italy, aerial perspective, 1971 (digital image The Museum of Modern Art / Licensed by SCALA / Art Resource, NY; © Eredi Aldo Rossi 2022, courtesy Fondazione Aldo Rossi).

standing reserve and expressed itself through sublimation or other forms of avoidance, architecture could only retreat into silence. Rossi hoped that this was a productively silent emptiness, one that evoked ghosts, memories, and meanings that might creep into the shadows. As he said in what became his most often-quoted antimanifesto:

> I felt that disorder, if limited and somehow honest, might best correspond to our state of mind. But I detested the arbitrary disorder that is indifferent to order, a kind of moral obtuseness, complacent well-being, forgetfulness. To what, then, could I have aspired in my craft? Certainly to small things, having seen that the possibility of great ones was historically precluded.[61]

If these "small things," this work of repetition, repair, and retrospective foreboding had a form that was most dear to him, it was that of the *teatrini*: the small, temporary theaters that popped up in his youth in Italian bathing resorts. The notion of staging something, in a modest manner, that would then disappear obviously appealed to him.

In 1980, Rossi built a monument to this world, a wood-clad theater that floated on Venice's lagoon during that city's Biennale events. Without ground, it appeared like a mirage: an octagonal abstraction both of a Byzantine chapel and of the lighthouses that were another of Rossi's tropes, but rendered in the wood of a mountain hut and festooned with the square, cross-mullioned windows, blue-painted conical hats, and other details the architect derived from his understanding of the vernacular in which he worked. Rossi had the building photographed in the mist, at sunset and sunrise, and being towed across the Adriatic, heightening the sense that it was a fragment unmoored from architecture and left in limbo. This *teatrino* was both a fragment of the past and of the city, condensed into something that floated before us, almost untouchable and evanescent. It was, in fact, the most potent image of what he wrote he wanted to architecture to be, especially in contrast to what he then developed as a commercially successful practice.

The most complete construction of the sign of nothing in which Rossi engaged, however, was the project that produced his most iconic images, the San Cataldo Cemetery outside of Modena,

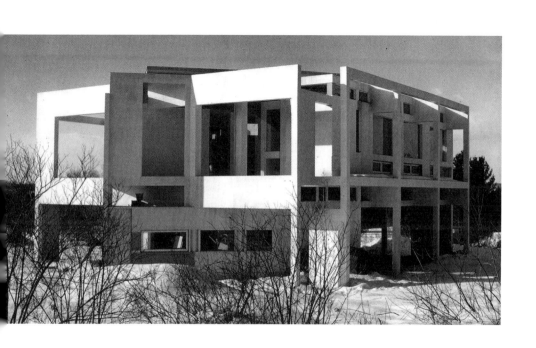

Peter Eisenman, House III, Lakeville, Connecticut, 1969–1971 (Eisenman Architects).

on which he worked from 1971 until his death. The design was itself a reworking of elements and themes he had developed for housing projects (most notably the Galaratese slab outside of Milan), schools (the elementary school in Fagnano Olana of 1972 to 1976) and monuments. All these projects, which still responded to functional and typological specificities, here disappeared into a pure and roofless cube, painted red and standing at the entrance to a large field surrounded by an ambulatory that was meant to serve as columbarium. A conical tower, which to some evoked factory smokestacks but to others those at the German concentration camps, and which certainly turned the incineration of bodies into a sign that might haunt those visiting, stood on axis with the empty red cube.

The cemetery is quite large, but it is also without life—except for those interring the dead or remembering them—and thus is as much a memory of a real, inhabited world human beings continually build for themselves. It is a collection of fragments, whose end resolution Rossi left unfinished. It was an instrument for burial, and a place for ritual. It was dominated by endless rhythms and cadences. The cemetery evoked the past and those who lived in it and escaped from the need for function or signification by being purely a monument: a memorial to the dead, but a democratic one that glorified not one ruler, but the faceless human reserve that lived and died in and around Modena (home of Ferrari cars, among other industries).

The San Cataldo Cemetery is as close as any architect came to building the empty sign or sign of nothingness. Because its function was to sign death, that worked, if you will, in function as well as form. The presence of this city of the dead made it an inhabitable sign, one that could embrace you in a way that the pure white paintings or gridded office buildings could not. Both fully and monumentally there and yet absent, the cemetery was and is more than a small thing, but its effect was limited by the specificity of its type. Architecture could build its own death only as a house of the dead.

To be even more radical was to not build or even to unbuild. The American architect Peter Eisenman arrived at that point in his House X, an unbuilt project he published in a book that collected all its versions and representations in drawings, models, and words in a purposefully perverse tribute to what was not there and—if you were to believe the author—was better for not being there.[62]

Eisenman came to what he called this "decomposition" through a process that started with a PhD thesis at Cornell dedicated to the reduction of architecture to as few operations and types as possible.[63] It then proceeded through the design of a set of nine houses (Houses I through IX, though only four of them were built) that dove into what was almost nothing and unearthed within it not so much new forms or spaces, as the complexity and contradiction inherent in those forms themselves. They were overlayed and purposefully confusing grids, carried out in white and hiding all signs of construction, that hovered over their exurban sites with little indication of direction, scale, front, or even top or bottom. They were as close to the building of LeWitt's structures as any architect has come, and the complexities of vestigial functions and three-dimensional enclosure the architect provided only made these built signs all the more enigmatic.

Eisenman's model was a linguistic one, and he spent several decades trying to translate the work of thinkers such as Noam Chomsky, Ferdinand de Saussure, and later Jacques Derrida into built form—this despite the fact that all these writers were interested in the impossibility or at least inherent contradictions of any form of cultural production. Eisenman's response was to make houses that were themselves more and more useless and contradictory, culminating with House VI, which became famous for including upside down staircases and a gap that ran through the middle of the marital bed (the owners were divorced after the house was finished).[64]

With the design of House X, Eisenman tried to take this process even further. Though the project was ostensibly a commission for a home in a suburban setting, the architect used the site and program, as well as the fee, to do something deliberately self-referential:

> House X starts from a set of given formal notions, for example the interaction of incomplete patterns, sequences and progressions within—in this particular case, a four-part relationship—such as two to two, three to one, etc. The process then attempts to uncover (or deconstruct) from them spatial relationships inherent in their structure. Rather than working towards a predictable end, decomposition starts with the end to find its inherent limits. . . . It is making by analysis.[65]

Harking back to the concerns of the postwar generation, Eisenman is careful to point out that "House X is strongly colored by metaphoric ideas of ruin, decay, and falling to pieces."[66] It is as much a memento mori as any of Rossi's work.[67] The house he proposed was to be a cube placed on a site and divided both horizontally and vertically by a cross-shaped void, part of which could be used as an atrium or stair hall, and an L-shaped part which was meant to be an inaccessible void. The composition appears a perfect geometric volume that has been shattered, fractured, and poised on a site without ground. The drawings and models deliberately make it difficult to understand its scale, function, or materiality:

> In assuming no historical or narrative logic, and in doubting or denying that an object consists of a set of hierarchical relationships that can be known, the new object becomes fragmented, relativistic, and unlike its modernist counterpart, referential and non-autonomous. Its fragmentation is not that of a whole, of parts which could be reassembled, but one which only suggests an essential apartness—an unreconcilable "twoness" (not a duality) between man and object.[68]

Only conventions such as door swings or indications of toilets rupture these signs' aspirations to unknowability. There are clues, but ones that Eisenman seems to want to give you only to deny any interpretations you night make, because the whole project is "an anti-ideological gesture against the present condition of architecture, and thus an active act of negation rather than a passive stance of neutrality."[69]

Like Rossi, Eisenman was interested in the past, which for him meant the legacy of modernism, and in impossibility and the ends of things: "House X is rooted in a pervasive and explicit ideological concern with a cultural condition, namely the apparent inability of modern man to sustain any longer a belief in his own rationality and perfectibility."[70]

The final sign of the status of the architecture as not pointing toward its finished project, let alone use or interpretation, is that Eisenman considered House X's most complete rendering to be an "axonometric model": the translation into three-dimensional form of the drawing tool that projects a plan at a 45- or 30-degree angle to delineate spatial relations without subjecting them to

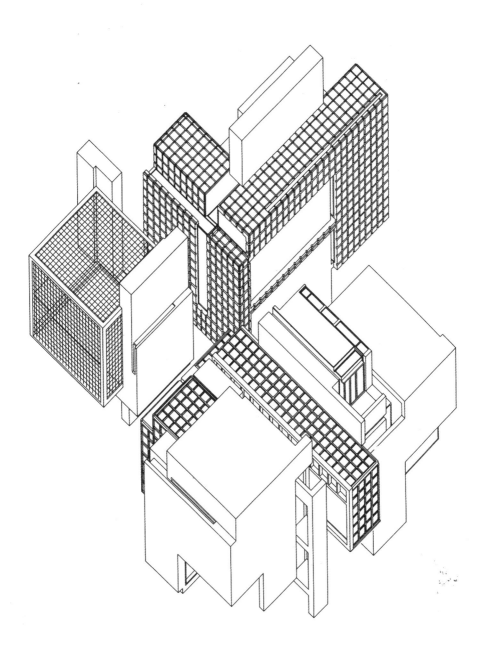

Eisenman Architects, House X, Bloomfield Hills, Michigan, 1975 (Eisenman Architects).

perspective. The model, which Eisenman wanted the owners to burn periodically so that he could replace it with another one in a ritualistic reenactment of construction, was exclusionary, as he himself points out in the text. Unlike a photograph of a building, or even of a model, which invites you in to experience the space, or unlike presentation drawings or photographs, which present an ideal state of the design, this model is a dense artifact that you cannot enter through either interpretation or empathy.

Eisenman designed one more house after House X, which he called House Eleven-Odd, or House L. Even more unbuildable than its predecessor, it unearthed the L-shaped void in the "cross house," as students came to call House X, and turned it into a figure poised on an even steeper site and delaminating into thin planes. After that, Eisenman turned away from further research in this manner, resorting instead to visual analogies of what came to be called "deconstruction" to justify his designs of large cultural institutions.[71]

House X remains as the "x that marks the spot" at the possible end of architecture. While some of Eisenman's pupils and cohorts, most notably Daniel Libeskind, took his archaeology of signs to ever further extremes, and then resurrected their own productive careers out of the self-contradicting forms and geometries that resulted, House X as a book, a text, a collection of designs, and an axonometric model remains the most complete architecture of death, denial, and nothingness that any architect has ever attempted. Even more than the San Cataldo cemetery, which was never intended to be inhabited but whose scale made it a monument one could experience, House X remains a ritualistic entombment of architecture. It is not even a "small thing"; it is an anti-thing that precludes, at least in theory, the possibility of any building, not just small or abstract buildings. It is almost not there, and yet sticks in the craw of twentieth-century architecture as the emblem of how architecture, if it is to truly confront capitalism and the contradictions of modernity, must kill itself.

5 Representational Space

W ere Tafuri, Rossi, Eisenman, and the others right in thinking they were operating at the end of architecture? Was there no possibility of productive practice that would, even if it did not produce inhabitable buildings, at least propose models for or dreams of such? Certainly the architects and theoreticians mentioned in the last chapter did not come to that conclusion in a void, nor were the architects the only ones to feel as if they were at a dead end. The philosophical sense of dread, ennui, and loss of purpose pervaded the academy to the extent that it seeped through into popular culture, with a *Time* magazine cover of 1966 summing up the question that supposedly haunted everybody in the Western world: "Is God Dead?"[1] Such signs of the self-destructive nature of the economic and social system under which that world operated were seemingly everywhere, from the futility of the Vietnam and Cold Wars to the assassination of major political figures, the destruction of inner cities in the United States and Europe through redevelopment and, in the former case, through riots and white flight, and the realization of the pernicious effects of industrialization on the natural environment.

The culminating statement of most of these problems is to be found in *The Limits to Growth*, released in 1972, that made the possible end of civilization as most readers then knew it eminently real. The book, assembled by a group of scientists, politicians,

Larry Burrows, *Aerial Bombing, Vietnam*, ca. 1963 (The Museum of Modern Art / Licensed by SCALA / Art Resource, NY).

and thinkers starting in 1968 and sponsored by the Club of Rome, starts with a quote from the Secretary General of the United Nations, U Thant:

> I do not wish to seem overdramatic, but I can only conclude from the information that is available to me as Secretary General, that the Members of the United Nations have perhaps ten years left in which to subordinate their ancient quarrels and launch a global partnership to curb the arms race, to improve the human environment, to defuse the population explosion, and to supply the required momentum to development efforts. If such a global partnership is not forged within the next decade, then I very much fear that the problems I have mentioned will have reached such staggering proportions that they will be beyond our capacity to control.[2]

The group delineate the research they have used to test this hypothesis and come to the conclusion that "if the present growth trends in world population, industrialization, pollution, food production, and resource depletion continue unchanged, the limits to growth on this planet will be reached sometime within the next one hundred years. The most probable result will be a rather sudden and uncontrollable decline in both population and industrial capacity." However, they also note: "It is possible to alter these growth trends and to establish a condition of ecological and economic stability that is sustainable far into the future. The state of global equilibrium could be designed so that the basic material needs of each person on earth are satisfied and each person has an equal opportunity to realize his individual human potential."[3]

Although the Club of Rome saw itself as an agent calling for action in order to save the planet, the reaction to its book was a widespread sense of gloom, especially as it appeared on the eve of the first period of pronounced economic decline the West had seen since the Second World War.

For those architects and thinkers who did not succumb to the sense of fear and foreboding, the ability to do "small things" was matched only by a sense that the profession itself had to be abandoned in order to engage in civic activism, ecological intervention, or the creation of shelters against the gathering storms. If we leave aside those escape mechanisms, though, there were

some who sought to examine the possibilities inherent in architecture itself to find a way forward. The two most prevalent of these approaches, perhaps paralleling the ultimately self-defeating paths Tafuri had outlined, were to find an enigmatic space that was beyond the nothingness that Rossi and Eisenman had dug up; and to find within the complexity and contradictions inherent in architecture a way to get to a state that was a "nearness to chaos, but its avoidance."

The latter was a quote from the American scholar August Heckscher, which the architect Robert Venturi reproduced on one of the last pages of his 1966 *Complexity and Contradiction in Architecture*.[4] Partially a simple monograph of his own work, partially a recording of his aperçus after spending a term at the American Academy in Rome, and partially, as he himself calls the opening chapter, "a gentle manifesto,"[5] the book was a call for designing in a manner that built on tradition. Venturi was mining a particular part of that tradition, though. Rather than focusing on the major elements of major buildings, he concentrated on those bits and pieces that were quirky, off-kilter, or otherwise strange.

The text is a compendium of such moments, organized according to different categories: the "double functioning element,"[6] the juxtaposition of scales compressed into a single facade or plan, or the moments of contradiction when a sequence of columns or rooms that lead the viewer to expect more of the same is broken. Venturi also loved the sense of architecture as stage fronts that announced themselves as such, rather than pretending to have a deeper reality, and of techniques such as trompe l'oeil, in which painted decoration evoked materials or shapes that were not actually there beyond the surface of the illusion.

What Venturi gave the reader, in other words, was too much, and what he showed and made as a designer might sometimes be thought of as in bad taste—or at least as small gestures in an otherwise banal composition. To save architecture, Venturi implied, you had to rely on its bastard children, mine its mistakes, find its contradictions, and delight in its absurdity. You also had to be willing to understand it as part of a broader culture of deceit and play. Rather than creating signs of nothing, you had to dive into the consumer world Tafuri and Naftalini had decried and figure out whether, by speaking in a rhetorical and oratorical surfeit of phrases, you could fill the impending silence. Instead of

saying nothing in the void, architecture had to scream ornately and metaphorically.

Venturi's concerns were with image as sign. He and his future wife, Denise Scott Brown, developed the notion of buildings as either "ducks," which is to say structures that signed what they did (after a restaurant in Long Island that served duck and was built in the image of a duck), or "decorated sheds," which are structures that put up a sign in front of their otherwise compact and efficient boxes to tell the world what they are doing.[7] In either case, the building's mass and form do not matter. Venturi's thesis was essentially that architecture had become both so scientific in its composition and so aware of its elements that it could make buildings almost automatically. It had indeed disappeared into capitalist planning. What was left, however, was not nothing, but rather how the architect responded to context, client, function, and other conditions through the adaptation of the variety of signaling elements available. Such architecture did not disappear into an empty sign, and in fact Venturi went to great pains to emphasize that "architecture is form and substance, abstract and concrete and its meaning derives from its interior characteristics and its particular context"; but its "complexity and contradiction," and thus its true nature, come "from the juxtaposition of what image is and what it seems."[8] "The architect selects as much as he creates," he said, adding that what the architect does create are "meaningful contexts."[9]

That the book was filled with photographs and drawings of both buildings Venturi had studied and those he had designed with his partners masked the radical part of his message. If buildings were no more and no less than instruments of signification, veils of poetic juxtaposition, superimposition, and references hung over superefficient boxes, thereby transforming those building into carriers of meaning, it meant that architecture had completely dissolved into a crossing point between an ever more rationalized building industry and an equally mechanized system of representation. That this stance was prophetic, predicting the development of the profession in the decades after the book came out and giving further weight to Heidegger's, Benjamin's, and Tafuri's predictions, made that message even more obtuse when the book came out. The book was received as a "how to" handbook for making what came to be called postmodern architecture—including by the

author himself, who built a large practice producing banal structures for several decades.

Venturi and Scott Brown, however, made their attitude clear in the book they produced six years later, *Learning from Las Vegas*. Based on a studio they taught at Yale's School of Architecture, it subjected the casinos on the Las Vegas Strip to the same sort of analysis Venturi had performed on the buildings of Rome and other parts of Europe.[10] That they restricted themselves to the buildings on the Strip, ignoring and in fact dismissing the rest of what was a burgeoning metropolis as just the necessary backdrop to these temples of chance, contradicted Venturi's interest in vernacular and "lesser" monuments in the earlier volume. He might have said that "Main Street is almost alright,"[11] but he was obviously more interested in bringing the churches of Rome or the casinos of Las Vegas to bear on what for him was clearly still a second-rate environment.

What Venturi saw in Las Vegas, in other words, was better signs in front of bigger and more anonymous buildings. If the destiny of architecture was to be a sign and a box, either one in front of the other or melded into one, then one should learn from the biggest and shiniest out there. In *Learning from Las Vegas*, he, Steven Izenour, and Denise Scott Brown proposed looking carefully at signs and billboards and treating them as an integral part of what defines and modulates space. They then explored some of the implications of this, both in building designs such as their proposal for the Football Hall of Fame and in their exhibition at the Renwick Gallery in Washington, D.C., of 1976, "Signs of Life."[12] Even more thoroughly, their design for the Benjamin Franklin museum and memorial in Philadelphia, of 1976, almost realized the dissolution of architecture into electronic signs floating in the ether together with billboards and television ads. The actual functions of the museum were underground, in a dark space lit completely by artificial means and overwhelmed by slick surfaces, glass display cases, and signage. All that was visible outside was the outline of Franklin's house, standing as a steel ghost of what was once a solid piece of architecture.

Yet Venturi was never able to build or carry out the kind of pure sign for which he seemed to call. He was too much of a traditional architect, happy to show off his skill at manipulating spaces as well as his knowledge of historical elements, and also content to build up a large firm that produced a slew of thoroughly mediocre

Robert Venturi and Denise Scott Brown, "Signs of Life" exhibition, Renwick Gallery, 1976 (Venturi Scott Brown Collection, The Architectural Archives, University of Pennsylvania. Photo by Tom Bernard).

buildings. Perhaps that is why, at the end of *Complexity and Contradiction*, he stepped back from the "honkytonk" and "vitality" of vernacular and found imagery, looking instead for

> an inherent sense of unity derived from the dominant binder or the motival [sic] order of simpler, less contradictory compositions, but that derived from a complex and illusive order of the difficult whole. . . . It is the unity which "maintains, but only just maintains, a control over the clashing elements which compose it. Chaos is very near; its nearness, but its avoidance, gives . . . force."[13]

Pop art, he ends the text by saying, has shown us the way; but the architectural discipline—and ultimately he himself—are too hidebound to truly learn from it, turning instead to the vernacular that became the mainstay of architectural inspiration for postmodern architects in the decades to come.

A more fitting definition of the architecture Venturi pointed toward, and which could have truly turned his "electronic expressionism" into a poetry of the absence of meaning and form that shimmered with the perhaps false hope of liberation through technology, can be found in some of the many descriptions of Las Vegas in the 1960s by nonarchitects. The most famous is no doubt that of Hunter Thompson's 1971 gonzo sojourn there, *Fear and Loathing in Las Vegas*, which described "Circus Circus as what the whole hep world would be doing on Saturday night if the Nazis had won the War," and otherwise evoked the utterly surreal nature of the place.[14] In my mind, though, the description that comes closest to producing Las Vegas as a model is the last passage of Norman Mailer's 1965 novel *An American Dream*. There he produced a counterimage to the monster leviathan, a place in which the machine, being both the car and the casino, had dissolved into not a living but a spectral organism that was both human—although in this case only as the disembodied voice of the Marilyn Monroe character—and as cold as steel and air conditioning:

> Five times a day, or eight, or sixteen, there was a move from hotel to car, a trip through the furnace with the sun at one hundred and ten, a spring along the Strip (billboards the size of a canyon), a fast sprint in the car, the best passenger car racing America, driving not only your own piece of the

mass production, but shifting lanes with the six or seven other cars in your field of collision. It was communal living at its best, everybody ready for everybody else, and then an aces fast turn off the Strip to land in the parking lot of the next hotel, lungs breathing up the bellows of the desert that hundred-and-ten air, hotter than hot flannel of the lining of the throat, and once again it was hopeless to know whether one could go to the end, or if in two hours, four hours, six, or six-and-twenty, the heat would swell some hinge of the brain, and madness would burn up out that rent in the hinge. But then always into a hotel where the second atmosphere was on, the seventy degrees of air-conditioned oxygen, that air which seemed to have come a voyage through space as you were in the pleasure chamber of an encampment on the moon and fortified air was brought in daily by rockets from the earth. Yes the second atmosphere had a smell which was not the air conditioning of other places: the hollow sucked out by the machine left a hole which was deeper here. You caught the odor of an empty space where something was dying alone.

Lived in this second atmosphere for twenty-three hours of the twenty-four—it was life in a submarine, life in the safety chambers of the moon. Nobody knows that the deserts of the West, the arid empty wild blind deserts, were producing again a new breed of man.

The night before I left Las Vegas I walked out in the desert to look at the moon. There was a jeweled city on the horizon, spires rising in the night, but the jewels were diadems of electric and spires were neon of signs ten stories high. I was not good enough to climb up and pull them down. So wandered farther out to the desert where the mad before me had come, and thought of walking into ambush. . . . I was safe in the city—no harm would come to me there—it was only in the desert that death would come up like a scorpion with its sting.[15]

Strangely enough, Robert Venturi had come up with an approach to architecture that, at least in theory, came close to that Peter Eisenman developed. Coming from opposite sides of the semantic spectrum, they both came near to arguing for the total victory of the sign over building, as Tafuri had predicted. While

Photographer unknown, Las Vegas Strip in the 1960s.

Eisenman stepped into building to find its grave and unearth its bones, Venturi stepped out and found its historical fragments in order to reimbue the discipline and practice with meaning.

Much of the debate in architecture during the 1970s and 1980s took place between the poles of historical and intra-architectural reference, but in that manner the discussions were thus always between different ways to sign. In fact, the scribe of postmodernism (and the man who may have invented the phrase, at least in architecture), Charles Jencks, defined all of architecture as nothing more or less than a form of communication, celebrating its many languages and dialects rather than taking a stance in the style and meaning war that he helped to instigate.[16]

Yet if all these debates led back to nothing, just the sign, was that sign indeed just one of absence and nothingness, as Tafuri claimed? Or was it possible to find a way to evoke architecture that was both critical and world-making, that could evoke the possibilities inherent in modernity? If one wanted to do so, one had to start from other standpoints. One of these would be to begin with images themselves, and to work to strip them, paradoxically, from signification or reference, or to otherwise make them so complex and contradictory that they freed themselves from their status as signs. However, to arrive at that point, you had to think more about the whole system of representation in and of architecture.

One thinker who pursued that question with rigor was Henri Lefebvre. A convinced Maoist and at the same time a member of France's intellectual elite, he approached this task, again paradoxically, by starting to ask questions about that aspect of architecture that would seem to be furthest away from signification, namely space.

Lefebvre pointed to space as the central problem in architecture in his *The Production of Space*, first published in France in 1974 just as architects were beginning to fetishize space exactly in opposition to postmodernism's preoccupation with image, sign, and signification.[17] The preoccupation with space, though rooted in the work of such plastically oriented designers as Le Corbusier, rejected modernism exactly because of its dual characteristics of flatness and spatial uniformity. Against forms and three-dimensional relations defined by geometry, reason, and grids, they proposed some sort of intuitive molding of space that would make, as Louis Kahn put it, "the Room": a space endowed with mystical, auratic capabilities.[18] That space would

also be of a place, rooted to a particular site through a *genius loci*, as the writer Christian Norberg-Schulz would have it, to vernacular practices, according to Kenneth Frampton, or to the particularities of the sights, sounds, and even smells of a place, as the architect Charles Moore claimed.

Space and its manipulation could thus be a kind of poetry of place—except that it could only do so as singular, specified responses to one situation and site, which inevitably changed in the process of construction itself. It could be detected and sensed but never reproduced, leaving it as the province of unique artifacts created at great cost and for singular purposes, such as cultural monuments or the houses of wealthy clients. It had moreover to remove itself from the urban experience, however much such groups of architects as the New Urbanists tried to mass-produce it.

To understand what space could be as poetry of modern urban life, Lefebvre pointed out, you had to understand the historical evolution of the term. In fact, he argued, every society produced its own space, inhabited its own space, and confirmed itself through those spaces. What architecture, and any form of critical making, had to accomplish was to somehow be able to worm their way between physical reality, the representations of that reality created by dominant social forms (e.g., capitalism), and the unknowing reflection of that state of affairs in daily practices. Lefebvre thought of this impossibly thin possibility as "the space between the face and the mask."

For Lefebvre, reality is what he called "mental space"[19] and, later, absolute space.[20] It just is, but we can only know it through interpretation: abstract space. This abstraction is the realm of science, which postulates geometries and coordinates that become ever more complex and precise until they wind up digging into and threatening to dissolve all of that absolute reality into the fractured and relative world in which they, as well as space, object, reality, potential, and energy, are all indistinguishable.

That scientific space serves a function. It makes it possible for us to operate in and on the real world, transforming it, in the manner that the Rhine became hydroelectric power, into a field that we can glean for food or minerals. On that "second reality" we then built our own world, that of agriculture and ultimately cities. This artificial world is a representation both of absolute space and of what we have made out of it: a reality of houses, skyscrapers, shipping lanes, roads, and farms. Those representations

themselves become ever more abstract, turning into language, laws, and political and economic systems that are the highest order of representation.[21]

The final representation of this second world is a society, and at the same time that society is the summation of all those representations. As a society changes, either gradually or through revolutions and upheavals, those representations—be they buildings or laws—also change.[22] While a society stands, the representations ensure its proper operations and its division of power, down to and including, Lefebvre points out, the modes and forms of human reproduction.[23]

This system of reproduction always remains an artifice, leaving the first world to persist in what we think of as daily practices, lived experience, or memory. In the case of architecture, Lefebvre points out, buildings of significance or what we think of as the core of architecture start as sites that are seen to have certain properties that make them worthy of attention and then adoration. Those qualities turn them into refuges, shrines, and sites of gathering and pilgrimage. These functions become fixed in monuments such as temples, and then those forms are reproduced, as the classical system of building was, in the service of those in power to house palaces, granaries, treasure houses, or, later, museums and concert halls.[24]

The result is that architecture becomes the production of such representations of power, and the spaces it encloses become not just containers but affirmations of power. While the vernacular or daily practice is not so overtly dominated by representations of power, building and design practices, like those in language, law, sciences, and art, are governed by and in the service of the creation of rational, well-working social arrangements.

What escapes from that power of appropriation and control? Not much, and certainly nothing legal or seen, because all that is resistive or revolutionary is suppressed or appropriated, as Tafuri had also shown. Only when something becomes "obscene," or not in the scene of daily life, or truly in opposition to all the accepted modes of practice, behavior, and appearance, does it escape from the laws of representation. However, paradoxically, such work must remain hidden (clandestine), because as it comes to the light of day it, like a vampire, shrivels and dies. For "representational space," as Lefebvre describes it, to exist, it must remain in the

shadows, unspoken, or otherwise exiled from the scenes of both regular spatial practice and the representations of space.

Lefebvre sums up this tripartite relation between spatial practice, representations of space, and representational space as follows:

1. Spatial practice, which embraces production and reproduction, and the particular locations and spatial sets characteristic of each social formation. Spatial practice ensures continuity and some degree of cohesion. In terms of social space, and of each member of society's relationship to that space, this cohesion implies a guaranteed level of competence and a specific level of performance.
2. Representations of space, which are tied to the relations of production and to the "order" which those relations impose, and hence to knowledge, to signs, to codes, and to "frontal" relations.
3. Representational spaces, embodying complex symbolisms, sometimes coded, sometimes not, linked to the clandestine or underground side of social life, as also to art (which may come eventually to be defined less as a code of space than as a code of representational spaces).[25]

What Lefebvre hints at here is the possibility of art as a kind of countercode, with the unruly and uncontrollable world of symbols and other forms of nonrepresentational self-expression offering a counter to the rigid orders of the spaces of representation and the spatial practices they govern.

What might such a representational art look like? Truth be told, Lefebvre gives us few clues. What he does is to evoke spaces of representation layered on top of representational space in such a manner that the previous social practices continue, in a repressed manner, or that new ones emerge literally underneath the temples, palaces, and other bureaucratic structures of prevailing power arrangements. It is the space of crypts underneath Paris and Rome where both criminals and religious sects hid and built their own worlds. It is the space of rituals and magic shows that delight and amaze but also trouble us; and thus, if it is possible to extrapolate from Lefebvre, it is also the shadow world of horror movies.

Whether such representational spaces might exist, and whether or not they might be able to survive long enough to allow some form of resistance or lived reality to offer a true alternative to spaces of representation, is for Lefebvre an open question. If they do, they must answer, paradoxically, to the rules and regulations of spatial practice and its representations:

> The working-out of the code calls itself for an effort to stay within the paradigmatic sphere: that is, the sphere of essential, hidden, implicit and unstated oppositions— oppositions susceptible of orienting a social practice—as opposed to the sphere of explicit relations, the sphere of operational links between terms.[26]

Lefebvre adds that such a code "has to be conscious of its own approximativeness . . . it is at once certain and uncertain. It announces its own relativity at each step, undertaking or at least seeking to undertake self-criticism, yet never allowing itself to become dissipated in apologias for non-knowledge, absolute spontaneity or 'pure' violence."[27]

To find such representational spaces, Lefebvre proposes a "spatiology."[28] It would have "rhythms" rather than structure, and other forms of recognizability that could not be put directly into words. This would take the search back to the body,[29] where all the senses would be able to apprehend such a space but not put it into words or other codes. Such a space would be that of art, which exists between the public face of social codes and the inner self of representational space.[30]

"On the horizon, then," Lefebvre concludes *The Production of Space*, "at the furthest edge of the possible, it is a matter of producing the space of the human species—the collective (generic) work of the species—on the model of what used to be called 'art'; indeed, it is still so called, but art no longer has any meaning at the level of an 'object' isolated by and for the individual."[31]

So, are we back to the same evocation of poetry, the same notion of an art of democracy, the same veil, the same explosion of the tenth of a second? Might we be able now, in the era of advanced semiotics and technology that has made many of the dire predictions of early thinkers come true, be able to define that mass art with more precision or at least evoke it more fully?

The problem, of course, is that the whole point of this poetry or art is that it has to "shimmer," exist in shadows, and always recede as we try to put it into words or even defined images. It must remain abstract, intimative rather than imitative, and speculative rather than propositional. That does not mean, however, that makers cannot make such art, or that thinkers cannot propose particular forms in which it might exist. While for some, proposals such as Lefebvre's might justify an intuitive art-making that resolutely refuses to be judged, others have listened with more care to the conundrums these thinkers evoked and wondered how they could make an art that would "pass" or seem to be acceptable, coded, and clear, but that managed to slip away to evoke something obscene, illicit, or just unknowable that might be representational.

One architect, although it is not clear that he ever read Lefebvre, clearly picked up on the notion of an architecture that exists somewhere between the face and the mask.[32] John Hejduk, for many years the dean at New York's Cooper Union School of Architecture, started much like Peter Eisenman in complicating and contradicting the geometries of houses. By the early 1980s, however, he had turned to the making of objects that started as proposals for simple wood constructions but turned into evocative drawings of objects that had personalities or animate traits more than they were governed by the laws of statics of function. He collected these into what he called "masques," a term he adopted from the sixteenth- and seventeenth-century tradition of staging participatory court performances in Italy, France, and England. For Hejduk, the masques were collection of objects that were intended for very specific inhabitants—the *Berlin Masque* had a "House for the Eldest Inhabitant," for a "Conciliator," and a "Mask Taker"—as well as for specific activities, ranging from a Reading Theater to an Arbitration Hall and a Bell Tower. These objects, drawn in colored pencil in light shades that made them appear all the more tenuous, in some parts recalled vernacular versions of such functions (although you had to wonder what something that looked like a New England meeting hall was doing in Berlin), but quite often they veered into the weird. The Arbitration Hall sprouted tubes emerging from a body that could be a section through a tank, while a simple Crossover Bridge became a monstrously large but geometrically tamed centipede dwarfing a singular figure Hejduk drew in for scale.[33]

What they achieved, the scholar of this phenomenon, Gregory Wilson, has pointed out, is the production of a "space between possibility and reality, of the place between the mystical sphere of the idealized vision and the actual sphere of recognized physical, social, and political norms."[34] He calls this space, quoting the theater scholar Victor Turner, "liminal space," which he defines as

> [the] transition between one stage and another. Liminal space is fluid, difficult to delineate, and generally a condition in which normal, social, political, and aesthetic positions and hierarchies can be either partially altered, inverted, or entirely undercut and removed. In such cases, these normative conditions can often be replaced by newly created or previously inferior positions while still within that liminal space. . . . Deeply complex and "ambiguous" then, liminality is not only an in-between, transitional space, but one in which the space it lies between can be critiqued without fear of censure.[35]

Hejduk's masques developed a mode that he carried out in the *Hanover Masque*, a project called *Vladivostok*,[36] and then in sketches of conditions he observed or invented. They sprouted appendages from square or rectangular forms, with these additions resembling hair, tentacles, or the inner tubes and ganglia or a body. As latter-day fragments of the monster leviathan, they were the remains of a vision of terror or utopia in which human beings, by melding with the characters they played, the objects they inhabited, and mythological beasts, would build a new society. Hejduk called his first collection of such images *The Mask of Medusa*, and it performed a reverse magic: rather than turning people into stone, it brought them to life in stone, or at least in drawings of wood.[37] One of the starkest images, simply titled "Security," is a glaring snake with fins in the form of slanted smokestacks emerging from a back that could also be a tank's gun turret, sitting on two stilts and accessible by a staircase that is also its tail.[38]

The bestiary of forms Hejduk built up repeated elements and turned, over time, into his own private collection of allusive elements, in which bridges, enclosed staircases, chimneys, and small huts mingled with the flora and fauna that grew out of these bits and pieces of construction with no transition. Somewhere between representations of architecture and evocations of dreams

and nightmares that were strange enough to elude direct interpretations, their endless iterations worked their way into the brains of several generations of designers Hejduk trained and influenced. Once seen, the masques could not be unseen, but they also resisted interpretation and, except in a few rare and not very successful cases, construction.[39]

If Hejduk, whether consciously or not, thus drew what could be an architecture between the public and the private, representation and representational, in the realm of architecture as poetry, the social geographer Ed Soja, who taught for many years at the University of California at Los Angeles, articulated and interpreted Lefebvre's work in a more literal and socially engaged manner, making it more specific to the practices of urban planning and activism. He also influenced the work of his most prolific student, Mike Davis, whose 1990 *City of Quartz* took these ideas into a trenchant analysis of southern California.[40]

Soja did not accept Lefebvre's work wholesale, but rather deepened and extended it with his readings of philosophers such as Jean Paul Sartre and Martin Buber. As a result, he developed a spatial reading that both called for the necessity of action and speculated on the self-contradictory nature of any attempts by human beings to make themselves at home in the modern world. He identifies a spiral of identification and objectification that starts from spatialization. Space is primal, but in a manner that is connected to being human:

> It is in this sense that spatiality is present at the origin
> of human consciousness for it permits—indeed it
> presupposes—the fundamental existential distinction
> between being-in-itself (the being of non-conscious reality,
> of inanimate objects, of things) and being-for-itself, the
> being of the conscious human person. Objectification,
> the primal setting at a distance, relates to what Sartre calls
> "nothingness," the physical cleavage between subjective
> consciousness and the world of objects that is necessary for
> being to be differentiated in the first place, for being to be
> conscious of its humanity. In this essential act, this original
> spatialization, human consciousness is born (although
> borne may be just as appropriate). Nothingness is thus
> nothing less than primal distance, the first created space,

John Hejduk, *Victims: Sketches of Structures*, 1984 (John Hejduk Fonds, Canadian Centre for Architecture).

John Hejduk, *Masque of Medusa: Security*, from the book *Mask of Medusa: Works, 1947–1983*, edited by Kim Shkapich, 1985 (Canadian Centre for Architecture).

the vital separation which provides the ontological basis for distinguishing subject and object.[41]

To be human is not just to come from that condition, but to attempt to cross it: "To be human is not only to create distances but to attempt to cross them, to transform primal distance through intentionality, emotion, involvement, attachment."[42] The more we do so, however, the more representations, and thus barriers, we create in that space. He ends his discussion with the evocation of the spiral Sartre uses to evoke that continual attempt to connect with the world in space that only succeeds in creating more modes of alienation.[43]

That does not mean that we should give up and not act. Soja believed, with Lefebvre, in the necessity of action, but also warned that such action would not lead to a clear result, even if it could alleviate certain injustices. His most gifted pupil, Mike Davis, made a career out of finding and describing such moments of failed action. Their evocation is most powerful, such as when he finds the ruins of a utopian community in the southern California desert, describing the manner in which the geometry and ruins of the hopes of Llano del Rio are inscribed in the proto-suburban grid that now extends over the area, or when he finds echoes between gated suburban communities and not only utopias but also prisons and concentration camps:

> The desert around Llano has been prepared like a virgin bride for its eventual union with the Metropolis: hundreds of square miles of vacant space engridded to accept the future millions, with strange, prophetic street signs marking phantom intersections like "250th Street and Avenue K." Even the eerie trough of the San Andreas Fault, just south of Llano over a foreboding escarpment, is being gingerly surveyed for designer home sites. Nuptial music is provided by the daily commotion of ten thousand vehicles hurling past Llano on "Pearblossom Highway"—the deadliest stretch of two-lane blacktop in California.[44]

To travel around California and northern Mexico with Davis, as I did several times in the 1990s, was to find communities that were both emblems of hope and self-made architecture, and examples of repression and exclusion. We found them in the favelas of

Tijuana, which were so much more alive than the planned communities just across the border but were also places of crime, poverty, and pollution; and in the tunnels at the edge of downtown Los Angeles, where homeless people made their own underground world, sometimes living off fees they earned from film companies shooting dystopian scenes in their "masques."[45]

The philosopher Peter Sloterdijk, in contrast to the perhaps vaguer models Lefebvre and his followers posited, developed two rather concrete models for the art of being human in our almost posthuman society: bubbles and foams. The three-part treatise in which he meanders through his theories develops an alternative ontology of human existence: what makes us humans lies not in being molded or appearing as a body, whether made by a deity or not, but inspiration: the initial taking or giving of a breath that blossoms into our being. The outer form is a mode of technology that is always deficient and subject to control, but that first breath still exists within us, and we aim to externalize it or make it our own.[46]

Sloterdijk uses as his initial image the child playing with soap bubbles:

> The child stands enraptured on the balcony, holding its new
> present and watching the soap bubbles float into the sky as
> it blows them out of the little loop in front of his mouth. . . .
> The little wizard's attention follows their trail and flies out
> into the open, supporting the thin walls of the breathed
> bodies with its eager presence. There is a solidarity between
> the soap bubble and its blower that excludes the rest of the
> world. And each time the shimmering entities drift into
> the distance, the little artist exits his body on the balcony
> to be entirely with the objects he has called into existence.
> In the ecstasy of attentiveness, the child's consciousness
> has virtually left its corporeal source. . . . The bubble and
> its blower coexist in a field spread out through attentive
> involvement. The child that follows its soap bubbles into
> the open is no Cartesian subject, remaining planted on its
> extensionless through-point while observing an extended
> thing on its course through space. In enthusiastic solidarity
> with his iridescent globes, the experimenting player plunges
> into the open space and transforms the zone between the
> eye and the object into an animated sphere. All eyes and

Site of Llano del Rio, Palmdale, California, 1994 (author photograph).

attention, the child's face opens itself up to the space in front of it.[47]

The philosopher likens this process to an artist creating their work in a manner that is reflexive of both its own making and the world to which it refers. Although the analogy he has launched with his soap bubbles—those ephemeral reflections of what is around them that defy rules and disappear as soon as you would catch them in words or images—would seem an obvious one, his main concern is to trace the many layers of alienation, or rather exposure, that have emerged since the first inspiration either of the child being born or of the human race in general. Ripped from our placenta, defined increasingly by social codes, left in a sky that is not sheltering but ever-expanding according to the discoveries of science, and otherwise continually unbubbled, we can only try to catch that sphere of protection in games or speculations. Only in his subsequent practice has Sloterdijk proposed an analogy to the bubble in the sphere of architecture: portable "domes of democracy" that can be erected as ways for the population to determine their own fate.[48]

Although this project has been plagued by so much political controversy that Sloterdijk has, as of this writing, lost much of his attraction as an inspiration to architects and artists, his fascination with domes, and in particular those designed by Buckminster Fuller and his followers, is an architectural thread that runs through much of his work. Without being explicit in his endorsement of these structures, his frequent allusions to them, as well as the photographs that sprinkle the book and the political project they inspired, make it clear that he sees them as a human-made replacement for the lost sphere of encompassing and social protection offered by the imagined vaults of heaven and the communal dwellings of previous social arrangements.

Sloterdijk also proposes the notion of islands, which he categorizes as either absolute, hydrospheric, and atmospheric, as a possible model. The island is not just a place isolated in the water (like the geological version), but also a place with a controlled environment and enhanced sensual pleasure. The most concrete example he offers is the greenhouse, especially in its public, nineteenth-century version as a place for common enjoyment, escape from the strictures not just of the weather but of social mores, and a luxurious, organic alternative to the gridded and rational existence

beyond its bounds. Sloterdijk does not propose such structures as literal models, let alone ways in which we should organize space or create communities. Even the greatest greenhouse of all, the 1851 Crystal Palace in London, is the very model of both modernity and modernism, meaning that it embodies the freedom and possibilities the modern world offers, but represents and organizes those qualities in a manner that establishes the voracious appetite of a capitalist economic and social system to know, control, and own everything, including its inhabitants. It is the final colonization, he claims in another text, of the interior that Benjamin had once proposed as a bulwark of individual self-expression.[49]

Sloterdijk has also proposed another, albeit vague, model for such inspired art: the "microsphere." As he puts it toward the end of *Bubbles*:

We are in the microsphere whenever we are

 —firstly in the intercordial space

 —secondly in the interfacial sphere

 —thirdly in the field of "magical" binding forces and hypnotic effects of closeness

 —fourthly in immanence, that is to say in the interior of the absolute mother and its postnatal metaphorizations

 —fifthly in the co-dyad, or placental doubling and its successors

 —sixthly in the care of the irremovable companion and its metamorphoses

 —seventhly in the resonant space of the welcoming maternal voice and its messianic-evangelistic-artistic duplications.[50]

The work of art thus needs to somehow replicate the womb, but in a transformed manner that makes it social—a definition Sloterdijk explores in the notions of the "placental doubling." Beyond this rather dubious fetishization of existence *in utero* and the subsequent

adoration of the Maria figure, the other phrases the writer uses are familiar: magic, hypnosis, metaphors and metamorphosis, and resonance. These are all the qualities of an art that would seek not to reveal itself to the scrutiny and bounding effects of codes. What is new here is the notion of the "interfacial sphere," which certainly evokes Lefebvre's notion of the space between the face and the mask, in that "intercordial" space. This would be what we might call the "ties that bind." Though for Sloterdijk the social binding force is rooted in the physical connection to the mother, he goes on to explore its transformation into complex, spongelike networks of relations that do not follow hierarchy and remain impossible to separate into inside and outside, logic and illogic, or any other form of order. They are fractal, infinite, intense, and extensive.

Foams are as fragile as soap bubbles, Sloterdijk points out, but more extensive. They are also part and parcel of modernization, as they represent and make real the spread of networks of economic, social, and knowledge connections, theorized by science, that constitute the reality of modernity. As he uses them, foams are also the reverse, a magical misreading of data and form and thus a reassertion of no less than life itself, which comes together to form, at least metaphorically, "a republic of spaces."[51] They also take us back to "the stages of civilization in a space-analytically defamiliarized way: the loose, evasive character of the original forms of segmentary small societies now becomes more apparent than before." These early societies were not ideal, as they were made of "single-minded and self-narcotized groups," but they were the generators of what you might almost call the mythic counterform Sloterdijk recognizes in society. Instead of being an ever more hierarchically organized and separated arrangement of different classes and people, this instead would be an ever denser and more interconnected "foam" of microsocieties of groups of people aligning themselves or being forced to align by states and later corporations.[52] Sloterdijk makes no judgments (or rather dissipates his conclusion as a debate among various thinkers of his own invention), leaving it up to "history" to decide where this is tending. It is up to us to decide if such spheres and domes, movable and arrangeable at will, democratic in their circularity, and aggregating into foams of self-organizing peoples, might be an appropriate model for a counter-architecture of democracy.

Michel Foucault, most of whose work was dedicated to documenting exactly how and why architecture, to misuse one of his

titles, had become an instrument of discipline and punishment, offered one small countermodel that has intrigued architects ever since it made its way into the Anglo-American academy during the 1990s. Entitled "Of Other Spaces: Heterotopias," the text begins by offering a concise description of "emplacement," Foucault's phrase for the kind of spatial arrangement evoked by many of the thinkers we have discussed:

> This space of emplacement was opened up by Galileo. For the real scandal of Galileo's work lay not so much in his discovery, or rediscovery, that the earth revolved around the sun, but in his constitution of an infinite, and infinitely open space. In such a space the place of the Middle Ages turned out to be dissolved, as it were; a thing's place was no longer anything but a point in its movement, just as the stability of a thing was only its movement indefinitely slowed down. In other words, starting with Galileo and the seventeenth century, extension was substituted for localization.
>
> Today the site has been substituted for extension which itself had replaced emplacement. The site is defined by relations of proximity between points or elements; formally, we can describe these relations as series, trees, or grids. Moreover, the importance of the site as a problem in contemporary technical work is well known: the storage of data or of the intermediate results of a calculation in the memory of a machine, the circulation of discrete elements with a random output (automobile traffic is a simple case, or indeed the sounds on a telephone line); the identification of marked or coded elements inside a set that may be randomly distributed, or may be arranged according to single or to multiple classifications.
>
> In a still more concrete manner, the problem of siting or placement arises for mankind in terms of demography. This problem of the human site or living space is not simply that of knowing whether there will be enough space for men in the world—a problem that is certainly quite important—but also that of knowing what relations of propinquity, what type of storage, circulation, marking, and classification of human elements should be adopted in a given situation in order to achieve a given end. Our epoch is one in which space takes for us the form of relations among sites.[53]

Foucault then offers an alternative to these spaces "that have the curious property of being in relation with all the other sites, but in such a way as to suspect, neutralize, or invert the set of relations that they happen to designate, mirror, or reflect." "There are also" he goes on to say,

> probably in every culture, in every civilization, real places—places that do exist and that are formed in the very founding of society—which are something like counter-sites, a kind of effectively enacted utopia in which the real sites, all the other real sites that can be found within the culture, are simultaneously represented, contested, and inverted.[54]

These spaces have come in various forms at various times. One group is what he calls "crisis heterotopias," such as spaces where women withdraw in some societies when they are menstruating or are pregnant. In our society, he points out, we reserve those heterotopias for "deviants" we lock up in psychiatric hospitals or prisons. Then there are heterotopias of removal or negation, outside of the norms and the physical bounds of both the human and social body and its place. Foucault provides the cemetery as an example, which is much like the "city of dead" Aldo Rossi tried to evoke.

As a third example, Foucault cites the unreal spaces where spatial rules are suspended. These heterotopias are

> capable of juxtaposing in a single real place several spaces, several sites that are in themselves incompatible. Thus it is that the theater brings onto the rectangle of the stage, one after the other, a whole series of places that are foreign to one another; thus it is that the cinema is a very odd rectangular room, at the end of which, on a two-dimensional screen, one sees the projection of a three-dimensional space.[55]

The garden, he goes on to say, is the oldest of such spaces, reproduced and made portable in the form of carpets. This kind of heterotopia is a kind of momentary, fleeting, or enclosed Eden or place where the rules are suspended.

That suspension is also the guiding principle of the fourth kind of heterotopia, the one you might find in a museum or a library, but also in a fair: accumulations of artifacts and events

from all over the world and all history, assembled and immersing you in a place where the usual rules of time and place are in abeyance as long as you pay for the ticket and follow both the rules of the institution and the guidelines of the suspension of disbelief.

Even thinner or more elusive are the heterotopias of thresholds, which in certain societies, Foucault points out, expand to reception rooms or guest spaces that are neither public nor private, neither truly inside nor outside, and only function as such through a ritual of hospitality. The liminal space is a place of appearance and of appearances, where you pose as guest or host, and where you enact social rituals in a way that opens you up to new experiences and human relations. This is where certain rules are suspended, but it is, I would note, also often a space that is in between inside and outside: the porch, the stoa, or the temporary reception tent where architecture frames but does not enclose.

Such other spaces can expand, at least for a while, into homes for those who have been exiled, such as lepers or, these days, political refugees. That possibility is, however, clearly bounded not just by space but also by time. Though Foucault wrote before the numbers of political and climate refugees had reached such a scale that their encampments are everywhere and of a huge size, it is worth considering these instant cities, transitory communities, and embattled refuges as building blocks of something that has the characteristics of an urban and formal order, but also has a nascent, albeit always restricted, freedom and social flexibility.[56] What Foucault concentrates on instead is the brothel, the ultimate place of obscenity and of social connection that escapes the strictures of power, but only for the middle-class patron. The ultimate heterotopia, on which Foucault ends his short text (based on a lecture and thus having the character of a kind of sketch), is the oceangoing vessel:

> if we think, after all, that the boat is a floating piece of space, a place without a place, that exists by itself, that is closed in on itself and at the same time is given over to the infinity of the sea and that, from port to port, from tack to tack, from brothel to brothel, it goes as far as the colonies in search of the most precious treasures they conceal in their gardens, you will understand why the boat has not only been for our civilization, from the sixteenth century until the present, the great instrument of economic development (I have not

been speaking of that today), but has been simultaneously the greatest reserve of the imagination. The ship is the heterotopia par excellence. In civilizations without boats, dreams dry up, espionage takes the place of adventure, and the police take the place of pirates.[57]

Lefebvre, Soja, Sloterdijk, and Foucault all seek for something that is by its very nature elusive. It would be a space that is recognizable and can sustain itself, if even just long enough for us to experience it, while at the same time being the obverse of that: a dark, unknowable, free, and, above all else, deeply personal space. It would be personal, though, in a manner that would be social, affirming the fact that we as human beings only exist in relation to others and, even more than that, affirming that the self is not enclosed by the human body, but is a relational entity that, from the perspective of architecture, we are seeking to make at home in the modern world.

6 Implosion

In the 1980s, things began to fall apart, but in a new way. To be more precise: in the architecture schools of the Western world, the idea began to hold sway that coherence and logic were outdated notions reflecting attempts to exercise control over our lives. Instead of either accepting the canon or seeking to extend it into community activities, architects looked to thinkers outside of the field to find modes of escape from what seemed to be a dead-end profession that just reproduced the rules and regulations of building codes, allowing architects only enough room to decorate the resulting structures with semiotic facades or spatial sequences that would further confirm what the buildings were meant to do.

The "deconstructivist train wreck," as an architect friend of mine attempting to turn this movement into architecture at a large firm was fond of calling it, steamed through the large opening provided by postmodernism. By reducing architecture to a form of communication, the latter had opened a way to think of the whole endeavor as a game with its own rules, independent of validation from construction or inhabitation. In a consumer society that was aware of the limits to growth, architecture had to be a vassal in the Empire of Signs and had to figure out how to play the field with the limited tools left to it by an increasingly rationalized building and construction industry.

Partially in rebellion against this situation, partially in implicit acceptance, a slippery, sneaky, wry form of criticism wormed its way into the academy and from there into the drawings and models of some architects and designers. Generally called "deconstructivism," after the technique of "deconstruction" propounded by one of its most prominent theorizers, Jacques Derrida, it encompassed a range of attitudes, techniques, and even worldviews that had in common only their refusal to accept the notion that reason, truth, and rational behavior were to govern the practice of architecture. What might replace the reasoned production of buildings according to an accepted canon, even if it was extended, and what it might make, however, was and is much less clear.

To start with Derrida, who certainly was the most famous, if not directly influential, of such thinkers to whom architects looked during this period, his literary analysis—for that was, as it were, his home field—contains certain phrases or techniques that seem promising for their application in architecture: the pharmakon, which is both a cure and a poison, dissemination, deconstruction itself, spurs, and even invagination. Although Derrida dabbled in architecture himself, even collaborating with Peter Eisenman on some projects,[1] he was too obtuse for direct consumption by most architects.[2] His influence spread through the work of interpreters and extenders who took not only his ideas but also his style of writing into the task of pulling apart, questioning, and reassembling buildings and their imagery. Instead of turning directly to Derrida, therefore, I have chosen to use the relatively clear text written by the American critic Gregory Ulmer, who was one of a host of interpreters who delved through the Frenchman's dense writings to find concrete, albeit also slippery, concepts.[3]

The basis for much of this work, Ulmer points out, predates the critique of semiotics that shaped what came to be known as poststructuralism. Instead, Ulmer goes back to the notion of collage and assemblage as lying at the heart of deconstructivism (if we may use that popularizing term). He identifies the moment of genesis for this blowing up of reality into bits and pieces not with the advent of film, but in the moment in 1913 when Pablo Picasso and Georges Braque, whether separately or together, developed a method of assembling works of art that was not just innovative but a fundamental break from the modes of representation and making that had governed art until then. It was, he says, "the single

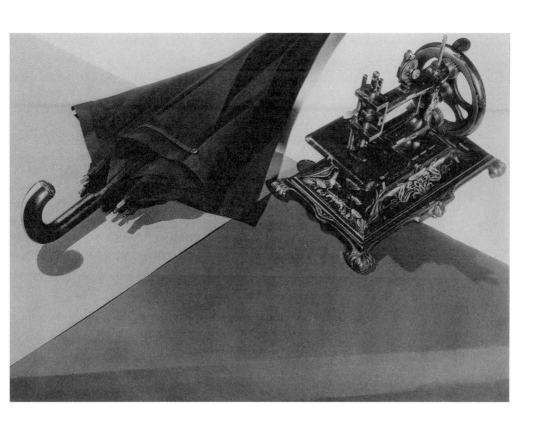

Man Ray, *Beautiful Like the Chance Encounter on a Dissecting Table of a Sewing Machine and an Umbrella*, 1933 (Man Ray 2015 Trust / Artists Rights Society (ARS), NY / ADAGP, Paris 2022).

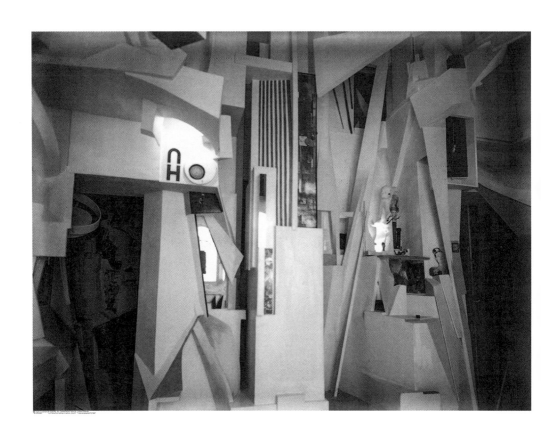

Kurt Schwitters, Merzbau, 1933 (© 2022 Artists Rights Society (ARS), New York).

most revolutionary formal innovation in artistic representation to occur in our century."[4]

The work of collage starts not with a blank state, Ulmer points out, but with reality or, rather, the detritus of the world we inhabit. Out of the bits and scraps of what has been discarded and what is no longer useful, artists assemble a picture. Its newness and its very worth thus inhere in the act of assembly and not in the materials. It is composing and aligning, layering and the acceptance of cutting and discarding, rather than innovation or vision, that are the modes of causality here. Moreover, it is not the maker by themselves who creates the work, as the fragments come with their own associations or even meanings. Each fragment is just that: it is incomplete, referring to other and larger structures, but at the same time is present in the work of art. That picture or object has itself no beginning or end, only a coherence. It can extend beyond the frame and, in some of the more daring experiments that came in the years after the initial implosion of fragments, it took over the spaces around it to the point that you truly could not find its boundaries.[5] Such was the case, for instance, in Kurt Schwitters's Merzbau, a three-dimensional cave of bits of cast-off building material, trash, and half-used art materials that wound up surrounding the artist and completely erasing the boundaries of the shell in which it grew up.

As such, the collage and its three-dimensional equivalent, the assemblage, confused the technology of art as Heidegger might have defined it, along the way challenging the usefulness, authorship, and worth of the "final" piece. The history of collage and assemblage and all that they wrought in the world of art is that of the various modes of resistance and otherness challenging the entropy of the empty sign that has been the dominant mode in which art has tended to develop throughout the twentieth and into the twenty-first century. It is the other, obscene history of art and, as we shall see later, of architecture. It is the monster leviathan inherent in the urban city, brought out in the frame of the painting, sculpture, photograph, or construction.

What concerns Ulmer is the mode in which this technique crept into and subverted the very dominant modes of meaning and interpretation it sought to implode. Collage (to stick with that phrase) is, he points out, a "simulacrum," not a simulation: one piece of the composition can stand for the whole, while at the same time there is no clear referent. The work of art does not stand

for something, it is something, but something composite, unstable, dependent on multiple references and continuations beyond itself in both time and place.

"Post-criticism," as Ulmer designates the particular kind of writing that interests him, is then not a text about something, but itself such a collage. It "mounts a process" in the way a camera mounts a photograph out of the technology inherent in its machinery, what it sees, the light, and the work of the photographer. It thus does not describe or critique an object as much as it constructs one itself. Collage is not about something, but is a kind of "parafiction," a phrase coined by Derrida, that weaves its way through a text and in the process (and it is a continuous process) confuses the object of criticism, the subject of the writer and the critic both, the beginning and the end point of the work, and, quite simply, the point of the whole exercise.

Why would collage do that? Ulmer's answer, speaking for Derrida and others, is that it assembles itself to get away from the structures of power that define both the work of art and its reception.[6] That is to say, Derrida, Ulmer, and most of the other makers and critics who use such tactics do so in order to break down exactly the kind of clarity about who makes what for whom in what manner that Heidegger described in his essay. If you engage in such an implosion, rather than either reasoned making or explosion, you do not "set the object on its way to unconcealment," but rather leave it at least partially concealed and, by weaving your way into the process, perhaps allow a veil of poetry to shimmer through the skein of what does finally appear. Implosion rather than explosion, assembly rather than reasoned and purposeful making, acceptance and subversion, and uncertainty in space, time, and meaning become the hallmarks of the ever-elusive work of deconstructivist art.

What you can see or read is a text (and Ulmer and his subjects insist that all the works of art on and through which they write are texts) that weaves new and old, existing language and new forms, and author and reader together in such a way that you can no longer distinguish or define any separate element. If there is any single piece that is the building block, it is the "gram" at the core of grammar, which is not a sign but a "difference": an operator, connector, disconnector, and switching station that governs continually changing meanings and relations. Ulmer quotes Derrida on what the gram does:

Whether in the order of spoken or written discourse, no element can function as a sign without referring to another element which itself is not simply present. This interweaving results in each "element"—phoneme or grapheme—being constituted on the basis of the trace within it of the other elements of the chain or system. This interweaving, this textile, is the text produced only by the transformation of another text. Nothing, neither among the elements nor within the system, is anywhere ever simply present or absent. There are only, everywhere, differences and traces of traces.[7]

There is a method to this madness (if you assume sanity is a clear set of references, purposes, makers, and users). Ulmer lists some of the techniques Derrida proposes, including grafting one text into another, mimesis or direct mirroring, "invagination," a rather vague term whose titillation is no doubt part of its point, and mounting one text on the other.[8] What is left is an "anomorphous" work of art or criticism (at this point the two are interchangeable)[9] that traces as much as it is or makes. In fact, traces are all that is left of art. The implosion, like that of a dark star, leaves only aftereffects. Ulmer provides a wonderful example of such a work of art from Derrida in his description of another technique, the spur or unexpected and perhaps dead-end growth:

The style-spur, the spurring style, is a long object, an oblong object, a word, which perforates even as it parries. It is the oblong-foliated point (a spur or spar) which derives its apotropaic power from the taut, resistant tissues, webs, sails and veils which are erected, furled and unfurled around it. But, it must not be forgotten, it is also an umbrella.[10]

While this mode of writing became Derrida's signature and thus in part launched him as a star author and critic exactly in the manner he claimed to want to wriggle away from, creating along the way an army of imitators whose mimesis was as fawning and inept as it was ignorant of the notion of such parafiction, he did along the way launch a series of images and techniques that permeated the world of art in many of its forms. Ulmer traces and tracks several of these. They range from the preference for allegory, with its many possibilities and layers of meaning, over metaphor, and a certain fondness for the obfuscation between forms

proper to baroque and rococo architecture, to the notion of the parasite or supplement: that which is either seemingly useless, or which in fact eats its way into its host and alters its body. Such an organism or chemical can become a "pharmakon," such as the hemlock that Socrates took to kill himself. Derrida points out that the Greek word means both poison and medicine, acknowledging that medical procedures alter the body irrevocably, sending it on a path that it otherwise would not have taken. As he says in his text on the subject: "The pharmakon goes against natural life: not only life unaffected by illness, but even sick life, or rather the life of the sickness. . . . In disturbing the normal and natural progress of the illness, the pharmakon is thus the enemy of the living in general, whether healthy or sick."[11] Derrida connects this directly to his text, which he says displaces and dismembers the original account it treats.[12]

It is also, he points out in the text, an "alien . . . it does not come from around here."[13] It is always an insertion from elsewhere, thus mixing and weaving bodies or even whole ecologies together. That alien being that is yet embedded in the detritus you pick up on the street, the texts you read, and the buildings you make, is continually unbuilding reality, cracking it open or covering it with so many layers of meaning and allusion and allegory that it is impossible to tell what the original or "true" structure or meaning might have been.

In the last few pages of his text on Derrida's texts of texts, Ulmer veers off into a perhaps unexpected direction. His discussion of the pharmakon leads him to consider mushrooms, which have for millennia been used for both delight and destruction and are often unknowable in their effects.[14] What interests him further is the very nature of mushrooms, which are saprophytes, a particular kind of parasite that feeds on, but also feeds, its host. Moreover, they do not grow out of seeds, but are networks that weave themselves across and through bodies of trees, soil, and other organic and inorganic matter, popping up in spurs that blossom, die off, and spring up in new ways.

This "symbiotic ecology" was a particular area of interest to the composer and artist John Cage, and Ulmer ends his essay by discussing how that maker's art can be seen as an allegory of mushrooms—or the other way around. Cage was fond of noise, of silence, and of unfinished and contradictory systems and rhythms. He was more interested in the unfinished and the work where you

could not figure out where it started or what its contours were. At its best, his work achieved the status of being an "exact fantasy" that Ulmer holds up as a possible definition—of course contradictory—of the kind of art that interests him.

The contradictions and impossibilities of such a mushrooming, spurring, grafted, and otherwise rich and self-deconstructing pharmakon, which surely is a good definition, but also an imploded inversion of the explosions, veils, shimmering possibilities, and impossible spaces we have encountered so far, make it difficult to define or even find. In fact, as soon as you manage to do so, it either slips away or, like the space between the face and the mask, disappears by that very act. Elsewhere in the same collection of essays in which Ulmer's summation appeared, the critic Fredric Jameson proposes the schizophrenic, for whom the world does not necessarily cohere, as a model: "schizophrenic experience is an experience of isolated, disconnected, discontinuous material signifiers which fail to link up into a coherent sequence."[15] The schizophrenic is no longer an individual, but a dissolving and refracting operator in a larger set of networks. Jameson proposes schizophrenia in general as the model for an art of a time marked by "the transformation of reality into images, the fragmentation of time into a series of perpetual presents."[16]

Jameson calls this way of being postmodernism, which he acknowledges also means that the technique has become exactly that, namely a mode of communicative action that emerges in a consumer society and assembles itself out of the shards of the modernist attempt to make sense of modernity. It thus has been put to work to make artwork in capitalism and to make capitalism work better by providing images and working methods that are appropriate to its networked, image-based structure. Yet he hopes that it will also find a way to "resist," ending with yet another vague but hopeful vision of such a postmodern poetry: "that is a question we must leave open."[17]

The techniques of collage and assemblage and the slippery allegories of poststructuralism in and of themselves might be such an open poetry. To further describe or at least to allude to their possibilities, we can look at both the roots and what might be the endpoint of their possibilities: the notion of bricolage developed by the anthropologist and philosopher Claude Lévi-Strauss, and the critique of postmodernism offered by another French thinker, Jean-François Lyotard.

Lévi-Strauss, an anthropologist who did field work in South America but transformed his research into much larger and more sweeping statements on the nature of society and the place and function of art, was an acknowledged influence on Derrida and others and his notion of bricolage remains relevant today, even if the work on which he based his theories was flawed by his own unacknowledged cultural biases.[18]

In his seminal and revealingly named *The Savage Mind*,[19] Lévi-Strauss starts by observing the arrangements "primitive" people make in certain activities, ranging from storytelling to rites. "Sacred objects," he concludes, "contribute to the maintenance of order in the universe by occupying the places allocated to them."[20] It is their place and the relationship between each of them and their surroundings, not some intrinsic worth—as they are often twigs, leaves, clumps of clay, or other found objects—that gives them value and meaning. These arrangements and their meanings do not just appear out of nothing or the heads of the assemblers. Lévi-Strauss points out that they are based on careful observation of the world these peoples inhabit and are in and of themselves part of the organizing of this knowledge so that it will have an effect. The assembling of sacred objects is, he says, an act with its own rules and logic. It is a form of "rigorous determinism" that is concrete and intuited, rather than abstract and postulated, as it is in what he calls science.[21]

The work the shaman, storyteller or artist makes consists of an arrangement—and even "micro-arrangement" of small gestures and adjustments—out of predetermined pieces that are available in their world, with tools that are also made out of what is around them. In contrast to what Lévi-Strauss calls science, which he defines as a project that starts with a series of known elements and speculates toward something unknown, the "magic" of this work lies exactly in evoking, recreating, and in some cases restoring the order that is already inherent in the world. This mythic reality is neither discovered nor made but remade and made real for the people who experience the act of the maker.[22]

Lévi-Strauss calls the maker a "bricoleur," a French word both for the kind of craftsman who uses what is at hand, but also for a collage maker who assembles cast-off materials into new structures. The bricoleur is, whether consciously or not, the person who uses "mythical thought" that "expresses itself by means of

a heterogenous repertoire which, even if extensive, is nevertheless limited." The bricoleur "builds up structured sets, not directly with other structured sets but by using the remains and debris of events."[23] They work exactly in the realm of signs, which Lévi-Strauss defines as existing between images and concepts, or "percepts and concepts: . . . Signs resemble images in their concrete entities but they resemble concepts in their powers of reference."[24]

These signs are, by definition, never abstract: "signs allow and even require the interposing and incorporation of a certain amount of human culture into reality."[25] What also exists in the object is the maker: "the bricoleur derives his poetry from the fact that he does not confine himself to accomplishment and execution: he 'speaks' not only with things . . . but also through the medium of things: giving an account of his personality and life by the choices he makes between the limited possibilities."[26]

In this short text, but also in the remainder of the book of which it is the first chapter and in fact in much of his work, Lévi-Strauss tries to reevaluate a way of making things that has no particular purpose. It is a form of magic but also, he points out, of such activities as art-making and game-playing. Both are means of reproducing, adjusting, reframing, and otherwise offering a kind of mirror and map of a reality that is too large, complex, and fluid for us to experience it all at one time. Although his treatment of art is rather restricted, art historians such as Svetlana Alpers extrapolated from this position to claim for particular kinds of art-making that quality of measuring, mapping, mirroring, and rearranging within the frame of what already exists. Art is a form of remaking, not making; of presenting, not merely representing; it is the aesthetics of and in the real.[27]

Modern art-making, the theoreticians of poststructuralism then argued, started with an attempt to recapture the nonlinear, non-project-driven aspects of art-making by being self consciously "primitive" or "crazy." The work of bricoleurs working as self-trained artists and architects could take its place along with the assemblies non-Western cultures continue to make, but also along with the unwitting products of popular culture that produced collages in the forms of movie posters, cartoons, layers of buildings added onto over time, and, later the fast-cut assemblies of music videos and certain advertisements. Bricolage had not only presaged the grafts and spurs of Derrida but continued its work

outside of the strictures of the art world. Inspired by such thinking, writers, artists, and architects began experimenting with forms of assemblage, collage, and bricolage.

The danger of such work was, as was almost immediately evident, that it became a style in its own right, bought and sold at great value and with methods of judgment both aesthetic and economic. The maker of the train wrecks I described above produced office buildings and other large structures. A whole cottage industry emerged of designers claiming to blow up or slide away from order while continuing to build the central institutions of the state.[28] One of the most explosive of these firms, Coop Himmelb(l)au, or the Cooperative of the Blue of Heaven, started their career by making unbuilding sketches and proceeded to design the headquarters of the European Bank. Peter Eisenman used his conversations with Derrida to design art centers, convention centers, and stadia. Order was restored. Poststructuralism and its art were assimilated, turned into a style, taught in the academy, and accepted by a general public. Did that process not kill its critical or mythopoetic power?

Jean-François Lyotard sensed that danger:

This is a period of slackening—I refer to the tenor of the times. From every direction we are being urged to put an end to experimentation, in the arts and elsewhere. I have read an art historian who extols realism and is militant for the advent of a new subjectivity. I have read an art critic who packages and sells "Transavantgardism" in the marketplace of painting. I have read that under the name of postmodernism, architects are getting rid of the Bauhaus project, throwing out the baby of experimentation with bathwater of functionalism.[29]

His list is extensive and, as he admits, heterogeneous. It consists not only of retromodernists who call for a return to a simpler order and "anchored" language, but also those who use the new techniques to create a glib and sellable form of art or criticism. Echoing Tafuri, he wonders whether the response to modernity is to be found in a "sociocultural unity at the heart of which all elements of daily life or thought would have a place, as though within an organic whole? Or is the path to be cut between heterogeneous language games—knowledge, ethics, and politics—of a different

Chapter 6

order of these?"[30] What is needed in any case is not the kind of retreat he sees all around, but the continued search in the wide-open space created by the "shattering of belief . . . a discovery of the lack of reality in reality" at the heart of modernism.[31] Instead of believing that we rescue humanity, we should conceive a new kind of "inhumanity" that would be "the extension of being and jubilation which comes from inventing new rules of the game."[32]

Modernism in that sense is still nostalgic: it still seeks to discover a new order to replace the one that was shattered. Lyotard is interested instead in what he defines as a different kind of postmodernism, which would be a particular kind of sublimity that faces the terror and the beauty exactly of absence, immeasurability, and chaos that still allow for something that we might call art exactly through the deconstructivist implosion and cracking open of art itself. As he puts it: "The Postmodern would be that which in the modern invokes the unpresentable in presentation itself, which refuses the consolation of correct forms, refuses the consensus of taste." If the sublime presents the unpresentable as being exactly that, postmodern art pulls that other, that emanation of being, back into presentation. It is exactly the blank sign, the empty canvas, and the dense minimalism of postmodernism that is its point, for it forces us to confront the unpresentable in our daily, lived reality. The postmodern artist and writer, Lyotard says, "work without rules, and in order to establish the rules for what will have been made."[33]

This gives the work a particular quality: "This is why the work and the text can take on the properties of an event." "It is also," he concludes, "why they would arrive too late for their author or, in what amounts to the same thing, why their creation would always begin too soon. Postmodern would be understanding according to the paradox of the future (post) anterior (modo)." In that way, it does not makc or do anything, which would mean it would just be a product to be bought and sold. Instead of trying to "provide reality," it works to "invent allusions to what is conceivable and presentable."[34]

The artist, writer, architect, or critic thus does not make anything, nor do they critique anything. They assemble and take apart reality to hint at or allude to, and perhaps to create allegories or myths of what cannot be known and what is always modern, which is to say, not yet done and thus past. If something comes out of this effort, it is a byproduct, a form of slag or refuse that should

not have worth in itself. It is the act of allusive, poetic, and post-modern making that is the purpose. Lyotard ends what has, in the course of its development, become a form of manifesto with a clarion call for impossible action not unlike that of the futurists:

> Beneath the general demand for relaxation and appeasement, we hear the mutterings of the desire to a return of terror, for the realization of the fantasy to seize reality. The answer is: Let us wage a war on totality; let us be witnesses to the unpresentable; let us activate the differences and save the honor of the name.[35]

In this manner, Lyotard and others like him opened up a possibility for architects in particular who had long fought with the problems of double transference, in that they were making something for others and were trying to be both the client and the user, while still maintaining a distance and autonomy from that sublimation. Instead of either giving in and sublimating their subjectivity in certain gestures or allusions within the work or escaping into utopian or dystopian visions, they could now create a poetic and mythic architecture that would exist with the discipline itself, but before, after, and during the making of its object. Their architecture would have the quality of an event, or would disseminate itself through existing work, or would act as a graft or spur. It would be difficult to recognize and yet save the honor of the name of modernism and wage war on totality. This form of "deconstructivism" became what some of the architects themselves called "experimental" and others called "paper architecture."

New Zealand-born Mark Wigley, the philosopher and architect and later dean at Columbia University, home to the first "paper studios,"[36] worked most diligently to translate some of this thinking to the realm of architecture. After encountering Derrida's writing in a bookstore in Wellington, New Zealand, Wigley moved to the United States and pursued a PhD while working with Peter Eisenman. He also curated the 1988 exhibition "Deconstructive Architecture,"[37] which sought to define how exactly poststructuralist thinking could be applied to the discipline.

In his 1993 book *The Architecture of Deconstruction: Derrida's Haunt*, Wigley pointed out that "architecture is no more than the strategic effect of the suppression of internal contradictions."[38] For him this was both a practical and a philosophical argument. First,

Chapter 6

architecture seeks to bring into a single entity a variety of different forces, from the structural to the social, and then attempts to evidence or represent them. It cannot, however, do it all. It must represent some aspects of what it structures and houses, in the process quite literally plastering over the differences and differentiations. This is most evident, Wigley points out, in the age-old debate about the place of ornament, which seeks to be a sign of what is not truly present in the finished structure: "It is precisely the relation between structure and representation that is always at stake in architecture."[39]

In earlier writing, to which he refers in this text, Wigley had pointed out that it not just the internal complexities of building that architecture sought to both order and represent, always ensnaring itself in difficulties and contradictions. It was the very act of building itself, which builds on and thus represses the land or site on which the new is erected.[40] That preexisting condition remains, however, and is in fact the very foundation of the edifice. Architecture always builds on unstable ground, as what it replaces remains—forgotten, hidden, but still present. This repression evidences itself in the architecture of the "leaky crypt," which in the most mundane sense is the way the miasma of the ground, with its sewer smells and potential rot, always threatens the stability of buildings. On a more speculative level, both Wigley and the writer, philosopher, and one-time fellow dean Anthony Vidler have argued that this repressed foundation is present in the cellar, which becomes that crypt where secrets or simply the past are buried. Yes, this is the place of the obscene and representational art, but it is also the site of horror movies and bat caves, the *unheimlich* or unhomely that always haunts the *heimlich* or homely atmosphere of the home.[41]

Wigley delves more deeply into this crypt to excavate its philosophical meanings as well. Referring to Derrida, he points out the architectural metaphors that are central to the construction of most Western philosophy, and in particular to the work of Immanuel Kant. In those structures, reason is erected on base reality, reaching toward the heavens of pure being, but always finding itself caught up in the complexities of both organizing and representing its various parts and pieces. It does so in relation to the context in which the thinker is working. The final result is a system of signs. That context is both language itself, which is the equivalent of building material, and the larger cultural conditions and past modes of

reasoning in which they work. Architecture is thus foundational but repressed. It is never present or signed in the final argument, but only used to construct the edifice of reason. Even when such elements as the sublime offer alternatives to that measured arrival at truth, they are resolutely extra-architectural. Deconstruction, Wigley points out, is the effort to reveal the structure hidden in any system of signs, including and especially philosophy or modes of thought, and in so doing it reveals the repression of the real, of what is unsaid, and of the architecture of thought itself.

What remains are hints of that leaky, smelly crypt and the edifice that teeters on it. Wigley calls the process of following those hints a "deconstructive shaking"[42] that "identifies structural flaws, cracks in the construction that have been systematically disguised, not to collapse those structures but, on the contrary, to demonstrate the extent to which the structures depend on both these flaws and the ways they are disguised."[43] Following Tafuri and Lyotard, it is what cannot be present or represented, and what yet somehow presences itself not as truth but as denial and contradiction, that becomes the text out of which deconstruction weaves a different interpretive structure.

Delving further into Derrida's work, so to speak, Wigley points out: "Writing is not simply located 'in' space. Rather it is the production of space."[44] In fact, he quotes Derrida as describing how it constructs space. To Wrigley, the neat distinctions between mental or absolute space, representations of space, and representational space do not truly exist, but are themselves a construct. Space, as the in-between but also as the difference out of which meaning is constructed, is both constructional and semiotic, but invisible and unrepresentable. As such, it, and not just the foundational crypt, haunt architecture and language both. In the former, it is what justifies much of the discipline as it tries to pursue the ideal of "good space," which usually means good proportions in combination with calibrated lighting and a relationship to the rooms around the space, while in the latter it is the silence, the intimated, or the allegorical that is the always illusionary mark of being. Postmodernism and its imperative of communication still envelop the discipline of architecture.

The irony is that space can only work exactly by and through this invisibility. In so doing, it threatens both architecture and philosophy: "The exclusion and subordination of space produces an orderly façade, or, rather, the façade of order, to mask an internal

disorder. The traditional anxiety about space marks a forbidden desire that threatens to collapse the edifice of philosophy from within."[45] "Spacing," however which is the verb Derrida uses,

> is precisely not space but what Derrida describes as the "becoming space" of that which is meant to be without space (presence, speech, spirit, ideas, and so on). It is that which opens up a space, both in the sense of fissuring an established structure, dividing it or complicating its limits, but also in the sense of producing space itself as an opening in the tradition. Spacing is at once splintering and productive.[46]

Like representational space, it is the ephemeral, fleeting production of something that, as soon as it is fixed, contained, and defined, disappears.

"The institution of architecture," Wigley concludes his text,

> is clearly more than buildings and the practices by which they are produced. Architecture is not simply a specific kind of object that is produced by a number of material practices and can be represented before, during, and after its construction and in itself exceeds, in its physical presence, any such representation. The building "itself" is no more than a specific mechanism of representation.[47]

This is true not only in terms of the philosophical issues Wigley has been, *pace* Derrida, parsing, but also and more specifically in the sense that a building is the result of social, educational, and construction codes, not to mention economic ones, as well as a dizzying variety of different ones the author goes on to list.

Wigley calls not for a new kind of architecture but rather for a "rethinking" of the discipline, a process that "identifies the multiple openings that already structure architecture and on whose veiling so many cultural transactions depend."[48] This would involve both what has been excluded from the discipline and what is repressed within it. This otherness, whether innate or alien, is what Wigley calls "anarchitecture," using, for the first time to my knowledge, the phrase defined by Gordon Matta-Clark in a philosophical and architecture-defining text. That anarchitecture is not in and of itself a text or a thing but a continual revealing and

rereading, a complication and spacing, and a troubling adjunct to both philosophy and the practice of architecture. It is a parasite. It invades the rational practices of construction and thinking about construction at the same time and in the same way that architecture itself invades and troubles the neat constructions of philosophy.[49]

Wigley leaves his text only as a continual questioning and rewriting, and he himself has not practiced the discipline in which he was originally trained. He has left it to others, including many of his colleagues at Columbia, to construct what came to be called deconstructive architecture. The exhibition he curated at the Museum of Modern Art, thus inhabiting and attempting to question the very heart of the architecture culture that defined the rational and new structure, contained examples that preexisted his formulation, and thus remained as much evidence of the makers' own predilections and agendas. It was the curator who redefined them, in exhibition and writing, as deconstructive edifices.

At least theoretically these were, as pointed out above, "paper," in that they existed only as drawn and modeled projects. After all, they had to act in a manner that would continually question the very edifice they were proposing. They could never be finished, let alone erected, or they would stop the process of spacing, questioning, opening, and destabilizing. Perhaps that was why Wigley's predecessor as dean at Columbia, the architect Bernard Tschumi, wrote: "To really appreciate architecture, you may even need to commit a murder." "Architecture is defined," he went on to point out in a rather cryptic mode below an image of a man either falling or being pushed out a window, "by the actions it witnesses as much as by the enclosure of its walls. Murder in the Street differs from Murder in the Cathedral in the same way as love in the street differs from the Street of Love. Radically." Sex and death, realities usually excluded from the discipline, were central to his thinking: "Architecture is the ultimate erotic act. Carry it to excess and it will reveal both the traces of reason and the sensual experience of space. Simultaneously." Or, in a more sober formulation: "Architecture only survives where it negates the form that society expects of it. Where it negates itself by transgressing the limits that history has set for it." Echoing Wigley, he opined, "The most architectural thing about this building [the Villa Savoye by Le Corbusier] is the state of decay in which it is."[50]

To really appreciate architecture, you may even need to commit a murder.

Architecture is defined by the actions it witnesses as much as by the enclosure of its walls. Murder in the Street differs from Murder in the Cathedral in the same way as love in the street differs from the Street of Love. Radically.

Bernard Tschumi, "To Really Appreciate Architecture, You May Need to Commit a Murder," from *Advertisements for Architecture*, 1976–1977 (Bernard Tschumi Architects).

Such statements, Tschumi claimed, were not meant to evoke an alternate reality, but, as he explained in the larger project of which they became part, the *Manhattan Transcripts*, they were a form of parafiction:

> The architectural origin of each episode is found within a specific reality and not in an abstract geometrical figure. Manhattan is a real place; the actions described are real actions. The *Transcripts* always presuppose a reality already in existence, a reality waiting to be deconstructed— and eventually transformed. They isolate, frame, "take" elements from the city. Yet the role of the *Transcripts* is never to represent; they are mimetic. So, at the same time, the buildings and events depicted are not real buildings or events, for distancing and subjectivity are also themes of transcription. Thus the reality of its sequences does not lie in the accurate transposition of the outside world, but in the internal logic these sequences display.[51]

Tschumi's model for such an architecture was not a structure, but an event: "a turning point—not an origin or an end—as opposed to such propositions as form follows function. I would like to propose that the future of architecture lies in such events."[52] "The event is the place," he goes on to explain, "where the rethinking and reformulation of the different elements of architecture, many of which have resulted in or added to contemporary social inequities, may lead to their solution. By definition, it is the place of the combination of differences."[53] Note that Tschumi here still allows himself the possibility of coming to a conclusion or "solution," and in fact he was, by the time he wrote this text, already pursuing an active practice of construction.

The nature of his first major construction, however, was as much para-architectural, or anarchitectural, as it was constructive. Containing very little usable "space," but spacing and parsing out an interweaving set of rhythms and narratives, Tschumi's design for the Parc de La Villette, at the time the largest new public park built in Europe since the Second World War, consisted of a grid of pavilions, each painted red, connected or at least related to each other by parks and paths. The latter elements the architect designated with the name *promenade cinématique*, because he saw them as creating a coherence to one's experience of the space that

was not fixed, but that unfurled and disappeared as one moved through the park.[54]

The design's foundation, both literal and figural, and in true deconstructive fashion, was the presence at one edge of the park of one of Claude-Nicolas Ledoux's tollbooths. Erected just a few decades before the French Revolution, these implosions of triumphal entry arches, bureaucratic boxes, and small monuments marking what was then the edge of the city became the much-hated symbol of the government's control over people's lives and commerce. Most of them were later burned or torn down, but the one at the corner of the new park remained. Tschumi started from there, both conceptually and in the geometry he used to organize his design, and then replicated the cube in his grid of *folies*. The name referred to the garden pavilions, or follies, that wealthy French and English landowners erected in their parks as both retreats and emblems of their knowledge—bits of reason erected in tamed nature—and also to an antirational craziness, or *folie* in French. Tschumi deconstructed the tollbooth in numerous different configurations, adding a reference to another deconstruction of rational building practices, the one promulgated by the first wave of architects working in the then-new Soviet Union. Called constructivists by critics, these designers took apart the bits and pieces of what were considered normal building practices to create new forms, types, and even constructional logics for the communist state that would itself rewrite and destroy the very idea of state. Deliberately referring to forms developed by such architects as Yakov Chernikov, Ivan Leonidov, and Konstantin Melnikov, Tschumi designed assemblies of fragments with jutting elements, fragmentary geometries, and a collage of forms, and then painted them red. That color, he pointed out, referred both to the danger of such radical ideas and to the communist regime for which the originals were designed.

The whole exercise, he claimed, was an act of transference that would make architecture's slavery to state power, reason, and restrictions (the original tollbooths were called "barrieres") visible, signal its danger, and at the same time assign it to its contrary, a liberation-oriented act of continual construction of a new and free reality. That the source building failed to do anything but construct monuments to another repressive state (if they were built at all) was one of the many references or texts Tschumi wove through his design. Sunken gardens, bridges over existing canals,

Bernard Tschumi, exploded axonometric, design drawing for Parc de La Villette, Paris, 1983
(© Bernard Tschumi Architects).

and plazas cut off at the corners, along with the renovation of existing buildings and the erection of some horrid cultural institutions designed by other architects, completed the park.

Except that the park was never meant to be completed, at least conceptually. Tschumi drew his design in exploded axonometrics and other fragments layered on top of each other, and saw the experience of the park, which lacked either the central focal points and axes or the sinuous staging of supposedly natural elements that make up almost all such public spaces, as being always incomplete, temporary, and contradictory: an event. Even the addition of other architects' work was part of this extension, leading Tschumi to accept their flailing forms as found fragments.

As such, the Parc de La Villette remains much more successful as an example of what a deconstructive architecture might be than any of the singular objects, composed of crashing forms and gesturing, that became associated with the phrase. Far more interesting than such neo-monuments to knowing order were the text- and texture-like projects, the drawings and models without any reference to a possibility of a real construction, that emerged during the 1980s.

The most evocative and sweeping of these were the ones the Iraqi-born architect Zaha Hadid drew. Hadid was a student at the European equivalent of Columbia in terms of channeling the most advanced theory, London's Architectural Association. She entitled her 1982 thesis project, ostensibly a proposal for a new bridge over the river Thames, "Malevich Tectonics," and, like Tschumi's work of the period, she meant it to evoke the constructivist architects and artists of the early Soviet era. More a painting than a three-dimensional project, it consisted of an actual bridge she composed out of rectangular blocks of various sizes strung together on a walkway, but it was how she drew the thesis that mattered. Its plans rotated off the main object, which she showed in a skewed isonometric projection. Composed of black, red, gray, and blue planes, it pulled the design apart into fragments or skeins woven together on a large canvas.

Shortly after graduating, Hadid won an international competition for a club and residential development on Hong Kong's Peak with an even more audacious set of images. In the largest of the paintings, she showed a slightly abstracted version of all of downtown Hong Kong, its skyscrapers, residential blocks, and landforms all mixed together in a vertiginous view that might have

Zaha Hadid, Eaton Place apartment, 1982 (Zaha Hadid Foundation).

Zaha Hadid, overview, design drawing for The Peak Hong Kong Competition, 1982
(Zaha Hadid Foundation).

been familiar to travelers who flew into the city's airport, located right across the Peak, at the time. Out of the tectonic assembly of both human-made and natural forms emerged the smaller blocks and planes of the actual design proposal, which cantilevered impossibly off the mountain and even levitated in parts in the air. Closer views showed the roofs and walkways, walls and windows of the leisure club and its residences behaving in a similar way. They defied gravity in order to direct the eye to experience the proposed spaces as if the viewer were flying or zooming in and wandering through the possible planes rather than actual places.[55]

The Peak was an implosion of forms, which Hadid matched with an explosion in a design a year later for the conversion of a London building for her brother. The apartment had been the site of an IRA bombing and, rather than covering up that history, Hadid chose to make a visual celebration of it in her drawing. It was only by zooming in through the shards and fragments she sent flying through the English air that you could perhaps discern what might be the floor plans and what the composition of the walls she had designed.

For several years, Hadid continued this technique as she entered competitions around the world. For each project, she made, first, a series of hand sketches that were notations of direction, each a combination of curves and diagonals whose intersections or parallel adjacencies produced what Wrigley might call spacing. These differences then turned into paintings that she produced with a small group of associates. Each of them showed the site from a highly skewed angle, whether from below in the case of a project for Leicester Square, or from above in one for Düsseldorf. The outskirts faded off into abstraction, while the core of the design brought together the whirling geometries in a moment of density that implied an actual construction without actually giving you a sense that there was a closed and logical block anywhere to be found.

There was such a building inherent in the process, at least in most cases, for Hadid was also a remarkably practical designer, and pursued the idea of building her visions with single-minded fervor. In the end, she succeeded, overseeing large-scale projects that increasingly approached, though they never fully attained, the fervor of her designs. That trajectory, which was also followed by several of her colleagues who were in the Museum of Modern Art exhibition, such as the Viennese collective Coop Himmelb(l)au

Coop Himmelb(l)au, *Psychogram: Open House Drawn with Eyes Half-Closed, Sketch over Plan*, 1983, Malibu (Coop Himmelb(l)au).

and the Los Angeles-based Frank Gehry, made deconstructivism into something that most people experienced as a style.[56] Whether or not Hadid or any of her fellow designers actually believed in the warnings against how architecture would always be an affirmation of the existing structures of power, reproducing its spaces and suppressing its contradictions, and whether or not they realized that the poetic power of their work would be lost in the buildings, they realized that they could present their work in such impossible ways and still obtain and complete commissions.

Coop Himmelb(l)au, most poetically, argued that they wanted to design "the architecture of the leaping whale," whose freedom to levitate out of the sea represented a messy and fishy version of their utopian architecture—an appropriation of the "smelly, slippery fish" Gehry paralleled in his piscine lamps and buildings of the time. They also said that they believed in "an open architecture of the open eyes, the open heart, and the open mind." Their practice had started with what Tschumi might call an event: the burning of a project in the form of a flag in the courtyard of their Viennese architecture school. They developed a process by which two principals, Wolf Prix and Helmut Swiczinsky, would study a project for a long time and then, fortified by alcohol, would hold hands and draw a sketch with their eyes together. Their aim was, they claimed, to build this "psychogram," which notated their interpretation of the conditions and potentials of the project without reference to the hierarchy and codes of building processes, exactly.[57]

In their early work, they came close to achieving this messy ideal, but they soon had to abandon their fervor in favor of making structures that fit within the building conditions they had sought to escape. What was left was the expression of their original freedom. Such signing of the intentions of the explosion, or at least the questioning and problematizing, of buildings became the norm in what was called deconstructivist architecture. The movement toward parasites, invaginations, and other creepy invasions of rational practices and modes of representation became, in other words, a style. Nowhere was this clearer than in the work of Daniel Libeskind, whose *Micromegas*, black-and-white ink drawings of crowded fields of architectural fragments, did not even allude to any one project. With the precision of somebody trained not only in architecture but also in music and philosophy, Libeskind argued for many years that to build was to commit a crime—not in the productive sense of Tschumi's murder, but in the sense that

Lebbeus Woods, drawing from *Centricity*, 1987 (Estate of Lebbeus Woods).

any building was a repression of freedom, a pact with the capitalist devil, and so riven with internal contradictions that it could not stand the test of criticism, even if it managed to withstand gravity. Yet, as soon as he began receiving commissions, he completely abandoned this position and proceeded to spin one particular explosion of diagonal planes he devised in the early 1980s out into shopping malls, apartment buildings, museums, and any other program he was asked to fulfill, each time claiming that it was the representation of a Hebrew letter or phrase that gave meaning to the design.[58]

Such salesmanship did not go unnoticed by large practices, and soon they were following the deconstructivists in composing sharded designs that were often no more than facade effects. There were only a few of the original deconstructivists' students, such as Hani Rashid and Greg Lynn at Columbia, Raoul Bunschoten at the Architectural Association, or Andrew Zago (who had penned the *Micromegas* with Rashid) in Los Angeles, who, at least for a while, continued this kind of paper architecture.

There were, however, two architects who had been working in this mode for a number of years and were just as inspirational for several generations of architects. They built almost nothing: John Hejduk, Vidler's predecessor as dean of the Cooper Union School of Architecture in New York, built only a few houses and apartment buildings, while his faculty member and friend, Lebbeus Woods, built nothing that you might think of as a habitable building. Hejduk's early work, before he turned to the masques described in the last chapter, had the elusive and slippery qualities that made him, also in his positon of authority, into a St. John the Baptist of deconstructivism.[59]

While Hejduk's work has been discussed in the last chapter, the master of the making of allusive allegorical worlds was Woods. After working for several years in New York on corporate projects, he retreated in the 1970s, first to the production of renderings for other architects, then to the inventions of his own realities. His first complete project, *Centricity*, of 1985–1986, evoked an urban agglomeration that resembled nothing so much as a refinery, albeit a ruined one.[60] Its structures consisted of bulbous, curved, and cantilevered towers and turrets, interconnected by ramps, bridges, and stairways, that grew out of a ground that he, like Zaha Hadid, drew as an extension of the paneled facades of the buildings—or the other way around. It was a version of the monster leviathan

Lebbeus Woods, drawing from *Underground Berlin*, 1988 (Estate of Lebbeus Woods).

that merged with the landscape, a vision of River Rouge imagined in a science fiction film. In the pencil drawings, it was difficult to tell where human and natural landscapes gave way to each other, and the very materiality was in doubt—though steel plates, rusted and cobbled together in imprecise ways, seemed to be implied. Often shown in the same extreme and skewed perspective that Hadid and Tschumi favored, the bits and pieces of *Centricity* and similar projects of the early 1980s had the quality of a new civilization rising out of a ruined landscape, either in a sci-fi future or an unknown past the architect had discovered.

In the following years, the main body of Woods's drawings, most of which were as small and dense with pencil lines as Hadid's were large and abstract, concentrated on a series of three possible sites. The first, *Underground Berlin*, of 1988, imagined a collective that had taken to reinhabiting the underground railroad stations and lines that had been cut and abandoned when Berlin was divided in 1961. The cylinders they found and transformed into spheres or cocoons became gyrating spirals that jutted out into chairs and stairs evoking not only the *Carceri* of Piranesi, but also the insides of spaceships as they were being shown in sci-fi movies at the time. Woods said that the people in this hidden world under Berlin, who might already be there and at work but undetected, were studying the energies of the earth and calibrating them to human energies to create a more harmonious society.

By the *Aerial Paris* project of 1989 this group of collage scientists had burst out of the ground through a warship of diagonal thrust Woods showed exploding out of the Alexanderplatz, sending rays and tendrils into the surrounding landscape. They then had escaped—or would escape, in the uncertain time frame of his project—to France, where they tethered themselves to such structures as the Eiffel Tower and floated on air currents, harnessing solar and kinetic energy to live their free lives. The *Aerial Paris* project was full of gauzy hope and open skies through which fragments of human beings and their constructions floated in freedom.[61]

This anarchitectural quasi-utopia proved as ephemeral in Woods's commitment as it was in its evocation. After spending time in the war zones of the former Yugoslavia, Woods drew *Architecture and War*, a set of drawings that showed the buildings of Zagreb and Sarajevo not so much inhabited or fixed up by architects and anarchitects as being destroyed and rebuilt at the same time. Anarchitecture was, in good deconstructivist fashion, an

Lebbeus Woods, drawing from *Underground Berlin*, 1988 (Estate of Lebbeus Woods).

act of spacing that was as much an unbuilding and carving into certainty as it was the elaboration of architecture into possible other worlds.[62]

Woods continued to explore these contradictions in projects such an examination of San Francisco after, during, or perhaps even before a major earthquake. Here the landscape became even stronger than what might have seemed to be buildings. All Woods showed was shifting planes, lines that implied energy released or compacted, layers of construction and destruction, and, somehow, a coherence of forms emerging out of all these drawings. His work after this became more geological in its nature, even as he pursued building fragments of his vision as full-scale fragments.[63]

The power of Woods's work was the way it was, first, so beautifully and meticulously drawn as to be utterly convincing. After a career of selling standard buildings to developers and other clients, Woods now sold possible worlds with the same verve. They borrowed explicitly from both architecture history and popular culture, exploding with the energy of movies, advertisements, and the urban fabric itself while imploding with the types and models architects have tried to use to control these forces, with facades, progressions of spaces, and composition.

Beyond that visual pleasure, the work was able to evoke so many possibilities because none of the allusions were direct. Woods rejected the notion that he was producing a sci-fi architecture, calling it "experimental" instead. He also did not copy any of the models he used, even though his knowledge of architecture was encyclopedic. Instead he wove together allusions and illusions into a landscape that resembled lived experience just enough to be believable as a new way of seeing that reality in a manner that revealed what had already been there. This was especially true in a New York that was, when Woods did most of his classic work, still reeling from severe economic problems while being confronted with massive redevelopment, not to mention in the war zones Woods visited. A new world was being constructed, but the old one refused to give up, and all became interwoven in a manner Woods drew out in his skeins of colored pencil lines. If there ever was a visual elaboration of deconstructivism, it certainly can be found in the drawings of Lebbeus Woods. If there ever was a set of drawings that evoked what the monster leviathan could be as an actual construct, however impossible to build and mythic in nature—as anarchitecture—it is to be found in the projects of this architect.

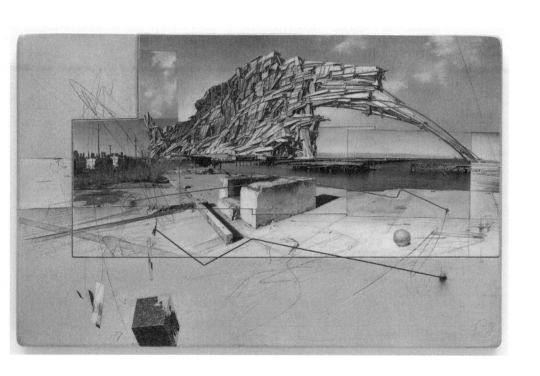

Lebbeus Woods, drawing from *San Francisco Project*, 1995 (Estate of Lebbeus Woods).

7 *Myths and Datascapes*

As well as for Lebbeus Woods's anarchitecture, New York was the inspiration for a number of other architects during this period. The most prominent among these was the Dutchman Rem Koolhaas, who spent several years there studying at the research facility and school Peter Eisenman had set up, the Institute for Architecture and Urban Studies.[1] While there, Koolhaas produced what he called a "Retroactive Manifesto" for what the city was, or could be, or at one point might have become. Entitled *Delirious New York*, it became the most concrete model for a post-structuralist architecture and, along the way, turned Koolhaas into the single most influential architect of the late twentieth and early twenty-first century.[2]

Delirious New York is ostensibly a research study of certain phenomena that caught Koolhaas's attention. These included such basic issues as the city's grid and such important buildings as Rockefeller Center and the UN Building, but also the amusement park in Coney Island, the interior of the Waldorf Astoria Hotel, and a rather minor skyscraper of which Koolhaas, with a strong interest in exercise and the male body, was particularly fond, the Downtown Athletic Club. By weaving together analysis of these spaces, along with drawings created by his wife and collaborator Madelon Vriesendorp, he evoked a mythic New York. In the final chapter Koolhaas, following rather self-consciously in the footsteps of Le

Corbusier and Robert Venturi, among others, then presented his and Vriesendorp's (and their students' and other collaborators') proposals for continuing some of the themes and forms he had unearthed and at least partially invented.

The book's cover was itself a summation of much of the work. The Empire State Building and the Chrysler Building, one-time rivals to be the highest building in the world, are shown horizontally, in bed. They are not only prone, but they are also animate, with soft edges and some of their features distended to appear almost human. A used condom, drawn to resemble one of Salvador Dalí's soft watches, makes clear what they have been doing; the Empire State Building's tip still glows red. Other fragments of New York dress the scene: the carpet is a map of the city, with Central Park sliding under the bed. The Statue of Liberty's arm, removed from its body, has taken a reverse course of the buildings' trip to animation by becoming an object: a bedside lamp. The memory of how she once lit the way to democratic shores is illustrated in a painting hung behind the bed. The city itself lies outstretched beyond the grid of the window, which is itself a fragment of a studio Le Corbusier designed for his friend Ozenfant. Skewing the scale, the RCA Building of Rockefeller Center peers in, shining a spotlight on the sated couple.

As a pendant to Wright's image of Chicago, the *Delirious New York* cover offers a version of the workshop of democracy turned into a coupling, perhaps illicit, and certainly perverse and surreal in its elements. Rather than smoothing over the differences between human beings, machines, urban fields, and printing presses, Koolhaas, Vriesendorp, and their collaborators have expressed each of them in an impossible collage of readymade fragments only slightly altered and elided but transformed through the frame of the painting into a portrait of a possible city as performance piece or comedy-of-errors stage set whose believability belies its absurdity. History repeats itself as a salacious joke.

The strength of the book's rather rambling text is to elaborate that image in a manner Wright never bothered to do. Koolhaas does this by posing explicitly what Wright had only intimated: that he was describing or evoking not a real city but the essence, mythic proportions, or possible past or future qualities of a section of New York, to wit, Manhattan: "Manhattan as conjecture of which the present city is an imperfect realization."[3] He calls the quality or phenomenon "Manhattanism," which he says is "to

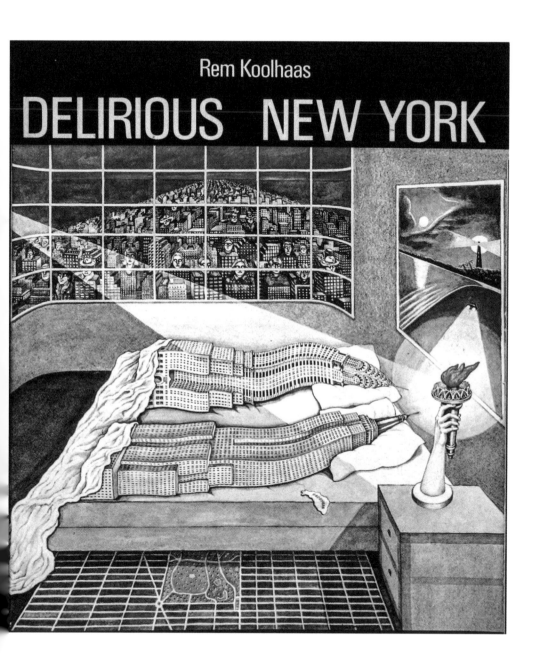

Delirious New York, 1978, cover art by Madelon Vriesdendorp (courtesy of OMA).

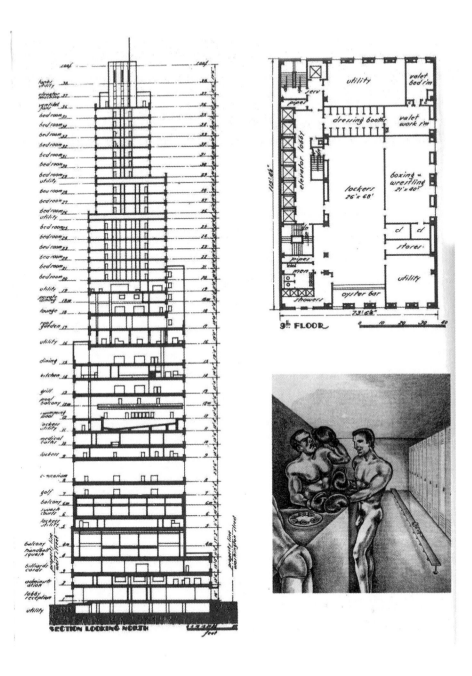

Madelon Vriesendorp, Downtown Athletic Club, illustration for Rem Koolhaas, *Delirious New York: A Retroactive Manifesto for Manhattan*, 1978 (courtesy of OMA).

live inside fantasy." He offers the conjecture that a-Manhattan, to extend Gordon Matta-Clark's evocation, should exist because of what he believes it contributed to the development of architecture:

> Especially between 1890 and 1940 a new culture (the Machine Age?) selected Manhattan as a laboratory: a mythical island where the invention and testing of a metropolitan lifestyle and its attendant architecture could be pursued as an experiment in which the entire city became a factory of man-made experience, where the real and the natural ceased to exist.[4]

"The city," he goes on to say, "is a catalogue of models and precedents: all the desirable elements that exist scattered throughout the Old world finally assembled in a single place."[5] "I was Manhattan's ghostwriter," he concludes.[6]

What Koolhaas then catalogs is this version of Manhattan as exactly a collection of what was already present around the world. He chooses to concentrate, however, on several salient characteristics that make the island as it developed since the arrival of Western colonizers of particular interest. The first and foremost of these is the grid, laid out after the report of a group of Commissioners issued in 1811 that foresaw the rational development of the city across the hilly, sometimes marshy, but bounded terrain to the north of the original settlement. Koolhaas calls it "a utilitarian polemic."[7]

The grid did more than just unlock the landscape for real estate development, however. For Koolhaas, it was what the grid made possible within each block that is of particular interest. The geometry of the streets is just a background; what it produces is a boundary, later extended ever higher into the sky, that concentrates activities, often of a heterogeneous sort, in an unstable container. The grid produces in the block the most intense social mixer and condenser of any urban situation: "It develops a maximum of urbanistic Ego."[8] "The Grid's two-dimensional discipline," he points out, "also creates undreamt-of freedom for three-dimensional anarchy. The Grid defines a new balance between control and de-control in which the city can be at the same time ordered and fluid, a metropolis of rigid chaos."[9]

The essence of that Manhattanism is the mixed-use skyscrapers that were completed in the late 1920s and early 1930s, ranging

from the McGraw-Hill Building ("the fire of Manhattanism inside the iceberg of modernism")[10] to the Waldorf Astoria Hotel, a kind of built Hollywood movie[11] with its fantasy landscapes of stores, restaurants, bars, and ballrooms; the Downtown Athletic Club, whose gym-going inhabitants worked out, he says to become Manhattanites;[12] and, above all else, the Chrysler and Empire State buildings.

All this reaching to the skies and mixing and condensing finally culminated in Rockefeller Center, which exploded beyond the block to colonize a whole section of the grid, while decomposing that original geometry's rigid directions and, in its underground shopping arcades connected to the city's subway system, oozing into a machine of connection: "Rockefeller Center is the fulfillment of the promise of Manhattan. All paradoxes have been resolved. From now on the Metropolis is perfect."[13]

It is not just the perfection and its sign, the grid, that make Rockefeller Center such a summation. It is also that it maintains and shelters within its "womb"[14] the fantasies that Koolhaas claims were first developed in the rides at Coney Island and were then installed in Manhattan. There they took the form of all the pipes, telephones, and air conditioning equipment that turned the interior of the block into a fantasy world of technological connections breeding endless possibilities and artificial realities.[15] That, at least, was its overt transformation. For Koolhaas, the Coney Island importation also brought with it the secret and even illicit fantasies which lived on in the nightclubs, theaters, and later movie theaters that architects installed at the heart of the skyscrapers. It brought the obscene other into the heart of Manhattan. Of these the giant Ziegfeld Theater, with its sun rising at every performance and its Rockettes becoming human robots in the elaborate choreography of their shows, was the summation.[16]

For Koolhaas, the architect and renderer Hugh Ferriss is the hero of this tale of assimilation and hybridization between the utmost logic and the most extensive fantasy. Ferriss drew versions of Manhattan in charcoal, abstracted and extended into a future where not only would the skyscrapers reach prodigious heights and sizes, but roads and thus the grid would crisscross in the sky, while each block would be hollowed out to allow for the sort of dream metropolis Koolhaas recognized as latent in the actual city. In Ferriss's work, the writer recognizes a city transformed into a new kind of nature, where "the mountain must become

Hugh Ferriss, *Buildings Like Mountains*, 1924 (courtesy of Avery Library).

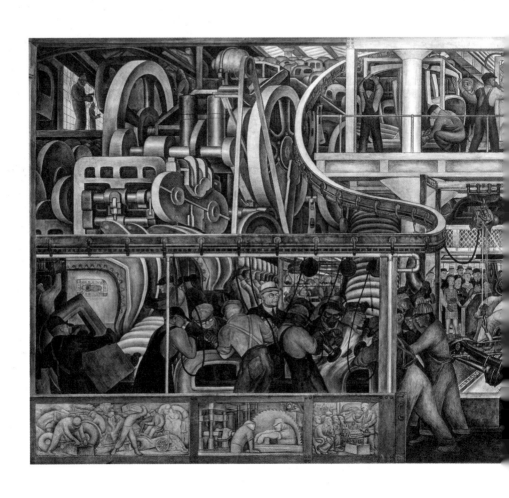

Diego Rivera, *Detroit Industry*, south wall, 1932–1933 (© 2022 Banco de México Diego Rivera
Frida Kahlo Museums Trust, Mexico, D.F. / Artists Rights Society (ARS),
New York).

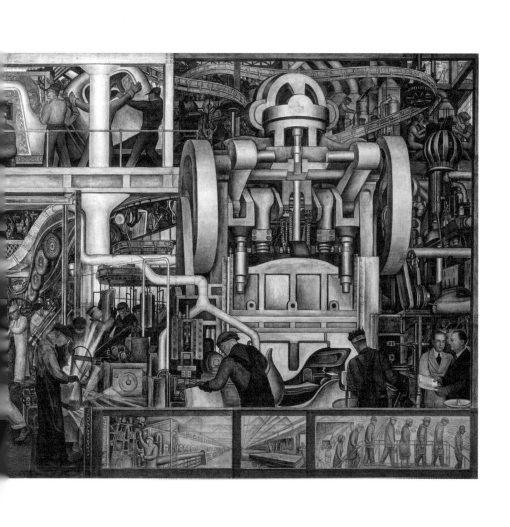

architecture."[17] For Koolhaas, if you squint at Manhattan, perhaps at night, you can see that reality already existing, and if you go see a science fiction film in one of its cavernous theaters, Manhattanism envelops you.[18]

Before this triumphal conclusion, Koolhaas does note the presence, literally repressed by being painted over, of another possible destiny for Manhattanism. While Rockefeller Center was under construction, its patron, John D. Rockefeller III, had commissioned the Mexican artist Diego Rivera to create a mural for the lobby of its centerpiece, 30 Rockefeller Plaza, which came to be known as the RCA Building. In *Man at the Crossroads*, Rivera created a vision of industry, commerce, and all other aspects of metropolitan life intersecting and leading to a glorious and productive future. That destiny, however, involved a transformation of the political system into communism, duly noted through portraits of Marx and Lenin on the walls and the depiction of the evils of factory work. It was too much for Rockefeller, and the mural disappeared before the lobby could open to the public.[19]

To get a sense of what that mural looked like, you have only to go to Detroit, at the time the fourth largest metropolis in the United States and the home of its automotive industry. There, in 1932–1933, Rivera painted an even more inclusive version of the United States as a place where labor, industry, agriculture, and all other human enterprises came together to form a tapestry of human life that existed only within the diagonal lines of technology, though it had its roots in a fruitful soil and was obviously riven by conflict.[20] Pipes and levers, workers pulling those devices, machines and buildings, human beings inhabiting and creating those structures, and assemblies of both humans and what they made were layered over the implied grid of the Detroit Art Institute's walls and ceilings on which Rivera laid his integrated vision. This was the monster leviathan as the artist saw it existing in the factories, fields, office buildings and grids of Detroit and beyond. The mural promised a United States of collaborative building that, thanks to the achievements of the labor unions and the economic forces unleashed by the Second World War, for a short period would seem possible.

Rivera's art remained just that, even if its Midwestern patrons allowed it to remain on the walls. It was a picture, without the ambiguity of either Wright's words or the implications and intimations Koolhaas teased out of Manhattan. To make the mythic

Chapter 7

Elia and Zoe Zenghelis, *Hotel Sphinx*, illustration for *Delirious New York*, 1978 (courtesy of OMA).

Marlon Vriesendorp, *The Arrival of the Pool*, illustration for Rem Koolhaas, *Delirious New York*, 1978 (courtesy of OMA).

concrete means to destroy it. That does not mean, however, that you cannot continue to evoke it in architecture—as long as you do not build it. At the end of *Delirious New York*, Koolhaas and his collaborators, including Vriesendorp, Elia Zenghelis, and others, imagined a series of projects that would unearth and extend a-Manhattan. These included the *City of the Captive Globe*, "the capital of Ego, where science, art, poetry and forms of madness compete under ideal conditions to invent, destroy and restore the world of phenomenal Reality."[21] A hybrid structure straddling the center of Manhattan, it is an "incubator" in which you can see traces of all the great buildings Koolhaas revered, but here abstracted into an eroded three-dimensional grid that revealed bits and pieces of its active imagination.

Other projects included the *Hotel Sphinx*, a new hotel for Times Square that presaged the vast structures designed by the likes of John Portman and Arquitectonica that rose there several decades later. Though Koolhaas's Hotel was more animated, the scale of the new buildings of Times Square, with the screens of scrims and neon signs and their atria overlooked by countless bars and rooms, came closer to expressing the vision of a fantastic womb at the heart of the island than Koolhaas was able to create.

Then there was the transformation of parts of the East River into *New Welfare Island*, mixing residential structures and Coney Island-like rides—again later made real in the development of Roosevelt Island, complete with its tram, its towering apartment buildings, its educational condenser designed by Morphosis, and its monument to Franklin Delano Roosevelt, completed in 2012 to designs by Louis Kahn.[22] An explicit home for welfare recipients was also intended to mix different classes, but that structure remained fantasy.[23]

The most exotic of the structures Koolhaas and his fellow designers proposed was a gridded pool, which they showed in exaggerated perspective moving toward an idealized Manhattan filled with their own structures. Here the author told a story of a group of Soviet scientists, exiled to Siberia under the communist regime, who built this structure and, through synchronized swimming that would put the Rockettes to shame, swam the whole floating slab toward the idealized freedom of New York. Here human beings, machines, architecture, and fantasy again merged into an image that floats in front of our eyes, promising freedom through and in technology.[24]

Before coming to the United States and devising *Delirious New York*, Koolhaas had developed an even more extreme mythology for his 1972 thesis project, a mythology of London he called *Exodus, or, The Voluntary Prisoners of Architecture*.[25] It told the story of a London that had decayed even beyond the dire state the author found it in when he was studying there, to the point that a group of people had created a walled enclaved, which they called the Good Half:

> Once, a city was divided in two parts. One part became the Good Half, the other part the Bad Half. The inhabitants of the Bad Half began to flock to the good part of the divided city, rapidly swelling into an urban exodus. If this situation had been allowed to continue forever, the population of the Good Half would have doubled, while the Bad Half would have turned into a ghost town. After all attempts to interrupt this undesirable migration had failed, the authorities of the bad part made desperate and savage use of architecture: they built a wall around the good part of the city, making it completely inaccessible to their subjects.

The result was the emergence of architecture that at first seemed utopian:

> Suddenly, a strip of intense metropolitan desirability runs through the center of London. This strip is like a runway, a landing strip for the new architecture of collective monuments. Two walls enclose and protect this zone to retain its integrity and to prevent any contamination of its surface by the cancerous organism that threatens to engulf it. Soon, the first inmates beg for admission. Their number rapidly swells into an unstoppable flow. We witness the Exodus of London. The physical structure of the old town will not be able to stand the continuing competition of this new architectural presence. London as we know it will become a pack of ruins.[26]

Yet this was not a place of pure pleasure. It was a machine that at its "Tip" devoured parts of the Bad Half with great violence. It also subjected its own inhabitants to controls and was merciless: instead of a hospital, there was an Institute of Biological

Rem Koolhaas, *Exodus, or, The Voluntary Prisoners of Architecture*, 1972 (courtesy of OMA).

Transactions, where euthanasia was the answer to senescence. Not only that but, as the title implied, "the inhabitants of this architecture, those strong enough to love it, would become its Voluntary Prisoners, ecstatic in the freedom of their architectural confines." In that very violence, Koolhaas found pleasure as well:

> Contrary to modern architecture and its desperate afterbirths, this new architecture is neither authoritarian nor hysterical: it is the hedonistic science of designing collective facilities that fully accommodate individual desires. From the outside this architecture is a sequence of serene monuments; the life inside produces a continuous state of ornamental frenzy and decorative delirium, an overdose of symbols.[27]

What Koolhaas drew (again, with the help of his wife and friends) was a version of the Superstudio grids taking over London. Within the wall, which was a long plinth, he carved out major spaces, ranging from a Reception Area to a Ceremonial Square, which was a kind of Kaaba separated off from the rest of the world. There were places of control, but mainly the grid produced, like his mythical version of Manhattan, moments of great hedonism. These were concentrated in parks and in the Baths, which were giant versions of the kind of sex clubs and baths he must have explored in London and Amsterdam at the time.

The logical outcome of the modern metropolis to Koolhaas was this kind of controlled hedonism, which had sadomasochistic overtones: one had to give oneself over to the machine, like the Wall Street executives working out in the Downtown Athletic Club or the denizens of certain clubs in Soho or the West Village, in order to experience the complete satisfaction of the body. This was true also on a social level, where the freedom of social spaces could only exist within the grid and fed by technology that would create air and water that would feed our sensual delights.

The monster leviathan was, in other words, not a place of production where human beings, machines, and urban structures became intertwined and merged, but rather a place more like Constant's *New Babylon*, where that merger happened in the pursuit of pleasure. Mankind might be witnessing its own self-destruction as an aesthetic pleasure of the highest order, but they were doing so actively, in an orgy.

In the years following his return to his native Netherlands, Rem Koolhaas set out to turn this orgy within a grid into a built reality. To do this, he founded a firm, the Office for Metropolitan Architecture, based both in Rotterdam and London. Collaborating with Vriesendorp, Elia Zenghelis, a young Zaha Hadid, and others, Koolhaas began entering competitions and creating theoretical projects that would embody this form of mythic architecture.

Remarkably, he won one of the first of these with the office's proposal for an addition to the Dutch Houses of Parliament. The 1978 brief had called for the insertion of an array of new and extended functions into the amalgam of structures, some of them dating back to the Middle Ages, that make up the Parliament's site. OMA responded not with a singular strategy, but rather with fragments from the *Exodus* and *Delirious New York* projects, slicing and sliding through the existing structures. Extending the connective tissue of Rockefeller Center, passageways and underground plazas connected the fragments. Asserting he hopscotch nature of the area, OMA heightened that variety with forms whose grids, bright colors, and honed materials asserted the place of modernity within the complex.

OMA rendered the project in three-dimensional projections that, like the team's other work, managed to translate the grids and machine imagery they were actually presenting into something that had the soft and alluring presence of a kind of pop structures its audience might by then be familiar with from the graphics used by groups such as the Beatles, or from the comics that were the inspiration for so many other architects and artists at the time. Those skewed perspectives in soft colors had the effect of making the collection of fragments make sense, even as they blew open the structures they were meant to enhance. Despite OMA winning the competition, the radical nature of the design was such that the Parliament soon turned to more staid and lumpen alternatives.[28]

OMA went on to produce related projects such as their proposal for the reuse of one of the most complete panoptical prisons in the world, Arnhem's "koepelgevangenis." In these drawings as well, they showed the roof floating off, the ground opened up with passageways, and fragments and grids tying the existing building together while allowing new functions to penetrate through its forms.[29] A project for an office building near their Rotterdam headquarters on the Maas River turned into urban fragments akin

to the New Welfare Island scheme. They showed the city itself fading into a grid, allowing slivers of towers, a bridge reimagined as a place of pleasure, and other urban additions to dance through the shadows of the metropolitan scene.

None of these projects were built, though a housing project in the northern area of Amsterdam and a mixed-used project in that city's heart were constructed. Yet their impact was immense exactly because they remained as evocations. What the drawings, like the text of *Delirious New York* and *Exodus*, could propose was another metropolitan architecture, one that fused and tamed technology and hedonism into a culture of fragments that drew as much on the logic of film, television, and music as it did on the knowledge of the discipline. Koolhaas, who had trained as a filmmaker before switching careers, was one of a group of designers that also included Hadid and Tschumi who brought popular culture and in particular the collage, fast pace, and irreverence of advertising and action movies to the profession. To a large extent, that was metropolitan architecture, they argued. This explosive, fragmentary narrative infused by machines and jump cuts already infused the city scene. It was up to architects to selectively build fragments of it, taking care to leave the forms open-ended and vague enough to allow the Voluntary Prisoners to imagine their own pleasure within its partial confines.

Koolhaas, like a good ad salesperson, became a master of the catchy phrase and image, whether it was his domes floating off into the air or his pool swimming through the Atlantic, or his assertion that both content and context were something to be invented. He went on to lead massive studies of metropolitan areas such as the Pearl River Delta and Lagos, as well as of such phenomena as shopping and the transformation of agricultural land by technology.[30] In all this work, he did not focus on the definition of solutions, whether in form or in a theoretical position, but rather saw himself as surfing the tides of modernity, finding its rhythms and delighting in both its pleasures and its pains. Without judgment, he sought to capture, highlight, extend, and turbo-boost the realities of the late twentieth- and early twenty-first-century world. He even extended his forays into national identity, designing a flag for the European Union, and into corporate consulting, acting as a kind of glorified brand consultant for the fashion company Prada and the media conglomerate Time Life.[31]

That is not to say that the Office for Metropolitan Architecture did not seek to obtain commissions and build. One of their first major projects to be constructed managed, better than any of their subsequent works, to capture some of the excitement, pleasure, and terror they evoked in their theoretical work. Called Euralille, it is an eight-million-square-meter urban district built around the new station for the high-speed train between Paris, Brussels, and London. The French authorities saw the then-new mode of transport as a catalyst for the transformation of the postindustrial city of Lille, and OMA designed not just a train station that evoked the soaring spaces of the nineteenth-century prototypes, but then office buildings, apartments, hotels, a congress center, a shopping mall, and a host of ancillary programs.

The crisscrossing walkways here became roads and viaducts, amping up their scale to something that seemed almost too big for Lille. Lines of blocks, abstractions of a modernist vision of apartment living, marched across what had been a miasma of streets and buildings. An ovoid congress center swung through the space, its seemingly thin roof extending on equally slender pylons and its facades sliced open to invite entrance. An L-shaped hotel balanced on top of a glass box. Everywhere you looked, your view of both the project itself and the surroundings was cut up, fragmented, and recomposed at a larger scale. Though many of the buildings themselves were banal and badly detailed, OMA here achieved a fragment of an almost mythic metropolis in a manner that approached their drawings.[32]

Once it was built, however, it became just another megaproject. That, in fact, was the fate of all of OMA's work, even its most successful and largest structures. Once constructed, they fixed the grids, the possibilities, and the collage into place, killing the open-ended liberty and the implied hedonism that still existed in the mythic project. Only at the small scale of such intensely involuted projects as the 1992 Rotterdam Kunsthal and the Dutch Embassy in Berlin of a decade later were they able to hint at what might be possible if a truly unstable, violent, and sadomasochistic modernism could be built.

Koolhaas's other contribution to architecture, however, turned out to exist at another level. Though he exercised an outsized influence on what was meant to be a cooperative office, he had an uncanny knack for finding people from outside the profession who

were able to extend his vision through interiors, landscapes, and modes of communications. These included, over time, the artist Joep van Lieshout, who built a temporary commune in the Rotterdam docklands and proposed a kind of extreme version of the Exodus project as a slave colony in Antwerp;[33] the model maker Vincent de Rijk, who pioneered a way of building models out of colored resin that extended the instability of communication from drawings into physical dimensions; the furniture designer Richard Hutten, who condensed the playful forms and fragmented grids into ritualistic assemblies for everyday life; the interior designer and landscape architect Petra Blaisse, whose gauzy curtains became central to the instability of many of the firm's most successful works; and the photographers Bart Princen and Iwan Baan, who extended his sensibility and its operatic grandeur into the way the projects appeared in print. This loose collective went on to devolve and spin off into many other areas of design, bringing with them the OMA sensibility of a hedonistic myth of technological modernism.

The same was true of the many talented people who worked at OMA. The most prominent offspring of the firm include the Dutch firm MVRDV and the Danish BIG. MVRDV is of particular importance to the development of the monster leviathan. By now a firm that approaches OMA in size, it was founded by Winy Maas, Jacob van Rijs, and Nathalie de Vries. Although only Maas had worked for OMA, their early work, most notably the headquarters of the progressive Dutch broadcasting company VPRO, extended and hyped up OMA's methodology to a remarkable degree.

What has marked MVRDV's work from the first designs they completed to their best current projects is the ductility of space, form, and image that act as building blocks of a monster leviathan-like version of a human-made environment. The difference from the work of previous generations of designers who sought to evoke a monstrous and living city whose borders and flesh were so woven into the fabric of daily life that we as humans dissolved into its cellular forms is that this firm has based their visions on the digital. In their work, the ability of the computer to reduce all data to zeros and ones, and then to build structures out of this reduction that are not hampered by many of the physical boundaries and distinctions that form our legacy world, has led to both globe-spanning speculations and the production of small monsters or buildings.

Atelier Van Lieshout, *AVL Ville*, 2000, watercolor on paper (courtesy of Atelier Van Lieshout).

Daniel Lee, *Manimal*, cover for Ben van Berkel and Caroline Bos, *Move* (courtesy of UN Studio).

To a large extent, both OMA and MVRDV are able to achieve this no-nonsense fluidity because they are building on a Dutch tradition. The reduction of all physical reality to data has its roots in Cor van Eesteren's 1934 plan of Amsterdam,[34] while the notion that all of reality can be endlessly manipulated by human hands to create both living hybrids (in plants and animals) and a perfected reality goes back, at least according to some art historians, to the formation of an independent Dutch culture in the sixteenth and seventeenth centuries (the so-called Golden Age). Above all else, however, the reality of the Dutch landscape, which is largely an artificial one that has been made by human beings out of reclaimed sea, swamp, and lakes, and that is continually being remade as a three-dimensional puzzle by an intricate structure of governmental agencies and designers, has allowed MVRDV and others to think of the possibility of that "makeability," as the Dutch call it, growing into a globe-encompassing, data-driven realm.[35]

MVRDV were certainly not the only ones in the Netherlands to pick up on those possibilities. Starting in the 1990s, architects working from different approaches, ranging from Lars Spuybroek and Kas Oosterhuis, who developed fully digital and fluid forms, to OMA itself, to Ben van Berkel and Caroline Bos, who reshaped themselves into UN Studio in 1988, developed both buildings and theories based on the malleability of reality through digital means.

In 1999, van Berkel and Bos published their collected work in a three-volume book called *Move*.[36] Its slipcover showed none of the buildings and projects the firm had designed in the preceding decade, but instead a fictional animal that their computers had produced by using "morphing" software to combine human and animal images. This monster was meant to be the figurehead of the firm, giving a face to what they intended to be an open collaboration between designers and technicians with various areas of expertise.

The architects based their projects, or so they claimed, on the twin ideas of liquid architecture and deep planning. "The ways in which the world is organized have liquefied on many levels," they claim in the first volume:

Systems comprising politics, economy, demographics
and the natural sciences are increasingly thought of
as amorphous and lawless assemblages of energetic
principles lacking clearly delineated borders. The study

of living organisms generates understandings that apply equally to economic regimes and to the development of urban settlements. The transformation of the democratic western culture of nations into a system of denationalized processes is paralleled by a similar paradigm shift in the way we regard the body, where chemical processes take the place of organs as the prime constituent. As different thought systems infiltrate each other, presumed stratified orders disappear on many levels. Inherent energetic forces shape all organizational structures. Structures no longer represent homogeneous, linear systems, but process fields of materialization. These are based on spatial and material devices and their dissipative nature allows energies incorporating genetic, chemical, economic, cultural and political information to flow in and out.[37]

The response, they say, should be a "liquid architecture." This does not necessarily mean the production of "fluent, melting shapes," although that is what the firm has become known for in the two decades since this text appeared. Rather, they claim it is the ability to "access remote and complex situations by combining specific knowledge and visualizing techniques" that matters.[38] They then combine this technique with "deep planning," which they describe as "using combinations of digital techniques, an integral approach to projects combining infrastructures, urbanism and various programmes have been developed."[39] This "involves generating a situation-specific, dynamic organizational structure plan with the aid of parameter-based techniques."[40] The approach is similar to what economists and other scientists do to plan for ordered growth and development. The difference is that the architect does not optimize for all these forces, say van Berkel and Bos, but rather uses it to "generate potentials."[41] "Structures emerging in this way," they conclude, "operate through living forces at physical and public levels; they are performance envelopes. They are in motion as long as those forces are in motion and contain no hidden meaning independent of those forces." What deep planning and liquid architecture achieve, in other words, is the channeling of otherwise invisible and abstract forces, which operate at many scales and in many situations, into form.[42]

Van Berkel and Bos call this result not form or shape, but effect: "Effects are manifestations of the phenom [sic], which includes

sensory experiences of the external world, experiences of the inner world, such as fantasies and ideas and, finally, experiences or emotion or affect."[43] The architecture they are after is a synthesis that evidences itself as "a vivid awareness that is rhizomatically connected to a multitude of properties."[44] Although this would seem to imply architecture that would be ephemeral, collage-based, and truly fluid in form and image, van Berkel and Bos then tie their work to a limited range of topological effects, such as the Siefert Surface and the Moebius Strip. The chimeral architecture that would blend emotions, apperceptions, and experiences into a continually changing and growing set of effects disappears into surfaces that lead back into each other. In their early work, the firm proceeded to build several structures that displayed such effects, such as the 1998 Moebius House and the 2006 Mercedes-Benz Museum, while also exploring facade effects that would change continually, as in the La Defense building in Almere of 2004,[45] but in later works they contented themselves with styling large buildings with curves. Only the Arnhem central train station, conceived in 1996 but not completed until 2015, is a true proof of concept. Starting from a central "knot" of concrete that is both a structural post and a connection between the underground parking garage, a massive bicycle garage, and the outside plaza and inside hall, the structure curves out to encompass these spaces as well as the platforms, a bus station, retail, and three office buildings that rise up out of swelling canopies covering the station's main spaces.

MVRDV began their career with a structure that carried on the mode of making that one of its partners, Winy Maas, had learned as a project architect at OMA.[46] The Villa VPRO is remarkable because of its acts of elision, not only between functional spaces but between ground and building, as well as elision of hierarchies. You enter the structure, which houses the headquarters for the country's progressive broadcast company, through the parking garage, and the floor of that facility flows without interruption into the reception area. There, the concrete curves up, inviting you to clamber up past a yard sale chandelier and equally nonmodern desk to the main office floors. As you spiral up through those spaces, you never encounter any obstruction to your movement until you arrive at the top, which is an outdoor terrace. At no point do you have a sense of having entered or left the building (beyond passing through glass doors), and there is no sense of hierarchy within its spaces. The materials are all simple—concrete, glass, and

MVRDV, Costa Iberica, 1998 (courtesy of MVRDV).

wood frames—and the furniture was originally gathered together from storerooms and existing offices. The Villa VPRO is not so much a building as it is a momentarily fixed flow in which various functional elements float.[47]

Having developed several structures in such a liquid architecture mode, MVRDV set out to theorize their practice in such books as *Metacity Datatown*, based on an exhibition they organized in 1997, and the more expansive *KM3*,[48] as well as in specific proposals for the Costa Brava in Spain[49] and the Ruhr valley in Germany.[50] Each of these speculative studies proposed a radical revision of spatial arrangements, in which the digital manipulation of economic data, population statistics and projections, and a host of other information about what our currently reality might be if you reduced it to statistics, and what it might become, led them to propose rearrangements of all the elements of that world in three dimensions.

The architects describe the working area they have chosen as the "metacity," a connected urban expanse that has replaced the notion of the global village and operates as much in the ether of computer memory as it does on the ground. Its characteristics are concentrated ways not only of living and working, but also of providing agriculture and even forms of leisure, as all forms of human activity are rationalized and tied together.[51] "How to study this Metacity?" they then ask, answering:

> Initially, one can describe its vastness and explore its contents perhaps only by numbers or data. Its web of possibilities— both economical and spatial—seems so complex that statistical techniques seem the only way to grasp its processes. By selecting or connecting data according to hypothetical prescriptions, a world of numbers turns into diagrams. These diagrams work as emblems for operations, agendas, tasks. A "datatown" appears that resists the objective of style. One way to study the world of numbers is through the use of "extremizing scenarios." They lead to frontiers, edges, and therefore to inventions. If we imagine the most extreme state of the Metacity's enlargement of urban conditions—and thus the reduction of available space—new urban inventions might start to emerge.[52]

MVRDV, Metacity/Datatown, 1999 (courtesy of MVRDV).

The "extremizing scenarios" they develop then are what are also commonly known as "what if" scenarios, but they concentrate not only on problems or challenges ("what if agriculture does not pay enough to justify the use of land that is yet necessary to feed an urban region"), but rather on extreme solutions: creating a three-dimensional agricultural field that might include vertical greenhouses and what became MVRDV's most infamous suggestion, a "Pig City" housing the Netherlands' then considerable porcine population in skyscrapers placed on reclaimed land along the coast.[53]

In their analyses, MVRDV quantify as much as they can with rigor and ruthlessness. The amount of space needed to live, work, play, or grow can and is analyzed at several levels, the results then go into the firm's computer servers, their designers convert the data into three-dimensional diagrams, and then the firm manipulates the cubes and rectangles that represent the lives of millions of people, animals, and plants in a number of different scenarios.

The projects they then present as possible outcomes are, despite the firm's protestations, not without style. Not just satisfied to create abstract grids, they scan images of fields of buildings, cows and windmills, and other fragments of "meat space" elements into their datasets, giving the results the aura of being both eminently real and surreal in the juxtapositions between these scanned or constructed (in dataspace) and then collaged elements. Their logic leads them to have a preference for megastructures, either as skyscrapers lining the coast of the Netherlands or Spain, or as horizontal grids that recall Constant's *New Babylon* without its ludic aspects.

This vision of a digital leviathan, outstretched over the whole globe and changing with a few keystrokes to continually accommodate the flow of people, goods, and information, remains one of the most total and pure translations of the notion of the integrated city, productive apparatus, and animate being produced in the twentieth century. Carried out in pure geometries whose rigidity dissolves as the traces of their outlines fade out into being just plotted lines in a graph and are replaced by the recall of reality in scanned-in images of meadows and housing, their Metacity is the ghost of the leviathan, existing now as a rationalized but no less both frightening and alluring memory of that "living tissue" Frank Lloyd Wright had evoked almost a century earlier.

Over the next decades, MVRDV produced a number of projects that built at least small versions of this three-dimensional vision. Though eminently successful at proving their point, their small scale deprived these buildings of their monstrous aspects. In some cases, as in the villa they designed for the chairman of the country's largest bank, they were able to create collages that brought together what appeared to be preformed elements from older grand houses to create a three-dimensional jigsaw puzzle. In their housing project for the new town of Ypenburg, they cut apart the rows of standard Dutch house blocks into snippets they strew across the plot, creating a confusion between front and back, and public and private outdoor spaces. They then clad each of the houses in different materials, from brick to tile to metal panels, applied to all exterior surfaces, so that they appeared like Monopoly tokens in a giant game of economic maximalization—which is what MVRDV felt they were. In the Depot, the open warehouse for the Boymans van Beuningen Museum in Rotterdam, the storage of art becomes the excuse for creating a mirrored interior its designer, Winy Maas, claims evokes the work of Piranesi, while the equally mirrored exterior becomes, for no rational reason, a giant flower pot.

The most successful of all these exercises and attempts to build fragments of their monster Datatown is the small commercial building Maas designed for his hometown of Schijndel. Created to contain a row of shops with offices above, the building anchors the town square of this small agricultural settlement. Maas worked with the photographer Bas Princen to document every structure in the village. They scanned these images in, combined them into what they felt was the archetypal Schijndel building, and blew that result up 120%. The result was then printed on a glass shape that is both a barn and a house, as well as being, of course, a shopping mall. Because the object is transparent, you are never quite sure what is real, where the edges are, or what you are seeing. This abstraction, enlargement, and destabilization of the existing reality and its transformation into a new economic and physical reality promises to be a building block for a future Datatown.

While several other architects have continued MVRDV's approach to data-driven form making ultimately intended to propose not the construction of individual buildings, but a total reorganization of both natural and human-made landscapes in such a manner that the two interpenetrate and become

indistinguishable, while the scales of connections and operations that activate and resolve our daily lives into living, working, playing, and movement become complete flexible and even lose scale completely, few architects have carried out these implications fully. Mainly, they have led to gaming scenarios, whether literally through the steady flow of architecture students trained by Maas and the like into the industry, or figuratively, both through MVRDV's experiments in applying the principles of games in projects such as the Regionmaker, referred to above, or in fellow Rotterdammer Kees Christiaanse's development of an interactive scenario planner that allows developers and municipalities to react to "moves" by architects by resetting and adjusting their planning parameters.[54]

What remains fixed in all these experiments and planning proposals, however, are the traditional elements of architecture. Buildings remain objects, materials remain restricted to concrete, steel, glass, and perhaps some wood, and the allocation of activities stays relatively true to types and scales that have developed over the centuries, even if MVRDV produces interesting warpings and combinations of such elements. The same is even true in games, where, for all the elisions of time and space produced by use of "portals," jumps, and parcours-based uses of building edges, the actual structures and their relationships to the streetscape around them remain traditional.[55]

In 2016, the architect and theoretician Benjamin Bratton, working at the Strelka Institute, a Moscow-based research and development laboratory and school cofounded by Rem Koolhaas, did infuse these by then almost two-decade-old proposals for a globe-spanning manner of rethinking architecture into his book *The Stack*.[56] An analysis that brings together many of the then-current economic and environmental analyses with theories of how designers should embroider on such thinking, the book proposes that all of reality should be seen as consisting not of different materials, scales, or even gradations between living and inanimate things, let alone control structures and lived experience, but of "six independent layers: Earth, Cloud, City, Address, Interface, User."[57] These together create an "accidental megastructure" that is neither a thing in the manner that the thinkers and artists of the 1960s proposed, nor a pure postulate in the way economists propose that we think of our global trade economy.[58] Rather, it is the ghost or reflection of "planetary-scale computation":

Planetary-scale computation takes different forms at different scales—energy and mineral sourcing and grids; subterranean cloud infrastructure; urban software and public service privatization; massive universal addressing systems; interfaces drawn by the augmentation of the hand, of the eye, or dissolved into objects; users both over-outlined by self-quantification and also exploded by the arrival of legions of sensors, algorithms, and robots. Instead of seeing all of these as a hodgepodge of different species of computing, spinning out on their own at different scales and tempos, we should see them as forming a coherent and interdependent whole. These technologies align, layer by layer, into something like a vast, if also incomplete, pervasive if also irregular, software and hardware Stack. To be clear, this figure of The Stack both does and does not exist as such; it is both an idea and a thing; it is a machine that serves as a schema as much as it is a schema of machines. It lets us see that all of these different machines are parts of a greater machine, and perhaps the diagrammatic image of a totality that such a perspective provides would, as theories of totality have before, make the composition of alternatives—including new sovereignties and new forms of governance—both more legible and more effective.[59]

This "coherent and interdependent whole," though, is difficult to define. Though it might be all-encompassing, it is so only or purely as codes—not just computer codes, but the codes of action and behavior, which is to say the social and economic codes, that come out of such calculations. It is, in other words, a data construct:

This addressability of the object (or sub-object, or relation of assemblage, or SPIME, or event of association, or trace, or commodity life cycle phase) zooms between spatial and temporal scales, gaining complexity exponentially as data and metadata for second- and third-order relations accumulate. This ecology of proliferating data points generated by and about the flows of material cultures seems to aspire toward a beyond-human-scale universal architecture for addressing the qualities of relations between all parameters.[60]

Chapter 7

What is different about Bratton's analysis of this data-generated reality, and what makes his image so resonant with some of the earlier interpretations of a machine-based organism of uncertain scale and nature that we both inhabit and make, is that he believes this data does not operate in abstraction. Instead, the relations between data become real, or at least appear to become so. They together throw up a number of different images and icons that are the real, if one may use that word, effect of these calculations:

Today's political geographic conflicts are often defined
as exceptions to that normal model, and many are
driven, enabled, or enforced in significant measure by
planetary computation: byzantine international and
subnational bodies, a proliferation of enclaves and exclaves,
noncontiguous states, diasporic nationalisms, global brand
affiliations, wide-scale demographic mobilization and
containment, free trade corridors and special economic
zones, massive file-sharing networks both legal and illegal,
material and manufacturing logistical vectors, polar
and subpolar resource appropriations, panoptic satellite
platforms, alternative currencies, atavistic and irredentist
religious imaginaries, cloud data and social-graph identity
platforms, big data biopolitics of population medicine,
equities markets held in place by an algorithmic arms race
of supercomputational trading, deep cold wars over data
aggregation across state and party lines, and so on. In relation
to the incommensurate demands of diverse protocols, these
rewrite and redivide the spaces of geopolitics in ways that
are inclusive of aerial volumes, atmospheric envelopes, and
oceanic depths. In response, certain geopolitical modernities
drift from the center of the frame, are obscured by the
multiple-exposure image of competing claims over the same
place, and are sometimes even overcome by these effects.[61]

We live, in other words, in a vast agglomeration of images, icons, and "imaginaries" that permeate everything we do and think. It is not that the city, as it has expanded and dissolved into a global network, has become monstrous in the manner Wright imagined, but rather that its only reality is the fluid definitions of borders, "imaginaries" and protocols that turn into claims on space. The abstraction of both space and a data-world is then

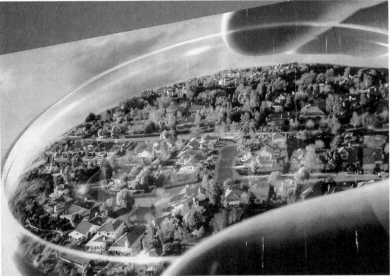

Benjamin Bratton, The Stack (1), 2015, The Stack (2), 2015.

replaced by an ephemeral collage of operative images, which is to say, ways of seeing and knowing the world that do not have to be true but only seductive, or at least convincing for a moment.

For Bratton, the result is a full-blown aesthetic, one that continually resolves itself in the Stack:

> For this, a different kind of placefulness is reestablished, one that is not the organic inverse of artificial abstraction, but an experience of place as one resonant scale within a much larger telescoping between local and global consolidations. That reestablishment is not a generalized secessionism or irredentism, a natural regrounding, or transcendent escape into technological raptures. It is a designation, a composition, a design aesthetics, and a projective ethics of pan-infrastructure deployed for a geopolitical reality that cannot possibly untangle material from information, materialism from informationalism, earth from sky.[62]

And, it is, without a doubt, a machine as well:

> It is a machine literally circumscribing the planet, which not only pierces and distorts Westphalian models of state territory but also produces new spaces in its own image:[63] clouds, networks, zones, social graphs, ecologies, megacities, formal and informal violence, weird theologies, all superimposed one on the other. This aggregate machine becomes a systematic technology according to the properties and limitations of that very spatial order.

We live inside this machine, even if we do not always realize it. Or, rather, we live inside its interstitial spaces. Bratton seems to still afford to human beings (and certain other, unnamed entities) a particular status that does not so much make them part of the machine in an integral manner as it lets them occupy the fluid spaces the machine opens as it operates:

> A constitutional geography is at work. As the nomos of the Cloud rotates from a two-dimensional map to a vertical, sectional stack, its topography is shaped by the multiplication and superimposition of layers of sovereign claims over the same site, person, and event. The

microenclaves that it spawns are a pixelated patchwork of discontiguous partial interiors and enclaves. Their double exposures are the exceptions that constitute a new rule. Strategic networks of data centers, fiber-optics cables, energy pipelines, freeways, warehouses, and shipping ports magnetize other geographies around themselves, generating legal exceptions, economies of monetized cognition, and platform wars for expanding populations of Users, both human and nonhuman.[64]

The theoretician W. J. T. Mitchell has an even more visceral image of this vast, organic machinery. He sees it as "as a reproduced organic form, seen simultaneously as an organism and as the environment inhabited by that organism." "Thus," he says,

this final image can be read as a kind of embryonic form nourished by a placental network of veins and fibers descending from the body of its progenitor. The globe is thus, as environment, a kind of womb in which life-forms are gestating, or a biomedial "culture" like a Petri dish. As a singular body, on the other hand, it is the globus or "collective body," as in the "body politic" of a nation; only in this case the political unity is that of species being, the "body of humanity" as such. This organic image of the global is surely the most fantastic and far-reaching in its implications. Globalization, in this view, becomes a totalizing biopicture of a "life-world" rendered in the most literal, corporeal terms, as if we were observing a spectacle of a birth-trauma, a multistable image of wounding and bleeding, reproduction, nourishing, and parturition. This corresponds to Lefebvre's perceived or "secreted" space, the world as an embryonic and evolutionary eco-system.[65]

For Bratton, however, this is not something altogether new. Rather, he sees the modern city in the manner of Walter Benjamin wandering, both physically and in his imagination and citations, through a Paris filled with hidden spaces within its many layers. The city still coheres, Bratton claims, but only as the effect of the Stack, or as the manner in which it resolves our existence into a presumed and wholly operative order:

Zipping back to the present, the City layer may be seen not only as enveloping space into fields of control, but also a return to these elemental functions of passage, direction, and narration. The modern urban surface is striated by regularized voids that provide self-directed passage from one enclosure to the next; we call some of those voids "streets" and some of those enclosures "blocks," and we call the generative platform striation "the grid." The grid serves the dual purpose of enclosure and escape noted above. At once, it subdivides urban space into geometric units, each bound by legal and physical membranes, and each also situated along the shore of avenues of linear flight toward other cities over the horizon. The City layer is filled with interfaces shifting between acceleration and enclosure, of both physical objects coursing through congested logistical routes.[66]

What keeps this city alive is not the schemes of human beings working in concert with the Stack, however, but the disturbance of the body as it feeds on, and thus survives and even thrives within, the Stack:

We will see that this integration of one into the other looks less like Leon Battista Alberti's organismic city, all parts fitting into natural wholes, than gory multispecies nested parasitism, one organism living inside another, itself perhaps living inside yet another, and shuttling energy in and out, through skins and interfaces.[67]

What, then, is the designer or maker to do beyond being an effective parasite in the Stack? What is the design task if we want to remain and have some sense of being at home in the Stack? Bratton hints at answers to these questions at the end of the book with a few speculative designs, which he bases on the notion of symbols. Though he never quite articulates his definition of this phrase, it seems to be as the carrier of a germ (or parasite?) of memory, endurance, and significance within the lacerations of the competing icons and images that are what we experience of the Stack:

Another way of conceptualizing the design problematic of this sort of assembly is in symbolic artifacts and how

they come to seemingly absorb traces of memory and significance that are imparted to them through use. Whether by genealogical possession or through ritual, repeated use and iconic significance, simple objects are a repository of intentions and sometimes are thought to be haunted by them.[68]

These symbolic artifacts he proposes we bring together through his version of deep planning, which he calls deep address:

> But deep address is not only a mechanism for the capture of what exists and a formalization of its space of juxtaposition; it is also, as conceived, a medium for the creative composition of those relations, positions, and interrelations. It is a machine for mapping states and procedures of interrelation that are as ancient as they are ephemeral.[69]

These will also be "cosmograms, offering prototypical geographies for worlds to come."[70]

In the torrent of words and slipping definitions Bratton layers on top of each other in this lengthy text, it is difficult to obtain a clear sense of what the Stack is and how we might design within or on it. But that is exactly the point: as the Stack is our reality as we experience it, and as we can only inhabit this organic-machine synthesis as parasites, all we can offer or are offered are moments of memory or keys to the all-encompassing map in terms of cosmograms. Like sand maps of mandalas laid out by Tibetan monks, such figures are elusive, magical, even if they also do give some sense of where we are and how we fit into a larger universe and its orders. That the sand is digital, and thus may pervade our machinery of knowledge and calculation, makes the cosmograms even more attractive. Perhaps they offer keys to navigating through a human-made world that resembles not just a scientist's dataset, but an online game?

We are here very far away from Wright's vision of controlling the machine-city-beast-human through the printing press and the seductive logic of the words it produces. We are even further away from the notion of architecture as a way to make sense out of this unreal reality, although we can imagine making ourselves at home in its shifting layers. What we are is free to wander through data

in a manner that, thanks to Bratton's recall of the images that fed and animated so much of architecture from the beginning of the twentieth century, seduces us into some veil of coherence. Perhaps this might also be anarchitecture.

8 *Smooth and Striated*

In the late twentieth and the beginning of the twenty-first century, theoreticians postulated the emergence of a liquid or smooth space. Basing themselves on advances in science that had raised questions as to whether the borders of objects were ultimately indescribable and could only be determined statistically, while also realizing the limits of an absolute reality defined by observation, and thus changeable depending on when and how it was observed as well as on the continual growth of an interconnected and rapidly changing socioeconomic reality dominated by imagery, fed by the continual flow of information, and destructive of most fixed organizational structures, they argued for a liquid modernity. This would be a state in which the distinctions between borders and bodies, between humans and inanimate beings, and between different levels and scales of perception would be wiped out, with everything reduced to combinations of zeroes and ones extended into codes that fed transactional relationships governing all of our experiences of reality, with the result of those combinations evidencing itself as ephemeral imagery.[1]

None of this was new, as most of the science, as well as the social phenomena, dated back to a least the beginning of the twentieth century, but the practical results of that research and those postulations, in everything from the spread of the internet to the

ability to alter not only the human body but our moods and modes of consciousness through chemical means, became so widespread that they called for the same kinds of explanations and images that the writers and designers of the early twentieth century had given to the industrial revolution.

The key images or metaphors in this effort congealed around notions of liquidity or flows. *Liquid Modernity* was in fact the title of the book the Polish philosopher Zygmunt Baumann published at the turn of the millennium.[2] In this volume, he rehearses the essential divorce between the world as we experience it and as we postulate it:

> Modernity starts when space and time are separated from living practice and from each other and so become ready to be theorized as distinct and mutually independent categories of strategy and action, when they cease to be, as they used to be in long pre-modern centuries, the intertwined and so barely distinguishable aspects of living experience, locked in a stable and apparently invulnerable one-to-one correspondence.[3]

In our modern world, space has long resisted the fluidity of existence that has made us all into nomads wandering an increasingly homogeneous landscape, but now even that space of resistance is being wiped away:

> In the modern struggle between time and space, space was the solid and the stolid, unwieldly and inert side, capable of waging only a defensive, trench war—being an obstacle to the resilient advances of time. Time was the active and dynamic side of the battle, the side always on the offencive: the invading, conquering and colonizing force. Velocity of movement and access to faster means of mobility steadily rose in modern times to the position of the principal tool of power and domination.[4]

What we are left with is continual change, not only of and in our social conditions, but of the spaces we inhabit and the objects we use. They have become slippery and ephemeral, giving us very little aid in what Baumann considers the essential work we still have to do, which is to construct our own identity.[5] We try to build

communities and shared places for intimacy as part of that effort,[6] and we try to hold onto whatever we can remember or sense, but both our bodies and our buildings are under continual attack:

> Giant industrial plants and corpulent bodies have had their day: once they bore witness to their owners' power and might; now they presage defeat in the next round of acceleration and so signal impotence. Lean body and fitness to move, light dress and sneakers, cellular telephones . . . , portable or disposable belongings—are the prime cultural tokens of the era of instantaneity.[7]

Bodies or objects have been replaced by spectacles, slippery images, and continually changing forms or landscapes in which we cannot be at home and in which we cannot recognize ourselves. "What was some time ago dubbed (erroneously) 'postmodernity', and what I have chosen to call 'liquid modernity'," he adds in the addendum to the 2012 edition, "is the growing conviction that change is the only permanence, and uncertainty the only certainty. A hundred years ago 'to be modern' meant to chase 'the final state of perfection'—now it means an infinity of improvement, with no 'final state' in sight and none desired."[8]

Baumann was certainly not alone in noticing a marked dissolution of permanence and solidity that, though first detected by Karl Marx and Friedrich Engels a century and a half earlier and having become, as Marshall Berman documented in the 1980s, a subject of artistic and design practice, seemed to be growing at a rate that was exponential during the period around the turn of millennium. Specifically, the emergence of the internet as a common phenomenon, the transformation of supply chains into global logistics systems, the containerization of all goods, the disappearance of information in general into the cloud, and the mass migrations of peoples caused by economic and climate upheaval made what had only been traced and noted by critics into an acute, if ephemeral, reality.[9]

That this smooth space was the result of modernization seemed logical, but what if its roots were deeper than this? What if the very development of technology, even in the original sense of *techne* Heidegger postulated, was in fact a history of differentiated smoothing or, as the French thinkers Gilles Deleuze and Félix Guattari put it, "retroactive smoothing"? Just as Heidegger had

developed ideas and images that started from the advent of technological domination but then attempted to make a wider point about human society, so these thinkers attempted to root the phenomena many people were observing in deeper speculations.

Deleuze and Guattari, who began their work from the perspective of psychology and developed their major works, most notably *Anti-Oedipus* (1972)[10] and *A Thousand Plateaus* (1980),[11] into one of the last sweeping compendia of literary, philosophical, aesthetic, and social analysis (or collection of analyses) of the modern era, based their theories in a reading of the human body and its psyche, as well as on their interpretations of an array of scientific postulations and assumptions. Out of a collage of ideas and speculations, they built nonlinear texts that construct a chimeric assembly of ideas and images of the modern body, society, and psyche.

At the heart—if there is such a thing—of much of their writing are the twin images of the "body without organs" and the "machinic assemblage." Over hundreds of pages of text, they build up allusions to what these actually are and, at times, extend them into sweeping imagery of the whole conscious and unconscious world. They are careful not to be pinned down, however. The fullest exposition of their ideas comes in the form of a supposed report on a lecture by a Professor Challenger, a fictional character they lifted from the work of Arthur Conan Doyle who is both an anthropologist and a zoologist and has a notoriously uneven temper.

"The body without organs," they explain (or have him explain), "is not an empty body stripped of organs, but a body upon which what serves as organs . . . is distributed according to crowd phenomena, in Brownian motion, in the form of molecular multiplicities."[12] The "BwoO" is no longer a singular object or container, but rather is a landscape of pores, cavities, parasites, or other growths. Deleuze and Guattari, in other words, refuse to accept the body at the scale and according to the definitions that allow us to contain it within our common understanding. Rather, they propose that, from a certain perspective or way of knowing, including that of the schizophrenic, the body might only be "expression" that allows it to be the site of interpretations, desires, fears, or other modes of being. That does not mean that the BwO is fictional. It is, rather, a construct of phenomena in what they refer to as strata.[13]

"The distinction to be made," they (or Professor Challenger) go on to say,

is not at all between exterior and interior, which are always relative, changing and selective, but between different types of multiplicities that coexist, interpenetrate, and change places—machines, cogs, motors, and elements that are set in motion at a given moment, forming an assemblage productive of statements.[14]

As they weave their description further, Frank Lloyd Wright's vision of almost a century earlier comes to mind. Here is an assemblage that is both a machine and a body (albeit without organs); the body not only contains the multitudinous realities of an urban environment and the human body all rolled into one and revealing itself only according to your perspective or interpretation, but has an organic life of its own. That entity is, however, not the mystical and complete being that stands in contrast to the realities of the machine: "An organic form is not a simple structure but a structuration, the constitution of an associated milieu."[15]

As a result, Deleuze and Guattari's analysis, though it starts in the realm of psychology, wanders through geology, chemistry, physics, and other sciences. True to its interpretation of the machinic assemblage, however, it treats those supposedly hard territories of knowledge as speculative narratives that evoke strata, territories, and areas of coherence more than they classify. In fact, if there is anything *A Thousand Plateaus* and their other writing avoids, it is indexing phenomena or physical entities in any way. It is always the double interpretations, the fluidity of boundaries, the continual shifting of perspectives, and the transformation of one thing into another that shapes their equally shape-shifting writing.

Winding your way through the plateaus (and their treatment of the libido and psychoanalysis in *Anti-Oedipus*) means finding yourself waking into a dream world, which is where, following psychoanalysis and (its equivalent in fiction) detective stories, they set their parameters. You could see all the almost 600-page volume (in the English paperback version) as no more than a dream that unfolds across the vague terrain proper to that realm. Or you could see it as a film, which mimics some of the same changes in direction and reality, as Walter Benjamin pointed out. Or you could see it as a form of architecture, exhibiting the transformation of mineral realities into intricate geometries, some of which are visible while others remain buried underneath the facade, and

which changes its impression upon us continually depending on our perspective on this fictional reality we create around us.

Deleuze and Guattari come closer to this anarchitecture when they describe the "abstract machines":

> In addition, the plane of consistency is occupied, drawn by the abstract machine; the abstract machine exists simultaneously developed on the destratified plane it draws, and enveloped in each stratum whose unity of composition it defined, and even half-erected in certain strata whose form of prehension it defines. That which races or dances upon the plane of consistency thus carries with it the aura of its stratum, an undulation, a memory of tension.[16]

The abstract machine exists within two realms: the "planomon" and the "eucomon." It is the latter that is the most complex, consisting of "stratifications" or complexities that make a phenomenon into an animal, a body, or pure energy. The abstract machine is continually working, as machines do, to "territorialize" and "deterritorialize."[17] The human being (or "man," as they call them) is only "an illusion exceeding all strata."[18]

The landscape Deleuze and Guattari describe is both a natural and a human-made one. In fact, there is no overt distinction between the two. There are only materials, energy, or bodies without organs that exist or cohere through momentary and fleeting coherence depending on the perspective we gain on these elements or "strata." As these slippery entities transform into what we might think of as landscapes, or into bodies with organs, or buildings, they continue to house and to even be these strata, deterritorialized and reterritorialized but always unstable except in the economy of physiology or structure that gives them the workable illusion of coherence.[19]

What are we to make of this, or how are we to act? The difference between a sane (albeit always neurotic, *pace* Freud) human being and a schizophrenic or "crazy" one is that the former accepts and works within these territories, accepting their illusions, while the latter is so overwhelmed by the complexities and multitudes of truths that make up the world they perceive that they create their own territories, which the economy of our society labels as paranoid or schizophrenic. The neurotic, Deleuze and Guattari start their discussion by pointing out, may conflate a sock with a

vagina. This, because of their formal relations, is at least plausible, and operates at a level that accepts the reality of objects or parts of bodily objects. The psychotic patient "sketches a field of vaginas," confusing the territories and the artificial, but highly operative, limits we place on objects.[20]

The attraction to architects of understanding what we might otherwise think of as the separate realms of the organic, the natural, and the poetic (to use Heidegger's distinction) and the artificial, the object-oriented, and the purely functional as actually just different appearances of the same set of physiological, chemical, and, ultimately, energy relations seems obvious. Here was finally an interpretation that allowed architects to make sense of and build on, in both senses of that phrase, the discoveries of the early twentieth century that had seemingly taken their traditional reference points away from their practice. If it is true that energy is matter, and vice versa, and that our ability to experience reality is but one way in which an understanding of our existence is possible, how do we build without the human body and its perspective on a material world? The answer would be to accept the flows as they appear, which is to say, as realities that we know to be oneiric, but that we can judge, accept, and use according to the place they have in the equally dreamlike structures of social and economic strata.

By the same logic (if that is still what we can call this evocation), a critical architecture would be one that would selectively refuse to accept those structures, that would see itself as a machine of de- and reterritorialization, and that would not just reveal other worlds hidden within the materials out of which buildings and spaces are made, but would spin them out in an active manner. Architecture would be neither a veil nor an explosion, neither a utopian or dystopian vision nor a restatement of existing conditions, but a continual act of remaking across levels of material and theoretical practice that would itself act as a machine. It could operate like Wright's monster leviathan, or rather, like the evocation of that indeterminate beast-machine, and be highly operative.

What is remarkable to this author is that, although Deleuze and Guattari were widely read and quoted by architects (at least in the academy)[21] at the end of the twentieth and the beginning of the twenty-first century, it is difficult to find design or even oneiric projects that overtly draw on the possibilities opened by these authors. Deleuze himself gave a few hints as he developed his ideas toward the field in his 1988 book *The Fold: Leibniz and the Baroque*.[22]

Starting from Leibniz's notion of the "monad," he focuses on the ways in which interior and exterior, as well as the solid and the fluid, the large and the small, and even the real and the unreal spiral through each other in a manner that architects and artists of the baroque period were able to trace most fully. Both the body and building in this mode are made up now of infinite folds, which are a more plastic version of the territories of *A Thousand Plateaus*, and coalesce, if only for a period of time, into the coherence that allows us to operate in and make sense out of them. "The Baroque refers not to an essence," Deleuze starts the text, "but rather to an operative function, to a trait. It endlessly produces folds." Such folding is inherent in buildings (and paintings, and bodies), he goes on to say, but in the Baroque it "approaches infinity."[23] "Baroque architecture," he explains, "can be defined by this severing of the façade from the inside, of the interior from the exterior, and the autonomy of the interior from the independence of the exterior, but in such conditions that each of the two terms thrusts the other forward."[24] The baroque is also a world of "high and low," both in terms of art perception and in terms of the spiraling up of the building.[25] Here cells build up into complex machines[26] and into the realm of endless variations of light, dark, and shadows.[27] There are no more "parts," only "degrees."[28] Beyond those mutations, the Baroque extends not just spatially and formally, but also in tending toward the "extensive unity of the arts,"[29] which turns its main task into being a stage set for important occasions, such as the masques of which John Hejduk was so fond.

What, then, does that mean for our contemporary situation? Deleuze is cautious, making a few references to the baroque qualities of painters such as Jackson Pollock, finally venturing:

> Perhaps we rediscover in modern abstract art a similar taste for a setting "between" two arts, between painting and sculpture, between sculpture and architecture, that seeks to attain a unity of arts as "performance," and to draw the spectator into this very performance. . . . Folding and unfolding, wrapping and unwrapping are the constants of this operation, as much now as in the period of the Baroque. This theater of the arts is the living machine of the "new system," as Leibniz describes it, and infinite machine of which every part is a machine, "folded differently and more or less developed."[30]

Chapter 8

"It is a broad and floating world," Deleuze goes on to say, suggesting that it encompasses not just the arts but spiritual and conceptual unity as well.[31] Yet that world is, true to the shifting realities of the machinic assemblage, one that is continually made up of fragments that cohere in one sense or perspective and trail off into their own worlds of allegory or allusion when they become decoration, applied painting, or other constituent elements of the baroque work of art.[32] The author's final vision is that of a "spiral in expansion that moves further and further away from the center."[33]

The model would seem to be a surprisingly clear one: there could be something that we might call architecture, but which could also be thought of as art (whether visual or musical) that also has an aspect of performance. It would be as a whole abstract, though it could act as an allusion to a body (whether human, animal, or constructed). It would have the aspect of a collage, though in such a manner that you would never be able to define or pick out its constituent elements. It would have the aspect of continually folding inside and outside, while maintaining a sense of unfolding as it moved up and around, developing into the figure, whether implied or not, of a spiral. It would also exhibit a "harmonics," or Leibnizian sense of reverberation across these aspects.[34]

Certainly, the spiral as a figure is one we have encountered before, in Soja's reading of Sartre, Buber, and Lefebvre, but it is also one that became increasingly popular among architects at the end of the twentieth century and beyond, and it is particularly tempting to interpret the work of the Office of Metropolitan Architecture, Rem Koolhaas's firm, in such "baroque" terms. In particular, major structures such as the Rotterdam Kunsthal (1992), the Dutch Embassy in Berlin (2004), and the Seattle Public Library (2012) are all organized as spirals that unfold and bulge out as they open up. The Seattle building has many of the aspects to which Deleuze alludes in terms of that figure, while the Kunsthal retains an aspect of collage that the firm dropped in later buildings. Firms headed by disciples of Koolhaas, such as MVRDV and Neutelings Riedijk, also used these figures. MVRDV's VPRO Villa of 1996 in particular develops as a spiral that sponsors performances as much as functions, while Neutelings Riedijk's Museum aan de Stroom in Antwerpen (2010) uses a similar strategy as a public path leading up to a public viewing platform at the top of the building where the surrounding city can act as a stage set, while the galleries the

Elizabeth Diller and Ricardo Scofidio, *The Rotary Notary and His Hot Plate*, 1987; photograph by J. Vezzuzo (courtesy of Diller Scofidio + Renfro).

Elizabeth Diller and Ricardo Scofidio, *Para-Site*, 1989; photograph by Diller + Scofidio
(courtesy of Diller Scofidio + Renfro).

viewer passes on the way remain as closed cells, interiors within the interior of the building.[35]

In terms of the weaving together of performance and using the actual fold, the work during the 1980s and 1990s of Diller and Scofidio (now Diller Scofidio + Renfro) is most evocative. Early work such as *The Bride's Revenge, or, The Rotary Notary and His Hot Plate*, which consisted of a combination of a machine and a performance whose work is the dis- and reassembly of Marcel Duchamp's 1915–1923 *Large Glass* (or *The Bride Stripped Bare by Her Bachelors, Even*) so that the woman is liberated, but only within the manipulations of the machine, seems to refer quite clearly to Deleuze and Guattari's work. A later work, *Bad Press* (1993), uses the literal act of folding, in this case of white shirts, to create analogous architecture that adheres to the human body. While these are performance pieces, a realm the architects extended through their collaboration with choreographers and writers in a number of collective projects, including the large *Mile-Long Opera* of 2018, their work during the period around the millennium also continued to be concerned with acts of de- and reterritorialization. Thus, they set a drill to work on the walls of the Whitney Museum in New York during their exhibition "Scanning: Aberrant Architectures" of 2003, so that the solid separation between two galleries disappeared during the run of the show through the work of what seemed to be a random machine poking holes in the plaster. Other works concerned displaying what was on the inside of buildings through cameras, or what was on the outside inside cellular spaces. *Project 17* (1989) was an early example of turning surveillance equipment against its intended purpose, piping images of people outside of the gallery into monitors, where they became disembodied entities to be observed as art, while the San Francisco project *Facsimile* (1996–2004) went further by mixing similar captures with staged scenes invented by the designers on a screen that scrolled across the facade of an addition to the city's convention center.[36]

However, founding partners Elizabeth Diller and Ricardo Scofidio largely turned their focus toward the making of more "normal" buildings in subsequent years, addressing other issues such as reuse and reinterpretation, as well as global climate concerns, within the framework of a large practice. Though they both taught and inspired several generations of young designers, few of these pursued the performance and folding or deterritorializing aspects of the firm's early work.

Another way of using Deleuze's Guattari's evocations of bodies without organs and machinic assemblies was developed by theoreticians such as Manuel De Landa. In a series of texts starting with the 1991 book *War in the Age of Intelligent Machines*, De Landa looked in particular at the notion of smooth and striated space that Deleuze and Guattari developed in *A Thousand Plateaus* and other texts, and then spun out a notion of how we have used machines to create differentiations in space, then smooth those complexities only to build ever greater complexity, in the literal realm of place, landscape, and geographic territory.[37]

De Landa in particular picks up on the notion of the relationship between "smooth" space and nomadism. In his telling, civilization developed after human beings moved out of forests and onto the open steppes. There they not only needed to walk upright, but also to create a human-made alternative to the cover the forest canopy provided, to locate themselves in relationship to scarcer resources such as water, and to establish a place for themselves in an unbounded terrain. What they engaged in, in other words, was territorialization. They delaminated the smooth surface of the steppes—as that environment appeared to them—and specified it into hunting ranges, places of inhabitation and gathering, and eventually grazing areas. The making of inhabitations involved gathering together fragments delaminated from vegetative (tree bark and stalks) and animal (skins) resources, just as keeping themselves alive meant gathering and differentiating food through cooking and breeding of selective species.

Out of such transformative place-making, which deterritorialized many aspects of the organic assemblage to make it into a more efficient, human-oriented machine, eventually emerged what De Landa calls the "war machine": a constellation of actual weapons, modes of organization, and social priorities based on the conquest of ever more territory. Out of such movements then arose the state machine, as well as its locus of power, the city and its monuments and redoubts. Eventually, this new territory became a "second nature," with its own organic machinery—a body without organs on a vast scale.

The story, however, does not end there. De Landa notes the continual territorialization, deterritorialization, and reterritorialization that marks human civilization. As soon as city-states arise, larger kingdoms and empires wipe out their distinction and amalgamate them into larger machines. Then marauding peoples from

Diller Scofidio + Renfro, *Facsimile*, San Francisco Convention Center, San Francisco, 2002 (courtesy of Diller Scofidio + Renfro).

the northern steppes sweep down into Assyria, the early Greek states, or the Roman empire, wiping away whole civilizations and burning down cities in an act of "retroactive smoothing." This movement happens repeatedly throughout the centuries, at first in the more recognizable manner sketched above and then, in the modern era, through the destructive wars waged by large, mobilized armies that first appeared in the Napoleonic wars and spread to such a scale that they led to world conflict. The destruction of 90 percent of Dresden or Warsaw, the bombing of Hiroshima and Nagasaki, and the devastations of countries in the Arab peninsula are all examples of such smoothing.

In the modern age, not only is this continual movement and destruction semipermanent, as there are wars and refugee crises around the globe, but we also experience the complexity reaching such a height that it appears to be a kind of "retroactive smoothing," in which the interconnected machinery, working behind facades and propaganda and penetrating every aspect of reality, makes it appear that we live in a smooth and liquid modernity.

At the core of all this movement is a particular kind of machinic assembly, namely the war machine. Starting out from our ability to first make weapons and then, in a crucial step, intervene in the organic strata of minerals through forging and annealing, causing a state change that leads directly to a change in spatial control, and extending to the organization of the true standing reserve of conscription and the utilization of the whole country's productive capacities for war efforts, the machinic assemblage continually changes our reality. That is evident in atomic weaponry, which made the abstractions of quantum physics all too real, but also in the developments of new materials such Kevlar, or technologies such as the microwave, that come directly out of the war machine. In our current era, De Landa describes the smoothing and then territorialization that has occurred in the virtual realm through the invention of the internet (another product of the war machine), but also through the emergence of global trade networks that transform the war machine into a commercial one.

Although some of De Landa's speculations are based on interpretations of the development of early civilizations that, though widely held when he wrote his early books, are now in question, the ebb and flow of territorializations and dissolutions, each involving an ever more complex machinic assembly of which human beings increasingly become only small parts, is compelling in its

Photographer unknown, bombing of Baghdad, 2003.

reach and in the manner in which it makes Deleuze's and Guattari's meandering considerations of many aspects of science and art as real as the atom bomb.

In his follow-up to *War in the Age of Intelligent Machines*, *A Thousand Years of Nonlinear History*,[38] De Landa not only enhances his descriptions but also turns to the question of accumulation and destruction. In his revision of Marxist theory, the massing of capital is reflected in material terms in the machinic assemblies of cities and their constituent elements, which is to say buildings, consumer goods, and machinery, all of which territorialize wealth. The ever-freer flows of capital, which are periodically fettered through regulations or destroyed by events such as revolutions, wars, or natural disasters, smooth over these territories by removing the value from such fixed assets in a cycle that is ever increasing in scale and speed.

The "mechanosphere"[39] that makes up this assemblage of machines and buildings is shot through with its own singularities, which also cause disruptions that turn worth or value abstract in such acts of internal smoothing. Stability in this reality is illusionary, or temporary at best, and thus is an effect that serves to make us believe in the coherence of the body without organs that is both the urban scene and our socioeconomic structure. De Landa draws the analogy to DNA, which creates stability both in and across human bodies in the way codes and regulations calibrate the different aspects of the machinic assemblage.[40]

The value of De Landa's perspective lies in both its mythic sweep and its reminder that architecture (to focus on the subject of this volume) is an accumulation of energy that ultimately goes back to the need for survival and food, progressing from there, through the state change of cooking and the rationalization of agriculture, through the development of storehouses and trading, to the abstraction of those values into wealth and then the fixing of that wealth in buildings.[41]

If we think of our built environment, in other words, as being as organic and as machinic as the realms of rocks and rivers, of flora and fauna, or of clouds and air currents, while also understanding that phenomena so large that we experience them both as facts and as universes contain us to such a degree that we cannot comprehend them, we can do away with the distinctions so dear to the likes of Heidegger and other post-Hegelian philosophers, but also to the romantic strain so prevalent in architecture

that continually calls for recapturing a "sense of place" or "organic building practices." While we might see some of these modes of architecture, such as the attempts to build with, rather than on, the land (the creation of what I have called "landscrapers"), as providing a salutary alternative to the wholescale rape of land and resources, they all depend on a peculiar perspective that does not accept the complexities either of "natural" forces or of our entanglement with those mineral and vegetable constructs.

De Landa and other critics who have built on Deleuze and Guattari's legacy, in other words, offer critiques of current modes of building that make it difficult to use their ideas in a constructive manner. If a building is only a temporary assemblage of materials, forces, and energy whose endurance serves only as a kind of potlatch of the accumulated resources of the commissioner of such a structure, what is the role of design in the act of the creation of such an artifact of seeming permanence? Should architects be complicit in the fixing of capital in one place in a manner that affirms the holders of those resources, but should they do so in a manner that either reveals this situation or somehow liberates those resources, through "wasteful" architecture embellished with decoration and extra, nonusable spaces of gathering or contemplation? Such a sneaky mode of operation might be useful for engaging in a form of retroactive smoothing, but it might also be a way to justify the creation of buildings that ultimately serve their clients even better by making them "better," which is to say, both grander and more enjoyable for their users.

Should architects instead engage in a form of unbuilding, creative destruction, or anarchitecture that might be a form of schizophrenia or craziness? Such a conclusion is the natural result of at least one reading of the work outlined not just in this chapter, but in much of this volume. The problem of such a direction for the discipline of architecture is obviously that it is radical critique of the whole professional and social machinery that constitutes its body of thought and action. How might an architect be paid to engage in such deterritorialization, or what might they call themselves? What is the function of such acts within the larger social and economic assembly in which the architect operates?

Such questions become even more pressing in the face of the global climate crisis, which affirms that humanity might be facing the ultimate retroactive smoothing of oceans and rivers washing over the accumulated capital represented by cities, or the

spreading of deserts across agricultural fields, let alone the dis-
solution of both physical bodies and social ones as the result of
accumulating climate catastrophes.

The extension of Deleuze and Guattari's modes of inquiry,
mixed with a peculiar reading of Heidegger's work that has become
known as "object-oriented ontology," became a popular mode of
extending these thoughts in the early teens of this century. Its
guru, the philosopher Graham Harman, offered his own version
of Heidegger's dam to explain the dissolution and recombination
of objects into not just technology, but tools:

> Walking across a bridge, I am adrift in a world of equipment:
> the girders and pylons that support me, the durable power of
> concrete beneath my feet, the dense unyielding grain of the
> topsoil in which the bridge is rooted. What looks at first like
> the simple and trivial act of walking is actually embedded in
> the most intricate web of tool-pieces, tiny implanted devices
> watching over our activity, sustaining or resisting our efforts
> like transparent ghosts or angels. Each of these objects
> executes a specific effect amidst reality. Bolts and trestles
> are not neutral facts, but exert a definitive power in the
> cosmos on the basis of their particular thickness and tensile
> strength. Forever contending with one another, these tool-
> beings throw their weight around in the world, each of them
> ensconced in some small niche of reality.[42]

"The important point," he goes on to say,

> is not so much that these tool-elements are manipulated by
> us; rather, they form a total cosmic infrastructure of artificial
> and natural and perhaps supernatural forces, powers by
> which our every last action is besieged. In short, the tool
> isn't "used"; it is. The work of being that makes up the tool's
> reality forever recedes from view. This is its first trait. The
> second is its totality.[43]

"What endures," he claims, "is not an individual object but a 'soci-
ety.'"[44] That focus of his book is not technology but tools, which
combine or are used to become more complex tools, while break-
ing apart into tool components. In that, it would seem to offer a
clear manner to proceed: a collage of implements combined and

transformed to become tool-buildings in tool-presentations. This, using the methodology of "kitbashing," is what Harman's prime architectural proponent, Mark Foster Gage, does in his visions of skyscraper-tools as assemblies of everything from toys to dildos.[45]

Harman's thinking (as well as the work of some of the other philosophers discussed here) also became the basis for a mode of almost postapocalyptic writing by authors such as Ian Bogost or Timothy Morton. Despite differing interpretations, emphases, and recipes, they tend to gravitate to a redeeming quality in the work of art and architecture, but in the anticonstructive manner that seems to be the logical outcome not just of Deleuze's and Guattari's thinking, but of the trains of thought traced in this volume as a whole.

The writer Lukáš Likavčan, for instance, writing at the Strelka Institute Benjamin Bratton directs, describes this reading of the machinic assembly in his *Introduction to Comparative Planetology* of 2019:

> Any orchestration of a large collection of humans and
> nonhumans requires an infrastructural power based
> on deploying large-scale socio-economic technologies
> that operate as active forms that standardise tendencies
> and regimes of engagement between bodies in space:
> postal address systems, languages and scripts, railways,
> transoceanic cables, calendars, time zones, international
> business standards, sewage systems, broadband and water
> pipes, websites, cloud platforms, and distributed ledgers.
> We can better understand the power of infrastructures if
> we recall Giorgio Agamben's analysis of apparatuses . . . as
> "anything that has in some way the capacity to capture,
> orient, determine, intercept, model, control, or secure
> the gestures, behaviors, opinions, or discourses of living
> beings."[46]

The resulting perspective is resolutely not an ideology or call to action:

> Seeing Earth as non-organic does not mean refusing the
> fact of life on this planet, but rather recognizing that a strict
> separation between organic and inorganic is redundant,
> since planetary dynamics emerge from mixtures of networks

and agencies of both kinds. Similarly, it is not an ethical or political call for extermination or negligence of life on Earth. It is an ontological stance that cannot be straightforwardly associated with one political agenda, and it can be meaningfully combined with the human species' duty to co-curate the continuation of life forms on this planet. The "non" in "non-organic" simply stands here for an agnostic attitude towards the organic/ inorganic status of the entities inhabiting the planet, not for the denial of the role of living creatures in planetary existence. Speaking about the planet as non-organic simply allows us to count many forces as truly planetary, be they technical, biochemical, geophysical, or socio-economic. Instead of defining planet in its (in) capacity to harbour organic matter (as in the vitalist approach of Gaia), one should treat evolution as a general property of any complex adaptive system, remaining agnostic towards its exact composition. Understanding Earth-without-us as a non-organic site gives a peculiar twist to the invocations of natural processes that come with the figure of the Planetary. In particular, it complicates the usual association of nature with life—from now on, we should look at the indifferent path-dependencies anterior and posterior to humans mainly as those concerning the unfolding of non-life: non-organic reality comprising many parts conventionally described as inorganic, be it geological or geophysical elements.[47]

What hope for making there is lies in rescuing some conception of the real: "Hence, the real may still be posited with a degree of opacity; the access to the real is carved out through its modelled approximations. In practice, operations of modelling resemble the productive engagement of an artist with the fabric of contingency."[48] "This would mean," Likavčan goes on to say, "mobilizing design and architecture as practices of deleting and deconstructing."[49]

What such a mobilization might involve, other than a wholesale attack on ownership and wasteful construction,[50] is unclear but, in a Deleuzian turn, Likavčan at least articulates a location for such a critical architecture:

> In this respect, it seems to be the case that one of the central fault lines in twenty-first century thinking, not just about

geopolitics, but also about the planetary scaling of design and architecture, will be the negotiation between interiority and exteriority—to what extent one continues to keep planetary feedback loops and territories within the confines of nation states, cultures, political economies, and other institutional regulative mechanisms, or whether one breaks with this tendency and opens up the closed loops to make space for spontaneous alignments and non-human processes.[51]

The thinker Ian Bogost, in his *Alien Phenomenology, or What It's Like to Be a Thing* (2013), takes the argument to a cosmic level:

On the one side of being, we find unfathomable density, the black hole outside which all distinctions collapse into indistinction. Yet, on the other side, we find that being once again expands into an entire universe worth of stuff. Thanks to the structure of tiny ontology, this relationship is fractal—infinite and self-similar. The container ship is a unit as much as the cargo holds, the shipping containers, the hydraulic rams, the ballast water, the twist locks, the lashing rods, the crew, their sweaters, and the yarn out of which those garments are knit. The ship erects a boundary in which everything it contains withdraws within it, while those individual units that compose it do so similarly, simultaneously, and at the same fundamental level of existence.[52]

If we understand this complexity as being "hyperobjects" which we are both part of and which we can, from another perspective, observe and analyze, we can develop a manner of being in relationship—albeit a contingent one—to such metaphenomena.

In fact, says Bogost, as we dive and spiral through this assembly, finding the myriad scales and things that appear as objects one moment, as tools for the making or understanding of objects the next, and deterritorialized flows of energy after that, only to have those flows become tools that let us constitute that flow as an object again, fissures open up. These cracks become chasms that are fractal versions of the disconnect between ourselves and the world as we observe it, or between the world as we can know it and

as we can understand it through speculations. They are themselves a form of smoothing.[53]

What emerges from these unbridgeable fissures is not a thing, a tool, or even a body, but wonder, which reconnects us: "Wonder describes the particular attitude of allure that can exist between an object and the very concept of objects." If allure is "the separation between objects," then "wonder is the separation between objects and allure itself. Wonder is a way objects orient."[54] This wonder is not the transcendent reaction to the sublime, but rather a form of "unattached knowledge . . . that resists external logics—whether those be physics or metaphysics."[55]

Such wonder when facing the hyperobject is thus itself a form of anarchitecture, though one that is far from the realm of buildings.

"Hyperobject" is itself a term pioneered (though not invented) by Timothy Morton. In his *Hyperobjects: Philosophy and Ecology after the End of the World* (2013), he describes them at first technically (so to speak):

> Hyperobjects have numerous properties in common. They are viscous, which means that they "stick" to beings that are involved with them. They are nonlocal; in other words, any "local manifestation" of a hyperobject is not directly the hyperobject. They involve profoundly different temporalities than the human-scale ones we are sued to. In particular, some very large hyperobjects, such as planets, have genuinely Gaussian temporality: they generate spacetime vortices, due to general relativity. Hyperobjects occupy a high-dimensional phase space that results in their being invisible to humans for stretches of time. And they exhibit their effects interobjectively; that is, they can be detected in a space that consists of interrelationships between aesthetic properties of objects. The hyperobject is not a function of our knowledge: it's hyper relative to worms, lemons, and ultraviolet rays, as well as humans.[56]

They "end the possibility of transcendental leaps 'outside' physical reality," he goes on to say, drawing on a succession of interpretation of our universe that have called into question every aspect of not just space and time, but coherence and physicality. What we

are left with instead are "sensual objects," which he describes as "an appearance-for another object." In this he clearly follows Harman. We work with stand-ins that construct a reality, and we must work with them or, rather, tune them:

> Hyperobjects likewise end the idea that things are lumps of blah decorated with accidents, or not fully real until they interact with humans. Art in the Age of Asymmetry must thus be a tuning to the object. Uncannily, the Platonic idea returns: art as attunement to the realm of demons.[57]

"Art," he goes on to say, "must attune itself to the demonic, inter-objective space in which causal-aesthetic events float like genies, nymphs, faeries, and djinn."[58] We are right back in the realm of myths, monsters, and living machines.

For all the popularity of such theories and the implications for such myth-making, there have been few echoes visible in the realm of architecture. While Mark Foster Gage engages in kitbashing, West Coast architects exposed directly to Harman's teaching there seem to have used it as an excuse to continue to explore the fluid, bloblike forms that first began appearing out of designers' computers in the 1990s.

On the other hand, the awareness of hyperobjects, a world tooled into continual layers of smooth and striated space, and the ability to shape some aspect into mythic evocations of urban conditions continues to be a task some have taken on without referring to or even knowing of Harman's work. No architect, or writer about architecture, has evoked hyperobjects with more power than Lars Lerup. He did so in a particular time and place, outside the mainstream of the academic discourse, as its participants were fond of calling their scholarly meditations, before Harman and his acolytes emerged on the scene, during the 1990s. Lerup, a Swede who had moved to the United States to study, had left the University of California at Berkeley, which had been his home for most of his studies and career, to become dean of the School of Architecture at Rice University. There he collected a group of talented designers and theoreticians, including Michael Bell, Sanford Kwinter, and Albert Pope, and focused his attention on what he saw as the emerging arena worthy of architectural analysis and design, namely sprawl. In the writing and designs of this group, sprawl itself began to emerge as a potential monster leviathan, although

Chapter 8

none of them so far has assembled the components of their research into such a vision.[59] Lerup, on the other hand, brought to his contribution to that effort a particularly oneiric sensibility, shot through with acute perception and clever phrase-making, that was informed by much of the writing mentioned in this and previous chapters, and used it to create if not a design, certainly an evocation of what sprawl might be as a machinic assemblage.

This writing found its most coherent and evocative form in an essay he wrote for the journal *Assemblage* in 1995, "Stim & Dross: Rethinking the Metropolis."[60] Illustrated with his own drawings, as well as moody photographs of Houston, it took that city as its prime subject. His perspective was a particular one: the view from his own apartment on the 28th floor of an apartment building near the Rice campus. From there, Lerup looked down at Houston, or at least the well-treed area of this wealthy district at first, and observed a metropolitan scene defined not by the grids of trees or the buildings, most of which were invisible to him from his perch, but rather a strange new kind of place: "The bio-vehicular, electro-commercial, socioelectronic, and opto-ocular metropolis knows no steady state. In a city predominantly constituted of motion and temporalities, space itself is about deformation and velocity—constantly being carved out in front of one and abandoned behind.[61]

In the foreground were the live oaks that did all the covering, while in the distance, visible to him as a clump or human-made mountain range, was downtown. Lerup described the scene as such:

> On the one hand, we have the Zoohemic Canopy constituted by a myriad of trees of varying species, size, and maturity and, on the other, we have a Downtown formed by the tight assembly of skyscrapers. Both shapes rely on repetition, one of many small elements, the other of a fairly small assembly of large elements. Though these two megashapes seem different, both are apprehended and appreciated only through shifts and distortions of scale and speed. The Downtown relies less on speed than on distance. Both require modern mathematics for analytical description. The Canopy demands a special kind of attentiveness since it operates truly on the periphery of everyday vision. Once focused on, however, trees "get counted" and form with

Michael Bell, *Blue House*, 1989.

time and repetition a zoohemic appreciation—even the pedestrian gets a sense of the forest. The Canopy, moreover, is understood from within, from the counting of trees, not from the realization of the whole; more correctly, there are two ways of seeing it, one from within and the other from the perspective of the Aerial Field. Radically different, they do not suggest the same appreciation (form?): one is close and intimate, the other cool and distant. This double reading brings Canopy and Downtown together conceptually since driving inside the Downtown may prompt an appreciation of its megashape—again, this would be quite different from the shape gathered from a distant position in the Aerial Field (such as from the 28th floor). There seems, then, to be at least two readings of any megashape: one from the inside leading to an appreciation of the algorithm of the shape (or its taxis, to borrow from classical thought) and one from the outside, leading to an understanding of the whole—the figure (the result of the algorithm, once solved).[62]

Houston was thus organic and machinic at the same time: "The commingling of nature and machines, be they houses, cars, or sky-scrapers, set on a prairie, on this crudely gardened version thereof, results in a Houston that is fully neither city nor tree." "Patently unloved yet naturalistic," he concluded, "this holey plane seems more a wilderness than the datum of a man-made city."[63]

What sets Lerup's analysis of Houston apart from other writing about the kind of posturban scene that has become ever more prevalent around the world is both the specificity of the site and the suggestiveness of his writing. Houston is, as he points out here and in subsequent writing, a particularly extreme case of the devolution of what we have long thought of as the urban condition. With no zoning, but also with no physical boundaries on the smooth plane on which it exists at the edge of the Midwestern plains, it has no limits to its growth and confusion. Because of the warm, swampy climate, vegetation takes over every bit of space that is not built. Water, meanwhile, is everywhere: threatening the city with floods from the hemmed-in and too-long-ignored bayous and coming down from the skies in torrents. It is as if the city were invented to prove the point that geological, climatological,

and technological assemblages are intertwined and difficult to separate. As Lerup puts it:

> Which suggests that it is the powerful web of organic relations that make Houston a palpable, cohesive reality. Here variously gendered machines rather than pedestrians are the predominating species, and clean and cool air (rather than the atmosphere of Paris or the energy of New York) is the determinant commodity. The plane, with its Zoohemic Canopy of trees, forms a carpetlike subecology dominated by dappled light, the collective purring of a panoply of machines, the invincible sting of mosquitoes. The planetary impression becomes even more compelling as the reader ascends: suspended overhead in a skyscraper two distinct strata or fields are apprehensible, one sandwiched atop the other: the Zoohemic Field below, the Aerial Field above. This huge bag of air is articulated by airplanes, helicopters, and the grandiose machinations of Gulf weather, which rolls into this upper strata quietly to surprise the drifters in the green sponge below or with terrifying fanfare. Unlike the lower strata, the bag seems underdeveloped—almost begging for more towers, more air traffic, more lights—the perfect setting for lofty speculations.[64]

This new kind of sublime is, true to the history of that condition, both terrifying and sensually attractive:

> However fractal and seismic the oceanic experience may be, it is also smooth and voluptuous. The almost continuous underside of the leafy canopy supported by the countless tree trunks forms an inverted mountain chain of green that begins to build—once again through repetition—a conception of an inside.[65]

Out of this observation, Lerup develops a theory that this "Houston" is a new kind of space. It is one that defies the traditional differentiation between inside and outside, object and field, and small and large:

> Thus Houston is at any one location both a giant room and an ocean of endless surfaces. This inner field-and-room,

Chapter 8

produced through a trajectorial subjectivity, is held in place by two planes: the ground and the canopy of trees. Both planes undulating, the fieldroom is not a space in the European (Euclidean) sense but a constantly warping and pulsating fluidity.[66]

The name Lerup develops for this particularly involuted surface/space is "dross." He defines that term at the beginning of the essay in the dictionary sense as either "waste product or impurities formed on the surface of molten metal during smelting," or "worthless stuff as opposed to valuables or value. Dregs."[67] It is thus a material that is perpetually, and in a continually changing way, undergoing state change. There is no end result to this process, however, as this particular war machine only reproduces itself without stop, growing at its edges (Lerup describes it as "a city always running away from itself") and fracturing and reforming within what we might loosely call its core.

The term "dross," however, is one that can be applied not just to Houston. Critics such as Alan Berger have picked it up to describe as "drosscape" the whole of sprawl, noting that the convolution and involution of machines of movement, buildings, and nature in a hole-ridden, fractally organized continuum is characteristic of the dissolution of the urban core all across the United States, Europe, and many other parts of the world.[68] The evocation Lerup produced can stand for much of that aspect of the global hyperobjects we inhabit at ground level.

Within, dross there are, however, moments when things happen, come together, open up, or change. Lerup describes going to a party at an art collector's house, driving through dross, confronting the security apparatus and the evocation of other places that insure and define the realm of the collection and the gathering, and finding himself in a moment where all his senses are stimulated: a "stim." Drawing on the neologism, coined by the cyberpunk writer William Gibson in his 1988 novel *Mona Lisa Overdrive*,[69] but also on the German connotations of the word with a voice (*Stimme*) or an ambiance (*Stimmung*), Lerup uses the stim to define moments of focus within dross:

> Space is granted little physical presence on the plane
> of this planet. Dominated by motion, time, and event,
> all components of this complex hide an essential

Lars Lerup, *Stim and Dross*, 1994.

THE OCEANIC

Lars Lerup, *Houston Storm*, 1994.

vulnerability—trees die, cars and markets crash, and the air slowly kills. In fact, in Houston, air functions much like our skin, an immense enveloping organ, to be constantly attended to, chilled, channeled, and cleaned. Pools of cooled air dot the plane, much like oases in deserts. Precariously pinned in place by machines and human events these become points of stimulation—Stims—on this otherwise rough but uninflected hide, populated only by the dross— the ignored, undervalued, unfortunate economic residues of the metropolitan machine. Space as value, as locus of events, as genius loci, is then reduced to interior space: a return to the cave. In these enclaves or Stims, time is kept at bay, suspension is the rule, levitation the desire—be it the office, the house, the restaurant, the museum, or the ever-marauding Suburban. Outside, the minimization of time is the dominant force that both draws lines on this erratically littered surface and gathers its pools of energy. Because once the time lines are seen to coincide and overlap, they begin to curl and twist.[70]

We should be careful, however, not to associate the stims with points or fixed moments. They are, like dross and like the condition that is Houston and sprawl in general, fluid, transient, and involuted in space and plane:

The new space emerging from the impulses of this huge envelope is transient, fleeting, temporary, and biomorphic rather than concrete, manifested, or striated. Barely visible to the classical eye, these forms appear as expanding ripples in one's consciousness, swellings, bumps, and grinds coursing through the nervous system. Erratic, unpredictable, the time line for the spatial event jumps, twitches, hums, and wiggles like an erratic hose in a gardener's grip.[71]

The stims are, however, very much rooted in technology. In fact, you might think of them as the appearance of technology, the tool-appearances or places where the particular machinic assemblage that is the urban condition reveals that aspect of our reality that consists of true machines, even if these machines are sometimes also vegetative or even human. The stim is the other to the dross, the deterritorializing and reterritorializing assemblage

operating on and as a body without organs that we see and experience as an urban site. That it is uncertain in its reality only makes the stim all the more powerful:

> Like a cyberspace, the Stim is anchored in place by much technology and machines of every type, mechanical, electronic, and biological. The imbroglio is vast, ranging from the Mexican laborers tending the gardens to the architects' studies at the academy in Rome; it gathers, in a single sweep, lawnmowers and airplanes, but also sewage pipes, floral designers, pool installers, electrical power grids, telephone calls, asphalt, automobiles, the birds drawn to bird feeder hubs, deathly silent air conditioners, mortgage banks, hunting rifles, and the little pink shrimps from the Gulf of Mexico. Many of these components and interlocking systems have, in common architectural practice, been taken for granted and ignored, while others have been dealt with as a kit of parts, each component neatly defined and rendered independent. This array forms a complex body that must, in the wet of the postwar city, be seen for what it is, a partially self-steering, partially spontaneous, yet cybernetic agglutination of forces, pulsations, events, rhythms, and machines. The neglect of any of its interlocked systems may, despite a multitude of checks, locks, gates, and balances, threaten its existence. The Age of Integration has come to call.[72]

If Chicago thus appeared as a monster leviathan to Frank Lloyd Wright, Houston, a little less than century later, appeared as an "imbroglio" of stim and dross: Stim/Dross.

In subsequent writings (and drawings), Lerup continued to extend, reiterate, and elaborate the images he produced in that first bit of revelatory observation from his apartment. He has tied the analysis to wider thoughts on sprawl but has also made suggestions for how the specific conditions of this city of Houston could be addressed by design. In the 2011 book *One Million Acres and No Zoning*, he concludes that what is needed is "The Giant Retrofit."[73] "Because it would be utopian to think the entire system could attain its former bucolic glory," he points out, "the project must begin as a piecemeal experiment altering the uneasy relation between nature and culture. There must be a way to link a

complex understanding of ecological systems to technology."[74] The operation would start with the bayous, the aqueous and uncertain ground on which much of central Houston is built, and extend from there out to encompass an understanding and a partial recuperation of the natural conditions with which Houston is intertwined. Yet his vision of subdivisions that are built with the land, of a "public awakening"[75] that will make this possible, and of a sense of place emerging out of the placenessness intertwined with the heavy dross of what Houston was and has become seems tentative, romantic, and even conservative. Gone is the embrace of the "optical pouch" through which Lerup saw the city a decade earlier and gone too is the sense of what he had placed as one of the three terms at the beginning of his "Stim & Dross" essay, together with those terms: "rethinking: to change one's point of view, find a new vocabulary."[76] What Lerup had discovered was that the hyperobject, the modern version of the monster leviathan, could not be answered or solved by traditional design operations.

What might be needed, instead, is different actors and actions, a perspective that might observe the world of stim and dross from a place different than the 28th floor of an air-conditioned aerie. Those actors turn out to have been there, at least to a certain degree, all along, but not to have found their place in a society controlled by such privileged white males as Lars Lerup—and myself.

9 Crossroads

This book has been a parade of white men. I make no bones about it: the voices that have been able to articulate and communicate ideas about architecture and urbanism in the Western world and beyond, especially ones that have been effective or evocative in the manner in which I have described, have almost all been those of males born into the privileges that come with their gender and their race. I am also such a person. What I looked for and what I have presented here is thus colored by who I am. Moreover, finding female architects and architecture critics before the 1960s involves a great deal of detective work and, though we have now identified that women were a larger part of the discipline than we had acknowledged even before the Second World War, and have come to the belated realization that their contributions were significant, we have yet to uncover visions of the sort I have outlined above that were written or drawn by women.

Some of that seeming absence is the result of direct repression, in that women were not given the chance to create or promote their visions. Even if they were able to enter the profession or the academic discipline, they faced the same pressure as men to make architecture that was serviceable and sellable, with the added difficulty that they also had to sell the fact that they as women were able to design buildings. More often than not, credit for their work was taken by men, as was often the case with one

343

of the best architects to come out of Frank Lloyd Wright's orbit, Marion Mahony Griffin.[1]

On a more fundamental level, the work of women was often confined to the making of interiors, in a manner I described in my 1993 book *Building Sex: Men, Women, and the Construction of Sexuality*[2]—and as many others have shown with more scholarship and breadth. Moreover, the work women did as interior designers was responsive, sensible, and specific, which makes deriving larger lessons from such work difficult. Where women collaborated on larger visions, as in the designs of Charlotte Perriand and Lilly Reich, credit went to their larger-than-life collaborators, Le Corbusier and Ludwig Mies van der Rohe.[3]

As I noted above, a critique of such a condition, or of my interpretation of this situation, is that the perspective and the premise are both wrong. If you start from a heroic overview of a city that is both a factory and a beast, as well as being an obviously male human body, you are bound to privilege not just a male vision but ideas of masculinity that value the grand, the large, and the sweeping over the stitching of a more subtle and material alternate reality that reveals itself at eye level or to the hand, rather than to the male gaze.

The same can be said of the lack of color in this account. Global culture has been dominated by white voices and by white constructs, not to mention that it has instantiated itself from Timbuktu to Toronto and from Xi'an to Istanbul in architecture that, if not directly created by white men, follows the precepts, principles, codes, and material choices created by and for white people.[4]

Though we are now also finding that there have been Black designers with greater achievements than we acknowledged in the past, as in the case, for instance, of Julian Abele, who was the principal designer of most of the original Duke University campus, though credit went to his employer, Horace Trumbauer,[5] here as well the ability of Black people to unfold a particular version of reality out of their skills and vision has, until recently and even today, been severely limited. As Nikole Hannah-Jones, the editor of *The 1619 Project*, puts it: "The vision of the past I absorbed from school textbooks, television, and the local history museum depicted a world, perhaps a wishful one, where Black people did not really exist. This history rendered Black Americans, Black people on all the earth, inconsequential at best, invisible at worst."[6]

Similarly, it was not until the 1970s and 1980s that Japanese and Indian architects began to develop alternatives to the Western modes of making buildings and envisioning architecture that they had learned at academies founded on Western models or by attending schools in the United States or Europe. It has only been in the last decade that similar alternatives have developed in China, though they are now doing so at a scale and a speed that dwarfs any such previous assertions of alternative traditions and ways of seeing and making in Asia. And, finally, Africa is beginning to produce some of the powerful answers to the wasteful and hierarchical modes of design that have for so long dominated the discipline around the world, although here the examples evidencing such an alternative in built form are still few.

Here as well, my perspective is compromised in that it assumes that the whole idea of a coherent, productive vision that uses built form, or at least the speculation about buildings and urban conditions, as its raw materials to construct a proposal for making a better world is tied into a particular cultural set of preconditions and biases. This is true even though what I have tried to highlight above is some of the work of those thinkers and designers who exactly questioned that tradition and sought to dissolve or problematize or simply blow it up. A nonlinear, postdualistic, and just other approach to our landscape might be in order.

It is for that reason that I turn here to other voices and perspectives that have offered contributions to anarchitecture. I do not mean to turn "the other," long a presence in Western—and many non-Western—traditions as the image to be feared, the dark unknown or the bad self, into its opposite: the alternative, promising salvation from the bad faith and internal contradictions, not to mention the environmental devastation and social violence created by white men. That Other is as much a creation of white vision and power as it is an answer to that domination, and thus has itself to be picked apart and fractured in order to restore it to its own power or realm.[7]

Rather, it is the ways in which the fracturing, fragmenting, and fractal ordering of reality; the continual breakdown of dualities and definitions; the involution of space and time, as well as truth and fiction; the continual smoothing, striation, and resmoothing; and all the other forms of dissolving the structures of power that I have been attempting to describe have found their roots,

inspiration, or even readymade constructs in cultures outside of those white, male-dominated orders that interest me. The images, texts, and, what is just as important, the voids and denials produced by people excluded from architecture are beginning to construct anarchitecture with a distinct character and characteristics.

Already, the tides have turned in many other areas of culture. Black people and voices dominate much of popular music, even though they (and women) have largely still been kept out of power in the classical realm. In visual art, if I were to make a list of the most interesting, provocative, influential, and simply best artists working in the United States and Europe today, they would almost all be either people of color or women—or both.

Only in architecture and design do the bastions of white male power still hold strong, both in terms of those making and in terms of ideas and theorizing—again, this book is a symptom of that condition. Yet, by that same token, it is exactly that exclusion that is now feeding some of the most effective and insidious (which I mean in a good way) critiques and alternatives to the bankrupt, destructive, and wasteful practices that dominate the disciplines of design. It is therefore to other voices that I now turn to find a way out of the conundrums and stalemates that have taken on such leviathan-like proportions.

I have always enjoyed the imagined other worlds postulated by (white male) writers such as Thomas Pynchon, Don DeLillo, or Neal Stephenson. The notion that there is a trace of the Thurn und Taxis postal network still surviving today,[8] or that there is a secret system of highways underneath the United States,[9] let alone that there is a secret war machine or treasure that permeates countries all around the world, has been intriguing, at least until the political climate in recent years has devolved to the point where such fictions have become pernicious memes of exclusion and outright sex, class, and race warfare. The line between the war machine and its fictional other has become thin. Yet these fictions, though they have come close to creating anarchitecture, have always stopped just short of that possibility by posing their own fictionality and painting the world in dualities between good and evil that mimic our current perceptions and preconceptions.

It is that undecidability that makes such "parafictions" so intriguing. In 1970, the Black American writer and activist Ishmael Reed imagined one of the most delicious of such other worlds in

his novel *Mumbo Jumbo*.[10] Weaving together historical occurrences and real places (some of them documented in the pages of the book through supposedly documentary photographs) with fantastical times and spaces that are believable enough to imbricate themselves through the narrative, he suggests the presence in the United State of a movement or reality called "Jes Grew," opposed by a Ku Klux Klan-like Wallflower Order:

> The foolish wallflower Order hadn't learned a damned thing. They thought that by fumigating the Place Congo [in New Orleans] in the 1890s when people were doing the Bamboula the Chacta the Babouille the Counjaille the Juba the Conga and the VoodDoo that this would put an end to it. That it was merely a fad. But they did not understand that the Jes Grew epidemic was an anti-plague. Some plagues caused the body to waste away; Jes Grew enlivened the host. Other plagues were accompanied by bad air (malaria). Jes Grew victims said that the air was as clear as they had ever seen it and that there was the aroma of roses and perfumes which had never before enticed their nostrils.[11]

Jes Grew is an aura, an aroma, a sense of presence that becomes evident only in ephemeral activities such as dance or live music. It is a way for Black people to connect and create their own community. It also has a function, though, namely, to fight white oppression and to bring back stolen artifacts to Africa and other continents. It also has deep roots in Egyptian religion, where it is associated with Osiris, supposedly the lord of the underworld but actually the true liberator who must fight the sun-worshipers of Aten, or the Atenists. Embedded in African traditions, it evidences itself in the many deities and spirits, or Loas. "Feed the Loas" becomes its mantra.

There is something Dionysiac about Jes Grew, and Reed implies the connection directly.[12] That god, who came late to the Greek pantheon from Anatolia, or perhaps Africa, is the opponent of Apollonian order.[13] Dionysius promotes excess and sensuality, but also community and a direct relationship to the land. In his world, and in that of Jes Grew, everything is completely alive—the body without organs is a continual presence. Here is how it evidences itself, in one of the few evocations of something that

might approach architecture in Mumbo Jumbo, the movement's temple in Harlem:

> PaPa LaBas' Mumbo Jumbo Kathedral is located at 119 West 136th St. The dog at his heels, PaPa Labas climbs the steps of the Town house. He moves from room to room: the Dark Tower Room the Weary Blues Room the Groove Bang and Jive Around Room the Aswelay Room. In the Groove Bang and Jive Around Room people are rubberlegging for dear life; bending over backwards to admit their loa. In the Dark Tower Room, artists using cornmeal and water are drawing veves. Markings which were invitations to new loas for New Art. The room is decorated in black and gold.
>
> A piano recording plays Jelly Roll Morton's "Pearls," haunting, melancholy. In the Aswelay Room the drums sleep after they've been baptized. A guard attendant stands by so that they won't get up and walk all over the place. PaPa LaBas opens his hollow obeah stick and gives the drums a drink of bootlegged whiskey. Stunned by the Berbelang's attack upon him as an "anachronism," he has introduced some Yoga techniques. In the 1 main room, people are doing the Cobra the Fish the Lion the Lotus the Tree the Voyeurs Pose the Adepts Pose the Wheel Pose the Crows Pose and many other. There is a room PaPa LaBas calls the Mango Room, so named to honor the great purifying plant. On a long maple table covered with splendid white linen cloth rest 21 trays filled with such delectable items as liqueurs, sweets, rum, baked chicken, and beef. The table is adorned with vases containing many types of roses. This room is the dining hall of the loas, and LaBas demands that the trays be refreshed after the Ka-food has been eaten. His assistants make sure this is done. The room is illuminated by candles of many colors.[14]

Alive with music, spirits, scents, and movement, with an uncertain sense of internal geography, let alone limits to the space, the "Kathedral" is vast and dense, spreading across many different religions and practices as well as aesthetic preferences. This anarchitecture, which predates the arrival of Deleuze and Guattari, but also has no truck with Heideggerian or Benjaminian notions of power, develops into an assemblage of possibilities that Reed

then picks apart, reiterates, and amplifies through the remainder of this relatively short text.

Ishmael Reed's writing was consciously part of the Black Power movement, not only in the United States but in the rest of the world as well. Finding its most articulate and influential voice in the writer Frantz Fanon, the movement argued for the violent usurpation of the prisons, from the literal to the national, that white people had built for people of color.[15] It also called for the formulation of different identities and ways of making. The effect in the cultural sphere was the recuperation of emblems, art-making practices, and even modes of dress and appearance that sought to recapture the traditions of, especially, West Africa. It also gave rise to the Afrofuturist movement, which proposed a mythical version of a future through the elaborate shows of groups such as Funkadelic or in the calls to action of Gil Scott Heron,[16] resulting finally in the remarkably postmodern pastiche vision of Wakanda in the 2018 film *Black Panther*.[17]

The strange—both in terms of oddness and in terms of a quality of otherness—aspect of this African aesthetic and vision was that it had by then not only survived in the underground networks Reed imagined and other sought to bring to light but had also permeated Western culture. Robert Farris Thompson, for many years a professor of art at Yale University (and white), spent much of his career meticulously tracing the ways in which aesthetic preferences in rhythms and cadences, high-affect colors and particular forms that had become beloved of artists, permeated the cultures of the Americas. He also traced how African cosmographical diagrams, pictograms, burial practices, and even stances of human figures had found themselves in every aspect of visual and oral art from Brazil to California.[18]

In 2004, the critic John Leland summarized many of these influences and attitudes in his book *Hip: The History*.[19] Tracing the word of his title back to West Africa and then to the "slave language"[20] Black people used among themselves, he describes it as follows: "Through its changes, hip maintains some constants: a dance between black and white; a love of the outsider; a straddle of high and low culture; a grimy sense of nobility; language that means more than it says."[21] That quality is one that has to escape power, which to Leland is embodied, so to speak, by abstraction. Abstraction removes resonance and room to move in favor of

function and meaning that are productive and linear. It was also the world of industrial work and the productive city.[22]

Hipness snuck in not (only) through music and popular culture, Leland claims, but also through advertising:

> Like hip, ads celebrated the aura around the object, not the thing itself. In the logic of advertising, what matters is not the essence of the thing, but the perception of it. Advertising reinvented things in the same way that Americans reinvented themselves. Identity no longer depended on pedigree like workmanship or materials, which belonged to an object's past, but was as fungible as the copywriters said it was. Ads did with products what proto-hip Americans were doing with their own identities. The explosion in hype met a quenchless hunger for the new—the perfect appetite for a country that erased the past.[23]

The purveyor of hipness is the trickster, a figure Thompson also points to as being the quintessential figure not only of the artist, but also of speaking truth to power and opening alternate, hidden worlds and possibilities:

> The role of tricksters is to introduce contradiction. Hip's role is to circulate this contradiction and validate its authors— hip is the incentive for making trouble. In *Trickster Makes This World*, Hyde argues that this learning, which incorporates the chaos of outside ideas, is a true escape from unreality— not towards misrule but toward truer order. "[M]aybe it is not the trickster who is unruly; maybe our own rules and need for order are the true authors of misrule and cruelty," he writes. "The prophetic trickster points toward what is actually happening: the muddiness, the ambiguity, the noise. They are part of the real, not something to be filtered out." Tricksters chase away the naivete that believes in life without ambiguity. The people who built America had a word for this stripping of illusion. The word was *hepi* or *hipi*, to see or open one's eyes. It is the beginning and end of hip.[24]

This trickster art, aligned with advertising and entertainment industries, becomes the alternative not only to production and consumption that is regularized and rationalized, and to human

beings who have become standing reserve, but also to violence and overt revolution. Sneaky and insidious, it makes it ways through power structures, changing everything but remaining almost invisible. To Leland, its final instantiation is the internet, in a passage he quotes from none other than Ishmael Reed:

> Long after commodity fetishism divided society from the objects around it, the logic of the Internet or DJ culture carries this dualism to its natural conclusion: the physical objects that hold samples or computer codes are practically irrelevant. The information doesn't exist to give the objects meaning; it is whole in itself. This relationship is fundamentally metaphysical, exalting something that cannot be seen or touched.[25]

To be hip," Leland finally ends his book, "is to believe in the possibility of reinvention—to understand oneself as between states, neither one nor the other, without original sin, forever on the road. Or as they said in Wolof: to see, to open one's eyes."[26]

Such an attitude is perhaps unproductive, even if it emanates out and changes so much around it. It is certainly difficult or define. This is particularly true in the realm of architecture. Any search for the evidence of architecture created by or for Black people is already complex because, as noted above, Black people received little or no credit for their work, but also because when they did manage to build, all too often their buildings were destroyed or expropriated. Even when they did finally build, they worked in the modes and within the strictures of the white world. It is notable that Reed's Kathedral, whose site is a narrow brownstone that in 2014 was replaced by a neotraditional building of a similar kind, is vast and vibrant only in its fantastical interior, and that Leland avoids any discussion of architecture.

If we look for Black architecture, as several critics have done recently, we have to open ourselves up to nothing—to the void, or the lack, or what is outside. Such a space, for instance, is Congo Square in New Orleans, one of the few larger-scale public spaces with a Black tradition in the United Sates. Now called Louis Armstrong Park, it was originally a Native American site of gathering, and then was left outside of the city grid. Perceived as a useless edge of the swamp shaded by live oaks, it became the site where Black people could gather and where much of the musical innovations

François Aimé Louis Dumoulin, *Calinda, Dance of the Negroes in America*, watercolor, 1783
(Musée Historique de Vevey).

Photographer unknown, *Rural Crossroads in the American South* (public domain).

that formed blues, jazz, and rock music first developed. As Randy Fertel notes, it was asymmetrical and focused on the round forms of the trees as well as circles of people, thus standing in contrast to the formal gathering places of white people:

> Perhaps there is something more to learn from the circles in Place Congo. Congo Square was an informal space the city planners did not lay out. Hence, improvised. There, circles organically formed according to tribal background for call-and-response drumming, chanting, and dancing. Though rivalries among tribes of origin were felt, a community emerged that crossed tribal boundaries that never would have been broached in Africa.[27]

Commenting on Benjamin Latrobe's visit to Congo Square, during which the architect observed the call and response music of people gathered there, he adds:

> Call and response goes to the very heart of the notion of good government, of popular response to the ideal leader. The community the Bamboula circles expressed and created was, we can suppose, an unspoken commentary on the imperfections of the grid-bound community across Rampart Street. The colonists, though in the first generations largely made up of the dregs of French society, used reason and logic to declare the enslaved not fully human even while the music and dancing in Place Congo articulated their humanity well-enough to impress the father of American architecture. Call and response.[28]

The result is a place of innovation and even liberation:

> Create a fixed, rule-bound, inflexible order and you can be sure that a longing for freedom with a taste of chaos will come calling. Almost like a natural, chthonic force that rises from the earth or from the soul when men in their quest for certainty get a little too orderly, disorder is sure to emerge to challenge that order. To the intuitive mind, an ordered world has always left something important out. The history of improvisation since antiquity bears this out. Improvisation is the site of a perennial battle between reason and

unreason, a battle out of which cultural innovation has flowed.[29]

Fertel goes on to discuss how that improvisation still occurs within the city grid, even when Black people find themselves caught in that realm. That improvisation, though, has a particular site and place: the crossroads. The crossroads is the realm of Elegba, the Yoruba trickster (and thus a version of every such figure from Hermes/Mercury to Loki), who asks you to make decisions about your life and its path.[30] In the Black experience in the United States, it becomes where you meet the devil and he offers you, in the case of the great blues musician Robert Johnson, the gift of music in return for your soul. The crossroads is a rural phenomenon, a place where the local church, the general store, or the bar is located. To this day, it survives in the South as the focal point of communities dispersed because of their lack of power. It is not a recognizable building or center, but rather a site of possibilities. It is not a void, but an intersection whose configuration, size, and value change over time—not just over the years, but during the course of the day, depending on who is present—and whose attributes derive from the shifting presence of structures, signs, machines, and people present there. It is an ephemeral construct that is central.

The crossroads was not lost to the Black experience once many former slaves migrated to the industrial cities of the East and Midwest. There the crossroads became the street corner where social life occurs. It became a place of trouble and possibility. Against the formal containers of the church, school, or place of work, but also in contrast to the linear spaces of the road and the formal containers of squares or parks, it was the place where you "hung out," where music and conversation appeared, and where a form of culture was born.

There is no architecture or design history of the crossroads or the street corner, and it is difficult to define.[31] It has been the subject of countless songs, from Lou Reed's "Sweet Jane"[32] and Cream's "Crossroads"[33] to Bone Thugs N Harmony's "Tha Crossroads."[34] It has appeared in movies, in literature, and in paintings, but always as a backdrop, never as a focus.

Nevertheless, there are qualities to both the crossroads and street corner that are worth recognizing. The combination of linear frontage, which was, as J. B. Jackson[35] and others have pointed

Photographer unknown, *View of Lenox Avenue, Harlem, at 135th Street, Showing Businesses, Pedestrians and Shoe-shine Stand*, March 23, 1939 (Prints Division, The New York Public Library).

out, so central to the development of a peculiarly American architecture of street fronts, and the presence by definition of signage, objects of locomotion, and other fragments of the machinic assemblage in a place where you can see and use them in relationship to each other—static, responding to each other and to you, and the subject of observation—transforms both the rural and the urban scene into a more complex reflection of that machine than the static objects that otherwise make it up. The syncopations of rhythms, forms, colors, and materials offered by this three-dimensional assemblage make it into a three-dimensional work of art or design in which you are a participant, with your perspective changing continually, so that the scene itself also evolves. The ephemerality of the space, which only really acts when people are present, makes it an even better reflection of the ways in which our social conditions are present in space.

A full history and analysis of the evolution of the crossroads, from its twin origins in West Africa and Europe, to its thickening of the Jeffersonian grid and its development as both a focal point of the Black experience and a node of American vernacular culture, to its dissolution, but also its thickening of the urban grid and its intensities, remains to be written. It is the monster leviathan writ small, slinking its way into our daily experience in a way that is barely perceptible, and thus also offers the possibility of a way to know and be at home in the complexities and contradiction of our modern scene.

On the other hand, you can also find within the seeming absence of Black subjects and marks of their presence in the built world a kind of willful negation that uses the excuse of otherness and negation to construct its dialectical other, namely light, order, and revelation. This is what the writer Darell Wayne Fields claims in his 2000 book *Architecture in Black: Theory, Space, and Appearance*:

> Much has been said of the dialectical maneuvers needed to make history "superior," but then there is barely a mention of where such procedures take place. Place is the operative word. It suggests a "place" in time, a dwelling, and (dis)placement. Nineteenth-century philosophy wants us to believe historical errors are corrected by subjecting them to negation (i.e. thesis, antithesis, and synthesis). It suggests that the material natures of errors, beings or objects, are dissipated in the process. What actually occurs is dialectical

history produces a "space" to displace its errors. Being displaced is a peculiar form of entrapment. The relegation of being outside history is achieved by being concealed within it. For historical errors, such as blackness, nothing is outside. Even time surrenders its natural state to predictable and repetitive steps of the dialectical narrative.[36]

Fields suggests that the Black subject can escape its own negation if it reconstructs "a constructive space" and a "black spatial subject." This "unique spatial 'part'" will allow the Black subject to claim a space, place, and identify for itself.[37]

In the reissue of his volume in 2015, the author investigates the possibility of such a Black constructed space/figure in a series of design projects that follow up on images created by experimental architects ranging from Claude-Nicolas Ledoux to the more contemporary John Hejduk and Lebbeus Woods. Fields's own designs, for a house for the artist Kara Walker and a cemetery, among others, evoke forms that are familiar from both the American vernacular and the avant-garde of the late twentieth century. Fields accompanies them with considerations of absence, presence, and a sense of place. Undercutting the seriousness of these images, he ends with a final dialog between the author and "the monkey," who has filled the trickster role in the book and who summarizes his position: "I may be silly. / That's certainly true. / But I know where 'I am' is. / Which is more than I can say about you."[38] Splitting himself into a serious author critiquing Hegel and an architect, Fields also splits himself into somebody making a rational argument and a trickster (not just here, but throughout the book). Yet the implication of the dichotomy rings true: the place of the Black actor in the field—whether it is in the space of Western philosophy and the Western city, or in the discipline—is what needs to be constructed, and when it is, it will wreak havoc with the formal certainties of architecture in all its guises.

The enslavement and subsequent violence and injustice perpetuated on Black people in the United States certainly remains the main issue in this country, but we also have to see this exclusion and suppression as part of a larger, in fact global, history of colonialism that has raped and pillaged people and places for centuries. It was that condition that gave voice to Fanon and to many other asking how we could right such indescribable wrongs, including how we could do so through architecture and design.

Darell Wayne Fields, *House Project, Black Signifier*, 2011.

Note, for instance, that Congo Square was a site of gathering for the inhabitants of the area before the advent of European conquerors and oppressors, and that they gave the site its own qualities. Thus critic Shelton Waldrep claims:

> The built environment, as a definition of space, is subordinated to the interconnectedness of time and place. Postmodern Native American architecture, therefore, must represent that which is non-representational, or anti-representational by Western terms. The built environment must exist as little as possible, or must make the user of it aware of its opposite—the mobile architecture of tribes, the importance of living at one with nature, and identity that is based upon a place before it was changed by European settlement.[39]

Moreover, the experience of Black Americans and their contributions to a questioning of our reality and its architecture is part of a larger movement around the world. The emergence of a Black architecture in Africa, whatever that might evolve to become, is of particular interest.

Current "post-" and "anticolonialist" strategies in architecture abound, from South America to Africa and the Middle East, and are leading to both concrete structures and proposals for different ways to think of architecture and its projects in general. In that respect, the notions of "hybrid" cultures and "interculturality" are particularly of note. Such theories see the very divisions and antagonisms created between races as part of the act of colonial oppression. As the theorist Homi Bhabha puts it:

> The exercise of colonialist authority, however, requires the production of differentiations, individuations, identity effects through which discriminatory practices can map out subject populations that are tarred with the visible and transparent mark of power. Such a mode of subjection is distinct from what Foucault describes as "power through transparency": the reign of opinion, after the late eighteenth century, which could not tolerate areas of darkness and sought to exercise power through the mere fact of things being known and people seen in an immediate, collective gaze.[40]

Darkness, a confusion of identities, and the possibilities of crossing boundaries are what will help us break out of such modes of oppression:

> This is the question that brings us to the ambivalence of the presence of authority, peculiarly visible in its colonial articulation. For if transparency signifies discursive closure—intention, image, author—it does so through a disclosure of its rules of recognition—those social texts of epistemic, ethnocentric, nationalist intelligibility which cohere in the address of authority as the "present", the voice of modernity. The acknowledgement of authority depends upon the immediate—unmediated—visibility of its rules of recognition as the unmistakable referent of historical necessity. In the doubly inscribed space of colonial representation where the presence of authority—the English book—is also a question of its repetition and displacement, where transparency is technē, the immediate visibility of such a regime of recognition is resisted. Resistance is not necessarily an oppositional act of political intention, nor is it the simple negation or exclusion of the "content" of another culture, as a difference once perceived. It is the effect of an ambivalence produced within the rules of recognition of dominating discourses as they articulate the signs of cultural difference and reimplicate them within the deferential relations of colonial power.[41]

Throughout the book quoted above, *The Location of Culture*, Bhabha thus identifies liminal spaces, places dominated by shadows and ambivalence, and thresholds as holding the possibility of a different architecture that would bring with it not just social justice but an antiracist, antisexist, and anticapitalist space. As he says at the beginning of the text, "These 'in-between' spaces provide the terrain for elaborating strategies of selfhood—singular or communal—that initiate new signs of identity, and innovative sites of collaboration, and contestation, in the act of defining the idea of society itself."[42]

It is these "interstices—the overlap and displacement of domains of difference," that interest Bhabha. These spaces allow for a different form of representation or significance, one wrought

through with multiple meanings and addresses, but also with shifting modes of appearance. They can be as simple as stairwells:

> The stairwell as liminal space, in-between the designations of identity, becomes the process of symbolic interaction, the connective tissue that constructs the difference between upper and lower, black and white. The hither and thither of the stairwell, the temporal movement and passage that it allows, prevents identities at either end of it from settling into primordial polarities. This interstitial passage between fixed identifications opens up the possibility of a cultural hybridity that entertains difference without an assumed or imposed hierarchy.[43]

Instead of boundaries, Bhabha is interested in bridges;[44] instead of distance, closeness and overlap.[45] Hidden within the domestic space, there are more possibilities to be found:

> The recesses of the domestic space become sites for history's most intricate invasions. In that displacement, the borders between home and world become confused; and, uncannily, the private and the public become part of each other, forcing upon us a vision that is as divided as it is disorienting.[46]

This space should not, or cannot, be contained within the home, however. It is exactly the confusion between public and private that creates the possibility for the open kind of hybridity Bhabha has in mind:

> If, for Freud, the unheimlich is "the name for everything that ought to have remained . . . secret and hidden but has come to light," then Hannah Arendt's description of the public and private realms is a profoundly unhomely one: "it is the distinction between things that should be hidden and things that should be shown," she writes, which through their inversion in the modern age "discovers how rich and manifold the hidden can be under conditions of intimacy."[47]

And: "To live in the unhomely world, to find its ambivalences and ambiguities enacted in the house of fiction, or its sundering and splitting performed in the work of art, is also to affirm a profound

desire for social solidarity: 'I am looking for the join . . . I want to join . . . I want to join.'"[48]

Though Bhabha describes this space quite literally, he also means it as a political space, an abstract site of translation and transformation:

> The challenge lies in conceiving of the time of political action and understanding as opening up a space that can accept and regulate the differential structure of the moment of intervention without rushing to produce a unity of the social antagonism or contradiction.[49]

This explosion of the domestic realm or implosion of the public one, and the hybridity that results, have already happened, says Bhabha, citing one particular example:

> The veil that once secured the boundary of the home— the limits of woman—now masks the woman in her revolutionary activity, linking the Arab city and French quarter, transgressing the familial and colonial boundary. As the veil is liberated in the public sphere, circulating between and beyond cultural and social norms and spaces, it becomes the object of paranoid surveillance and interrogation. Every veiled woman, writes Fanon, became suspect.[50]

The answer to this situation must be a new definition of culture, one that revels in its slippery, hybrid, unproductive hybridity:

> Culture becomes as much an uncomfortable, disturbing practice of survival and supplementarity—between art and politics, past and present, the public and the private—as its resplendent being is a moment of pleasure, enlightenment or liberation. It is from such narrative positions that the postcolonial prerogative seeks to affirm and extend a new collaborative dimension, both within the margins of the nation-space and across boundaries between nations and peoples.[51]

This "liminal moment of identification—eluding resemblance"[52] is a critical and elusive strategy, Bhabha claims. It allows

all of us, including the oppressed and excluded, to make a place and build an identity for ourselves, but only as part of a community. However, that grouping is fluid, turned outward (or rather spiraling between inside and outside), and always existing on edges, in shadows, appearing in modes that are unfamiliar and in spaces that are unhomely by definition. That does not mean it has no strength:

> Community is the antagonist supplement of modernity: in the metropolitan space it is the territory of the minority, threatening the claims of civility; in the trans-national world it becomes the border-problem of the diasporic, the migrant, the refugee. Binary divisions of social space neglect the profound temporal disjunction—the translational time and space—through which minority communities negotiate their collective identifications. For what is at issue in the discourse of minorities is the creation of agency through incommensurable (not simply multiple) positions. Is there a poetics of the "inter-stitial" community? How does it name itself, author its agency?[53]

What might such an "antagonist supplement of modernity" that forms a community be, if it is not to "resemble" anything? Bhabha spends much of his book speculating on the possibility that semiotics, mainly because of its necessarily open and self-contradictory structure, allows for such a post-mimicry of signification. He proposes intimations, implication, imbrications, and other forms of hints that are yet, and exactly because of their multiple possibilities, specific in the effects they have. The models Bhabha uses are to a large part taken from architecture. He talks about making a place, opening a space, crossing boundaries, occupying liminal space, confusing public and private spaces and modes of presentation (interior and exterior facades), and building community. It would be up to those with the skills and knowledge in architecture and design to take such evocations of possible anarchitecture toward some form of, however darkness-shrouded, form.

There is, in fact a tradition of such forms of boundary-crossing and ambivalent architecture. It comes from another history of repressed presences in architecture, namely of the half of humanity that is women. It is their bodies as alternate models

and presences, their modes of being in space as it has been forced upon them by male-dominated societies, and the places, appearances, and communities, the machinery of an organic architecture beyond the grid and axis, that are now becoming anarchitecture.

The particular place women have made for themselves in what is still an almost exclusively manmade world is the interior, and it is in the disciplines of interior design and decoration, with the particular skills that it demands, that women have, again until recently, made their most visible contribution as designers. The question is whether, from that perspective of interiority, with its turn away from outward presentation and limits, but also away from the hierarchical, geometry-based, and power-presenting attitudes architecture imposes on the outline of the interior, that interiority has anarchitecture to offer.[54]

Although I thought some of the most thoughtful and the most extreme interior designs of the nineteenth and twentieth centuries, as well as the fictional evocations of even more fantastic spaces and their decors, held promise for such an alternative way of world-making in the interior, in the thirty years since I started researching this aspect of design, I have found little that has, in my opinion, opened new possibilities within the discipline.

In the meantime, the active field of women's studies, while recovering the work of women architects and their contributions to that field, has also postulated ways of seeing, knowing, and making that do suggest or intimate other possibilities. Thinkers from this perspective turn back to the importance of the body, for so long ignored except as a tool of measurement or a machine demanding functional accommodation in the field of architecture, as well as to the modes of community-making that women, much more than men, have been able to construct over the millennia.

It is Luce Irigaray, together with Julia Kristeva and others, who has most clearly articulated the architecture not only of the human body in and of itself, but as a connecting, bridging, and pleasure-experiencing thing. Irigaray is explicit about the founding of such particular power in eroticism and, in particular, in the eroticism of which only women are capable:

> Thus, for example, woman's autoeroticism is very different from man's. In order to touch himself, man needs an instrument: his hand, a woman's body, language. . . . And this self-caressing requires at least a minimum of activity.

As for woman, she touches herself in and of herself without any need for mediation, and before there is any way to distinguish activity from passivity. Woman "touches herself" all the time, and moreover no one can forbid her to do so, for her genitals are formed of two lips in continuous contact. Thus, within herself, she is already two—but not divisible into one(s)—that caress each other.[55]

"Her sexuality," Irigaray goes on to say, "is plural . . . *woman has sex organs more or less everywhere*. She finds pleasure almost anywhere. Even if we refrain from invoking the hystericization of her entire body, the geography of her pleasure is far more diversified, more multiple in its differences, more complex, more subtle, than is commonly imagined—in an imaginary rather too narrowly focused on sameness."[56]

What arises from this sufficiency in and of itself and from this doubling that Irigaray believes is central to the way women experience and inhabit the world is an essential plurality that stands as an alternative to the rational economy of separate bodies and objects, and thus of ownership:

> Woman always remains several, but she is kept from dispersion because the other is already within her and is autoerotically familiar to her. Which is not to say that she appropriates the other for herself, that she reduces it to her own property. Ownership and property are doubtless quite foreign to the feminine. At least sexually. But not *nearness*. Nearness so pronounced that it makes all discrimination of identity, and thus all forms of property, impossible. Woman derives pleasure from what is *so near that she cannot have it, nor have herself*. She herself enters into a ceaseless exchange of herself with the other without any possibility of identifying either. This puts into question all prevailing economies: their calculations are irremediably stymied by woman's pleasure, as it increases indefinitely from its passage in and through the other.[57]

This nearness allows women to be in a position of "jamming the theoretical machinery itself," and thus challenging, by stating her own sufficiency and overflowing pleasure, her ability to operate through nearness, the "economy of the logos."[58]

Irigaray offers not a vision, let alone a proposal. What she instead brings into our awareness and into operation in the discipline of architecture (among other cultural endeavors) is sensuality, pleasure—for which she and Kristeva use the French word *jouissance*—and fluidity:

> *Yet one must know how to listen otherwise than in good form(s) to hear what it says.* That it is continuous, compressible, dilatable, viscous, conductible, diffusible. . . . That it is unending, potent and impotent owing to its resistance to the countable; that it enjoys and suffers from a greater sensitivity to pressures; that it changes—in volume or in force, for example—according to the degree of heat; that it is, in its physical reality, determined by friction between two infinitely neighboring entities—dynamics of the near and not of the proper, movements coming from the quasi contact between two unities hardly definable as such (in a coefficient of viscosity measured in poises, from Poiseuille, *sic*), and not energy of a finite system; that it allows itself to be easily traversed by flow by virtue of its conductivity to currents coming from other fluids or exerting pressure through the walls of a solid; that it mixes with bodies of a like state, sometimes dilutes itself in them in an almost homogeneous manner, which makes the distinction between the one and the other problematical; and furthermore that it is already diffuse "in itself," which disconcerts any attempt at static identification.[59]

What might such architecture of jouissance be? It would be something that could not be built, nor actually written precisely as a description or even posed as an entity. It could only be evoked, we have to assume, within the act of pleasure itself—which means not only sexual pleasure, but also the pleasure of nearness and connection, the community that exists in the construction of a community that always and only exists in relationship to the body and bodies. That would seem to be far away from what we think of as architecture, with its solid bodies of buildings, its functionality, and its rational orders. It is also difficult to find this architecture of nearness and pleasure as it hides in those places where it is not interrupted by the male machine and its structures. We can only dream of it, and I, as a man, might not even be given that pleasure.

Where such jouissance might enter the realm between the public and private is in architecture made by those people who do not identify themselves as men with all the attributes and preconditions we attribute as a society to that self-definition and who are, for that reason, often placed in the shadows, in an in-between, and in a place where they define themselves with the core of how they obtain sexual pleasure. I am speaking here of those people (such as myself) we today define with the ungainly initialism of LGBTQ. As a supplement, an embellishment, or a cut through this history, the contributions made by LGBTQ people cuts through the machinery of architecture, de- and reterritorializing it.

The primal model here is the closet, that place where implements and instruments are stored, as well as the clothes through which you appear to the world. It is a place of shadows and even complete darkness. Coming out of it means emerging from the shadows, accoutered with some of what you found there, but the closet always remains part of the life of any queer person (I use the phrase as shorthand here for the whole spectrum of gender and sexual choices beyond or around "straight" or "normative") who had this experience, even if only in their youth. The closet in fact becomes a social space, one that queer people could navigate in a manner that recalls the world of Jess or some of the other mythical descriptions of the urban landscape.[60] A network of gestures and modes of appearance connected people across, through, and within the spaces of "polite" society. The raise of a hand or of an eyebrow could move two people from social interaction in a drawing room, the kitchen of a party, or a store to another space where they could enact the kind of nearness Irigaray describes. The spaces of everyday life become riven and fractured by such connections, opening seams of sensuality, connection, and community within them.

Though such spaces and structures are largely invisible, latent, and dependent on the actions of the actors in the queer drama, they do open in the shadows. In private spaces where queer people make homes for themselves, but also in the places where they gather, queerness finds its sedimentation or its effusive display in the way interiors and their components are composed in a manner that emphasizes exactly the act of acting, of passing as something other than one is. It is here that the baroque lives on even in more classical or modern times, and even shades off into the waves of curves and curlicues that make up the rococo. That is not to say

that only such styles are possible, but it is the queering of neo-classicism into a neo-baroque and neo-rococo, and the queering of modernism into postmodernism, that becomes a hallmark of queer space.

At first, such space exists only inside, in the shadows, but it soon pushes to the outside, first in the buildings commissioned by queer people powerful and rich enough to do what they liked—such as King Ludwig II of Bavaria[61] or William Beckford,[62] even though both of these ultimately paid the price for their showy expressions—and then in the manner in which queer people managed to let their sensibilities flow out onto the facades of buildings, as Louis Sullivan did in late nineteenth-century and early twentieth-century Chicago, or as Jan Kotera did in Czechoslovakia a little later.[63] The history of twentieth-century architecture and urbanism includes a vein of such acts of queering, which I tried to document in my book *Queer Space: Spaces of Same Sex Desire* (1995),[64] and more of which appear as research uncovers the connections, the sensibilities, and the modes of appearance of queer people throughout that period.

Beyond such high-design machinery of queerness inserting itself through a deformation of both interiors and exteriors of buildings—as well, of course, as through similar mechanisms in visual arts, literature, and performance—and beyond the limits of polite society in general, another queer world emerged. In the shadows of buildings, at the edges of the city on piers and in abandoned buildings, in public parks, and in places of gathering in the back of other spaces, in basements or in attics, queer people found each other, nearness, and sex. Over time, some of these spaces disappeared or became part of what most people considered normal life, and their queerness was appropriated. A few survived as an obscene other space hiding in the shadows.

Out of such spaces, queer people pioneered the restoration of abandoned or disused sites, making piers and industrial sites into destinations that attracted other businesses and then whole communities around them. In cities around the world, queer people pioneered the renovation of neighborhoods such as the Castro in San Francisco, the East Village in New York, and the Marais in Paris. There, they created an artificial community, with all the attributes and services of neighborhoods that had grown up in cities over the centuries, but with a particular focus and a greater sense of theatricality. From the "painted ladies" of San Francisco to

John Rutter, Fonthill Abbey, Wiltshire: Great Western Hall, 1823 (RIBA Collections).

Leonard Fink, *Postcard 97*, 1979 (Leonard Fink Collection, The LGBT Community Center National History Archives).

the grunge bars of Berlin and the Love Parade that burst out of that scene, queer people made anarchitecture that traced urban forms, and especially the fragments of technology—from the postindustrial sites where sex and then clubs happened to its disco music of machine-created beats to the implements of S&M wear—woven around acts of nearness and jouissance.

Before that queer space could blossom into larger and more experimental forms, however, the twin phenomena of the AIDS pandemic and, ironically, the acceptance and eventual mainstreaming of queerness defeated that possibility. The mechanism of AIDS and the apparatus that came to surround it, from the insidious killer that came from jouissance and nearness, to the medical machinery surrounding sick people, became a sick and perverse other to the machinery of liberation queer people had constructed. Queer space became the space of hospitals and hospices, of isolation and distance, and eventually of drugs that kept the virus closeted, but always present in the body, a pharmakon continually doing war with other pharmakons.

Meanwhile, being queer ceased, at least in much of the developed world, to carry a stigma. Marriage became legal, as did queer sexual acts, and the need to hide in shadows dissipated. Who you wanted to be near to or have sex with, or how you identified yourself, became much less of a definer of culture or community, to the point that, among the young members of the educated elite not just in the West but in many countries around the world, who you fuck when has little to do with how you define yourself or your world.

Several artists and architects have still worked to create anarchitecture in the post-AIDS era. Most prominent among the former are the Berlin-based collaborators Elmgreen & Dragset. Their art has evolved from direct commentary on spaces, for instance by burying rooms in the ground or by warping the floor of a gallery so that it becomes inaccessible, to the construction of increasingly elaborate stage sets. Usually installed in museums or exhibition spaces, they are tableaux-vivants that invite participation. All assume a deceased or now-gone queer inhabitant, who has left behind a scene of collections through which memories and associations seep to those who look carefully enough or listen with enough skepticism to the words of the guides the artists provide, to figure out the hidden lives inherent in what is present.[65]

The Spanish architect Andrés Jaque takes a more direct approach. While his early work consisted of three-dimensional collages that gave inhabitants tools and implements in which to inhabit renovated buildings, either for living or for gathering for social settings, more recent projects are more complete, if decidedly baroque and sometimes even disturbing scenes. In 2016, Jaque turned his attention to the internet, and in particular to those apps and social networks, such as Grindr, that are focused on (male) queer sex. Seeing these as creating a new kind of social space, he speculated about how the otherwise banal and singularly goal-oriented frameworks this bit of software provides could be appropriated and elaborated.[66]

But he also found within the acts of using Grindr and similar apps the beginning of a new approach to design. As he pointed out in 2017:

> The texture of a smartphone's alkali-aluminosilicate glass screen is similar to smooth skin, so as you rub your thumb down the display of Grindr users, it is like touching the young, hairless skin of a naked body. The display promotes interaction: blocking, favoriting, and messaging are the next steps. When a user's picture is tapped, his profile expands to occupy the whole screen.[67]

"Grindr," he claims, "is an online archiurbanism that enables offline spatial layering; creating a multiplying type of space where simultaneous techno-human settings can be promoted."[68]

He goes on to claim:

> Grindr is a zone of its own. It is not a city. Whereas cities are often seen as places for social convergence, Grindr is a device that sorts out the social, an infrastructure rendering its users as selected members of a specialized community within society. It is enacted more than constructed. It is neither fully virtual nor physical. It is an archiurbanism that—evolving from the long-running traditions of queer urban lacunas where normativity was challenged and cruising strangers became possible—has reinvented the offline domain. . . . Grindr provides transparency, but not the universal transparency of modernist glass; it provides

Elmgreen & Dragset, *The Collectors*, installation view, Danish Pavilion, Venice, 2009; photograph by Sandra Stemmer (courtesy of The Danish & Nordic Pavilions and the artists, 2009).

selective transparency among those participating in an exclusive layer of a fragmented transnational urbanism, made in the intersection of bytes and flesh, that comprises five trillion bytes of data in use, stored in servers located in 23 sites in only two countries: the US and China. . . .

Cities do not accommodate Grindr. Grindr became the city. It is also itself a form of architecture, one based on the collaboration between heterogeneous technologies operating at different scales. One that has redefined what being in a room means, the notions of proximity we live by, what density is about. One that requires aesthetics, interfaces, and memberships that are sensed. One so successfully integrated in daily life that it is rarely noticed. Grindr is an archiurbanism. Operating globally from two world locations, Grindr is shaped by a simple code that diversifies locally in a myriad of ways for gayness to be collectively instituted. It becomes a milieu for gay men to constitute themselves as a collective of strangers, as a response to LGBTQ marginalization, overlapped with other forms of techno-human networking. It has also become an interface where entitled citizens and disenfranchised people may interact and where people, both settled and in transit, can find opportunities to connect and collaborate. In many Western cities, Grindr is in part both the cause and effect of the displacement of queer urban space by condominium towers.[69]

Jacque's exultant paean to the liberating possibilities of this particular app, though shot through with questions about its economic purpose and limitations, promises a trans- rather than a posturbanism, and a trans- rather than postmodernism. The technology and the human connections it carries along with it cut through physical structures to bring particular structures together, liberating the participants not just sexually but politically.

Might it be possible to imagine such a transurbanism operating in a queered community where "the binaries" are being replaced by multiple modes of being as well as appearance? Certainly, the music videos[70] the hip-hop artist Lil Nas X released as follow-up to his trans-genre "Old Town Road" (2018) promise a baroque constellation that is large enough to encompass both a jail and all of heaven, hell, and purgatory. Might such anarchitecture further

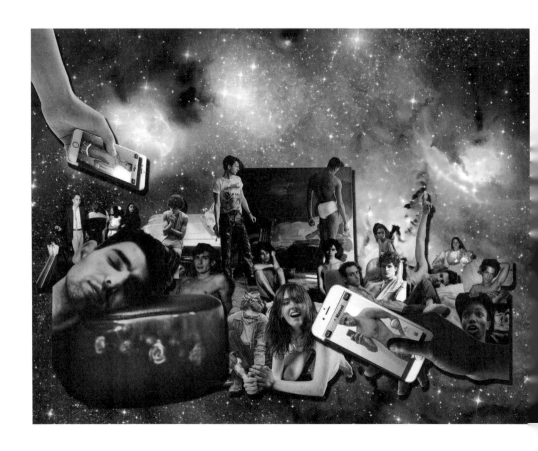

Andrés Jaque / Office for Political Innovation, *Intimate Strangers*, 2016; video installation
first presented in the London Design Museum as part of the exhibition "Fear and Love:
Reactions to a Complex World," November 24, 2016–23 April 23, 2017 (Elmgreen & Dragset).

infest the city and its forms to the point that its familiar shapes dissolve or fade into each other and into the machinery of everyday life—not to mention our own all too human bodies?

The promise of a transarchitecture as a mode of anarchitecture is, in other words, a vision of how we are in space and place in a postdigital environment. Though made possible by technology, it is, like all such modernist visions, not composed of the machinic assemblage but seeks rather to imbue it with . . . a soul?

10 *Ghost*

Imagine yourself standing at midnight in one of the great urban squares that have come to define our urban reality in the twenty-first century: Times Square in New York, of course, or Shibuya Crossing in Tokyo, but also the Strip in Las Vegas, or any number of locations in Shanghai, Shenzhen, Istanbul, or São Paulo. Images of other places, of people larger than skyscrapers, of swirling colors and mutating forms pulsate around and over you. Some of them are as small as the screen of the phone you hold in front of you as you continually locate yourself in these fluid places. Others are large enough to take over or obscure the facades of buildings where thousands of people are working, shopping, or living. You are surrounded by thousands of other people, few of them living or working right there, who have been brought to this site by an infrastructure of vehicles, but also of desire and advertising, that spans the globe. Maybe you are not even there as a body. You are part of the space as an avatar, or just watching from the constellation of screens you have arranged around your desk or bed. You are there in StimDross, and yet you are nowhere.[1]

There are no buildings in these spaces, and the machines that are present slide by behind skins that reflect the signs, glistening and even changing hues as they move. The surface of your phone is smooth and there is no obvious source for the images around you. People appear and disappear, for real and as images or texts,

Photographer unknown, Shibuya Crossing, Tokyo, no date (public domain).

Photographer unknown, Times Square, New York, no date (public domain).

accounting for themselves as avatars of the many clans to which they belong. The intensity of the place comes not from activity but from imagery, and its edges are as difficult to define as the border between you and the person you are seeing or chatting with as you wander. Except during celebrations or demonstrations, there is no focal point to either the structures or the activities in this space. There is only the miasma of human-machine-urban ebbing and flowing, coming into focus and dissolving again around you.

In the morning you are far away, waking up in your bed. The first thing you do is to open your screen and its endless collage of spaces and people. You plug yourself into the machinery of caffeine and cleansing, dress yourself fast in fast fashion that continually changes how you appear, and participate in the institutions of work, play, or politics, perhaps even without leaving the cell whose contours you have hidden with your own décor. Perhaps you do not even leave your space. Even if you do, your place of work, study, or sport is suffused with machinery that ranges from the real to the ephemeral, displaying, counting, surveilling, communicating, presencing, presenting, connecting, collecting, dissolving, constructing, and collaging together the stage set on which you act.

This is you and me in our daily lives, at least if we belong to a certain class and inhabit one of the urban scenes or their extensions and satellites in suburban and exurban settings. That scene is becoming ever larger and more pervasive. It is the monster leviathan as a ghost, haunting all of our lives. As the critic Reinhold Martin has said:

> a near-universal proscription against utopian thought and speculation. This, above all, is what puts the "post" in postmodernism. . . . But like a ghost, what is repressed tends to return, transfigured. This logic of futurity, the eternal return of the repressed utopian future, haunts postmodernism and to some extent defines it, even as its architecture seems condemned to reproduce a world-historical status quo.[2]

What is the role of the designer in this veiled, exploded, transurban, and otherwise slippery scene? What anarchitecture do we have here?

The obvious answer is to go with the flow, to surf the zeroes and ones, and to figure out how to make digital. That is to say:

how to not just use the myriad software programs, as well as the computer-operated methods, to create models or other representations of reality, but how to make form that is truly digital-native. That would mean making architecture that was not only produced by digital modes, but that could only exist within that realm. If the world out there is inhabited by digital ghosts, architecture could abandon its concern with gravity and scale, and just set the scene for all the digital actors to play their part. This might not even mean abandoning "meat space" per se, it would just mean concerning yourself as an architect with its digital effects rather than its structure or plumbing.

It is important to distinguish this digital anarchitecture from the styling of existing forms that dominates so much of the profession. Every architect uses computers these days, even if some of them have banned them from their actual studios. Not all buildings display the traces of these forms of design or production, at least not overtly, but just about all of them are only possible because of digital calculation at some point in the design and fabrication process. Many, however, are streamlined into bulges, bullnoses, and whiplashes that strain the ability of machinery to make them and can produce slicker or more exciting versions of existing forms. All continue to establish current power conditions and ways of seeing the world in their construction and entomb the values of those who commissioned them in forms we all have to live with.[3]

Since at least the 1980s, when computer-aided design methods became more available to architects, some designers have been theorizing that the computer might be a tool of liberation. The basis for a virtual building, after all, would be ephemeral by definition. It would be an extension of lines of codes that existed only within the storage device of the computer themselves. Moreover, codes work to territorialize and deterritorialize information continually, allowing it to appear in skins and relationships that could alter as one fed more code into the device. The most exciting possibilities, moreover, are nonstatic and nondeterminant. Algorithms are used to optimize and explore, and "splines" became the backbones of some of the more fluid forms.

The architecture that experimental designers were imagining then could be completely other in terms of its rules. Its geometries could be unknowable or continually shifting. It could be dynamic in time as well as space, morphing (a word these programs turned

into an accepted part of the English language). The computer, it turned out, was also not just a producer in the mode its name it implied. Hooked to scanning devices and later to cameras, it became a hunter and gatherer of images and forms. An architect could use anything as a building material, from the folds of medieval sculpture (as Frank Gehry was famously fond of doing) to the scraps these designers, like modern-day Schwitters, could find on the street. Scan, warp, layer, extend, and then scan again became a nonlinear and open-ended alternative to the usual processes of research, development, and construction that had guided architecture since its inception.

Other fields, from literature to the arts but also including the pre-Cambrian explosion of experimental website design that flourished at the end of the last decade of the twentieth century,[4] showed the possibilities of a mixed reality in which digital avatars could float in front of your eyes and in which you could immerse yourself in what the writer Neal Stephenson termed the "metaverse." Designers could imagine blowing up the boundaries of the real to boldly go wandering through veils of information and forms whose reality or meaning was unstable. On the internet, anybody or anything could be God or a dog, a machine or a human, there or not there. Thus, architecture could be, if not anything, many things in many ways of which architects had previously only dreamed. You could actually build Boullée's cenotaph for Newton, but you could also make architecture with the staccato rhythm of electronic music (or early video games) or the mutated imagery familiar from science fiction films.

This promised land faded into the farthest reaches of experimentation almost as soon as it appeared. Architects realized that translating their explorations into built form meant burying exactly the most ephemeral aspects of their design. It also meant quite simply making choices—famously, how do you put a door in a blob—that brought back the hierarchies of function and inside and outside that still kept buildings enchained.[5] The innovations early digitally based architects and designers developed lived on in some game design, as that field quickly became the largest commercial outlet for designers fascinated by digital design, even though they had to their bury their designs in forms that looked recognizable, and even if the resulting worlds were extreme versions of war-ravaged landscapes or death stars in outer space.[6]

On a more prosaic level, the socially critical modes of which Ben van Berkel and Caroline Bos had dreamed when they founded UN Studio, or which drove the work of Zaha Hadid toward what she saw as an open and democratic public architecture, turned into the continual production of large-scale commercial buildings in which only the slick skins and curving spaces memorialized their idealistic beginnings. While Greg Lynn, who first introduced the notion of "blobs" to architecture, dreamed of the ability to "model form in association with force"[7] and hoped to create architecture beyond the fixed prototype in space that had become a "medium populated by differential forces,"[8] he left behind his beautiful, biomorphic shapes that had existed in the computer, as well as experiments in gathering cast-off children's toys, cut and manipulated by lasers, in favor of designing luggage that would follow you around. And, while Patrik Schumacher, in one of the most complete disquisitions on the possibilities of what he called "parametric architecture," said that he would create architecture consisting of an "autonomous network of autopoetic system of communications," not just buildings,[9] he found salvation in taking over Hadid's office and turning it into a large-scale producer of office buildings. The "endlessly varied elements" he imagined became, despite his protestations (at first), a style.[10]

That is not say that some architects did not and do not continue to experiment.[11] Thus, the still-small studio Asymptote Architecture (Hani Rashid and Lise Anne Couture) has extended their experimentation with scanned and extruded objects into proposals for buildings, even if few of them are constructed, while Philippe Rahm continues to experiment with another ideal of modern architecture, namely the making inhabitable space purely through the manipulation of energy and thus temperature and atmosphere.[12]

Just as interesting as going with the digital flow, and perhaps more important, became the question of what this new technology meant on a more conceptual level for the very coherence and aim of architecture. By the early years of the twenty-first century, it was becoming clear that the digital domain was not only changing particular processes of making or modes of communication. Technology was now so pervasive that the doubts about reality thinkers had been voicing for decades were now becoming part of daily practices.

To figure out how to make a way for themselves in this reality, architects were already turning to philosophy that assuaged their fears and offered them new tasks, as Tafuri had predicted computers would. "Object-oriented ontology" was, after all, a way to think beyond the object as fixed or existing in itself, understanding its shifting reality as tool, appearance, stand-in, and ephemeral evocation of some unknowable real. On a practical level the digital takeover of reality, with the semiautomatic production of buildings it caused, made it clear that architects had to operate as operators of symbolic logic, as Robert Reich put it.[13]

What did that mean for architects as such creative software engineers? As Lev Manovich, who led the way in tracing the emergence of the digital sphere, suggested:

> Software has become our interface to the world, to others, to our memory and our imagination—a universal language through which the world speaks, and a universal engine on which the world runs. What electricity and the combustion engine were to the early twentieth century, software is to the early twenty-first century.[14]

"What I am saying," he goes on to say, "is that at the end of twentieth century humans have added a fundamentally new dimension to everything that counts as 'culture.' This dimension is software in general, and application software for creating and accessing content in particular."[15] The cultural operator is operating in and on a new field, albeit one of which philosophers and artists had been painting the contours for decades.

For Manovich, what is of the essence is the "remixability" of our culture, in which not just images but different media and degrees of reality become continual assemblages.[16] The result is what he calls the "metamedium" of the computer,[17] which is an all-pervasive, continually transformative machine for stripping, reconstructing, reassembling, and then recontextualizing and rebuilding reality. Individual works of art, let alone buildings, are only parts of this continual process of remaking.

The architect Adam Fure takes Manovich's reasoning one step further:

> Computation is not limited to computers anymore; it's all around us. We now face an ecology of digital media

Asymptote Architecture, NYSE Virtual Trading Floor, 2015.

that affects us empirically, ontologically, and aesthetically. Architecture is likely experiencing what new media theorist Lev Manovich described in 2001 as "transcoding," a process by which the computer's "ontology, epistemology, and pragmatics" fundamentally transform the cultural content that develops from its use. In transcoding, the artifacts that emerge from using digital technology deeply resemble its internal structures and logics. In other words, we start to see, think, and make like computers. . . . Today, architects are placing their speculative designs in overtly digital environments, rather than realistic physical settings. Stylistic imitation is no doubt at play here, but I believe this trend signals a deeper shift; namely, designers are starting to see the computer not as a tool to represent the "real," but as itself another real, one in which they are deeply embedded. Computational environments are becoming the default and defining contexts for architectural production. Real space is shifting from the physical world of buildings to the infinite, gravity-less modeling environments of Rhino and Maya and the layered canvases of Illustrator and Photoshop.[18]

Though he concludes that there is still a place for architects in this "expanded realm of materiality, where everything from bricks to bits can be authored," it is a rather nebulous one: "the act of revealing and authoring background computational processes."[19] The architect would thus be a revealer of the ghost inside the machine, perhaps in a twenty-first century of Wright's vision that is yet to be constructed.

Chandler Ahrens and Aaron Sprecher are a bit more definite (so to speak) about what that role could be. They note:

We are now able to identify that the nature of information technologies entails three main shifts in the way we approach architecture—its movement from an abstracted mode of codification to the formation of its image, the emergence of the informed object as a statistical model rather than a fixed entity and the increasing porosity of the architectural discipline to other fields of knowledge.[20]

The promise of such architecture is also uncertain, but certainly alluring:

Chapter 10

The images are supple and pliable in the process of generating them. The code can be adjusted and variations rapidly generated for analysis, measurement, and testing. The manipulability allows a flickering back and forth between data and image, the abstract and concrete. The movement from abstract to concrete, from non-image to image, is able to reveal non-visual worlds generated from information. The impact of this change in the status of the image resonates throughout the arts and sciences disciplines.[21]

"All of the various media in the arts," they continue,

can be argued to have the ability to affect human perception but given that architecture's main method of expression is through physical presence, materiality, tectonics, and spatial experience means that by its nature, it is affective. Thus, the discussion of images in architecture is not limited to graphic representations, but rather includes modes of experiencing physical objects and environments. The relationship of the viewer to an object's surface reconsiders the image as evidence of how people perceive and are affected by their environment. The affective dimension of the image is able to stimulate a "topography of sensations . . . that emotionally binds people to their world" through the subtle interrelations between people and the architectural surfaces that define their milieu.[22]

They conclude:

The source does not rely solely on geometry but has shifted focus toward environmental phenomena, ecology, atmosphere, mood, visual effects, historical references, and the affective dimension of human interaction to name a few. These diverse sources of relationships are integrated into the computational procedure to inform the generation of the object. The post-digital search for meaning following the excesses of formal exploration does not abandon computational procedures, but rather expands the capacity of the object to be synthesized from more informed relationships, creating an array of topological potentiality.[23]

These conclusions are not theirs alone: in the practices of academia, as well as in some of the more interesting endeavors of those who still think of themselves as architects, an emerging interest lies in the field as the territory of operation. "Topographics," first of all, builds on the notion of "building with the land" and seeing architecture as an unfolding of existing landscapes, both natural and human-made, rather than the construction of objects.[24] The difference now is that this unfolding is continuous, rather than occurring only in the process of design, leading to something that, though it might have landscape characteristics, is still ultimately a building. Yet there is a leviathan-like involution of form and images flowing through this field that belies its static nature. Instead, what is created is an "atmosphere" or setting of effects. That makes such topographics inherently difficult for architects to produce, and it is thus in the realm of art, in the work of Olafur Eliasson most notably, but also in the installations created by a score of post-object-oriented artists, that we can find such effects playing out. This work also merges with the needs of an experience-focused society which desires and even demands ever-novel experiences within the city, and thus has influenced the work of such stagers of popular events—as well as makers of art installations—as Es Devlin. It is just a small step from the experiments in which the collective TeamLab engages to the "virtual" art exhibitions that seek to immerse the viewer in some version of the work of Theo van Gogh or the goggle-driven experience of gaming worlds.[25]

Beyond such ephemeral geologies—itself a way of thinking about our world that by now seems natural given the onslaught of virtualizing thinking and technology—the natural way to extend the thinking about the machinery of architecture in a postdigital age is to address it as organic. Here the impulse also comes from a desire to rescue what is thought of as the real, in connecting us back to some imagined sense of the organic through "biophilic" and biomorphic design. The idea would be to research and adapt how biological objects grow, and then mimic or graft onto these processes in a way that will turn architecture into a natural system. A whole class of architects and designers dreams of anarchitecture of a hobbit-land sort that would involve growing our buildings and objects. Invariably, the images that illustrate such promises recall nineteenth-century landscape paintings or surrealist canvases more than what might come out of a test tube.[26]

Some architects, from the above-mentioned Philippe Rahm to groups such as Topotek, Ecologic Studios, and Mitchell Joachim, as well as schools such as the Autonomous Institute of Architecture (IAAC) in Barcelona, try to move beyond such visions to imagine a true synthesis between mineral and vegetable structures in a manner that elides the differences between the human-made and the natural.[27] Here the machine dissolves into mushrooms and molds, tendrils of vines and trees intertwined around plastic or metal supports. More radical are the installations made by the Toronto-based architect Philip Beesley, who gathers plastic components and other castoffs from machinery of everyday life and then animates them by using the presence of the human body itself, including the humidity and warmth we produce as we sweat.[28]

If we treat such work as research and development that will inevitably find its way into the practice of architecture, we soon find that it is geared not toward the true revelation of the ghostly machinic assembly generated by digital computation, nor to the production of worlds that continually evolve, cycling between material and ephemeral fields, but toward the production of "smart" buildings that accommodate "natural" materials to make otherwise rather conventional forms or, at best, forms that play out some of the dreams of radical imagery and shapes that have been a mainstay of the expressive wing of modern architecture since the end of the nineteenth century.

We thus must continue, I believe, to ask questions concerning this kind of technology.

One of the most radical visions of how architecture could evolve within the digital assembly is articulated by Lars Spuybroek, who started his career by producing some of the earliest and most complete experiments in how computers and the hardware they steer could be used to create fluid forms as both buildings and public monuments. In his 2020 book *Grace and Gravity: Architecture of the Figure*, he does not address the computer in and of itself, but rather draws on a tradition that has been part of aesthetic thinking in the West since at least classical Greece. He concentrates not on the object itself, but on its inherent movement or poise, in what he calls "the turn":

> The concept of the turn goes much further than curvature
> and smooth movement between edge obstacles, and
> undoubtedly further than a native opposition to the

straightness of doing things right. It is made up of motion and activity, naturally, yet the movement in itself does not follow the way things take a turn. Our concrete movements are fed by a motion that is both larger and more abstract. The turn is larger than its agent. It is as much born out of a situation as it is initiated by an individual, and it is as much a figurative movement as it is concrete. In fact, it would be more correct to say that the figure of the turn stands by itself, and stands out as a figure that has been released from its origin rather than remaining attached to it. Doing something well, then, would be better described as a lessening of control than as an increase in it: a letting-go and a letting-happen more than a making-happen. It its figurative mode, the turn is not so much a movement between objects as it is the turning of movement into an object and, conversely, the turning of an object into movement.[29]

The turn is thus not just the way in which an object appears, but also how we ourselves act: "The object and the act are inextricably intertwined." The particular nature of this act is that it is one of "generosity" and "giving" because "it is a movement that exceeds its agent . . . it is both of and beyond the individual, anchored as well as unanchored, immanent as well as transcendent."[30] Grace is something we find in objects and ourselves, in character as well as landscapes, but as soon as we recognize it, it disappears into those very conditions. It has, or is, Spuybroek goes on to say, a machinery:

> The figuring of grace appears to be based on a set of complex interactions, what we should perhaps call a machinery of workings. The figure seems like a machined product that occurs between two zones of influence, with (a) on one side, the input of a rhythm, of a turning cycle that conveys a constant supply of activity without producing specific activities as yet; a stream that does not in itself produce the figure, since for that to occur, the stream needs to (b) meet the vertical axis of gravity at the other end. It is as if grace relies on both a temporal component, a turning wheel, and on a spatial component, a standing structure, with the figure suddenly appearing in the gap between them, like an electrical arc between two poles.[31]

Chapter 10

We apprehend the grace machine in the making, as we make the object (or building), or as we perceive it. But, most of all, we apprehend it in custom, in the habit with which something fits us or we fit our environment. It is that sense of grace of use, fitting, accommodation, and development in, through, and beyond form that is the essence of the grace machine. That does not mean it is not real or present, but that its presence is vague, a term Spuybroek sees as central to its operation: "the thing-appearance is simply a massive, swirling cloud of images permeating all levels of scale, bending and stretching and keeping each other out of focus, merging into a powerful glow, a radiance that in the previous chapter was denoted by the Italian term vaghezza: vague yet wholly visible."[32]

In architecture, grace manifests itself in "the gap," a kind of "absence or crossing" that seems to be the spatial version of the notion of "contrapposto" in sculpture.[33] This is also where Spuybroek believes, like Derrida and those in architecture who have sought to follow him, that architecture starts.[34] The gap is caught within the traditional modes of appearance of architecture, such as the house, which Spuybroek describes as a "trap" for both space and ourselves.[35] What it needs to be instead is a kind of "deep decoration":

> On the contrary, architecture, or more specifically the house, is an apparatus to let in spirits; it is an indispensable part of the phenotechnical machinery. Recalling the fact that apparatus signifies readiness, this means that in the realm of architecture the impetus of movement—nothing less than a form of metempsychosis—is a matter of decoration, or better worded, a matter of deep decoration, since it affects the shape of walls as well as that of space. Architecture, then, is where we, deep mirrors, meet deep decoration.[36]

Such deep decoration first appeared, according to the author, during the period of Art Nouveau, and he sees his own work and thinking as a distinct continuation of that style or mode of making. What has intervened since then is not the computer and its mode of computation per se, but the "plasticity" it has made possible.[37] Spuybroek, in other words, seeks to rescue exactly the form-making that seemed to have disappeared into large commercial construction during the beginning of the twenty-first century.

Ghost 395

He wants to do this by preserving its aesthetic and even decorative qualities while claiming that these disappear into the world of appearances that flit within, on, and beyond the building, in what he calls the "cave" of living thickened by the "poché" of deep form.[38] The intertwined spatial and material components of architecture capture grace and spin it out in ways that give him hope for a cultural stance (it is unclear whether it is an object) that might be as "fabulous"[39] as what Piranesi imagined at the beginning of the modern era as spiraling machinery unearthing anarchitecture. It would be a "groundless floating" that he says is his passion,

> bringing the sending and receiving of useless images and useless messages to a state of perfection. It is not that gravity has been abolished, it's just all around us now, acting like a buoyancy or suspension, creating a general state of floating where stillness, rising, shining, falling, collapsing, and moving differ only fractionally, if at all.[40]

For the last twenty years, the English architect Nigel Coates has been drawing out such possible worlds in a series of projects focusing on an amalgamation of places he calls Ecstacity: a place that combines Tokyo with London and New York with Shanghai, but that also lives on the screens of computers around the world. Coates imagines this world seen at first from the air, as a collection of dancing images and buildings whose reality is always in doubt or at least morphing.[41] If there are focal points, they are monuments he describes as being part of a "hypology":

> Instead of buildings corresponding to stable repeating patterns, a hypology is a structure capable of expanding rather than containing experiences. It opens a window on what is not. It links the material and the immaterial, the literal and the metaphoric, the formal and the chaotic, the functional and the narrative, the here and the far, the singular message and the many messaged. Never a pure statement of power, democracy or individuality, each one is willfully pernicious and never utterly consistent. Avoiding the risk of consumption, it should impact, but hold enough back for a long-term follow-through. . . . They fuse the movie and the place, or, like the football grounds that count in the game as part of the architecture, combine the place and the

event into one. . . . They are provocative, open, and rarely off limits.[42]

Coates describes these buildings as personages who are "roguish" and have "an almost sexual energy." "Ideal forms get left behind," he summarizes.[43] In his vision, developed in drawings that are mashups of sketches and scans, video grabs and fragments of famous buildings, jouissance and promiscuity, not just of human bodies but of the buildings they produce, the city becomes "a means to stage the situation and bring a sense of performance to everyday activities." Is it real? It does not matter: "Ecstacity. The more you depart, the more you return to yourself. . . . Is this really the city we live in? Maybe we are ourselves the city, and its buildings are mere markers in our imagination."[44]

These kinds of hybrid, hyped-up forms are currently floating around the World Wide Web, like fragments of former utopias enjoying their own freedom. You can find them not only in the work of Coates and Jacque, who seems to have been strongly influenced by the former designer, but also in the work of Mark Foster Gage, each of whom has their own theory about what they are doing. Then there are those who, like Anton Markus Pasing in Germany, or Marshall Brown, Bryan Cantley, or Perry Kulper in the United States, and even Michael Webb, originally of Archigram and still producing enticing and enigmatic drawings, work with the fragments of a scanned reality.

What marks all this work is that it has assimilated the pharmakon of digital technology and has come out altered but gracefully posing what we still might call architecture, or anarchitecture. There is, in other words, still a possibility to find oneself within the computer and its effects, and to gather together its possibilities without losing oneself in endlessly refracted labyrinths. These designers engage in what Jordi Vivaldi describes, borrowing the phrase from the philosopher and social critic Donna Haraway, as "worlding":

Worlding as an active and ontological process of creating worlds, that is, stories, tales, fictions; worlding not only as the result of our passive encounter with events, locations, circumstances or scenarios, but as a vectorized practice, informed by our attention, our critical sensibility, our active engagement with the materiality in which we are

enmeshed. Advanced architecture aims at proposing, above all, embodied processes of worlding, liminal practices designing spaces within spaces under the very act of attending to the world.[45]

Almost all the architects who engage in such "worlding" are enmeshed in the digital, and the traces of computation come through in almost everything they do. Yet what becomes increasingly interesting today is the work of those who turn away from the screen and indeed look at the detritus this generation has already noted, taking it seriously enough to reimagine it as anarchitecture.

Then there is another generation, many of them students of the designers mentioned above, to whom such fanciful images seem to belong to a period in which the attempt to give form to how the computer worked was more important that reckoning with its deep involvement with all that is reality. They also investigate the complexities of the social and political landscapes shaped by technological machinery whose complexities we cannot understand. After all, the computer is just part of the larger construct that constitutes a continually evolving set of interconnected social, economic, physical (especially since the effects of climate change became obvious), and culture structures—the stack, the hyperobjects, or effective global capitalism, depending on what you what to call it—that is both so obvious in its effects and so complex as to be impossible to fully picture or structure. If we leave the job of analyzing and describing that reality to those focused on that construct's more abstract constituent elements, as opposed to the fraction that concerns not just architecture but lived experience and the stage sets for daily action, then we ignore architecture's ability to make us at home in a critical manner in that world. If architects find themselves not just using computers but also realizing that an increasing amount of their reality is projected around them at Shibuya Crossing or on their smartphone screen, and if those same architects observe the now very evident social and environmental effects of the same technology that produces those effects, what are they to do?

The question involves, many younger designers believe, moving beyond the forest of technology to find what remains of the trees of *techne*, and to find somewhere, either in those techno-organic constructs or in a glade opened up by them, poetry. That means first figuring out where to operate. The basic problem for

Nigel Coates, Ecstacity, 1992.

A. M. Pasing, *The Recess*, 2019–2021 (courtesy of Anton Markus Pasing).

the architect today is not that they must give shape to current technology, as that is out of their control, but that they must develop a stance within the social structure that pervades my myriad instances of appearance and oppression within which technology operates. Technology and oppression, as well as exploitation of both human and natural resources, are intricately connected by the ways in which structure and superstructure have become so intertwined as to make the two indistinguishable.

Thus the critical and experimental architect who might want to imagine another world has to figure out first where to operate. What is their site? After all, how things work is becoming increasingly invisible, apprehensible only as an epiphenomenon like the section of a screen that gives haptic feedback when you touch it. The role of the maker is vanishingly small in the constellation of cultural production, and only slightly more secure than in the world of material production. In reality, whether that is meat space or digital power structures, codes take care of almost all aspects of how things come into appearance. The ability to find and then provide perspective on the hyperobjects we inhabit is just as difficult.[46]

For a new generation of architects and thinkers, the answer is to turn away from Medusa's technological face and to look around at the landscape the sorceress and devourer of humans has left behind. It has been this generation who have begun to articulate what one of them, John May, calls "post-orthographic" architecture.[47] One group of designers and thinkers who met at the University of California at Los Angeles in the early aughts described this journey with some evocative power:

> The dissolution of a steady ground upon which things can
> be ordered resonated with us. The delightfully weird work of
> our colleagues challenged preconceived notions of order . . .
> [we] saw computationally derived topological forms assessed
> in classical aesthetic terms—such a beauty, elegance, or
> the grotesque, while the former veered towards scientific
> research. The "Digital Turn" that once dominated the 1990s
> and early 2000s started to dissolve, and the fragments of
> new orders and things emerged in its wake.[48]

"We are interested in the stages of architectural design that precede its instantiation as building," they conclude;[49] they are

looking for a "middle region where a new episteme is emerging" and want to design for that condition.[50]

So what is that particular situation? As May describes it:

What is the "digital" (or "postdigital") in architecture is "pseudorthography . . . the very real, residual psychology of orthography laboring in the absence of its own technical-gestural basis—a pathology in which familiarity, that crucial element of comprehension, is preserved as a coping mechanism in the face of completely unfamiliar conditions. . . . Pseudorthography is orthography after simulation: a mobile army of skeuomorphisms in which the world appears just enough as it used to; based on matrices and memory banks, archiving the present and mining it as the past, "finds its meaning and energy in the sensation of immediacy."[51]

Some believe that the task of the architect remains to delve through that technology, perhaps to find its "deep structures," which in this case turn out to be nothing more or less than malleable code. The architect Galo Canizares, for instance, is as melancholy as May about the death of the digital dream:

As the novelty of the digital wanes, and the world itself crumbles into a vague, dusty relic from previous unnamed futures, its attendant concepts (those of code, electric impulses, and virtual geometry) have receded into an inaccessible layer behind a wall of infinite software. This substrate, which makes up the backbone of our social, economic, and political realities, has become so pervasive that its previously accepted visualization as a set of ones and zeros is virtually obsolete. The Matrix screensaver has been replaced by images of data centers, stock photos of blue-ish gradients, clouds, and app icons, causing the word to paradoxically represent both everything and nothing simultaneously.[52]

The task then is not to run away from such depressing remnants, but to investigate them further. A true postorthographics, Canizares claims, uses the system against itself:

Chapter 10

Here we see architectural media that expands and makes use of simulation, animation, automation, communication, synchronization, and visualization technologies. . . . It also rejects the status quo, but does not linger at the loss. Instead, it accepts our informatic, data-driven society, and asks how art can be extracted from such a viscous layer of convoluted systems. Those working under the umbrella of postorthographic, whether explicitly or not, use the underlying substrate of computation as a medium for critical experimentation as well as representation. The work, therefore, takes on new forms of expression, such as simulations, real-time animations, misuses of programs, bespoke software, or hacked infrastructures.[53]

In the end, he reaches through modernist history to find a continuing seam of expressionism that he believes can be liberating: "Bringing in the mysticism of the Suprematists and conceiving of screen space as an ever-changing, infinitely deep orthographic space can be a productive way to advance our perceptions of these virtual realities."[54]

It is difficult to imagine what Canizares is going to be able find in his search through architecture's past, as such images would seem, despite their history, modes of production, and intention, and like Benjamin's movie, to serve to hide the flower of technology within the assemblage of technology, but now in a manner that is fully conscious and deliberate. To make architecture in current conditions, the maker has to go wandering through the detritus after the explosion of the tenth of a second, rip apart the veil, and otherwise engage in a new kind of pragmatism that, ironically enough, winds up being as unreal and fantastic as any of the previous attempts at anarchitecture, albeit now with a mode of self-consciousness that always questions itself. It becomes, to use a phrase that has become rather popular among certain academic architects long after Derrida first brought it into the academic discourse, a form of "parafiction."

Carrie Lambert-Beatty defines the characteristics of this parafiction:

Unlike historical fiction's fact-based but imagined worlds, in parafiction real and/or imaginary personages and

stories intersect with the world as it is being lived. Post-simulacral, parafictional strategies are oriented less toward the disappearance of the real than toward the pragmatics of trust. Simply put, with various degrees of success, for various durations, and for various purposes, these fictions are experienced as fact.[55]

"Parafictioneers," Lambert-Beatty goes on to say,

> produce and manage plausibility. But plausibility (as opposed to accuracy) is not an attribute of a story or image, but of its encounter with viewers, whose various configurations of knowledge and "horizons of expectation" determine whether something is plausible to them . . . a parafiction creates a specific multiplicity.[56]

The instances she cites are all art projects of various sorts that involve creating what we might think of as "fake" museums, exhibitions, or even art groups that propound particular stories and images that are believable enough to seduce us, complex enough to intimate many different truths, realistic enough to be something we in fact want to believe and can believe it, but ultimately undecidable as to their factuality. Critical judgment becomes entangled with the art-making, and becomes a way of continuing that project, even if the teller of that parafictional tale would not want to do so.[57]

Architecture would seem in many ways already to be parafictional in its ability to both evoke and state facts in buildings. The images it presents evoke realities that it tends to vouchsafe with its material presence. At the same time, the building by its very nature occludes, privileges, and interprets. It is a fictional composition that sparingly reveals what goes into making it. What happens in a postorthographic world is only that the material basis that might allow the observer to measure the veracity of the building as architecture, which is to say as a complex representation and condensation of the forces that led to its production, are in question. As the architect Michael Young puts it:

> As often noted, architects do not make buildings; they create representations. Architectural representation consists of drawings, renderings, verbal instructions, photography,

numeric calculations, simulations, text, models, etc. Recent years have also seen the adaptation of film, animation, and other new media modes of technology. From our stance in the early-twenty-first century, it seems a folly to preach that one type of architectural mediation is more real than another.[58]

Elsewhere, Young says:

> Parafiction . . . takes the conventions by which something looks real and then begins to pull at them, stretch them, distort them until doubts are raised regarding the facticity that the mediations propose. It begins with the aesthetics of the factual and works to produce spaces for people to consider alternate possibilities for how the world could be.[59]

The natural way for architecture to operate in this mode, he concludes, is through collage:

> When architecture has employed collage, visible seams are often interpreted as a sign of its criticality, a criticality which is increasingly defined by ironic juxtaposition. These fragmented forms expose their artifice, and wink as they do so. To erase the seam and conceal this artifice could be understood as deceptive. But within parafiction, this erasure is crucial, for these collaged interruptions are not to be experienced at the level of the medium. The seam is displaced from the surface into the reality the mediations produce, it becomes the doubt raised in the viewer.[60]

Collage and assemblage thus continue to make their way through the machinery of modernist architecture, even if now the elements of which the work consists are a mixture between the real and the unreal, the physical and the virtual, and the believable and that which takes us to a realm we can barely recognize. Given the realities we face today, even if the character of them is virtual, what would seem necessary is a means for the parafictional and all of the postorthographical to overcome their own shifty, slippery shape-changing long enough to emerge as the kind of resonant image, or at least haunting possibility, that continues to make anarchitecture so important. One simple way to do so is to place them

squarely within the utopian and dystopian traditions of modern-ism. That is certainly what Cruz Garcia and Nathalie Frankowski do in their call for what they call a "narrative architecture":

> Narrative Architecture is what is left when the Grid has been exhausted as a functional tool, repurposed as a speculative model, and transformed into perpetual infrastructural and representation reincarnations. Narrative Architecture begins at the precise moment when work, dwelling, recreation, and transportation refuse to melt into air at the "end of history." . . . Narrative Architecture presents Utopia as an achieved goal. Narrative Architecture is Thomas More on steroids.[61]

Such a narrative architecture draws on their peculiar interpre-tation of the history of cynicism, allowing them to construct what they call a "Kynical Manifesto":

> Kynical Manifesto of Narrative Architecture: 1. Write a subversive story about architecture and the city. Expose the system behind buildings and zoning laws; behind Redlining, and gentrifications, and whitewashing and smart crapstractions. Reveal the accumulation of wealth and its relationship to form, matter, and space. 2. Construct a philosophy of jokes without being facetious. Reveal through humor whatever is wrong with Architecture, from education to practice. . . . 3. Piss against the ideological wind. . . . 4. Lie evidently as to reveal the truth and make truths out of all the lies. . . . Invert the content of faux historical narratives. . . . 5. Sleep inside an allegorical wine jar. Strip architecture of every unnecessary baggage. . . . 6. Continue by other means the miscarried dialogue [fight the power]. . . . 7. Rise like a Kynic . . . realize all the experiences, signs, sensations, ways of living, ways to imagine the world that the hegemonic discourses of "high theory" overlooked. . . . 8. Light the fire inside Diogenes's lantern [that looks for a wise man in broad daylight]. Tear the pages of all those history books that ignored the complexities of life and use them to ignite a critical fire. . . . 9. Be ready to raise looks of suspicion. . . . 10. Reveal an

honest architecture. And if you can't find it, write your own subversive story about architecture and the city.[62]

The virtue of these architects' work is that have carried it out not only in such theorizing, but also through the hybrid design and writing project, What Architecture Is (WAI). Using mainly Photoshop as their software of choice, Frankowski and Garcia construct images in which fragments of utopian architecture mix with the alphabet of corporate office towers, now marooned in scanned versions of romantic nineteenth-century landscape paintings, to evoke a mythical world where such anarchitecture might already exist. They also write stories and even children's books to further their parafictional architecture, all the while using their work in a distinctly critical manner. They call their style "hardcoreism," denoting both the fervor with which they further their ideological stance and the nature of their images, which float as objects consisting of lithic fragments of monumental traditions in landscapes that are freed from the shackles of a capitalist society. In parafiction, or in the hardcore version of a Kynical architecture, you can still be a utopian.

Frankowski and Garcia are singular in their ability to combine a utopian perspective with a cynical or pragmatic one, and they remain limited by that very ability. What they produce are essentially fairytales, in the manner in which Allison Newmeyer and Stewart Hicks define them, writing in an afterword to an assemblage of the work of the UCLA graduates quoted above: "Fairy tales are designed constructions that arrange familiar and unfamiliar elements to produce a collision of realities. Fairy Tales exist within our world, but present the possibility of other worlds." This is achieved through such strategies as "unexpected shifts in scale (inside is bigger than the outside), suspensions in time (old things next to new things), over articulation (decorated things next to abstract ones), and nesting interiors."[63] What the designers of these "Possible Mediums" produce is difficult to classify. The group Bittertang here presents plush toys half-covered in fur as architecture; Andrew Kovacs gives us collages of floorplans of buildings famous to architects; Adam Fure, Meredith Miller, and Thom Moran show deliberately weird and unpretty objects made out of plastic, while the makers calling themselves Generic Originals offer objects that droop with tentacled extensions.[64]

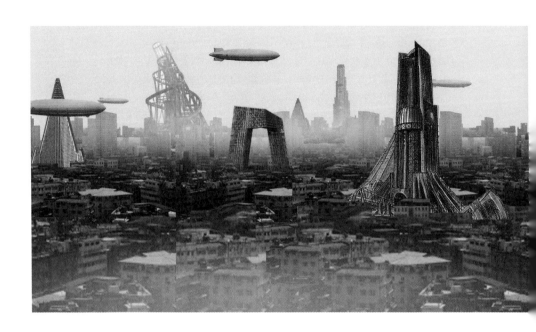

Cruz Garcia & Nathalie Frankowski / WAI Think Tank, *Capital of Ego (Wall Stalker Series)*, 2019 (Nathalie Frankowski & Cruz Garcia / WAI Think Tank).

These designers insist on the objecthood of what they do, even though some of that physicality is only implied. Not "media," which they say "foregrounds technical apparatus," but things interest them:

> The agency of architecture, its capacity to impact economic, cultural, and ecological conditions, derives primarily from its status as a physical object. This places great importance on the design of formal and material traits, which are understood not as isolated aesthetic phenomena, but as a means of establishing meaningful connections to broader contexts.[65]

The architect Andrew Atwood goes further, eschewing even the complexities this group of architects build into their work. In his book *Not Interesting: On the Limits of Criticism in Architecture* (2018), he argues instead for a "pluralistic" architecture, one without hierarchy and elitism, that might come from this turn:

> But what if we were careful to uncouple attention from interest? Would this remove the expectation that attention requires us to sort, distinguish, and discriminate between things? Might we get rid of the negative connotations of things that are not interesting? What if we deliberately tried to look without seeing, listen without hearing, touch without feeling? What if we forced ourselves to turn from the interest of the urgent, the signal, the foreground, and deliberately attend to the boredom of hum humdrum, the confusion of noise, the comfort of the background?[66]

This would be what he calls "Boring Architecture":

> Its parts are monotonous, repetitive, and inexhaustible in their limits. There is no variation from part to part; it goes on and on, so that its discernibility is limited by our abilities to stay attentive. This internal monotony forces attention to the periphery, to the context, which it usually meets abruptly, as if the parts seemed ready to extend forever. . . . Its parts are familiar, and they are arranged in familiar ways to produce familiar wholes. All formal relationships can be understood through prior experiences.[67]

His model is, ironically enough, the JPEG, that humble computer file that lies at the basis of the endless sharing of images feeding our daily social commerce while also flattening out reality. In the images Atwood inserts, without explanation and in such a manner that they are difficult to reproduce, he flattens out such images of landscapes in his native Los Angeles into affectless forms and flat colors. He mixes familiar buildings we might know from architecture history or guidebooks with sidewalk scenes he might have shot while driving in a car. There is, true to his text, no attention or focus here (he admits to growing up with attention deficit disorder), and no attempt to hold these images up as model architecture.

Instead, they form what he calls an "an-aesthetic":

An an-aesthetics describes that which we cannot see as it recedes, hides, or embeds itself in the service of other things. The tolerance of supporting things means that they take a back seat, at least when it comes to appearance; what they look like is largely contingent on the things they support or frame. Supportive things have no specific look of their own, no identifiable aesthetic, because they are connected to and defined by their support of other, more aesthetically dominant things. You might look at anesthetic things, but never see them.[68]

This opens the question as to whether anarchitecture may have become anaesthetic. Has the machinery of modernity dissolved so far into the ghostly effects that now contain our information, guide our social relations, and increasingly define our environments that it might have disappeared altogether, leaving behind only a memory of possible worlds or futures that might be precluded to our own acts of self-destruction?

Certainly, the world and its making are not over yet. Nor is the act of architecture. For too many years and in too many ways we have proclaimed the death of that discipline, only to see architects and their enablers dissect new economic models that allow them to maintain their livelihood while producing with equal fecundity theories that justify their transference and let them believe they are building a better world. Architecture is alive and well, even if most of what architects produce is, as has been true for too long,

dreadful not just aesthetically but in its social and environmental effects.

Certainly this book has suggested that wondering about, and being in wonder of, possible worlds, ones with fluid forms that make no distinction between organic matter, human-made things, and machines at any scale or from any perspective, is in and of itself central to making architecture that escapes from the strictures of the discipline and the profession. At the simplest level, this is what Anthony Dunne and Fiona Raby call "speculative design":

> Rather than giving up altogether, though, there are other possibilities for design: one is to use design as a means of speculating how things could be—speculative design. This form of design thrives on imagination and aims to open up new perspectives on what are sometimes called *wicked problems*, to create spaces for discussion and debate about alternative ways of being, and to inspire and encourage people's imagination to flow freely. Design speculations can act as a catalyst for collectively redefining our relationship to reality. . . .
>
> They usually take the form of scenarios, often starting with a what-if question, and are intended to open up spaces of debate and discussion; therefore, they are incredibly provocative. . . .
>
> To find inspiration for speculating through design we need to look beyond design to the methodological playgrounds of cinema, literature, science, ethics, politics, and art; to explore hybridize, borrow, and embrace the many tools available for crafting not only things but also ideas— fictional worlds, cautionary tales, what-if scenarios, thought experiments, counterfactuals, reductio ad absurdum experiments, prefigurative futures, and so on.[69]

The limit of this approach is that it remains within the realm of production, proposing that in the end capitalism will be better served by giving designers creative freedom. What many thoughtful designers are implying, however, is that we can move beyond the reliance of architecture on its function within our economic and social system, namely the production of buildings. Architecture, after all, is not building. It concerns itself with buildings.

Andrew Atwood, *5800 Colby St*, 2018 (Andrew Atwood).

Andrew Atwood, *Sale House, Johnston Marklee*, 2001–2004 (Andrew Atwood).

It is about buildings. It is how we know buildings, how we plan them, how we describe them, and how they appear. In our current situation in which we can no longer replenish natural resources we use for our buildings, and in which the injustice of our economic system is such that any building reinforces exclusion, oppression, and violence, fixing them into facts, we should no longer make buildings.

Instead, I would suggest finally that architecture can be the reuse, upcycling, rehabilitation, preservation, and reimagination of what we already have. This is a practical as well as a theoretical position. If the attention on the existing and the left-over is something that seems the logical outcome of any self-examination of where architecture should be today, it is also something architects must do as space and resources both become vanishingly rare and we realize the imperative to liberate the places we already have to allow for a more just social set of relations within and through them.

We can mine, as this book has tried to do, the monster leviathan.

There is a beauty to such an endeavor. The most astonishing moments in architecture I have witnessed in the last decade have been the rehabilitation of the High Line, a former railroad line cutting through structures in lower Manhattan, or the reuse of Beijing's former steel mill as the site for the 2022 Winter Olympics headquarters. Vast and sweeping in their scale and purpose, these acts of rehabilitation and reimagination are as stirring as anything Wright might have imagined. That is not to say they are all good architecture in the traditional sense of that word: the Beijing site, for instance, is marred by too many clunky additions and fussy landscape architecture. It is the scene these sites open that stirs and evokes the possibility of architecture beyond buildings.

Nor are such sites restricted to the making of structures for the elite. As DK Osseo-Asare describes the community of Agbogbloshie in Ghana, for instance, it is also a site of emergent architecture and city-making:

> From an ecological point of view Agbogbloshie is a paradox—the scrapyard is a highly polluted landscape that also displays agency, collectively, as a synergistic hub in a larger network of informal waste processing sites. While the PHH correlates the duality of production and pollution with low costs and regulation, spaces such as the Agbogbloshie

Photographer unknown, Agbogbloshie, Ghana, c. 2015.

scrapyard emerge equally through confluence—the nonrandom coincidence of ambiguous land rights and ownership, interrelations of waste and scrap, proximate and flexible mobility circuits, and agglomeration effects of resilient hyperlocal clusters of knowledge, expertise and capacity that perceive, bestow and manipulate value in spaces and materials where otherwise it would remain latent, invisible and intangible. . . . In Agbogbloshie, making is a process that encompasses remaking and unmaking. More than a situation or a scenario—and not unique to Agbogbloshie—this approach to circular economy represents a paradigm that precludes waste and references vernacular modes of technology production and material culture.[70]

Similar descriptions of neighborhoods such as Dharavi in Mumbai, India, or some of the favelas in South America might uncover similar possibilities for the development of a culture of reuse that might bring with it new modes of social organization and world-making. The monster leviathan is now made out of scraps and castoffs, out of countless workshops and combinations of craftspeople and machines, and out of a continually changing community. You cannot see it from an "uplifted" position, or at least you would not see much. It is only in it, through it, and in the reimagination of such places themselves that they make sense.

That making sense, making sensible, and then making real is the elusive activity that has haunted this book, especially in the collage of attempts and attitudes collected in this last chapter. The grand visions have dissipated, we have wandered long through the remains of the explosions, and we continue to look for the poetic veil, but still we find ourselves only reading of the monster leviathan of anarchitecture as that image of which we cannot make sense. It is not a goal, not a project to be made, and not real.

At the horizon lies another possibility, opened up by the latest advances (as I write this) in artificial intelligence: architects such as Cesare Battelli are producing collages of monsters (or at least animals such as tigers or sea lions), cities, machines, and buildings. Presenting them as under construction or already in ruin, he uses the program Midjourney to evoke the visions and myths that have haunted art and architecture for the last five hundred years, proposing them as a reimagining of our near future.[71]

What the AI at its best, when cleverly prompted, makes up is a myth, an intimation of a world that might have existed as the modern metropolis challenged architecture to give it form, that might exist some day in the future, when we will scavenge among the remains of our civilization to make ourselves at home in that modern world, or may already exist, in the images, forms, evocations, and spaces anarchitects are recognizing as much as producing. It is up to us to recognize them, to recite them, to make them our own, and use them to make a world that will be open to all.

Acknowledgments

This book is the result of many years of working through theoretical texts I thought were of particular relevance and importance to contemporary architecture with students at many different institutions, but in particular at the Southern California Institute of Architecture and the School of Architecture at Taliesin. I am grateful not only to the students who participated in these classes and helped me shape my interpretations and speculations, but also to the many colleagues who challenged and critiqued my critiques.

I was first introduced to many of these texts by my teachers at Yale, and in particular by Fredric Jameson, George Hersey, and Karsten Harries. Many hours of discussion with my friend and roommate Jaime Rua ensued. Later, critics with vastly more knowledge of the field, including Sylvia Lavin, Mark Wigley, the late Ann Bergren, Jeffrey Kipnis, Anthony Vidler, Kurt Forster, and Kevin McMahon, opened up many avenues of inquiry for me. I am grateful to all of them.

Cor Wagenaar encouraged me in this project and offered very helpful early edits and suggestions, and my husband, Peter Christian Haberkorn, was, as always, the most able and empathetic editor. I could also not have completed the project without the aid of Afrida Afroz Rahman, or without the support and editorial guidance of Thomas Weaver and the sharp eyes and invaluable suggestions of Matthew Abbate. To them also great thanks.

Finally, this book was made possible by funding from Virginia Tech University, and in particular the Faculty Publishing Subvention funds of its University Libraries. In addition, the project received funding from the Futhermore Grants in Publishing.

Notes

Introduction

1. The architecture of the Center is credited to three designers, G. J. van Grinten, Bart van Kasteel, and K. F. G. Spruit, but they were under the supervision of the much better-known Alexander Bodon. I wrote about this early history in "Hoog Catharijne, the Tomb of an Open Architecture," in Cor Wagenaar, ed., *Happy: Cities and Public Happiness in Post-War Europe* (Rotterdam: NAI Publishers, 2004), 269–281.

2. The new addition to the school, the Werkplaats Kindergemeenschap, was designed by Hendrikus Postel and opened in 1968.

3. I have been unable to confirm this publication. Although I have a very strong memory of seeing it, there is always the possibility of the sort of false recall Oliver Sacks has discussed.

4. While writing this book, Hal Foster published his *Brutal Aesthetics: Dubuffet, Bataille, Jorn, Paolozzi, Oldenburg* (Princeton: Princeton University Press, 2020), which performs a similar search in art, although its focus is only on twentieth-century work.

5. Reinhold Martin, *Utopia's Ghost: Architecture and Postmodernism, Again* (Minneapolis: University of Minnesota Press, 2010), 92.

Chapter 1

1. John Ruskin, *The Two Paths: Being Lectures on Art, and Its Application to Decoration and Manufacture. Delivered in 1858–9* (1862; Sunnyside: George Allen, 1884), 117.

2. There are countless books written about Frank Lloyd Wright in this early period, as well as by him; his memories in his *Autobiography* are most useful. For a commentary, see Neil Levine, *The Architecture of Frank Lloyd Wright* (Princeton: Princeton University Press, 1996). Wright left a good though selective record of his encounter with the city in his *Autobiography*; see Frank Lloyd Wright, *An Autobiography* (1943; London: Faber & Faber, 1945), esp. 62ff. His assessment was not kind, from his very first encounter on: "And where was the architecture of the great city—the 'Eternal City of the West'? Where was it? Hiding behind these shameless signs. . . . Chicago! Immense gridiron of noisy streets, Dirty. . . . A stupid thing, that gridiron. . . . Terrible, this grinding and piling up of blind forces. If there was a logic here who would grasp it? To stop and think in the midst of this would give way to terror" (62).

3. Jane Addams, *Twenty Years at Hull House* (1910; New York: Signet, 1999). Addams does not note Wright's appearance in particular.

4. Frank Lloyd Wright, "The Art and Craft of the Machine"; I rely here on the version printed in Edgar Kaufmann and Ben Raeburn, eds., *Frank Lloyd Wright: Writings and Buildings* (New York: Horizon Press, 1960), 55–73.

5. Ibid., 59.

6. Marshall Berman, *All That Is Solid Melts into Air: The Experience of Modernity* (1982; New York: Penguin, 1988), 16.

7. See Sigfried Giedion, *Mechanization Takes Command:* *A Contribution to Anonymous History* (1948; New York: W. W. Norton, 1969), 93ff.

8. Wright, "The Art and Craft of the Machine," 57.

9. Victor Hugo, *The Hunchback of Notre Dame*, trans. Isabel F. Hapgood (1842; Project Gutenberg Ebook, 2009), book V, chapter 2, n.p.

10. Jacques Rancière's statement on the arts and crafts movement and its heirs is relevant here: "I am thinking in particular of its role in the Arts and Crafts movement and all of its derivatives (Art Deco, Bauhaus, Constructivism). These movements developed an idea of furniture—in the broad sense of the term—for a new community, which also inspired a new idea of pictorial surface as a surface of shared writing." Jacques Rancière, *The Politics of Aesthetics* (London: Bloomsbury, 2013; Kindle edition), loc. 311. Rancière also notes that what he calls the "aesthetic regime" "asserts the absolute singularity of art and, at the same time, destroys any pragmatic criterion for isolating the singularity. It simultaneously establishes the autonomy of art and the identity of its forms with the forms that life uses to shape itself" (loc. 449). This regime, he says, "is the true name for what is designated by the incoherent label 'modernity'" (loc. 455).

11. Wright, "The Art and Craft of the Machine," 62.

12. Ibid., 61.

13. Ibid., 65.

14. Ibid., 68; Wright explicitly calls it an "arts and crafts society."

15. One thing that tied together Dewey and Parker was that the respective

schools they founded were both designed by an exact contemporary of Wright, James Gamble Rogers. I discussed the relation between this work and American pragmatism in my *James Gamble Rogers and the Architecture of Pragmatism* (Cambridge, MA: MIT Press, 1992). For Parker, see Flora J. Cooke, "Colonel Francis W. Parker: His Influence on Education," *Schools: Studies in Education* 2, no. 1 (May 2005), 157–170. For Dewey, see Robert R. Westbrook, *John Dewey and American Democracy* (Ithaca: Cornell University Press, 1993).

16. Ruskin, *The Two Paths*. For Ruskin's influence on the movement, see Christopher Long, "Ruskin's Two Paths and the Arts and Crafts Movement," in Monica Penick and Christopher Long, eds., *The Rise of Everyday Design: The Arts and Crafts Movement in Britain and America* (New Haven: Yale University Press, 2019), 1–36.

17. For a general history of the English arts and crafts movement, see Wendy Kaplan, *The Arts and Crafts Movement in Europe and America: Design for the Modern World* (London: Thames & Hudson, 2004), and Penick and Long, *The Rise of Everyday Design*.

18. Ruskin, *The Two Paths*, 110–111.

19. Ibid., 114. It should be noted that Ruskin founded his own such association, the Guild of St. George, with students at Oxford.

20. Levine, *The Architecture of Frank Lloyd Wright*, 447. For Ashbee, see Alan Crawford, *C. R. Ashbee, Architect, Designer and Romantic Socialist* (New Haven: Yale University Press, 1986), and Fiona MacCarthy, *The Simple Life: C. R. Ashbee in the Cotswolds* (Berkeley: University of California Press, 1981).

21. Morris outlined his vision in his novel *News from Nowhere* (Boston: Roberts Brothers, 1890; I refer here to the Kindle edition, 2018), esp. locations 1395, 1408.

22. And having acknowledged Ruskin's and Morris's importance in this (Wright, "The Art and Craft of the Machine," 56).

23. Ibid., 72–73.

24. Although the monstrousness of the industrial city was a trope in nineteenth- and early twentieth-century literature, I know no precedent for Wright's particular imagery. See Tania Bhattacharyya, "The City as Monster: Reading Monstrosity in the Nineteenth-Century British Urban Landscape," Ph.D. dissertation, Purdue University, 2012.

25. "He loved to talk to me and I would often stay listening, after dark in the offices in the upper stories of the great tower of the Auditorium building looking out over Lake Michigan or over the lighted city" (Wright, *An Autobiography*, 98); of particular interest is that Wright immediately follows this memory with: "As I have since reflected, he seemed unaware of the machine as a direct element in architecture, abstract or concrete. He never mentioned it."

26. The reference here is to Job 41. Although the term was used by writers and well as theologians throughout the eighteenth and nineteenth centuries, Wright might have been acutely aware of its imagery through his family, as he came from a family of lay preachers and his father was an ordained preacher and hymn writer. There are no references in Wright's archives to other uses of or research into the biblical text.

27. Wright, "The Art and Craft of the Machine," 72.

28. Ibid.

29. Ibid.

30. Ibid.

31. Ibid., 73.

32. Ibid.

33. Originally published in 1794, the poem's main focus is actually the scourge of syphilis, but its most lasting image is that of the imprisoning city: "I wander thro' each charter'd street, / Near where the charter'd Thames does flow. / And mark in every face I meet / Marks of weakness, marks of woe. / In every cry of every Man, / In every Infants cry of fear, / In every voice: in every ban, / The mind-forg'd manacles I hear." William Blake, *Songs of Innocence and Experience*, in David V. Erdman, ed., *The Poetry and Prose of William Blake* (New York: Doubleday, 1970), 26.

34. Thomas Cole's *Course of Empire* consists of five paintings, which he produced between 1833 and 1836. Now held by various museums, their influence on the popular imagination was strong from the moment they were first shown. See Earl Powell, *Thomas Cole* (New York: Harry N. Abrams, 1990), and Annette Blaugrund, *Thomas Cole: The Artist as Architect* (New York: Monacelli Press, 2016), esp. 82ff.

35. Carl Sandburg, "Chicago" (1914), https://www.poetryfoundation

.org/poetrymagazine/poems/12840/chicago.

36. The book is evocative especially of Chicago, although its main character ends her life in New York. Dreiser traces her trip from an unknown town in Wisconsin (which could almost be Wright's Spring Green) to the city, where she encounters both the horrors of the factories and slums (where her sister lives) and the allure of the department store and nightly entertainment, as well as the comforts of the suburban home. I know of no other work of fiction that evokes with more power the Chicago in which Wright would have lived and worked. Theodore Dreiser, *Sister Carrie* (1900; New York: W. W. Norton, 2006).

37. Sanford Kwinter, of all contemporary critics, thinks most highly of the futurists, and especially Sant'Elia's perceptions of the nature of both modern space and its possible construction: "Here the very notion of conjunction takes on its maximal significance: these are conjunctions not of buildings or isolated structures but of imbricating systems, both at the molecular level of interpenetrating guided, rotating, or sliding masses, and at the molar level of urban megasystems of transport, hydro-electric and informational lattices. . . . Interference, like the sporadic invasion of electronic images by foreign frequencies, becomes here a positive expression of polymetric spatial complexity allowing several disparate architectures (say, telecommunications towers, elevator stacks, tram

systems) to articulate themselves in a single block. Thus the dominant technique for ordering the various chains within this multilayered systemic space is a special use of transparency different from the literal and phenomenal versions endemic to visual modernism. Here the transparency is functional and explicitly concrete: masses are placed seemingly only to be pierced, stratified, or disaggregated—in other words, as passive and inarticulate carriers of the movement-bearing systems that traverse and penetrate them, or else huge framelike chassis baring their lading like skeletons yielding to the newly invented X-ray gaze that the futurists so emulated." Sanford Kwinter, *Architectures of Time: Toward a Theory of the Event in Modernist Culture* (Cambridge, MA: MIT Press, 2001), 82–83. See also Esther da Costa Meyer, *The Work of Sant'Elia: Retreat into the Future* (New Haven: Yale University Press, 1995.

38. Henry Adams, *The Education of Henry Adams* (1918; New York: Modern Library, 1931), 338.

39. For the uses of the *unheimlich* or "unhomely" in architecture, see Anthony Vidler, *The Architectural Uncanny: Essays in the Modern Unhomely* (Cambridge, MA: MIT Press, 1992), 1–14, and Mark Wigley, *The Architecture of Deconstruction: Derrida's Haunt* (Cambridge, MA: MIT Press, 1993).

40. Frank Lloyd Wright, "To the Young Man in Architecture," in Kaufmann and Raeburn, *Frank Lloyd Wright: Writings and Buildings*, 235.

41. Ibid., 242.

42. Ibid., 247.

43. Frank Lloyd Wright, "Architecture: New Principles," in Kaufmann and Raeburn, *Frank Lloyd Wright: Writings and Buildings*, 306.

44. The notion of buildings as the tomb of architecture, and the necessity of looking beyond buildings, is one that I have developed over a number of articles, exhibitions, and lectures during the last ten years. See the catalog for the 2008 11th International Architecture Biennale Venice I curated, *Out There: Architecture beyond Buildings* (Venice: Marsilio, 2008).

45. Sigmund Freud, "Observations on Transference-Love: Further Recommendations on the Technique of Psychoanalysis III" (1915), in Ethel Spector Person et al., *On Freud's "Observations on Transference-Love"* (London: Karnac Books, 2013), 17–29.

46. Jacques Lacan in particular came back to the notion throughout his career, changing his perceptions and interpretations. What remained constant was his interest in transference as the creation as an alternate, parallel reality, created by the analyst as much as by the analysand. See Jacques Lacan, "Intervention on the Transference," in Juliet Mitchell and Jacqueline Rose, eds., *Feminine Sexuality: Jacques Lacan and the École Freudienne* (New York: W. W. Norton, 1988), 61–73 See also https://nosubject.com/Transference.

47. Freud, "Observations on Transference-Love," 24–25.

48. "In a psychoanalytic situation, the transference fragments are transported to the psychotherapist. In an architectural situation, they

can only be transported to architecture itself." Bernard Tschumi, *Architecture and Disjunction* (Cambridge, MA: MIT Press, 1996), 178. He goes on to claim: "The Urban Park at La Villette offers the possibility of a restructuring of a dissociated world through an intermediary space—follies—in which the grafts of transference can take place" (179).

49. For the historical development of the profession, see Spiro Kostof, ed., *The Architect* (New York: Oxford University Press, 1977), and in particular the contributions of Catherine Wilkinson, "The New Professionalism in the Renaissance," 124–160; Myra Nan Rosenfeld, "The Royal Building Administration in France from Charles V to Louis XIV," 161–179; and Joan Draper, "The Ecole des Beaux-Arts and the Architectural Profession in the United States: The Case of John Galen Howard," 209–237. See also Andrew Saint, *The Image of the Architect* (New Haven: Yale University Press, 1983), and Dana Cuff, *Architecture: The Story of Practice* (Cambridge, MA: MIT Press, 1991). Historical developments in architecture were part of a larger cultural movement, first and most clearly delineated by Raymond Williams. As he points out, "The word Art, which had commonly meant 'skill,' became specialized during the course of the eighteenth century, first to 'painting,' and then to the imaginative arts generally. Artist, similarly, from the general sense of a skilled person, in either the 'liberal' or the 'useful' arts, had become specialized in the same direction,

and had distinguished itself from artisan (formerly equivalent with artist, but later becoming what we still call, in the opposite specialized sense, a 'skilled worker'), and of course from craftsman. The emphasis on skill, in the word, was gradually replaced by an emphasis on sensibility; and this replacement was supported by the parallel changes in such words as creative (a word which could not have been applied to art until the idea of the 'superior reality' was forming), original (with its important implications of spontaneity and vitalism; a word, we remember, that Young virtually contrasted with art in the sense of skill), and genius (which, because of its root association with the idea of inspiration, had changed from 'characteristic disposition' to 'exalted special ability,' and took its tone in this from the other affective words). From artist in the new sense there were formed artistic and artistical, and these, by the end of the nineteenth century, had certainly more reference to 'temperament' than to skill or practice. Aesthetics, itself a new word, and a product of the specialization, similarly stood parent to aesthete, which again indicated a 'special kind of person.'" Raymond Williams, *Culture and Society 1780–1950* (1958; Garden City: Doubleday, 1960), 47–48.

50. The most thorough analysis of the role utopias and other such escape mechanisms played in the profession remains Manfredo Tafuri's *Architecture and Utopia: Design and Capitalist*

Development, trans. Barbara Luigia La Penta (1973; Cambridge, MA: MIT Press, 1976), which will be the main focus—along with other notions of utopia—of chapter 4 of this volume.

51. For an accessible compendium of all of Piranesi's prints, see Luigi Ficacci, *Piranesi: The Complete Etchings* (Cologne: Taschen, 2018). See also John Wilton-Ely, *Piranesi as Architect and Designer* (New Haven: Yale University Press, 1993).

52. Susan Stewart, *The Ruins Lesson: Meaning and Material in Western Culture* (Chicago: University of Chicago Press, 2020; Kindle edition), loc. 3579.

53. Ibid., loc. 3439.

54. Ibid.

55. Tafuri, *Architecture and Utopia*, 15.

56. Emil Kaufmann, *Three Revolutionary Architects: Boullée, Ledoux, and Lequeu* (Philadelphia: American Philosophical Society, 1952).

57. Ibid., 538–558. Lequeu has not been well served by biographers. The most complete monograph devotes most of its space to a quasi-Derridean discourse on how Marcel Duchamp altered his writings. Philippe Duboy, *Lequeu: An Architectural Enigma* (Cambridge, MA: MIT Press, 1986).

58. For the Désert de Retz, see Diana Ketcham, *Le Désert de Retz: A Late Eighteenth-Century French Folly Garden, the Artful Landscape of Monsieur de Monville* (Cambridge, MA: MIT Press, 1997). The enigmatic Bomarzo deserves further study; see Jess Sheeler, *Bomarzo: A Renaissance Riddle* (London: Frances Lincoln, 2007).

59. Of note is the fact that, only in architecture, utopias (as well as dystopias) act as concrete proposals, as opposed to predictions. They serve not only to describe what could be, but also to provide a concrete working model against which current arrangements can be compared. They are a form of concrete "scenario planning," as it is called in the business world, applied to the organization of social and economic relations. For a good compendium of such schemes, see Roland Schaer, Gregory Claeys, and Lyman Tower Sargent, eds., *Utopia: The Search for the Ideal Society in the Western World* (New York: Oxford University Press, 2000).

60. Philip E. Wegner, *Imaginary Communities: Utopia, the Nation, and the Spatial Histories of Modernity* (Berkeley: University of California Press, 2002), xvi.

61. Mark Wigley traces the events around the exhibition for which Matta-Clark coined the phrase in *Cutting Matta-Clark: The Anarchitecture Investigation* (Zurich: Lars Müller, 2018). See also James Attlee, "Towards Anarchitecture: Gordon Matta-Clark and Le Corbusier" (Tate Research Papers, https://www.tate.org.uk/research/publications/tate-papers/07/towards-anarchitecture-gordon-matta-clark-and-le-corbusier). Attlee notes: "The first recorded use of the term pre-dates the Group's discussions. Robin Evans published an article called 'Towards Anarchitecture' in the *AA Quarterly* in 1970. It has not been established whether Matta-Clark was aware of this usage. Another possible reference may be to Duchamp's concept of An-Art: in an interview for BBC radio in 1959 he claimed to be not an anti-artist but 'an an-artist, meaning no artist at all'."

62. Woods used the term throughout the last part of his career. See *Lebbeus Wood. Anarchitecture: Architecture Is a Political Act* (London: Academy Editions, 1992).

63. I refer to the root meaning of the word as "without power," implying a lack of overall order imposed from above. While anarchism moved toward organic community development akin to William Morris's vision (in the work of Peter Kropotkin), it is better known for its attempts to destroy power and leave nothing standing. For a good history and description of anarchism, see Peter Marshall, *Demanding the Impossible: A History of Anarchism* (Oakland: PM Press, 1992).

64. Ultimately, of course, both Wigley and Vidler base their use of the term on Sigmund Freud, *The Uncanny* (1919; New York: Penguin, 2003). See Mark Wigley, "Postmortem Architecture: The Taste of Derrida," *Perspecta* 23 (1987): 156–172.

65. Cf. Jay Appleton, *The Experience of Landscape* (London: John Wiley & Sons, 1975), 69–73.

66. I will use the phrase as developed by Water Benjamin in his "The Work of Art in the Age of Mechanical Reproduction"; see chapter 2.

67. As proposed by Henri Lefebvre in his *The Production of Space*; see chapter 5.

68. Frances Richard, *Gordon Matta-Clark: Physical Poetics* (Berkeley: University of California Press, 2019), 233. Capital letters refer to Matta-Clark's own notes in his index card archive.

69. Mark Fisher, *The Weird and the Eerie* (New York: Penguin Random House, 2017; Kindle edition), 13.

70. Robert Venturi, *Complexity and Contradiction in Architecture* (New York: Museum of Modern Art, 1966).

71. Terence Riley collected examples of both transparency and translucency in his exhibition "Light Construction" (Museum of Modern Art, New York, 2004). As Riley said: "In this architecture of lightness, buildings seem intangible, structures shed their weight, and facades appear unstable and ambiguous" (https://www.moma.org/momaorg/shared/pdfs/docs/press_archives/7377/releases/MOMA_1995_0057_45.pdf ?2010). See also Todd Gannon, *The Light Construction Reader* (New York: Monacelli Press, 2002).

72. I traced the development of such spaces and their implications in my 1995 volume *Queer Space: The Spaces of Same Sex Desire* (New York: William Morrow, 1995).

73. Mario Praz, *An Illustrated History of Interior Decoration: From Pompei to Art Nouveau* (1964; London: Thames & Hudson, 1981), 24–25.

74. Walter Benjamin, *The Arcades Project*, trans. Howard Eiland and Kevin McLaughlin, ed. Rolf Tiedemann (1982; Cambridge, MA: Harvard University Press, 1999), 9.

75. The complete text of the letters is collected in *Crystal Chain Letters: Architectural Fantasies by Bruno Taut and His*

Circle, ed. and trans. Iain Boyd Whyte (Cambridge, MA: MIT Press, 1985).

76. Rem Koolhaas, *Delirious New York: A Retroactive Manifesto for Manhattan* (New York: Oxford University Press, 1978). Martino Stierli attempted a review of such techniques from a form perspective in his *Montage and the Metropolis: Architecture, Modernity, and Representation of Space* (New Haven: Yale University Press, 2018).

77. Michael Young, "The Art of the Plausible and the Aesthetics of Doubt," *Log* 41 (Fall 2017), 38. It could be argued that the whole notion of parafiction is just a new way to describe and extend the notion of allegory. Angus Fletcher has pointed out the mythic properties of allegory and, in particular, its superimposition of or embodiment of human figures by mechanical entities, whether "daemons" or robots. In an uncanny echo of Wright's essay, for instance, he writes of medieval allegorical poetry: "The body can become a building, a fortress, 'the castle of the body,' or it can become a natural burgeoning, as in the analogy between body and garden; after the invention of automatic machinery other daemonic analogies become available. Any armoring of the body makes it into a kind of fortress, hard, rigid, and impregnable. The elaborate heraldic armor of the Renaissance, so-called historical armor, then decorates the human fortress with the signs of its strength." Angus Fletcher, *Allegory: The Theory of a Symbolic Mode* (1964;
Princeton: Princeton University Press, 2021; Kindle edition), 156.

Chapter 2

1. For a good survey of the state of the world right before the First World War, with a special focus on the relationships among the cultural, political, and economic flows of the period, see Charles Emerson, *1913: In Search of the World before the Great War* (New York: Public Affairs, 2013).

2. For a case study that uses the parallel biographies of Picasso and Einstein to note the reciprocal relationship between science and art, see Arthur J. Miller, *Einstein, Picasso: Space, Time, and the Beauty that Causes Havoc* (New York: Basic Books, 2001); see also, especially for the relationship to popular culture, Leonard Folgarait, *Painting 1909: Pablo Picasso, Gertrude Stein, Henri Bergson, Comics, Albert Einstein, and Anarchy* (New Haven: Yale University Press, 2017).

3. It is worth quoting here the full passage, especially in relation to later remarks I will make on the issue of continual revolution and the explosive nature of socialism: "The bourgeoisie cannot exist without constantly revolutionizing the instruments of production, and thereby the relations of production, and with them the whole relations of society. Conservation of the old modes of production in unaltered form was, on the contrary, the first condition of existence for all earlier industrial classes. Constant revolutionizing of production, uninterrupted disturbance of all social conditions,
everlasting uncertainty and agitation distinguish the bourgeois epoch from all earlier ones. All fixed, fast-frozen relations, with their train of ancient and venerable prejudices and opinions are swept away, all new-formed ones become antiquated before they can ossify. All that is solid melts into air, all that is holy is profaned, and man is at last compelled to face with sober senses his real conditions of life and his relations with his kind." Karl Marx and Friedrich Engels, "Manifesto of the Communist Party," in *Marx and Engels: Basic Writings on Politics and Philosophy*, ed. Lewis S. Feuer (New York: Anchor Books, 1959), 10.

4. See Marshall Berman, *All That Is Solid Melts into Air: The Experience of Modernity* (1982; New York: Penguin, 1988).

5. For a survey of the development of science fiction, see Adam Roberts, *The History of Science Fiction* (London: Palgrave Macmillan, 2016). For a good collection of critical essays, although none grasp the imagistic and architectural qualities sufficiently, see Roger Luckhurst, ed., *Science Fiction: A Literary History* (London: British Library Publishing, 2018).

6. Utopian thinking and visions are intertwined with architecture, as I tried to show in the first chapter. The point that remains that such visions are, by their very definition, not realizable or inhabitable, as they would then not be "other" or "good" in any absolute sense. It is therefore up to science fiction writers to show their inevitable downfall, as almost all examples in the genre do.

For a very good survey of the development of utopian ideas and models, see Roland Schaer, Gregory Claeys, and Lyman Tower Sargent, eds., *Utopia: The Search for the Ideal Society in the Western World* (New York: Oxford University Press, 2000).

7. William Morris, *News from Nowhere*, op. cit.; Samuel Butler, *Erewhon* (1871; New York: Halcyon Press, 2015).

8. The Comte de Lautréamont (Isidore Lucien Ducasse) was a late nineteenth-century poet who was particularly influential for the futurists. His *Les Chants de Maldoror* (1869) evoked images and pioneered techniques of elision and the involution of various scales. However, one can find earlier examples of such conflations and mobile imagery, for instance in Alexander Pope's "The Rape of the Lock" (1717) and, closer in feel (and language), the work of symbolist poets such as Charles Baudelaire. In addition, Jean Moréas published a "Symbolist Manifesto" in *Le Figaro*, the same newspaper Marinetti used as his outlet, on September 18, 1886. See Andrei Pop, *A Forest of Symbols: Art, Science, and Truth in the Long Nineteenth Century* (New York: Zone Books, 2019).

9. In a more concrete sense, they also created an idealized version of an "original" United States, melding a love of nature with an interpretation of the culture of earlier settlers and a belief in spiritual retreat from the industrial city into a vision for a reclaimed, white, Anglo-Saxon America. The contours of this movement were traced by T. K. Jackson Lears in his seminal *No Place of Grace: Antimodernism and the Transformation of American Culture, 1880–1920* (Chicago: University of Chicago Press, 1983). Of particular interest here is his chapter on "The Figure of the Artisan: Arts and Crafts Ideology" (59–96).

10. See Lewis Mumford, *The South in Architecture: The Dancy Lectures Alabama College 1941* (New York: Harcourt Brace, 1941), 45.

11. For the direct influence of Walt Whitman's urban imagery on Frank Lloyd Wright, see John P. Roche, "Democratic Space: The Ecstatic Geography of Walt Whitman and Frank Lloyd Wright," in *Walt Whitman Quarterly Review* 6, no. 1 (1988), 16–32. It should be noted, however, that Whitman's direct and very urban imagery, though read with enthusiasm not just by Wright but by many other American architects, is difficult to trace (despite Roche's valiant effort) in any specific work.

12. See Alexander Braun, *Winsor McCay. The Complete Little Nemo 1910–1927* (Cologne: Taschen, 2019). To my knowledge, there has been no serious attempt to trace the effect of American or European comics in the work of architects and designers in the early twentieth century. This is not surprising, as it seems unlikely any "serious" artist or designer would acknowledge such an influence.

13. See Peter Kenez, *The Birth of the Propaganda State: Soviet Methods of Mass Mobilization, 1917–1929* (Cambridge: Cambridge University Press, 1985), 51ff. Because the core of the art and performance side of this movement, the "agit-trains," was temporary, there is little documentation remaining.

14. A trio of architects active in the early years of the Soviet state—Konstantin Melnikov, Ivan Leonidov, and Yakov Chernikov—eerily paralleled the work of the three utopian architects whose careers bridged the French Revolution. Of the three, only Melnikov (like Ledoux) was able to realize a significant body of work, but all three created designs that defied gravity and proposed cosmic visions of a new reality infused by science. It was Vladimir Tatlin, though, who proposed the most integrated version of such proposals, in his winning entry in the 1919–1920 competition for a Monument to the Third International. Combining the function of a celestial timekeeping device whose pieces rotated according to the cycles of the sun and the moon, a political meeting place with chambers for the various parts of the Soviet bureaucracy, and a public monument, the structure would have soared above the Moscow skyline. It is perhaps as close as any architect in the twentieth century came to bringing machinery and architecture together. The project remained unbuilt. See Norbert Lynton, *Tatlin's Tower: Monument to Revolution* (New Haven: Yale University Press, 2008); also Catherine Cook, *Architectural Drawings of the Russian Avant-Garde* (New York: Museum of Modern Art, 1990).

15. F. T. Marinetti, "Manifeste du Futurisme," *Le Figaro*, February 20, 1919.

16. See Elizabeth W. Easton, "Marinetti before the First Manifesto," *Art Journal* 41, no. 4 (Winter 1981), 313–316.

17. See Mario Praz, *An Illustrated History of Interior Decoration: From Pompei to Art Nouveau* (1964; London: Thames & Hudson, 1981).

18. Marinetti published several other versions of the manifesto in the year before the now canonical placement in the French newspaper. See *F. T. Marinetti, Critical Writings*, ed. Guenter Berghaus, trans. Doug Thompson (New York: Farrar, Straus and Giroux, 2006).

19. Marinetti, "Manifeste du Futurisme," n.p.

20. Ibid.

21. Ibid.

22. Ibid.

23. Ibid.

24. Ibid.

25. Ibid.

26. Ibid.

27. Ibid.

28. See Peter Marshall, *Demanding the Impossible: A History of Anarchism* (Oakland: PM Press, 1992).

29. For a collection of Kropotkin's writings on anarchism, see Peter Kropotkin, *Anarchism: A Collection of Revolutionary Writings*, ed. Roger N. Baldwin (New York: Vanguard Press, 1927). See also Lee Alan Dugatkin, *The Prince of Evolution: Peter Kropotkin's Adventures in Science and Politics* (New York: CreateSpace Independent Publishing Platform, 2011).

30. For the split between Bakunin and Marx, see Wolfgang Eckhardt, *The First Socialist Schism: Bakunin vs. Marx in the International Working Men's Association* (Oakland: PM Press, 2016). See also Robert M. Cutler, ed., *The Basic Bakunin: Writings 1869–1871* (New York: Prometheus Press, 1990).

31. The phrase, although not devised by either Marx or Engels, quickly became central to their platform and permeates their writing. It was picked up by Lenin to explain the notion of the leading place of the party (https://en.wikipedia.org/wiki/Dictatorship_of_the_proletariat).

32. For a history of the Wobblies, see Peter Cole, David Struthers, and Kenyon Zimmer, eds., *Wobblies of the World: A Global History of the IWW* (London: Pluto Press, 2018).

33. See Rudolf Rocker, *Anarcho-Syndicalism: Theory and Practice* (New York: Modern Publishing, 1947), and Victor Damier, *Anarcho-Syndicalism in the 20th Century* (London: Black Cat Press, 2009).

34. Helena Petrovna Blavatsky cofounded the Theosophical Society; she mixed an interpretation of various Buddhist and related texts to come up with her own brand of mysticism. Theosophism was particularly important for the painter Piet Mondrian. See Gary Lachman, *Madame Blavatsky: The Mother of Modern Spirituality* (New York: TarcherPerigee, 2012).

35. G. I. Gurdjieff was an Armenian mystic who claimed to have spent decades looking for enlightenment, finally finding it in a monastery somewhere in the Himalayas. His teachings mixed musical and dance rituals with rather odd dietary rules. Yet his influence was, for a period, quite strong, especially on Frank Lloyd Wright; Wright's third wife, Olgivanna, was one of his main disciples and brought many of his teachings to Taliesin. See Joseph Azize, *Gurdjieff: Mysticism, Contemplation, and Exercises* (Oxford: Oxford University Press, 2020). For Olgivanna's influence, see Roger Friedland and Harold Zellman, *The Fellowship: The Untold Story of Frank Lloyd Wright and the Taliesin Fellowship* (New York: Regan Books, 2006; Kindle edition), loc. 2667ff.

36. Although Rudolf Steiner remains better known today because of his influence on education (in particular the "Steiner" or Waldorf Schools he founded and inspired), he had distinct theories about art and architecture, which he illustrated through the design of his own headquarters, the Goetheaneum outside of Basel, Switzerland. Rudolf Steiner, *Toward a New Theory of Architecture: The First Goetheaneum*, trans. Frederick Amrine (1921; Hudson: Steiner Books, 2017).

37. See Roger Lipsey, *The Spiritual in Twentieth-Century Art* (Boston: Shambala Publishing, 1988).

38. Marinetti, "Manifeste du Futurisme."

39. For the best description and analysis of the works produced by the movement Marinetti founded in terms of their cultural import, see Marjorie Perloff, *The Futurist Moment: Avant-Garde, Avant Guerre, and the Language of Rupture* (Chicago: University

of Chicago Press, 1986). See also Umberto Boccioni's own book-as-manifesto, *Futurist Painting Sculpture (Plastic Dynamism)*, trans. Richard Shane Agin and Maria Elena Versari (1913; Los Angeles: Getty Research Institute, 2006).

40. Antonio Sant'Elia, "The Futurist Manifesto of Architecture," in Ulrich Conrads, ed., *Programs and Manifestoes on 20th Century Architecture*, trans. Michael Bullock (Cambridge, MA: MIT Press, 1975), 34–38; for a complete survey of his work, see Luciano Caramel and Alberto Longatti, *Antonio Sant'Elia: The Complete Works* (New York: Rizzoli International, 1988).

41. See Sanford Kwinter, *Architectures of Time: Toward a Theory of the Event in Modernist Culture* (Cambridge, MA: MIT Press, 2001).

42. Howard Eiland and Michael W. Jennings, *Walter Benjamin: A Critical Life* (Cambrdige, MA: Harvard University Press, 2014).

43. Walter Benjamin, *The Arcades Project*, trans. Howard Eiland and Kevin McLaughlin, ed. Rolf Tiedemann (1982; Cambridge, MA: Harvard University Press, 1999).

44. Ibid., 4.
45. Ibid., 804.
46. Ibid., 834.
47. Ibid., 852.

48. Walter Benjamin, "The Work of Art in the Age of Its Technological Reproducibility," in Benjamin, *The Work of Art in the Age of Its Technological Reproducibility and Other Writings*, trans. Edmund Jephcott, Rodney Livingstone, Howard Eiland, et al. (Cambridge, MA: Belknap Press, 2008), 19–55.

49. Ibid., 24.
50. Ibid., 23, 25–27.
51. Ibid., 23.
52. Ibid., 26.
53. Ibid., 29.
54. Ibid., 30.
55. Ibid., 35.
56. Ibid., 37.
57. Ibid., 38.

58. Ibid., 40. Jacques Rancière, *The Politics of Aesthetics* (London: Bloomsbury, 2013; Kindle edition), loc. 1094, again picks up on this treatment of art that is both almost unseen and uncanny: "Suitable political art would ensure, at one and the same time, the production of a double effect: the readability of a political signification and a sensible or perceptual shock caused, conversely, by the uncanny, by that which resists signification. In fact, this ideal effect is always the object of a negotiation between opposites, between the readability of the message that threatens to destroy the sensible form of art and the radical uncanniness that threatens to destroy all political meaning."

59. Benjamin, "The Work of Art in the Age of Its Technological Reproducibility," 42.

60. As we shall see, the idea that architecture can act as a tool for social change by refusing the techniques that lead to the representation of true economic and human relations became an integral part of much of the discipline that saw itself as "avant-garde"—as was true in most cultural fields. It is the notion of the work of art seen in distraction that received little further development.

61. Since the Second World War, architects claiming to make "normal" architecture have relied on three main arguments. The first is a return to traditional modes of making that are meant to be locally based, eschew an "excessive" reliance of technology, and claim to be more "honest" in their expression of materials and form. Many architects rely here on the writings of Christian Norberg-Schulz, *Intentions in Architecture* (Cambridge, MA: MIT Press, 1968) and *Genius Loci: Towards a Phenomenology of Architecture* (New York: Rizzoli International, 1979); and Kenneth Frampton, "Towards a Critical Regionalism: Six Points for an Architecture of Resistance," in Hal Foster, ed., *The Anti-Aesthetic: Essays on Postmodern Culture* (Seattle: Bay Press, 1983), 16–30. The second strain argues for a return to a form of monumentality and toward a "common" language, in particular classicism. Its reactive nature is beyond discussion. The third argues for an architecture that would embrace popular culture and mass production techniques, aiming, if it does anything, to create a refined version of these. Though interesting as a technique, it has failed to produce any notable architecture even on its own terms: see Steven Harris and Deborah Berke, *Architecture of the Everyday* (New York: Princeton Architectural Press, 1997); John Chase, Margaret Crawford, and John Kaliski, eds., *Everyday Urbanism* (New York: Monacelli Press, 1999).

62. Yve-Alain Bois, "Mondrian and the Theory of Architecture," *Assemblage* 4 (1987), 116.

63. Le Corbusier, *Towards a New Architecture*, trans.

Frederick Etchells (1923; New York: Praeger, 1960), 15–24.

64. Both Christopher Wilson, "Looking at/in/from the Maison de Verre," and Anne Troutman, "The Modernist Boudoir and the Erotics of Space," in Hilde Heynen and Guelsuem Baydar, eds., *Negotiating Domesticity: Spatial Productions of Gender in Modern Architecture* (London: Routledge, 2005), 234–251, 296–314, look at the relation between sexuality, domesticity, and architecture in the building; however, a more thorough examination of the relationship between the client's gynecological practice and especially the hardware of the interiors, which seems evident to this observer, still awaits us.

65. Le Corbusier, *Towards a New Architecture*. The author repeats the phrase throughout the book.

66. T. S. Eliot, "The Wasteland," in *The Complete Poems and Plays 1909–1950* (New York: Harcourt, Brace and Company, 1958), 39.

67. T. S. Eliot, "The Love Song of J. Alfred Prufrock," in *The Complete Poems and Plays 1909–1950*, 3–7.

68. See George Williamson, *A Reader's Guide to T. S. Eliot: A Poem-by-Poem Analysis* (Syracuse: Syracuse University Press, 1998).

69. Kevin Starr published his five-volume history of California starting in 1973. See also my "Riding the A Train to the Aleph: Eight Utopias for Los Angeles," in Tobin Siebers, ed., *Heterotopia: Postmodern Utopia and the Body Politic* (Ann Arbor: University of Michigan Press, 1994), 96–121.

70. These locations are part of the so-called California Adventureland; similar sites are also to be found at Universal City. Disney's secrecy makes an analysis of its architectural intentions difficult.

71. Halprin was a choreographer active in the Bay Area. Her husband, Lawrence Halprin, was also an influential landscape architect. See Janice Ross, *Anna Halprin: Experience as Dance* (Berkeley: University of California Press, 2009).

72. Hockney used Los Angeles as the subject for much of his art intermittently after moving there in 1964. The work cited here is *Mulholland Drive: The Road to the Studio* (1980).

73. Ed Ruscha documented Los Angeles in a laconic manner in his *Thirtyfour Parkinglots in Los Angeles* (1967) and *All the Buildings on the Sunset Strip* (1966), both artist's books. He also used the city as his subject. Of special note for this discussion are his paintings *Burning Gas Station* (various versions, 1965–1966) and *The Los Angeles Museum of Art on Fire* (1965, various versions through 1968).

74. Almarez's lush paintings of Los Angeles also often focused on the city either turning into a jungle or catching on fire. See Howard N. Fox, *Playing with Fire: Paintings by Carlos Almaraz* (Munich: Prestel, 2017).

75. Reyner Banham, *Los Angeles: The Architecture of Four Ecologies* (1971; Berkeley: University of California Press, 2001).

76. Ibid., 195–204. Banham considers the notion that human beings, the machine (specifically, the car), and the city's transportation infrastructure could merge, but dismisses this, as he sees the system working smoothly as it is (196).

77. Nathaniel West, *The Day of the Locust* (1939; New York: New Directions Ebook, 2015), 104–105.

78. Robert Lowell, "For the Union Dead," 1939 (https://www.poetryfoundation.org/poems/57035/for-the-union-dead).

79. Philip Levine, "They Feed They Lion," 1991 (https://www.poetryfoundation.org/poems/49117/they-feed-they-lion).

80. Arata Isozaki, "City Demolition, Inc.," in Arata Isozaki, *Unbuilt* (1962; Tokyo: TOTO Shuppan, 2001), 16–25.

81. Ibid., 18–19

82. Ibid., 19.

83. Ibid.

84. Ibid., 19–20.

85. Ibid., 20.

86. Ibid., 21.

87. Ibid., 21–22.

88. Ibid., 23.

89. Ibid.

90. Ibid., 24.

91. Ibid., 25.

92. Ibid.

93. Many years later, Isozaki produced an image of one of the most important designs, the Tsukuba Science Center, as a ruin (1983).

Chapter 3

1. I surveyed these reactions to technology in my book *Making It Modern: The History of Modernism in Architecture and Design* (Barcelona: ACTAR, 2016), but of course there are many perspectives on the topic. The classic descriptions are those offered by Sigfried Giedion

in *Space, Time and Architecture: The Growth of a New Tradition* (Cambridge, MA: Harvard University Press, 1941) and in *Mechanization Takes Command: A Contribution to Anonymous History* (1948; New York: W. W. Norton, 1969), and by Reyner Banham in *Theory and Design in the First Machine Age* (London: Architectural Press, 1960).

2. In 1943, Giedion, working with the architect J. L. Sert and the painter Fernand Léger, wrote "Nine Points on Monumentality" (published in the *Harvard Architecture Review*). Decrying the "devaluation of monumentality" in the modern period, they called for rebuilding Europe at a new scale and with new materials, but in a manner that would help it "regain . . . its lyrical value."

3. Central to Heidegger's work is *Being and Time*, trans. John Macquarrie and Edward Robinson (1927; New York: Harper & Row, 1962), which proceeds from an examination (p. 12) of what "Being" might be to the concept of "Dasein," the presence of being, that Heidegger then develops throughout the book. For a good synopsis of the relationship between Heidegger's general concepts, architecture, and technology, see Karsten Harries, *Martin Heidegger: Politics, Art, and Technology* (London: Holmes & Meier, 1994). Harries first introduced me to Heidegger's texts at Yale in the 1970s.

4. A good discussion of such writings from various perspectives is to be found in Aaron James Wendland, Christopher Merwin, and Christos Hadjioannou, eds.,

Heidegger on Technology (London: Routledge, 2018).

5. Martin Heidegger, "The Question Concerning Technology," in Heidegger, *The Question Concerning Technology and Other Essays*, trans. William Lovitt (New York: Harper Torchbooks, 1969), 3–35.

6. Martin Heidegger, "Building Dwelling Thinking," in Heidegger, *Basic Writings*, ed. David Farrell Krell (San Francisco: HarperSanFrancisco, 1993), 343–364.

7. Heidegger, "Building Dwelling Thinking," 361–362.

8. Ibid., 363.

9. Ibid.

10. Heidegger, "The Question Concerning Technology," 5.

11. Ibid., 4ff.

12. Ibid., 7.

13. Ibid., 12.

14. The fullest discussion of this tradition is to be found in Georges Bataille's *The Accursed Share: An Essay on General Economy*, trans. Robert Hurley (1949; New York: Zone Books, 1991).

15. Heidegger, "The Question Concerning Technology," 13ff.

16. Ibid., 10, 14.

17. Ibid., 14.

18. Ibid., 16.

19. Ibid.

20. Ibid., 21.

21. Ibid., 22ff.

22. Ibid., 28.

23. Ibid., 32ff.

24. None of these developments, however, reached to or even aspired to the integration of elements Wright envisioned or Heidegger imagined. This was largely due to the fact that they were designed in separate zones, with industry, living, and civic sections kept separate.

As Margaret Crawford points out in her seminal work on this phenomenon in the United States, *Building the Workingman's Paradise: The Design of American Company Towns* (London: Verso, 1995), 4, the model for the nonindustrial area was the model town or utopian community, not the efficient landscape of the factory. Over time, this disconnect expanded, as Crawford points out later in the book, to a regional level, further dissipating any formal relations (174ff).

25. The most fully imagined of these towns was Tony Garnier's Cité Industrielle, planned for the environs of Lyons, but here, as in the United States, grids of housing stood in contrast to the integrated mechanism of the places of production. See Tony Garnier, *Une Cité Industrielle* (1917; New York: Princeton Architectural Press, 1989).

26. Albert Kahn, who built one of the largest office practices in the world largely on the back of industrial commissions, most closely mimicked the manner in which industrial practices took place in his own office, while other firms chose to think of their enterprises more as corporate organizations; see Reinhold Martin, *The Organizational Complex: Architecture, Media, and Corporate Space* (Cambridge, MA: MIT Press, 2003). For the best description of Kahn's office, see Michael H. Hodges, *Building the Modern World: Albert Kahn in Detroit* (Detroit: Wayne State University Press, 2018). See also Claire Zimmerman, "Albert Kahn in the Second Industrial

Revolution," *AA Files*, no. 75 (2017), 28–44.

27. See Joseph P. Cabadas, *River Rouge: Ford's Industrial Colossus* (Detroit: Motorbooks, 2004). For its place in American industrial history, see Lindy Biggs, *The Rational Factory: Architecture, Technology and Work in America's Age of Mass Production* (Baltimore: Johns Hopkins University Press, 1996). Although River Rouge is still in operation, the scale and intricacy of the original design as it inspired artists can now only be gleaned from the images those observers made or from period photographs.

28. For Sheeler's relationships to industrial subjects, see Karen Lucic, *Charles Sheeler and the Cult of Machine* (Cambridge, MA: Harvard University Press, 1991). For the larger art historical context of such work, see Emma Acker, Sue Canterbury, Adrian Daub, and Lauren Palmor, *Cult of the Machine: Precisionism and American Art* (New Haven: Yale University Press, 2018).

29. Sonia Melnikova-Raich, "The Soviet Problem with Two 'Unknowns': How an American Architect and Soviet Negotiator Jump-Started the Industrialization of Russia," *IA The Journal of the Society of Industrial Archeology* 36, no. 2 (2010), 57–80.

30. For a full description of Rockefeller Center's architecture, see Alan Balfour, *Rockefeller Center: Architecture as Theater* (New York: McGraw Hill, 1978), and Carol Herselle Krinsky, *Rockefeller Center* (Oxford: Oxford University Press, 1978). For Wallace Harrison's work in general, see Victoria Newhouse, *Wallace K.*

Harrison, Architect (New York: Rizzoli International, 1989).

31. Giedion, *Space, Time and Architecture*, 850–851.

32. Giedion, *Mechanization Takes Command*, 714–722.

33. See my *The U.N. Building* (London: Thames & Hudson, 2005). Another interesting aspect of the design of this complex was the fact that it was truly designed by committee, and an international one at that.

34. For the Hilton hotels of this period, see Annabel Jane Wharton, *Building the Cold War: Hilton International Hotels and Modern Architecture* (Chicago: University of Chicago Press, 2004). There are few sources in English on the history and design of Intourist hotels; the observations here are based on personal experience and research into available images and plans. For a similar survey, see Mark Baker, "The Weird, Wacky Wonderful World of Communist-Era Hotels," *Radio Free Europe*, February 27, 2018, https://www.rferl.org /a/communist-era-hotels -central-eastern-europe -weird-wacky-architecture /29065179.html.

35. In many ways, these structures reflected the rise of what President Eisenhower famously called the "military-industrial complex," the interconnected corporate and government bureaucracies that coordinated the research and development as well as the production not only of war machinery but of many other products as well. The relation of this phenomenon to architecture were traced most thoroughly by Martin

in *The Organizational Complex*, esp. 34–35.

36. Agnes Nyilas in fact refers to metabolism as having replaced, or clad, utopia with what she calls "mythopia." Agnes Nyilas, *Beyond Utopia: Japanese Metabolism Architecture and the Birth of Mythopia* (New York: Routledge, 2018).

37. Michael Berlin Kasiske, "Universitaetsklinikum Farbstudien," *Bauwelt* 26–27 (2010), https://www.bauwelt.de /themen/bauten/Universitaet sklinikum-2153587.html.

38. Giedion, *Space, Time and Architecture*, 862.

39. Though there have been many interpretations of the films I cite here, to my knowledge there has been no integrated study of the manner in which megastructures are portrayed in cinema. Donald Albrecht, in his *Designing Dreams: Architecture in the Movies* (Santa Monica: Hennessy & Ingals, 2000), traces the general arc of modernism in film. Jacques Tati built his modernist structures from scratch rather than using existing structures, as many other filmmakers did. Ken Adams, who designed several science fiction films, is the subject of *Ken Adams Designs the Movies: James Bond and Beyond*, by Adams and Christopher Frayling (London: Thames & Hudson, 2008). Chad Oppenheim, in *Lair: Radical Homes and Hideouts of Movie Villains* (Miami: Tra Publishing, 2019), discusses some of the larger structures that approach megastructure scale as homes for such villains.

40. Although the quote is often referred to in discussions of Mies van der Rohe's

work, I have been unable to find a primary citation. See, for an early citation, Philip Johnson, *Mies van der Rohe* (New York: Museum of Modern Art, 1947), 140.

41. For a recent discussion of how Mies used glass, what it revealed, and what it occluded, see Kiel Moe, *Unless: The Seagram Building Construction Ecology* (Barcelona: ACTAR, 2021.)

42. Le Corbusier, *Le Modulor*, trans. Peter de Francia and Anna Bostock (1950; Basel: Birkhäuser, 2000). For the most complete treatment of Chandigarh, see Patrick Seguin, ed., *Le Corbusier Pierre Jeanneret: Chandigarh, India* (Paris: Editions Galerie Patrick Seguin, 2014).

43. For Parent's own description of the working method they used, see *The Function of the Oblique: The Architecture of Claude Parent and Paul Virilio 1963–1969* (London: AA Files, 2004). Virilio also published a collection of photographs of bunkers, *Bunker Archaeology* (1967; New York: Princeton Architectural Press, 1994). Virilio was particularly interested in the relationship between technology and accident, and thus on the inevitability of violence, including war, as part of modernity. See, for instance, his *Speed and Politics: An Essay on Dromology*, trans. Mark Polizotti (New York: Semiotext(e), 1977).

44. Robert Smithson, "Entropy and the New Monuments" (1966), in *Robert Smithson: The Collected Writings*, ed. Jack Flam (Berkeley: University of California Press, 1996), 11.

45. Ibid., 14.

46. The most complete catalog of the project is *Constant: New Babylon*, edited by Rem Koolhaas et al. (Cologne: Hatje Kantz, 2016). The best critical assessment of the work in the English language, which also collects some of his most important writing, is Mark Wigley, *Constant's New Babylon* (Rotterdam: 010 Publishers, 1999).

47. Quoted in Wigley, *Constant's New Babylon*, 13.

48. Johan Huizinga, *Herfstij der Middeleeuwen: Studio over Levens- en Gedachtenvormen der Veertiende en Vijftiende Eeuw in Frankrij en Nederland* (1919; Amsterdam: Polak & Van Gennep, 2017).

49. Johan Huizinga, *Homo Ludens: A Study of the Play Element in Culture* (1955; Kettering: Angelico Press, 2016).

50. Wigley, *Constant's New Babylon*, 67.

51. Constant Nieuwenhuys, "Tomorrow Life Will Reside in Poetry" (1956), in Wigley, *Constant's New Babylon*, 78.

52. Wigley, *Constant's New Babylon*, 32.

53. Ibid., 12.

54. Ruth Langdon Inglis, as quoted in Stanley Matthews, "The Fun Palace at Fifty," *Art in America*, October 1, 2016, https://www.artnews.com/art-in-america/features/fun-palace-fifty-63517/. For a complete survey of Price's work, see Samatha Hardingham, ed., *Cedric Price Works 1952–2003: A Forward-Minded Retrospective* (London: AA Publications, 2016).

55. Robert Venturi, Denise Scott Brown, and Steven Izenour, *Learning from Las Vegas* (Cambridge, MA: MIT Press, 1972).

Chapter 4

1. Manfredo Tafuri, *Architecture and Utopia: Design and Capitalist Development*, trans. Barbara Luigia La Penta (1973; Cambridge, MA: MIT Press, 1976), 1.

2. Ibid.

3. *Architecture and Utopia* is a condensed version of a large body of thought Tafuri developed through his career as a historian with a particular interest in "avant-gardes" or pivotal and catalytic architects of the early modern period. See his *The Sphere and the Labyrinth: Avant-Gardes and Architectures from Piranesi to the 1970s*, trans. Pellegrino d'Acierno and Robert Connolly (1980; Cambridge, MA: MIT Press, 1987).

4. Tafuri, *Architecture and Utopia*, 3–4.

5. Ibid., 5.

6. Ibid., 21.

7. Ibid., 14–21.

8. Ibid., 30.

9. Ibid., 29.

10. Ibid., 30–37.

11. Frank Lloyd Wright worked with the magazine for several decades, and it became a valuable way for him to market his skills. None of his urban proposals were realized, however, beyond a row of so-called "American System-Built homes" in Milwaukee that hewed closely to standard ideas of how to address the street, and his later Usonian houses. See Diane Maddex, *Frank Lloyd Wright's House Beautiful* (New York: Hearst Books, 2001).

12. For the most comprehensive discussion and analysis of Wright's urban proposals, see Neil Levine, *The Urbanism of Frank Lloyd Wright* (Princeton: Princeton

University Press, 2015). Wright continue to develop versions of Broadacre City throughout the 1930s and 1940s after first producing the idea in 1932 and exhibiting the large model of the proposal at Rockefeller Center in 1935.

13. Tafuri, *Architecture and Utopia*, 38.

14. Ibid., 50ff.

15. Ibid., 81.

16. Ibid., 84.

17. Ibid., 48.

18. He uses the examples of Le Corbusier's colonial adventure in Algiers as his example (ibid., 125ff.).

19. Ibid., 135, 143.

20. Ibid., 148.

21. Ibid., 161.

22. Ibid., 181.

23. Ibid., 172ff.

24. There have been quite a few case studies of such attempts during the 1970s, with special attention paid to such events as the emergence of People's Park in Berkeley, California, and the so-called "Nieuwmarkt Riots" protesting the building of the Amsterdam subway line, but there are no scholarly treatments of the systemization and integration into curricula of these movements. For a treatment of the development of pedagogy in this period, see Beatriz Colomina et al., eds., *Radical Pedagogies* (Cambridge, MA: MIT Press, 2022).

25. Tafuri speaks of "agnostic formalism" (*Architecture and Utopia*, 157) and "poetry of ambiguity" (166) as two of the modes of postwar coping mechanisms.

26. For the most complete collection of Boullée's work, see Jean-Marie Pérouse de Montclos, *Etienne-Louis Boullée* (London: Thames & Hudson, 1974). The classic treatment of the three architects, and the one that fixed them as a triad central to a protomodernist tradition, is Emil Kaufmann's *Three Revolutionary Architects: Boulée, Ledoux, and Lequeu* (New York: American Philosophical Society, 1952). See also Jean-Claude Lemagny, *Visionary Architects: Boullée, Ledoux, Lequeu* (Santa Monica: Hennessy & Ingalls, 2002).

27. Anthony Vidler, *Claude-Nicolas Ledoux: Architecture and Social Reform at the End of the Ancien Régime* (Cambridge, MA: MIT Press, 1990), concentrates on his work before the Revolution. Vidler expanded on this work in *Claude-Nicolas Ledoux: Architecture and Utopia in the Enlightenment and French Revolution* (Basel: Birkhäuser, 2006).

28. Fitting his enigmatic work, the only book-length treatment of Lequeu's work is a deconstructivist and speculative reading that does, however, reproduce much of his work in full color: Philippe Duboy, *Lequeu: An Architectural Enigma*, trans. Francis Scarfe (London: Thames & Hudson, 1986).

29. For a complete collection and analysis of architecture in the *Encyclopédie*, there is Terence M. Russell, *Architecture in the Encyclopédie of Diderot an D'Alembert* (Paris: Scolar Press, 1993). Like most treatments, however, it concentrates on the formal definitions and examples of architecture, rather than in the manner buildings appear as scenes or backgrounds in the portrayal of other trades and activities. It is here that the most modernist and proto-loft examples can be found.

30. The same is true of artists who were searching for silence and a "degree zero" in their work, as described by Smithson in "Entropy and the New Monuments" (1966), in *Robert Smithson: The Collected Writings*, ed. Jack Flam (Berkeley: University of California Press, 1996).

31. Of particular interest were the attempts in both the West and the Soviet bloc to create large structures that would represent the power of the government while providing modes of entertainment or escape that would make those social structures more acceptable. Cor Wagenaar, ed., *Happy: Cities and Public Happiness in Post-War Europe* (Rotterdam: NAi Publishers, 2004). For the Japanes reaction to the ruinous state of the postwar city see William O. Gardner, *The Metabolist Imagination: Visions of the City in Post-War Japanese Architecture and Science Fiction* (Minneapolis: University of Minnesota Press, 2020).

32. Banham, who became the muse of this and of several of the other movements I outline here, coined the phrase in his essay "The New Brutalism," *Architectural Review*, December 9, 1955, 354–359, 361. For the roots of the movement in larger postwar experience, see Claude Lichtenstein, *As Found: The Discovery of the Ordinary: British Architecture and Art of the 1950s, New Brutalism, Independent Group, Free Cinema, Angry Young Men* (Zurich: Lars Müller, 2001).

33. Kubrick's vision was the subject of an exhibition at

London's Design Museum in April to September of 2019, but no catalog was produced.

34. Banham was also one of the leading exponents of this development, writing about it frequently and publishing *Megastructures: Urban Futures of the Recent Past* (London: Thames & Hudson, 1976).

35. A complete documentation of Archigram's work is available in Warren Chalk et al., *Archigram: The Book* (London: Circa Press/Archigram Archives, 2018).

36. *Archigram: The Book*, 80–83.

37. Ibid., 114–121.

38. Ibid., 86–91.

39. Ibid., 158–166.

40. Ibid., 202–203.

41. Ibid., 218–215.

42. Roland Barthes, *Empire of Signs*, trans. Richard Howard (1970; New York: Hill and Wang, 1982), 107–108.

43. It is uncanny to consider how close to some of these visions was the film *Matrix*, which was released in 1999.

44. Andrea Branzi, *No-Stop City: Archizoom Associati* (Orléans: Hyx, 2006).

45. Most of Superstudio's work was collected and discussed in Peter Lang and William Menkings, *Superstudio: Life without Objects* (Geneva: Skira, 2003).

46. Succinct documentation of this and other projects is available in Emmanuele Chiappone-Piriou, ed., *Superstudio migrazioni*, vol. 2 (Cologne: Verlag der Buchhandlung Walther und Frank Koenig, 2020); for this project, see p. 154.

47. Ibid., 107–109.

48. These images are not in the catalog, but can be found at the archives of the Canadian Centre for Architecture in Montreal, cca.qc.ca.

49. Maria Cristina Didero, *SuperDesign: Italian Radical Design 1965–75* (New York: Monacelli Press, 2017), 210.

50. Philip Ursprung discusses these developments with clarity and with the perspective of an architectural historian in his 2013 *Allan Kaprow, Robert Smithson, and the Limits to Art*, trans. Fiona Elliott (Berkeley: University of California Press). For writings on the topic, see Gregory Battcock and Anne M. Wagner, eds., *Minimal Art: A Critical Anthology* (Berkeley: Unviversity of California Press, 1995).

51. Brian O'Doherty, *Inside the White Cube: The Ideology of the Gallery Space* (1976; Berkeley: University of California Press, 2000).

52. Hal Foster, *Brutal Aesthetics: Dubuffet, Bataille, Jorn, Paolozzi, Oldenburg* (Princeton: Princeton University Press, 2020), 150, 151.

53. The appearance of photographs of the dirt house had a strong impact on architects in the late 1970s and early 1980s, although the work was somewhat of an outlier in Shinohara's work. See *Japan Architect*, no. 93 (Spring 1993), 74–77.

54. One of the notebooks, the *Libro Azzurro*, was published in a complete facsimile by Jamileh Weber Galerie in Zurich in 1981 and is invaluable in giving a sense of his technique. See also Paolo Portoghesi, *Aldo Rossi: The Sketchbooks 1990–1997*, trans. Sarah Campbell (London: Thames & Hudson, 2000).

55. Aldo Rossi, *A Scientific Autobiography*, trans. Lawrence Venuti (Cambridge, MA: MIT Press, 1981), 2.

56. Ibid., 19.

57. Ibid., 5.

58. Ibid., 37

59. Ibid., 82.

60. Ibid.

61. Ibid., 23.

62. Peter Eisenman, *House X* (New York: Rizzoli International, 1982).

63. Peter Eisenman, *The Formal Basis of Modern Architecture* (1963; Zurich: Lars Müller, 2018).

64. Eisenman explained his method in "Conceptual Architecture II: Double Deep Structure 1," *A+U* 39 (1974), 83–88. For a short description of his influences and thoughts during the period, see Thomas Patin, "From Deep Structure to an Architecture in Suspense: Peter Eisenman, Structuralism, and Deconstruction," *Journal of Architectural Education* 47, no. 2 (November 1993), 88–92. In addition, Mario Gandelsonas, in his introduction to *House X*, "From Structure to Subject: The Foundation of an Architectural Language" (7–30), provides a clear analysis of these early houses.

65. Eisenman, *House X*, 38.

66. Ibid., 34.

67. Eisenman was closely connected to Rossi and Tafuri through his activities during this time as the head of the Institute for Architecture and Urban Studies in New York.

68. Eisenman, *House X*, 40.

69. Ibid., 38.

70. Ibid., 34.

71. Eisenman developed these ideas in two houses, the Castelli House and the Guardiola House. He published the latter with Aedas Gallery in Berlin in 1989.

Notes

Chapter 5

1. http://content.time .com/time/covers/0,16641 ,19660408,00.html.

2. Donella H. Meadows, Dennis L. Meadows, Jørgen Randers, and William W. Behrens III, *The Limits to Growth: A Report for the Club of Rome's Project on the Predicament of Mankind* (New York: Universe Books, 1972), 17.

3. Ibid., 24.

4. Robert Venturi, *Complexity and Contradiction in Architecture* (New York: Museum of Modern Art, 1966), 103.

5. Ibid., 16.

6. Ibid., 34.

7. They used the diagram of duck and decorated shed often in their lectures and placed it in their *Learning from Las Vegas* (Cambridge, MA: MIT Press, 1972), 17, which they wrote with Steven Izenour.

8. Venturi, *Complexity and Contradiction in Architecture*, 20.

9. Ibid., 43.

10. Venturi, Scott Brown, and Izenour, *Learning from Las Vegas*.

11. Venturi, *Complexity and Contradiction in Architecture*, 102.

12. The exhibition was held at the Smithsonian's Renwick Gallery (https://www.si.edu /exhibitions/signs-life-symbols-american-city %3Aevent-exhib-5236). In 2004, Venturi and Scott Brown published a resume of their thoughts in this area as *Architecture as Signs and Systems for a Mannerist Times* (Cambridge, MA: Belknap Press), which already steps back toward a more integrative position giving primacy to the built fabric.

13. Venturi, *Complexity and Contradiction in Architecture*, 103.

14. Hunter S. Thompson, *Fear and Loathing in Las Vegas: A Savage Journey to the Heart of the American Dream* (1971; New York: Vintage Books, 1989), 46.

15. Norman Mailer, *An American Dream: A Novel* (1965; New York, Random House, 2013), 268–269.

16. Jencks may even have coined the phrase earlier than uses that appeared in literature and music. He certainly became the critic most closely associated with it as a movement. Charles Jencks, *The Language of Post-Modern Architecture* (New York: Rizzoli International, 1977).

17. Henri Lefebvre, *The Production of Space*, trans. Donald Nicholson-Smith (1974; London: Blackwell, 1991).

18. It was a phrase Kahn was fond of using. For one of the better versions, see Alexandra Tyng, *Beginnings: Louis I. Kahn's Philosophy of Architecture* (New York: John Wiley & Sons, 1984), 131. Kahn's continual interest in ruins and in silence led him, unlike the architects described here, toward more monumental buildings that were yet scaled to the human body.

19. Lefebvre, *The Production of Space*, 2.

20. Ibid., 229ff.

21. Ibid., 8.

22. Ibid., 80ff.

23. Ibid., 32.

24. Ibid., 46ff.

25. Ibid., 33; he then reiterates and expands on these definitions on pp. 38–39.

26. Ibid., 65.

27. Ibid.

28. Ibid., 404.

29. Ibid., 405.

30. Ibid., 36.

31. Ibid., 422.

32. This is how Alberto Pérez-Gómez described the work in an article that picks up on the Heideggerian tradition and the notion of architecture as a form of radical poetry that somewhat parallels my interpretations. Alberto Pérez-Gómez, "The Renovation of the Body: John Hejduk and the Cultural Relevance of Theoretical Projects," *AA Files*, no. 13 (Autumn 1986), 28.

33. John Hejduk, *Mask of Medusa: Works 1947–1983* (New York: Rizzoli International, 1985), 373–355.

34. Gregory A. Wilson, *The Problem of the Middle: Liminal Space and the Court Masque* (Clemson: Clemson University Press, 2019), 212.

35. Ibid., 6.

36. John Hejduk, *Vladivostok* (New York: Rizzoli International, 1989).

37. The *Mask of Medusa* contains an unidentified sketch that is clearly of Medusa on p. 455. A more harrowing version is to be found in *Vladivostok* (165), where it is described as "The Magistrate."

38. Hejduk, *Mask of Medusa*, 211.

39. Hejduk was a highly captivating lecturer and critic, and much of his influence was also due to his ability to bind audiences, including the author, for hours. He also was able to attract highly talented disciples, such as Daniel Libeskind, Elizabeth Diller, and Ricardo Scofidio, whose work was strongly marked by the encounter.

40. Mike Davis, *City of Quartz: Excavating the Future in Los Angeles* (London: Verso, 1990).

41. Edward W. Soja, *Postmodern Geographies: The Reassertion of Space in Critical Social Theory* (London: Verso, 1989), 132–133.

42. Ibid., 133.

43. Ibid., 136–137.

44. Ibid., 3.

45. I taught with Davis at the Southern California Institute of Architecture (SCI-Arc) during this period. He had a strong influence on a generation of younger architects and theoreticians. The strongest publication coming out of this work may be Joe Deegan Day's *Corrections + Collections: Architectures for Art and Crime* (New York: Routledge, 2013).

46. Peter Sloterdijk, *Bubbles (Spheres I)*; *Globes (Spheres II)*; *Foams (Spheres III)*, trans. Wieland Hoban (1998, 1999, 2004; New York: Semiotext(e), 2013, 2014, 2016).

47. Sloterdijk, *Bubbles*, 16–18.

48. Sloterdijk, *Foams*, 564–626.

49. Peter Sloterdijk, *Het kristalpaleis: Een filosofie van de globalisering*, trans. Hans Driessen (Amsterdam: SUN, 2006), 185ff. This book has not been published in English.

50. Sloterdijk, *Bubbles*, 540.

51. Sloterdijk, *Foams*, 23.

52. Ibid., 810.

53. Michel Foucault, "Of Other Spaces: Heterotopias," translated from *Architecture, Mouvement, Continuité*, no. 5 (1984) (https://www.foucault.info/documents/heterotopia/foucault.heteroTopia.en/), 46.

54. Ibid., 48.

55. Ibid.

56. Mike Davis and his followers have made these the site of critical attention, but a whole cottage industry has grown up trying to learn from favelas and slums around the world. Some of the more successful attempts, such as those by the Swiss-based firm Urban Think Tank, take a stance that is as much about documentation and acupuncture-like urbanism.

57. Foucault, "Of Other Spaces," 59.

Chapter 6

1. Jacques Derrida and Peter Eisenman, *Chora L Works* (New York: Monacelli Press, 1997). The collaboration took place in the late 1980s.

2. It was not until 2018 that a philosopher published an interpretation of Derrida's work geared to architects: Francesco Vitale, *The Last Fortress of Metaphysics: Jacques Derrida and the Deconstruction of Architecture*, trans. Mauro Senatore (Albany: SUNY Press, 2018). Another volume attempting to make Derrida's work accessible to the discipline is Richard Coyne, *Derrida for Architects* (New York: Routledge, 2011).

3. I have chosen this particular text because of its ability to condense information concisely, but also because the volume in which it appeared became a much-used textbook (or cheat sheet) for architects and designers in the United States: Gregory Ulmer, "The Object of Post Criticism," in Hal Foster, *The Anti-Aesthetic* (Seattle: Bay Press, 1995), 83–110.

4. Ulmer, "The Object of Post Criticism," 84.

5. Ulmer here is giving his own, rather condensed interpretation of the meaning of collage and its art history. For a more thorough treatment, see John Enderfield, *Essays on Assemblage* (New York: Museum of Modern Art, 1992); as well as Diane Waldman, *Collage, Assemblage, and the Found Object* (New York: Harry S. Abrams, 1992), or the more narrowly focused Christine Poggi, *In Defiance of Painting: Cubism, Futurism, and the Invention of Collage* (New Haven: Yale University Press, 1992). For a more recent survey see Brandon Taylor, *Collage: The Making of Modern Art* (London: Thames & Hudson, 2006).

6. Ulmer, "The Object of Post Criticism," 86.

7. Ibid., 88.

8. Ibid., 89ff.

9. Ibid., 87.

10. Ibid., 99.

11. Jacques Derrida, *Disseminations*, trans. Barbara Johnson (1972; Chicago: University of Chicago Press, 1981), 100.

12. It is interesting to note that Kurt Schwitters called his work an *Eigengift*, which can be translated as both "own poison" and "particular poison." As Graham Bader says: "By this term, Schwitters means the established social uses and connotations of his works' component elements, that which needed to be eradicated for his compositions to gain the status of the work of art … a generative matter and deadly threat in one—as not accessory antidote but essential substance—and Merz was invented at the hinge between these two." Graham Brader, *Poisoned Abstraction: Kurt Schwitters between*

Revolution and Exile (New Haven: Yale University Press, 2021), 3.

13. Derrida, *Disseminations*, 133. In the text, Derrida points out the pharmakon's nature as what is both internal and external, and both tells truth (as in the case of Socrates' dying words) and produces visions and potential untruths.

14. Ulmer, "The Object of Post Criticism," 104ff.

15. Fredric Jameson, "Postmodernism and Consumer Society," in Foster, *The Anti-Aesthetic*, 119. He is here following, or offering his interpretation of, the work of Jacques Lacan.

16. Ibid., 125.

17. Ibid.

18. Lévi-Strauss most carefully tracked his pre-World War II field work in his *Tristes Tropiques*, trans. John and Doreen Weightman (1955; New York: Penguin Books, 1973). Later works were based as much on secondary sources as they were on his own field observations.

19. Claude Lévi-Strauss, *The Savage Mind* (1962; Chicago: University of Chicago Press, 1966).

20. Ibid., 10.

21. Ibid., 11.

22. Ibid., 16.

23. Ibid., 14.

24. Ibid., 12.

25. Ibid., 13.

26. Ibid., 14.

27. Alpers developed a way of contrasting "Northern" modes of picture-making with "Southern" modes. In the latter, the model is the window, which assumes that the painting presents another world outside of the viewer's ability to experience directly.

It is a wholly invented one. The northern mode acts as a mirror or map, giving the viewer back their reality in an altered, reversed, or abstracted mode, so imbued with the craft of making that the original world, the act of making the work of art, and the world pictured become complete intertwined. The clearest statement of this interpretation is to be found in her article "Style Is What You Make It: The Visual Arts Once Again," in Beryl Lang, ed., *The Concept of Style* (Ithaca: Cornell University Press, 1979), 137–162. See also her *The Art of Describing: Dutch Art in the Seventeenth Century* (Chicago: University of Chicago Press, 1984).

28. I was part of that industry, through the publication of my first book, *Violated Perfection* (New York: Rizzoli International, 1990). Much more seminal was the catalog for the exhibition on the subject organized by the Museum of Modern Art: Mark Wigley, *Deconstructivist Architecture* (New York: Museum of Modern Art, 1988). See also Andreas Papadakis, Catherine Cooke, and Andrew Benjamin, *Deconstruction Omnibus Volume* (New York: Rizzoli International, 1990).

29. Jean François Lyotard, *The Postmodern Condition: A Report on Knowledge*, trans. Geoff Bennington (Minneapolis: University of Minnesota Press, 1984), 71.

30. Ibid., 72–73.

31. Ibid., 77.

32. Ibid., 79.

33. Ibid., 81.

34. Ibid.

35. Ibid., 82.

36. The studios were first established under Dean Bernard Tschumi and the central faculty members leading them were Hani Rashid and Greg Lynn, both of whom later became faculty members at the University for Applied Arts in Vienna. Some of the archives of these studios are held by Columbia, others are in the collection of the Canadian Centre for Architecture in Montreal. To my knowledge, there has not been a published history of this influential pedagogical sequence.

37. https://www.moma.org /calendar/exhibitions/1813.

38. Mark Wigley, *The Architecture of Deconstruction: Derrida's Haunt* (Cambridge, MA: MIT Press, 1993), 209.

39. Ibid., 87.

40. Mark Wigley, "Postmortem Architecture: The Taste of Derrida," *Perspecta* 23 (1987), 156–172. Wigley also expounded on these ideas in lectures he gave during this period.

41. Anthony Vidler, *The Architectural Uncanny: Essays in the Modern Unhomely* (Cambridge, MA: MIT Press, 1992). Vidler had been fascinated with crypts and underground spaces in his earlier writings on Ledoux and nineteenth-century architecture in London and Paris, and brought some of his deep historical knowledge to bear on what are here both literary and psychological speculations.

42. Wigley, *The Architecture of Deconstruction*, 42.

43. Ibid.

44. Ibid., 69.

45. Ibid., 71.

46. Ibid., 73.

47. Ibid., 212.

48. Ibid., 215.

49. Wigley was long fascinated with Matta-Clark, studying and lecturing about him throughout the 1990s and aughts. He finally published *Cutting Matta-Clark: The Anarchitecture Investigation* (Cologne: Lars Müller) in 2018, tracking the artist's use of the word and the development of it as an operative concept in his work

50. These texts were printed as postcards under the title *Advertisements for Architecture in 1976*. They can be found on sites such as https://imgur.com/a/mIby5.

51. Bernard Tschumi, *The Manhattan Transcripts* (1981; London: Academy Editions, 1994), 8.

52. Bernard Tschumi, *Architecture and Disjunction* (Cambridge, MA: MIT Press, 1994), 257.

53. Ibid., 258.

54. Bernard Tschumi, *Parc de La Villette* (London: Artifice, 2014). This is a summation volume that also includes essays by Anthony Vidler and Jacques Derrida that were published shortly after the Parc's opening.

55. I rely here on my own research and observation of Hadid's work, which I first collected into the essay I wrote for *Zaha Hadid: The Complete Buildings and Projects* (London: Thames & Hudson, 1998), 6–14, and revised and expanded several times after that.

56. Wigley, *Deconstructivist Architecture*.

57. These are phrases Prix used in his lectures. For a good synopsis, see Wolf Prix, "Architecture Must Burn: Lecture by Wolf D. Prix at the Staedelschule, Frankfurt, 1984," in *Wolf D. Prix Get Off of My Cloud: Coop Himmelb(l)au Texts 1968–2005* (Ostfildern-Ruit: Hatje Cantz, 2005), 112–116, esp. 113. For a description of the psychograms, see Coop Himmelb(l)au, *The Power of the City* (Berlin: Georg Buechner Buchhandlung, 1988), 12–14.

58. The summation of Libeskind early work was a sequence of projects he collected in *The Line of Fire* (Milan: Electa, 1988): the so-called "Memory Machines," objects he designed for an exhibition in Italy that burned in transit; a project for Berlin; and then the specific proposal for the Jewish Museum at the Museum for Berlin History, whose commission led to his transformation from a paper to a building architect. For his beautiful early collages, see also Daniel Libeskind, *Between Zero and Infinity: Selected Projection Architecture* (New York: Rizzoli International, 1981).

59. Woods organized many of these designers together in a group he founded, the Research Institute for Experimental Architecture. See https://lebbeuswoods.word press.com/2011/06/25/riea -the-back-story/. A report of the group's first conference was published as *Research Institute for Experimental Architecture: The First Conference* (New York: Princeton Architectural Press, 1989).

60. Lebbeus Woods, *Centricity, Architekturphilosophische Visionen* (Berlin: Aedes Gallery, 1987).

61. This work was most comprehensibly collected in Lebbeus Woods, *Terra Nova, Architecture + Urbanism extra* edition, August 1991 (for which I wrote a short essay). For his own thoughts on the drawings, see Lebbeus Woods, *OneFiveFour* (New York: Princeton Archtiectural Press, 1989).

62. Lebbeus Woods, *Anarchitecture: Architecture as a Political Act* (London: Academy Editions, 1992).

63. For a collection of these later works, see the posthumous *Lebbeus Woods Architect* with essays by Joseph Becker and Jennifer Dunlap Fletcher (New York: Drawing Center, 2013).

Chapter 7

1. Some of the archives of the Institute are held by the Canadian Centre for Architecture in Montreal. In 2010, one of the participants, Suzanne Frank, issued a somewhat chatty reminiscence: *IAUS, the Institute for Architecture and Urban Studies: An Insider's Memoir* (New York: Author-House, 2010). In 2013, one of the other participants, Diana Agrest, released a documentary video on the IAUS, *The Making of an Avant-Garde: The Institute for Architecture and Urban Studies 1967–1982* (https://makingofanavant garde.com/the-film).

2. I refer here and in most of the following notes to the 1994 edition by the Monacelli Press, as my copy of the original, 1978 edition has long since disappeared. I therefore rely on reproductions for my description of the cover and several other aspects of the book.

3. Rem Koolhaas, *Delirious New York* (New York: Monacelli Press, 1994), 10.

4. Ibid., 9–10.

5. Ibid., 17.

6. Ibid., 10.

7. Ibid., 19.

8. Ibid., 20.

9. Ibid.

10. Ibid., 171.

11. Ibid., 150.

12. Ibid., 158.

13. Ibid., 185.

14. Ibid., 117.

15. Ibid., 87.

16. Ibid., 208ff.

17. Ibid., 185.

18. Ferriss's visions remained buried inside the buildings for which he produced renderings, but in the middle of the Depression he did produce a set of drawings and poems proposing a new version of Manhattan, which Koolhaas studied at the Avery Library. The 1929 *The Metropolis of Tomorrow* was reprinted by Princeton Architectural Press in New York in 1986.

19. While only black-and-white photographs survive, https://www.diegorivera.org/man-at-the-crossroads.jsp offers a colorized version of the original. See also Catha Paquette, *At the Crossroads: Diego Rivera and His Patrons at MoMA, Rockefeller Center, and the Palace of Fine Arts* (Austin: University of Texas Press, 2017).

20. The museum offers full reproductions of the murals at https://www.dia.org/art/collection/object/detroit-industry-murals-58537. See also Linda Bank Downs, *Diego Rivera: The Detroit Industry Murals* (New York: W. W. Norton, 2016). For a sense of the impact of the murals when they were painted I also rely on the memories of my mother, Sarah Betsky Zweig, who as an art student watched Rivera execute the commission and as the member of a family of labor organizers was aware of its impact on the city's strong labor culture.

21. Koolhaas, *Delirious New York*, 294.

22. Ibid., 298. The monument is properly called the Franklin D. Roosevelt Four Freedoms Park.

23. Ibid., 304.

24. Ibid., 307ff.

25. Most of the drawings for this project are held by The Museum of Modern Art in New York. The text is not available through the Office for Metropolitan Architecture or MoMA, but can be found on several sites; see chrome-extension://efaidnbmnnnibpcajpcglclefindmkaj/viewer.html?pdfurl=https%3A%2F%2Fbibliodarq.files.wordpress.com%2F2014%2F09%2Fkoolhaas-r-exodus.pdf&clen=324850&chunk=true.

26. Ibid., n.p.

27. Ibid.

28. Ironically, in 2017 Ellen van Loon, one of OMA's partners, was appointed by the Dutch government to make sense of the mess that resulted. She also, however, ran into political opposition that made her work impossible and she was fired in 2019.

29. For a thorough analysis of this 1980 design, see Elena Martínez-Millana and Andrés Cánovas Alcazar, "The Panopticon Prison as a 'Social Condenser': The Study of the Project for De Koepel Prison by Rem Koolhaas/OMA (1979–1988)," *Frontiers of Architectural Research* 11 (2022), 31–52.

30. For the Pearl River delta, see *The Great Leap Forward* (with Chuihua Judy Chung and Jeffrey Inaba) (Cologne: Taschen, 2002); the work on Lagos was released as a DVD (https://submarinechannel.com/lagos-wide-close/#:~:text=First%20released%20in%202004%20on,improved%20features%2C%20of%20course): *Countryside: A Report* (Cologne: Taschen, 2020).

31. Koolhaas's collaboration with Prada is the most long-lasting and extensive, ranging from the design of several stores in New York and Los Angeles, to consulting on branding issues, to the design of actual clothes and accessories. OMA has also overseen the company's Foundation building complex in Milan.

32. Rem Koolhaas, *Euralille: The Making of a New City Center* (Basel: Birkhäuser, 1996). In addition to the sources cited above, the classic compendium of Koolhaas's thoughts and work remains his *S,M,X,XL* (New York: Monacelli Press, 1995).

33. In many ways, van Lieshout acted as Koolhaas's dark twin, acting out some of his most extreme sexual and political fantasies. The project for Antwerp, *Slave City*, was published by the Museum Folkwang Essen as a book in 2008 and by Albion Gallery in London in the same year. See also Atelier van Lieshout, *Atelier van Lieshout* (Rotterdam: NAi Publishers, 2007).

34. See Vincent van Rossem, *Het Algemeen Uitbreidingsplan Amsterdam; Geschiedenis en Ontwerp* (Rotterdam: NAi Publishers, 1993). Van Eesteren collected his general ideas on urbanism in 1928 in *The Idea of the Functional City* (Rotterdam:

NAi Publishers, 1998). The original drawings are held at the New Institute, Rotterdam

35. The classic discussion of this situation is Auke van der Woud's *Een Nieuwe Wereld: Het Onstaan van het Moderne Nederland* (Amsterdam: Uitgeverij Bert Bakker, 2006).

36. Ben van Berkel and Caroline Bos, *Move* (Amsterdam: UN Studio, 1999).

37. Ibid., vol. 1, 22–23.

38. Ibid., 24.

39. Ibid., 29.

40. Ibid., 30

41. Ibid.

42. Ibid., 31.

43. Ibid., vol. 3, 15.

44. Ibid., 16.

45. The firm continued to develop this diachronic facade for buildings in Asia in following years.

46. The relationship between Maas and Koolhaas has long been a fraught one. Although Maas acted as project architect on several important OMA commissions in the early 1990s, upon founding MVRDV he was the recipient of continual invective and accusations of plagiarism by Koolhaas and his acolytes.

47. The most complete compendium of works by MVRDV is the frequently updated *MVRDV Buildings* by Andreas and Ilka Ruby (Rotterdam: NAi010 Publishers, 2016).

48. MVRDV, *KM3: Excursions on Capacities* (Barcelona: ACTAR, 2005).

49. MVRDV, *Costa Iberica* (Barcleona: ACTAR, 1998).

50. MVRDV, *The Regionmaker RheinRuhrCity* (Berlin: Hatje Cantz, 2003).

51. MVRDV, *Metacity Datatown* (Rotterdam: NAi Publishers, 1999).

52. Ibid., 18.

53. The project was produced for an exhibition at Gallery Stroom in The Hague in 2000. When a maverick politician running for prime minister, Pim Fortuyn, touted it as a good idea, he was assassinated by a self-proclaimed eco-warrior.

54. Kees Christiaanse, Tim Rieniets, and Jennifer Sigler, *Open City: Designing Coexistence* (Nijmegen: SUN Architecture, 2009). Christiaanse first applied his system to the Wijnhaven area of Rotterdam. See Paul Groenendijk, *The Red Apple and Wijnhaven Island* (Rotterdam: 010 Publishers, 2009), 40–49.

55. It is for this reason that I here do not discuss the major contributions of writers such as Saskia Sassen to understanding the relationships between capital, form, and urbanism at a large scale. For the most succinct and clearest discussion of such, see her *The Global City: New York London Tokyo* (Princeton: Princeton University Press, 2001).

56. Benjamin H. Bratton, *The Stack: On Software and Sovereignty* (Cambridge, MA: MIT Press, 2016; Kindle edition).

57. Ibid., loc. 497.

58. Ibid., loc. 433.

59. Ibid., loc. 339.

60. Ibid., loc. 6315.

61. Ibid., loc. 371.

62. Ibid., loc. 616.

63. Ibid., loc, 1622.

64. Ibid., loc. 3405.

65. W. J. T. Mitchell, *Image Science: Iconology, Visual Culture, and Media Aesthetics* (Chicago: University of Chicago

Press, 2015; Kindle edition), 118.

66. Bratton, *The Stack*, loc. 4649.

67. Ibid., loc. 4774.

68. Ibid., loc. 6515.

69. Ibid., loc. 6184.

70. Ibid., loc. 7235.

Chapter 8

1. Without attempting to summarize the sources and definitions of this reality, I would only point out the emergence in the 1980s and 1990s in the United States of certain books addressed to a more general audience that attempted to do so. Widely read by artists, architects, and designers, they included Ilya Prigogine, *From Being to Becoming: Time and Complexity in the Physical Sciences* (London: W. H. Freeman, 1981) and *Order out of Chaos: Man's New Dialogue with Nature* (New York: Bantam Books, 1984), and in particular Martin Hofstadter, *Gödel Escher Bach: An Eternal Golden Braid* (New York: Basic Books, 1979). Similar books also helped create a more general awareness in Europe and elsewhere.

2. Zygmunt Baumann, *Liquid Modernity* (2000; Cambridge, UK: Polity Press, 2012).

3. Ibid., 8.

4. Ibid.

5. Ibid., 49, 82.

6. Ibid., 37.

7. Ibid., 128.

8. Ibid., 197.

9. I make these statements here based on lived experience, but for a good summary of the development of the internet and its impact, see Brian McCullough, *How the Internet Happened: From*

Netscape to the iPhone (New York: Liveright, 2018).

10. Gilles Deleuze and Félix Guattari, *Anti-Oedipus: Capitalism and Schizophrenia*, trans. Robert Hurley, Mark Seem, and Helen R. Lane (1972; Minneapolis: University of Minneapolis Press, 1983).

11. Gilles Deleuze and Félix Guattari, *A Thousand Plateaus: Capitalism and Schizophrenia*, trans. Brian Massumi (1980; Minneapolis: University of Minnesota Press, 1987).

12. Ibid., 30.

13. The relationship to the work of Judith Butler here is of particular interest. In her seminal books *Gender Trouble: Feminism and the Subversion of Identity* (New York: Routledge, 1990) and especially *Bodies That Matter: On the Discursive Limits of Sex* (New York: Routledge, 1993), she argues for abandoning the "border wars" of the human body and understanding the continuity of social mechanisms past singular bodies.

14. Deleuze and Guattari, *A Thousand Plateaus*, 36.

15. Ibid., 50.

16. Ibid., 70.

17. Ibid., 56.

18. Ibid., 63.

19. Deleuze and Guattari, *Anti-Oedipus*, 141, 155.

20. Deleuze and Guattari, *A Thousand Plateaus*, 27.

21. There is even a *Deleuze and Guattari for Architects*, written by the architect and architectural historian Andrew Ballantyne (New York: Routledge, 2007).

22. Gilles Deleuze, *The Fold: Leibniz and the Baroque*, trans. Tom Conley (1988; London: Athlone Press, 1993).

23. Ibid., 3.

24. Ibid., 238.

25. Ibid., 27.

26. Ibid., 30.

27. Ibid., 32.

28. Ibid., 67.

29. Ibid., 123.

30. Ibid., 123–124.

31. Ibid., 124.

32. Ibid., 126.

33. Ibid., 137.

34. Ibid., 130ff.

35. The phenomenon has certainly been picked up by social media, were sites such as Dezeen.com collect examples and Pinterest invites contributions. It has also been remarked upon by the theorist Jeffrey Kipnis in his lectures. A serious treatment of the figure is not currently available.

36. Several of the early projects that are of particular note in this respect are collected in the catalog of the Whitney exhibition I coedited with K. Michael Hays, *Scanning: The Aberrant Architectures of Diller + Scofidio* (New York: Whitney Museum of Art, 2003). Also of note is Elizabeth Diller's and Ricardo Scofidio's *Flesh: Architectural Probes* (New York: Princeton Architectural Press, 1998). The firm also makes quite full archives of their projects available at their site dsrny.com.

37. Manuel De Landa: *War in the Age of Intelligent Machines* (New York: Swerve Editions/ Zone Books, 1991).

38. Manuel De Landa, *A Thousand Years of Nonlinear History* (New York: Swerve Editions/Zone Books, 1997).

39. De Landa: *War in the Age of Intelligent Machines*, 121.

40. Ibid., 133.

41. Ibid., 28.

42. Graham Harman, *Towards Speculative Realism*

(London: John Hunt, 2010; Kindle edition), loc. 334.

43. Ibid., loc. 343.

44. Ibid., loc. 676.

45. For kitbashing, a phrase the architect uses frequently, see Mark Foster Gage, *Architecture in High Resolution* (San Francisco: ORO Publications, 2022), 235. For the skyscraper project, see Mark Foster Gage, *Projects and Provocations* (New York: Rizzoli International, 2018), 82–91. See also Kutan Ayata and Michael Young, *The Estranged Object* (Chicago: Treatise Press, 2015), 43.

46. Lukáš Likavčan, *Introduction to Comparative Planetology* (Moscow: Strelka Press, 2019; Kindle edition), loc. 80.

47. Ibid., loc. 917.

48. Ibid., loc. 1120.

49. Ibid., loc. 1166

50. Ibid., loc. 12290.

51. Ibid., loc, 715.

52. Ian Bogost, *Alien Phenomenology, or What It's Like to Be a Thing* (Seattle: Amazon Digital Services, 2013), loc. 516.

53. Ibid., loc. 2561.

54. Ibid., loc. 2573.

55. Ibid., loc. 2676.

56. Timothy Morton, *Hyperobjects: Philosophy and Ecology after the End of the World* (Minneapolis: University of Minnesota Press, 2013; Kindle edition), loc. 112.

57. Ibid., loc. 3057.

58. Ibid.

59. The two most significant publications to come out of this period at Rice are Michael Bell and Sze Tsung Leong, eds., *Slow Space* (New York: Monacelli Press, 1998), which provides trenchant analyses of the changing spatiality of the world of sprawl, and Albert Pope's *Ladders* (New York: Princeton

Architectural Press, 1996), which begins the process of developing a formal analysis of sprawl.

60. Lars Lerup, "Stim & Dross: Rethinking the Metropolis," *Assemblage*, no. 25 (December 1994), 81–101.

61. Ibid., 86.

62. Ibid., 87.

63. Ibid., 88.

64. Ibid., 89.

65. Ibid., 90.

66. Ibid., 84.

67. Ibid.

68. Alan Berger, *Drosscape: Wasting Land in Urban America* (New York: Princeton Architectural Press, 2006).

69. William Gibson, *Mona Lisa Overdrive* (London: Victor Gollancz, 1988).

70. Lerup, "Stim & Dross," 94.

71. Ibid.

72. Ibid., 98.

73. Lars Lerup, *One Million Acres and No Zoning* (London: Architectural Association, 2011), 247ff.

74. Ibid., 247.

75. Ibid., 248.

76. Lerup, "Stim & Dross," 84.

Chapter 9

1. For a collection of discussion on her work, see David van Zanten, ed, *Marion Mahony Reconsidered* (Chicago: University of Chicago Press, 2011), and in particular Alice T. Friedman, "Girl Talk: Feminism and Domestic Architecture in Frank Lloyd Wright's Oak Park Studio," 23–50.

2. Aaron Betsky, *Building Sex: Men, Women, and the Construction of Sexuality* (New York: William Morrow, 1993).

3. Both women have been reconsidered extensively in recent years. Lilly Reich received a monographic exhibition at the Museum of Modern Art, with much of its material available in Matilda McQuaid and Magdalena Droste, *Lilly Reich, Designer and Architect* (Minneapolis: University of Minnesota Press, 2011). Similarly, the most complete overview of Perriand's work is the catalog of an exhibition organized by the Fondation Louis Vuitton, *Charlotte Perriand: Inventing a New World* (Paris: Gallimard, 2019).

4. There are many books on the emerging architecture scenes around the world, but I would mention in particular the invaluable survey of new architecture in Africa: Adil Dalbai and Philipp Meuser, eds., *Sub-Saharan Africa Architectural Guide* (Berlin: DOM Publishers, 2021).

5. The most recent book on his work is the first in what is intended to be a series called Minorities in Architecture: Dreck Spurlock Wilson, *Julian Abele: Architect and the Beaux Arts* (New York: Routledge, 2019).

6. Nikole Hannah-Jones, *The 1619 Project: A New Origin Story* (New York: One World, 2021), xvii.

7. The locus classicus for this discussion remains Edward Said's *Orientalism*, though it focuses on the perception of cultures from the Middle East and Asia (New York: Vintage Books, 1978).

8. Thomas Pynchon, *The Crying of Lot 49* (New York: J. B. Lippincott, 1965).

9. Thomas Pynchon, *Vineland* (1997; New York: Penguin, 2012).

10. Ishmael Reed, *Mumbo Jumbo* (1972; New York: Avon Books, 1978).

11. Ibid., n.p.

12. Ibid., 188ff.

13. Though I am reluctant to use Wikipedia as a source, its entry in this case is quite complete: https://en.wikipedia.org/wiki/Dionysus. Of particular note is the manner in which Euripides uses Dionysus in his *Bacchae*, as an outsider who destroys family and clan bounds while taking his converts both out of the city and out of moral structures.

14. Ibid., 54–56.

15. His most influential works were *The Wretched of the Earth*, trans. Richard Philcox (1961; New York: Grove Press, 2004), and *Black Skin, White Masks*, trans. Charles Lam Markmann (1952; London: Pluto Press, 2017).

16. Alex Zamalin, in his *Black Utopia: The History of an Idea from Black Nationalism to Afrofuturism* (New York: Columbia University Press, 2018), traces the formation and dissolution of various utopias and dystopias founded in the Black American experience. For a discussion of the movement in literature, see Ytasha Womack, *Afrofuturism: The World of Black Sci-fi and Fantasy Culture* (Chicago: Chicago Review Press, 2013). For influences of contemporary design, see Cher Potter, DK Osseo-Asare, and Mugendi K. M. M'Rithaa, "Crafting Spaces between Design and Futures: The Case of the Agbogbloshie Makerspace Platform," *Journal of Future Studies* 23 (March 2019), 39–56.

17. Set designer Ruth E. Carter received a great deal of favorable press for her "afrofuturist" designs, though they

seem equally rooted in post-modern visions produced by white architects.

18. Thompson was one of my teachers at Yale and has influenced much of my research in this area. His canonical texts are *African Art in Motion: Icon and Art* (Berkeley: University of California Press, 1974) and *Flash of the Spirit: African and Afro-American Art and Philosophy* (New York: Random House, 1983). See also his later *Aesthetic of the Cool: Afro-Atlantic Art and Music* (London: Periscope Publishing, 2011).

19. John Leland, *Hip: The History* (New York: HarperCollins, 2004).

20. Ibid., 10.

21. Ibid., 9.

22. Ibid., 47.

23. Ibid., 55.

24. Ibid., 185.

25. Ibid., 328.

26. Ibid., 356.

27. Randy Fertel, "Mapping Improvisation: The Role of Call and Response in Urban Planning," *Common Edge* January 4, 2022, https://commonedge.org/mapping-improvisation-the-role-of-call-and-response-in-urban-planning/, n.p.

28. Ibid.

29. Ibid.

30. See the author Leland quotes, Lewis Hyde, *Trickster Makes This World: Mischief, Myth and Art* (New York: North Point Press, 1998).

31. The crossroads also figures in other cultures, of course. However, in the European tradition the crossroads is more purely a place of intersection, tracing its roots back to the intersection of the *cardo* and *decumanus* of Roman settlements. In general,

there has not been a serious study of the crossroads phenomenon from a spatial perspective.

32. https://www.lyrics.com/lyric/3433999/Lou+Reed/Intro-Sweet+Jane.

33. https://www.lyrics.com/lyric/7279869/Cream/Crossroads.

34. https://www.azlyrics.com/lyrics/bonethugsnharmony/thacrossroads.html.

35. The relation between roads and frontage, and how these spaces should be treated as "serious" and very American landscapes, was a continual concern of Jackson's. See in particular his 1994 essay "Truck City" in John Brinckerhoff Jackson, *Landscape in Sight: Looking at America*, ed. Helen Lefkowitz Horowitz (New Haven: Yale University Press, 1997), 255–268.

36. Darell Wayne Fields, *Architecture in Black: Theory, Space and Appearance* (2000; London: Bloomsbury Press, 2020), 113.

37. Ibid., 129.

38. Ibid., 202.

39. Shelton Waldrep, *The Dissolution of Place: Architecture, Identity, and the Body* (2013; New York: Routledge, 2016), 123. Waldrep's investigation of the "edges" of architecture to a certain extent parallel the concerns of this book.

40. Homi K. Bhabha, *The Location of Culture* (London: Taylor & Francis, 2012; Kindle edition), 158.

41. Ibid., 157.

42. Ibid., 2.

43. Ibid., 5.

44. Ibid., 7.

45. Ibid., 5.

46. Ibid., 13.

47. Ibid., 14.

48. Ibid., 26.

49. Ibid., 37.

50. Ibid., 89.

51. Ibid., 251.

52. Ibid., 265.

53. Ibid., 330.

54. I am here thus again not focusing on the reassessment of the place of women in the discipline, which is currently a very active field. I would point to the International Archives of Women in Architecture at the university where I teach, Virginia Tech.

55. Luce Irigaray, *The Sex Which Is Not One*, trans. Catherine Porter (1977; Ithaca: Cornell University Press, 1985), 24.

56. Ibid., 28.

57. Ibid., 31.

58. Ibid., 78.

59. Ibid., 111.

60. One particular image that sums up this possibility is the monster leviathan-like collage the artist calling himself Jess (full name Jess Collins) created in his major opus, *Narkissos* (1976–1991), in the collection of the San Francisco Museum of Modern Art (https://www.sfmoma.org/artwork/96.492/).

61. The full range of the architecture Ludwig II commissioned has only recently been exposed in *The Architecture under King Ludwig II: Palaces and Factories*, by Andres Lepik and Katrin Bäumler (Basel: Birkhäuser, 2018).

62. Though there are many descriptions of Fonthill Abbey, and queer readings of Beckford's writing, there is no thorough analysis of Fonthill Abbey in print.

63. The queerness of Kotera is not "established," though, according to Czech historian Ladislav Zigmund-Lender, it

is assumed. See also Daniela Karasova, Petr Krajci, and Vladimir Slapeta, *Jan Kotera: The Founder of Modern Czech Architecture* (Prague: Kant Publishers, 2003).

64. Aaron Betsky, *Queer Space: The Spaces of Same Sex Desire* (New York: William Morrow, 1995).

65. For the most complete survey of their work, see Linda Yablonsky, Martin Herbert, Cornelia H. Butler, and Jason Schmidt, *Elmgreen & Dragset* (London: Phaidon Press, 2019).

66. Andrés Jacque, "Grindr Archiurbanism," *Log* 41 (Fall 2017), 74–84.

67. Ibid., 76.

68. Ibid., 77.

69. Ibid., 78, 84.

70. "Call Me by My Name," https://www.youtube.com /watch?v=nsXwi67WgOo; "This Is What I Want."

Chapter 10

1. Of these sites, I would hold up Shibuya Crossing as the most intense three-dimensional collage currently to be experienced. The tightness of the physical space, combined with the presence of the large train station as well as the scale and quantity of advertising signs, all of them surrounding an intricate retail and restaurant carpet at ground level, is, as far as I know, unparalleled. For a collection of treatments of such spaces, see Zlatan Krajina and Deborah Stevenson, *The Routledge Companion to Urban Media and Communication* (London: Taylor & Francis, 2019).

2. Reinhold Martin, *Utopia's Ghost: Architecture and Postmodernism, Again* (Minneapolis:

University of Minnesota Press, 2010), xxi.

3. It is interesting to note that this computer-inspired fluidity has become the favored form of large corporate structures, especially in Asia. Whether there is an intrinsic connection to the logic of how computers guide the production of buildings, especially since the advent of BIM (building information management) software that seeks to create a seamless flow from idea to construction, is very much open to question.

4. I would argue that there was a particular moment, between roughly 1998 and 2001, when the technology available to designers let them experiment in ways that were not yet too restricted by economic imperatives. I collected some of these sites for the San Francisco Museum of Modern Art, where some of them can be accessed at sfmoma.org (for instance http://www.rsub.com/rsub /corp_news5.html).

5. I speculated on these issues in "A Virtual Reality: The Legacy of Digital Architecture," *Artforum International* 46, no. 1 (September 2007), 440–449.

6. We are still awaiting a serious analysis of the relationship between architecture and gaming environments, both in terms of the influence of playing in these worlds on architects now coming of age, and in terms of how architects trained at such avant-garde-focused schools as the Southern California Institute of Architecture who are now working as game designers

might influence that aesthetic. The most promising work is being done by Ryan Scavnicky; see https:// archinect.com/news/article /150197127/let-s-talk-about -the-architecture-of-super -mario-bros.

7. Greg Lynn, *Animate Forms* (New York: Princeton Architectural Press, 1999), 1. See also his *Folds, Bodies and Blobs: Collected Essays* (Brussels: La Lettre Volée, 1998).

8. Lynn, *Animate Forms*, 5.

9. Patrik Schumacher, "Parametricism and the Autopoiesis of Architecture," *Log* 21 (Winter 2011), 2. See also his magnum opus, *The Autopoiesis of Architecture*, 2 vols. (London: John Wiley & Sons, 2011–2012).

10. Schumacher, "Parametricism and the Autopoiesis of Architecture," 10.

11. Some of this work was collected by Georg Flachbart and Peter Weibel in their *Disappearing Architecture: From Real to Virtual to Quantum* (Basel: Birkhäuser, 2005).

12. Asymptote in particular experimented throughout the late 1990s and early 2000s with "M Scapes," hybrids between digitally produced sculptures and projections. They also produced a digital "double" of the New York Stock Exchange as early as 1997. This work was collected in their monograph *Flux* (London: Phaidon, 2002).

13. Robert Reich, *The Work of Nations: Preparing Ourselves for 21st Century Capitalism* (New York: Vintage Books, 1992).

14. Lev Manovich, *Software Takes Command* (New York: Bloomsbury Academic, 2013), 2.

15. Ibid., 32.

16. Ibid., 273.

17. Ibid., 335.

18. Adam Fure, "Aesthetic Postdigital," in Mark Foster Gage, ed., *Aesthetics Equals Politics: New Discussions across Art, Architecture, and Philosophy* (Cambridge, MA: MIT Press, 2019), 111.

19. Ibid., 119.

20. Chandler Ahrens and Aaron Sprecher, *Instabilities and Potentialities: Notes on the Nature of Knowledge in Digital Architecture* (London: Taylor & Francis, 2019; Kindle edition), 1.

21. Ibid., 12.

22. Ibid., 13–14.

23. Ibid., 88.

24. It is interesting that some critics have noted the roots of the use of the word in the work of the conservative critic Kenneth Frampton: https://urbannext.net /topographic-architecture/.

25. For a critical assembly of such installations, see Ila Berman and Douglas Burnham, *Expanded Field: Architectural Installation beyond Art* (San Francisco: ORO Editions, 2016).

26. It is interesting to note that most young architects today grew up in a world formed to a remarkable extent by the *Harry Potter* books and extended through such television shows as *Game of Thrones*, so that they accept this sort of "organic" reality as an ideal. It has made my own students prefer neo-Gothic architecture, but it remains to be seen what the long-term effect of this phenomenon will be. For an analysis of the architecture in these books, see Holland Young, "Building Fiction: The Architecture of Narrative in Harry Potter," master's thesis, University of Waterloo, 2015.

27. For an argument grounding this work in architecture history, see Manuel Gausa and Jordi Vivaldi, *The Threefold Logic of Advanced Architecture: Conformative, Distributive, and Expansive Protocols for an Informational Practice 1990–2020* (Barcelona: ACTAR, 2021).

28. See http://www.philip beesleyarchitect.com/.

29. Lars Spuybroek, *Grace and Gravity: Architecture of the Figure* (London: Bloomsbury Visual Arts, 2020), 2.

30. Ibid., 6, 4, 3.

31. Ibid., 16–17.

32. Ibid., 65.

33. Ibid., 75.

34. Ibid., 125; see also the earlier discussion of the work of Mark Wigley and Anthony Vidler in chapter 6 of this book.

35. Ibid., 95.

36. Ibid., 97.

37. This plasticity was first pointed out as being tied into the technology of new materials, as well as streamlining, by Jeffrey Meikle in *American Plastic: A Cultural History* (New Brunswick: Rutgers University Press, 1997), 9.

38. Spuybroek, *Grace and Gravity*, 306.

39. Ibid., 316.

40. Ibid., 257.

41. Nigel Coates, *Ecstacity* (London: Laurence King, 2003).

42. Ibid., 103.

43. Ibid., 104.

44. In his autobiography, Coates gives Ecstacity even more of a sense of being a leviathan: "Like those warehouses, the Ecstacity concept of renewal seemed prescient because it evolved from the city where we already lived. Experimentation and preservation could work hand in hand, and reach toward the city as a complex paradigm of the human body, complete with its own bone structure, muscles, organs, metabolism and circadian rhythm. This symbolic, collective body was also our body, your body, my body. It should never be superficial or wasteful, but could, and should, sustain sensual rewards and emotions. As though reimagining Le Corbusier's Modulor Man for our times, the human condition, and not buildings, should always be the driving force behind the metropolis." Nigel Coates, *Nigel Coates* (London: RIBA Publishing, 2022), 90.

45. Jordi Vivaldi, "Towards a Limit-Space Architecture: After the Architectural Rhizome," in Gausa and Vivaldi, *The Threefold Logic of Advanced Architecture*, 367.

46. The importance of codes is overwhelming. Not only are building codes and regulations, including life and safety codes, so extensive that they severely constrain design, but these rules extend into zoning and other ways of defining what can be built. Even more defining are financial codes that "value-engineer" any architecture out of buildings. And, of course, all buildings are defined by the computer codes through which they are designed, which add their own restrictions.

47. John May, *Signal. Image. Architecture.* (New York: Columbia Books on Architecture and the City, 2019).

48. Kelly Bair, Kristy Balliet, Adam Fure, and Kyle Miller, *Possible Mediums* (Barcelona: Actar, 2018), 17.

49. Ibid., 19.

50. Ibid., 20.

51. May, *Signal. Image. Architecture*, 87.

52. Galo Canizares, *Digital Fabrications: Designer Stories for a Software-Based Planet* (San Francisco: Applied Research + Design Publishing, 2019), 114.

53. Ibid., 116.

54. Ibid., 145.

55. Carrie Lambert-Beatty, "Make-Believe: Parafiction and Plausability," *October* 129 (Summer 2009), 4.

56. Ibid., 72–73.

57. Ibid., 84.

58. Kutan Ayata and Michael Young, *The Estranged Object* (Chicago: Treatise, 2015), 71.

59. Michael Young, "The Art of the Plausible and the Aesthetics of Doubt," *Log* 41 (Fall 2017), 39.

60. Ibid., 42.

61. Cruz Garcia and Nathalie Frankowski, *Narrative Architecture: A Kynical Manifesto* (Rotterdam: nai010 Publishers, 2019), 80.

62. Ibid., 102.

63. *Possible Mediums*, 170–171.

64. One is reminded also of W. J. T. Mitchell's observation, "If the digital age is the age of calculation, control, and programmability, it must be recognized equally as the age of incalculability, loss of control, and unprogrammability. That is why, right alongside the rhetoric of cybernetics, the "science of control," we are encountering the uncanny return of the archaic language of vitalism and animism in contemporary image theory. The digital age is the convergence of technoscience with magic—with new forms of totemism, fetishism, and idolatry." W. J. T. Mitchell, *Image Science: Iconology, Visual Culture, and Media Aesthetics* (Chicago: University of Chicago Press, 2015; Kindle edition), 163.

65. *Possible Mediums*, 19.

66. Andrew Atwood, *Not Interesting: On the Limits of Criticism in Architecture* (San Francisco: ORO Editions, 2018), 13.

67. Ibid., 23.

68. Ibid., 200.

69. Anthony Dunne and Fiona Raby, *Speculative Everything: Design, Fiction, and Social Engineering* (Cambridge, MA: MIT Press, 2013), 2–3.

70. DK Osseo-Asare and Yasmine Abbas, "Waste," *AA Files* 76 (2019), 179–183.

71. https://www.visionary-architecture.com/.

Notes

Index

Page numbers in italic indicate illustrations.

Index

Index

The MIT Press would like to thank the anonymous peer reviewers who provided comments on drafts of this book. The generous work of academic experts is essential for establishing the authority and quality of our publications. We acknowledge with gratitude the contributions of these otherwise uncredited readers.

This book was set in Haultin by Jen Jackowitz. Printed and bound in the United States of America.

Library of Congress Cataloging-in-Publication Data
Names: Betsky, Aaron, author.
Title: The monster leviathan : anarchitecture / Aaron Betsky.
Description: Cambridge, Massachusetts : The MIT Press, [2023] |
 Includes bibliographical references and index.
Identifiers: LCCN 2022059069 | ISBN 9780262546331 (paperback)
Subjects: LCSH: Architecture—Philosophy—History—20th century. |
 Architecture—Philosophy—History—21st century.
Classification: LCC NA2500 .B4746 2023 | DDC 720.1—dc23/
 eng/20230222
LC record available at https://lccn.loc.gov/2022059069

10 9 8 7 6 5 4 3 2 1

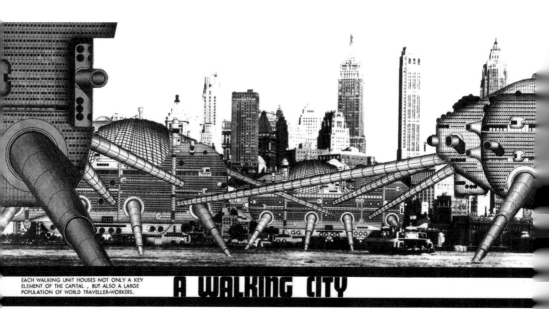

EACH WALKING UNIT HOUSES NOT ONLY A KEY
ELEMENT OF THE CAPITAL , BUT ALSO A LARGE
POPULATION OF WORLD TRAVELLER-WORKERS.

A WALKING CITY